Reader's Digest
COMPLETE DRAWING COURSE

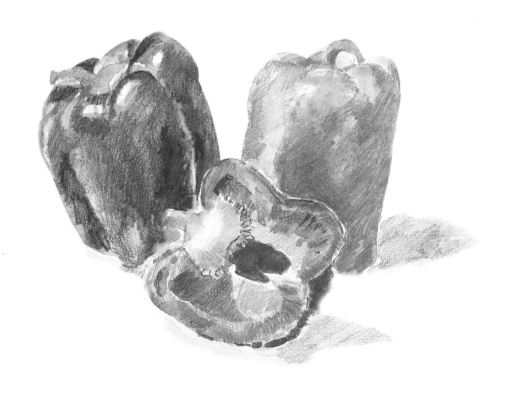

A READER'S DIGEST BOOK

Published by The Reader's Digest Association Limited
11 Westferry Circus
Canary Wharf
London
E14 4HE

www.readersdigest.co.uk

We are committed to both the quality of our products and the services we provide
to our customers.
We value your comments, so please feel free to contact us on 08705 113366, or via
our website at www.readersdigest.co.uk
If you have any comments about the content of our books, you can contact us at
gbeditorial@readersdigest.co.uk

ISBN 0 276 42743 2

A CIP data record for this book is available from the British Library

This book was designed and edited by De Agostini based on the partwork
Step-by-Step Art Course

Produced by Amber Books
Bradley's Close
74–77 White Lion Street
London N1 9PF
www.amberbooks.co.uk

Printed in Singapore

PICTURE CREDITS
Bridgeman Art Library: 186 (br) – Hermitage, St Petersberg: 166 (nr)
Adrian Taylor: 11
George Taylor: 7–10

CONTRIBUTING ARTISTS
Chris Braley: 12–20
Tig Sutton: 245–252
Michael Warr: 21–37
Albany Wiseman: 38–165, 166 (tl, tr, cl), 167–185, 186 (t), 187–244, 253–256

Reader's Digest

COMPLETE
DRAWING
COURSE

*60 projects, practical
lessons, expert hints and tips*

Published by the Reader's Digest Association Limited
London New York Sydney Montreal

CONTENTS

PENS FOR DRAWING 6

CUTTING A QUILL PEN 10

ANYONE CAN DRAW 12

DRAWING WITH A GRID 17

SHADOWS IN STILL LIFE 21

USING PATTERNED BACKGROUNDS 25

DRAWING WITHOUT OUTLINES 29

DRAWING FLOWER HEADS 34

WHITE ON WHITE 38

SURFACE PATTERN 43

DRAWING PATTERNED FABRIC 48

STILL LIFE IN COLOURED PENCILS 52

STUDIES OF LEEKS 57

COLOURFUL SWEETS 61

STILL LIFE OF PEPPERS 65

A JAR OF HUMBUGS 69

KITCHEN IMPLEMENTS 73

'PAINTING' WITH GRAPHITE 77

DRAWING A PERFECT CHAIR 81

DRAWING WITH FIBRE-TIPPED PENS 85

CHAIRS IN TONE 89

HOLIDAY MEMORIES 93

OLD TRAINER IN PEN AND WASH 97

BUTTON TIN IN FELT-TIP PEN 101

CORNER OF AN ARTIST'S STUDIO 103

HAT COLLECTION 107

REFLECTIONS IN A CURVED SURFACE 111

LETTERING ON CURVED SURFACES 115

CLASSICAL WALL PLAQUE 119

LEAVES IN CLOSE-UP 123

FABRIC TEXTURES IN CHARCOAL 127

REFLECTIONS IN GLASS 131

KITCHEN STOOLS IN CHARCOAL 135

STUDY OF A SKULL 139

DRAWING A BUILDING 143

FLOWERS IN LINE AND WASH 147

FORESHORTENING THE FIGURE 151

DRAWING AROUND THE FORM 155

DRAWING LIGHT OUT OF DARK 159

ONE SUBJECT, TWO STYLES 163

CHOOSING THE BEST FORMAT 169

LONDON STREET IN PERSPECTIVE 173

LOOKING AT ANATOMY 179

DRAWING A NUDE FIGURE 183

CITRUS FRUITS AND MELONS 188

USING GRAPHITE STICKS 191

SCRAPERBOARD HARBOUR SCENE 195

ADDING COLOUR TO SCRAPERBOARD 199

CAPTURING PERSONALITY 204

DRAWING THE HEAD 208

SHELLS IN PEN AND WASH 212

HILLY STREET IN FRANCE 215

USING A BAMBOO PEN 219

SELF PORTRAIT 224

COMPOSING CARPENTRY TOOLS 228

PORTRAIT OF A GIRL 232

DECORATIVE DETAILS 236

GAME OF CHESS 240

BIRD STUDY IN COLOURED PENCILS 245

TONAL DRAWING 249

EXPERIMENTAL STILL LIFE 253

Pens for drawing

The range of pens available to the artist is vast and inspiring, ranging from traditional dip pens made from quill, bamboo or reed to fibre-tipped pens in many shapes, sizes and colours. Here we review the choices available.

Your choice of pen is very personal and most artists have a favourite. However, it is worth knowing what is on the market because you might have special requirements from time to time.

Dip pens are the most basic type. As their name suggests, they are loaded by being dipped into ink and have to be recharged at intervals. At the other end of the scale is an ever-expanding range of innovative markers and brush pens which come in a vast array of colours.

Traditional dip pens

These are made from quills, bamboo and reed. Quill pens are cut from the flight feathers of birds such as swans, ravens, ducks or geese (see pages 10-11 to find out how to cut a quill), and produce a slightly scratchy line. They are particularly popular with calligraphers. Bamboo pens are very tough and vary in size depending on the piece of bamboo used. Reed pens are more flexible than bamboo pens, but tend to chip easily. Both reed and bamboo pens are still used in Japanese and Chinese art today.

Metal dip pens

The metal pen has been traced back as far as Roman times, but it wasn't widely used until the nineteenth century, when technical innovations made it possible to mass-produce steel nibs. From this time, steel nibs became more popular than quill, bamboo and reed. Most metal dip pens consist of a shaft or handle into which a separate metal nib is slotted. It is worth experimenting with some of the many different nibs available to discover the marks they are capable of producing and to find out which suits your needs and your style of drawing.

Script pens Old-fashioned script nibs consist of a shaped piece of metal with a slit cut in it. Some have fine or rounded points, while others are chiselled for italic lettering. They are ideal for sketching.

Mapping pens These have slender, straight nibs with very fine drawing points. They are specially designed for detailed work such as technical drawing and map-making.

Lettering pens The nibs used for lettering pens are available in various shapes, which are designed to produce the special serifs, flourishes and ribbon shapes used

VARYING THE LINE WIDTH

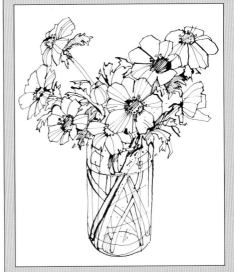

Technical pen
The fine lines produced by a technical pen are ideal for delicate drawings with a lot of detail. Use hatching for darker areas.

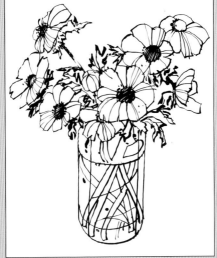

Brush pen
With the flexible tip of a brush pen, you can adopt a more fluid approach, using both thick and thin lines in a sketch.

Marker
A marker with a chisel tip makes thick, bold lines that can fill shapes such as the flowers' stalks with a single stroke.

DIP PENS AND THEIR MARKS

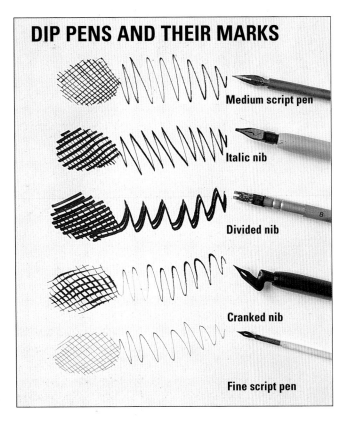

Medium script pen

Italic nib

Divided nib

Cranked nib

Fine script pen

TYPES OF DRAWING PEN

Ⓐ **Ballpoint**
Ⓑ **Fineline ballpoint**
Ⓒ **Chisel-tipped marker**
Ⓓ **Brush pen**
Ⓔ **Fibre-tipped pen**
Ⓕ **Three chisel-tipped markers**
Ⓖ **BiC ballpoint pen**
Ⓗ **Technical pen**
 with nib units

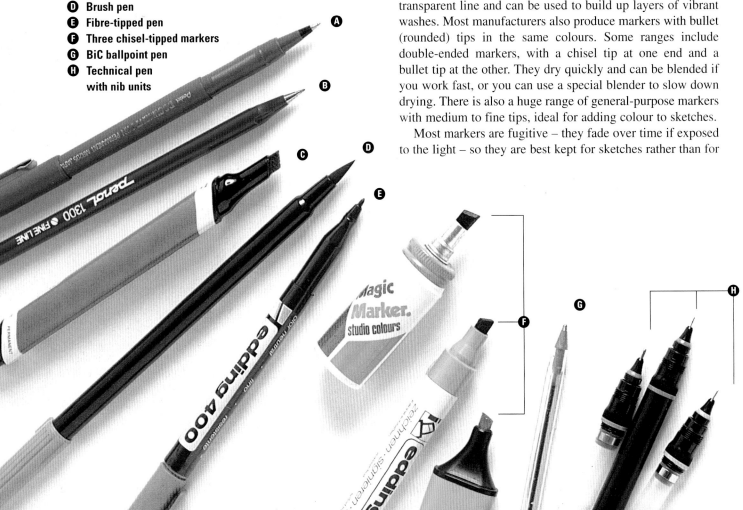

in calligraphy. Nibs consisting of two pieces of metal are designed to hold more ink. Some lettering pens have broad nibs with two or three splits in them, making it possible to produce a wide line. Others are divided, giving parallel lines for calligraphy. Pens for musical notation are cranked (bent at an angle so that the tip of the nib is not in line with the pen shaft), which makes them more springy.

Reservoir pens

These pens contain their own store of ink and are ideal for use on location, as you don't have to carry a bottle of ink with you.
Fountain pens The ink for these pens is carried either in a replaceable cartridge or a refillable, pump-action reservoir. Most are designed for writing, but others are for sketching.
Technical pens Originally designed for illustrators and draughtsmen, these pens produce consistent lines in specific widths. The nib units fit into a holder and can be changed when you require a different line width. Use technical pens with the correct ink, never leave the nib exposed and wash out the units from time to time.
Ruling pens These are also specialist drawing tools. The reservoir is filled using a brush or dropper, and the size of the tip can be adjusted by turning a screw. They give a consistent line and don't have to be recharged as often as dip pens.

Markers and fibre-tipped pens

This category includes a wide and colourful range of pens, some of which are designed for professional applications, while others are intended for everyday use.
Markers Chisel-tipped felt pens, or markers, leave a broad, transparent line and can be used to build up layers of vibrant washes. Most manufacturers also produce markers with bullet (rounded) tips in the same colours. Some ranges include double-ended markers, with a chisel tip at one end and a bullet tip at the other. They dry quickly and can be blended if you work fast, or you can use a special blender to slow down drying. There is also a huge range of general-purpose markers with medium to fine tips, ideal for adding colour to sketches.

Most markers are fugitive – they fade over time if exposed to the light – so they are best kept for sketches rather than for

images that will be displayed. Solvent-based markers should always be used in a well-ventilated space.

Fineliners These allow you to work with more precision, although the tip will eventually become blunt. Some fineliners are available in specific line widths.

Brush pens The tip on a brush pen is longer and more pliable than on other markers, and some ranges have a huge choice of colours. By varying the pressure, you can produce fine, medium or bold strokes. Some double-ended pens have a brush pen on one end and a fine fibre tip on the other.

Ballpoint pens

The first ballpoint pen was invented in 1938 by a Hungarian journalist called Laszlo Biro, who was inspired by the quick-drying, smudge-proof ink used for commercial printing presses. The thicker ink would not flow from an ordinary nib, so he devised a pen with a tiny ball-bearing in its tip. Biro is often used as a generic term to describe ballpoint pens. One of the most popular ballpoint pens today is the BiC, launched by the French Baron Bich in 1950. Ballpoint pens are cheap and convenient, and can be a useful addition to your sketching kit.

Rollerballs These pens work on the same principle as ballpoints, but the ink in them is more like that used in cartridge pens or fibre-tipped pens. It dries quickly by evaporation and does not create blotches as ballpoints sometimes do.

Inks

The main distinction between inks is whether they are waterproof or water-soluble. Waterproof ink allows you to lay a wash over a line without dissolving it, whereas a water-soluble ink will spread and run. Indian ink is the best-known drawing ink – it is black, permanent and waterproof. Coloured waterproof drawing inks are dye-based and not lightfast, so are best used in sketchbooks where they won't be exposed to light for long periods. Waterproof inks should not be used in fountain pens, as they will clog the mechanism.

Liquid watercolours and acrylics Like coloured inks, these can be used with dip pens and are available in a wide array of shades. Liquid watercolours are soluble once dry, while liquid acrylics are not.

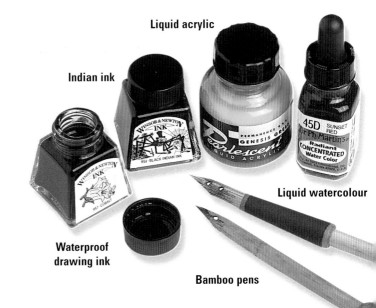

Liquid acrylic

Indian ink

Liquid watercolour

Waterproof drawing ink

Bamboo pens

I Selection of nibs for a dip pen
J Divided nib for parallel lines
K Mapping pen
L Cranked nib for music notation
M Script pen
N Ruling pen
O Sketching fountain pen
P Selection of coloured fibre-tipped pens
Q Bullet-tipped pen
R 3mm (⅛in) chisel-tipped pen
S Fineliner

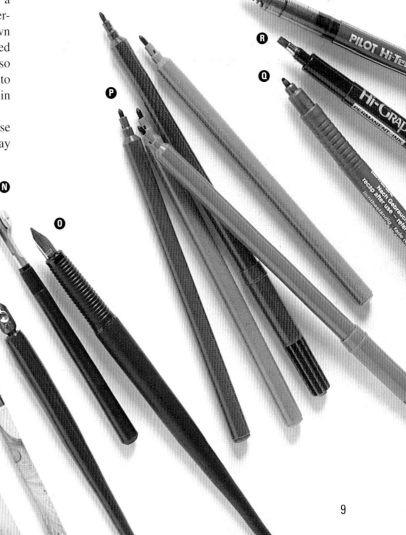

Cutting a quill pen

Learn how to make a pen from a bird's feather and follow in the footsteps of generations of artists and calligraphers. All you need is a sharp knife and a little practice.

The earliest writing implements were made from domestic birds' feathers, mainly because they were easy to get hold of – literally! Demand for quill pens was low, as few people could read or write.

As the population grew and literacy became more widespread, the need for pens increased. By the early nineteenth century, the demand for quills had far outgrown the domestic supply and quills were imported from all over Europe. These quills were generally known as Hamburg quills, after the German port from which they were sent to England.

Back to basics

Steel nibs, then ball points and fibre tips eventually took over from the quill for everyday writing use as they were cheaper to produce in their millions. But in the early twentieth century the study of calligraphy or decorative writing was revived by followers of the Arts and Crafts movement, particularly Edward Johnston (1872-1944), who made an extensive study of historic manu-

scripts held in the British Museum. His book *Writing, Illuminating and Lettering*, published in 1906, is still considered to be one of the most important textbooks on the subject.

As calligraphy regained popularity, the art of cutting quills was rediscovered by enthusiasts who wanted to recreate early manuscripts in an authentic way.

Feather fashions

Goose feathers are the most widely used for quill pens. They are durable, easy to obtain and long enough to be re-cut many times. Turkey quills are even harder, but quite short, while long, thin duck quills can be cut to a very fine nib.

Swan feathers are very long, so they can be trimmed even more often than goose quills, but they are rather difficult to find. Crow quills are even rarer today – they are very small and can be cut to a very fine nib.

Drawing with quills

Quill pens are also popular as drawing tools, and are especially effective for suggesting subtle variations of tone and texture. The nibs can be cut to different thicknesses, making them particularly versatile; the finest nibs are ideal both for creating varieties of tonal effects, and for very fine details in a picture. The marks you can make also depend on the

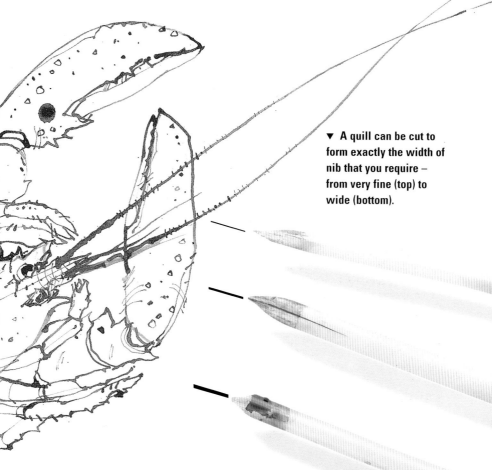

▶ The rather scratchy and unpredictable qualities of a quill pen makes it ideal for this lively line drawing of a lobster.

▼ A quill can be cut to form exactly the width of nib that you require – from very fine (top) to wide (bottom).

shape of the nib and the amount of pressure you apply when drawing.

Quill pens can be unpredictable and rather blotchy, but this need not be a problem when you are drawing. These effects can enhance the appeal of a picture and if you use thick, textured paper, you can exploit these qualities even more. For centuries, the quill was an essential drawing tool – artists such as Rembrandt (1606-69) used it with exquisite results. You can recreate this 'old master' feel in your own drawings by using traditional sepia-coloured inks.

All in the curve

The five largest feathers from a bird's wing are the best for making pens. When selecting feathers, bear in mind that wing feathers are naturally curved, and for the quill to curve comfortably over the back of the hand, right-handers should use a left wing feather and left-handers should use a right. If the feather is correct, it will fit naturally in your hand. When you start learning to cut quills, have a large supply of feathers to hand; it might take a few attempts to perfect your technique.

Removing the barbs

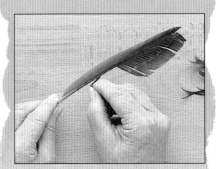

When you see someone writing with a quill in a film or on television, their pen will usually still have its feathers or barbs. For serious use, they tend to get in the way. However, the barbs on the narrow leading edge are sometimes left intact, particularly on the first of the five best wing feathers. There is also a tradition which says that swans' quills should be left fully feathered. To remove the barbs, simply grasp a few firmly between finger and thumb, and pull towards you.

PREPARING A FEATHER

Feathers that are cured and ready for cutting are available from many art shops and craft suppliers. However, you might have to cure the feather yourself. Simply strip off the feathers (sometimes known as barbs – see below), cut off the closed end and soak this end of the feather in water overnight. Then fill the feather shaft with warmed fine sand for a few moments to dry it out. Shake out the sand and the quill is ready to be cut.

1 ▶ Make a nib Hold the quill flat on the cutting mat or cardboard with the curved end pointing upwards. Slice into the quill at an angle about 2.5cm (1in) from the open end. Flatten the angle of the cut as you slice through to the point.

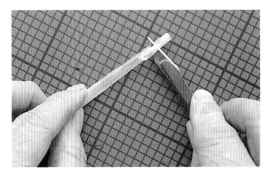

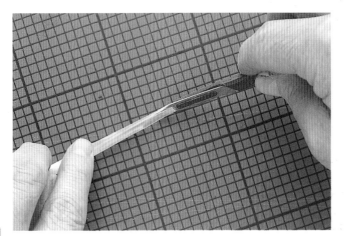

2 ◀ Cut the split To help the flow of ink, you need to cut a split in the nib. Hold the nib flat on the cutting mat and make a straight cut about 0.5cm (¼in) long down the centre.

3 ▶ Cut shoulders on the nib Turn the quill over so that the cut you have just made is flat on the cutting mat. Make diagonal cuts on either side of the nib to create 'shoulders', tapering the tip of the nib away from the main part of the quill.

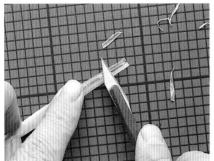

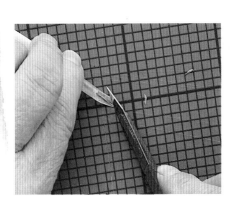

4 ◀ Trim the nib Make tiny cuts at the point of the nib to create the width you require. When making these final adjustments, it is better to cut away just a tiny amount from each side in turn. Blow gently across the nib to remove any offcuts left behind, and your quill pen is ready to use.

Anyone can draw

If you can put pencil to paper, you can draw. Get started by drawing and shading an apple.

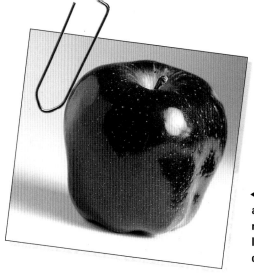

People have a tendency to say "I can't draw". But they can, if they take some time to learn the basic rules of good drawing practice. After all, good draughtsmen aren't simply born – first they must learn their craft.

Creating a 3-D image

Successful drawing is all about translating three-dimensional (3-D) objects onto two-dimensional (2-D) paper or canvas. This is achieved by studying the way that light and shadow fall on an object, and then giving that object the illusion of 3-D form by building up areas of tone.

Tones are built up by shading, and you can see the dramatic effect that this can have by trying out the steps that follow on page 13.

As a general rule, when making an outline, you should hold the pencil as you would a pen for writing. Use a series

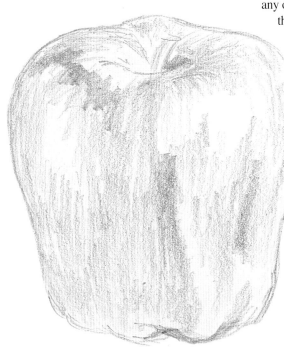

of smaller strokes rather than a single, continuous line, and don't press too hard in case you make a mistake and have to use the rubber. When shading, hold the pencil more loosely, and use the flat edge of the pencil lead rather than the point to build up the areas of tone.

Study your subject matter

A key part of successful drawing lies in properly observing your subject. You should study the curves and contours of any object you draw and assess the way the light plays across its surface. Also, remember to keep looking up at your subject matter as you draw, and don't worry if your apple doesn't turn out exactly like the one shown here – it's how you interpret it that counts.

So set up your apple, shine a lamp onto it from one side to create a shadow, and start drawing!

◀ Drawing on a flat piece of paper is all about creating an illusion of shape, depth and form for an object. This three-dimensional effect is achieved by shading: building up layers of light and dark tone.

YOU WILL NEED

Sheet of white paper

2B Pencil ('H' rated pencils are too hard for you to be able to shade the apple effectively)

Rubber

Scalpel or pencil sharpener

HOW TO DRAW YOUR APPLE

This apple exercise is in two stages. In the first you create a realistic outline (remember to keep looking up at the apple as you draw). And in the second, you progress to shading.

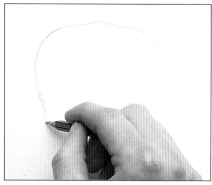

1 ▲ Start drawing the basic outline Study the apple hard, and search out all the contours that make up its shape. Then start drawing in the outline, using a series of small, light edging strokes, rather than a single flowing line. Start top right and then work in an anti-clockwise direction.

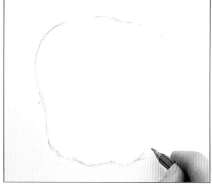

2 ▲ Continue the outline round Keeping looking at the apple, draw in the bottom section of the outline. Make sure to include all the various bumps along the apple's bottom edge.

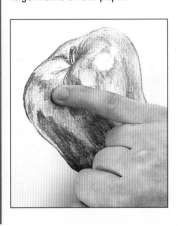
3 ▶ Add the apple's stalk Roughly draw in the stalk that sits on the top of the apple, plus its surrounding depression. Depict the depression by adding an almost crescent-shaped line around the base of the stalk itself.

4 ▶ Finish off the outline
Add a couple of small, slanting lines as shown, to depict the way in which the stalk sinks into the top of the apple, creating a small well. Then continue the outline until it joins up at the original starting point.

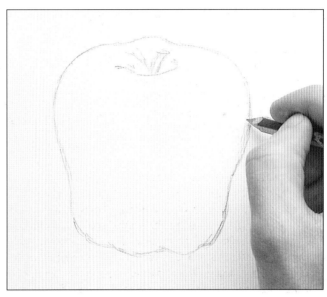

HOW TO ADD SHAPE BY BUILDING UP TONES

Once you have drawn your apple outline, you can add shading and give the fruit a three-dimensional appearance. This is done in steps by building up the tonal values, adding the darkest tones where the surface of the apple seems to be in shade, and leaving the highlights – where light bounces directly off the skin of the fruit – white.

5 ▶ Add the lightest tones for the shading
Start shading the apple from the left-hand side, using the flat side of the pencil. Use light, but fairly long, strokes which follow the apple's contours. Leave the patches of highlight - where the light bounces off the apple's surface – white.

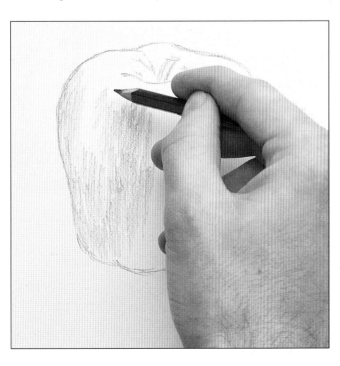

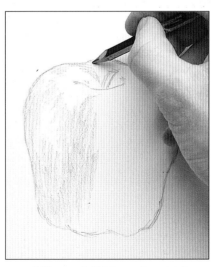

6 ▲ Add some definition to the apple's top
Lightly shade around the top left area of the fruit, adjusting the direction of your strokes accordingly to mimic the apple's contours and curved shape.

7 ► Work on the right-hand side

Turn to the other side of the apple, again adding light shading using the side of the pencil. Add a few darker lines around the bottom of the apple, to lend a bit of extra definition.

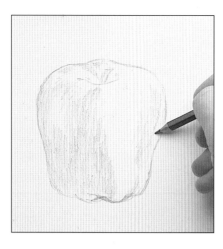

8 ► Create the main highlights

Continue shading, adding a darker central 'strip' and leaving the top right highlights blank. Add shading around the stalk depression, splaying out the lines to portray its sloping sides.

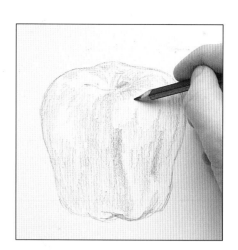

9 ► Continue building up the tones

Work up the shading some more, smoothing out any very rough areas. Add the line of darker shading across the top left of the apple, where its curved edge lies, and tidy up the shading around the top area. This is a good place to leave your drawing if you feel you have gone far enough for a first session. If not, you can continue with the steps on the next page.

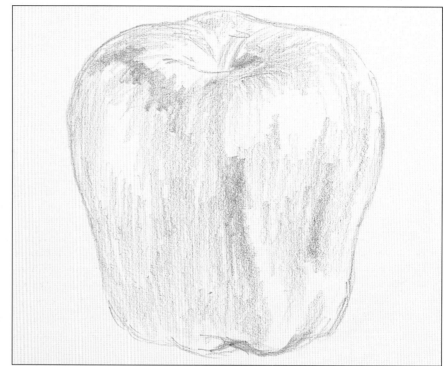

EXPERT ADVICE Graphite pencils

Graphite pencils are one of the most versatile of drawing mediums – and they're cheap to buy. Available with soft, medium or hard leads, the pencils are graded from 10H (very hard) to 10B (extremely soft), with HB – most likely the type of pencil you used at school – lying in the middle of the range.

◄ HB pencil
This is an average pencil and lies in the middle of the softness/hardness range. It is not as well suited to shading as softer pencils.

◄ B Pencil
This marks the start of the B range pencils, all of which make a rich, dark line. The higher the B rating, the softer the pencil and the darker the line.

◄ 2B Pencil
This soft pencil is ideal for general drawing and medium shading. A 2B pencil was used to produce the apple drawing shown above.

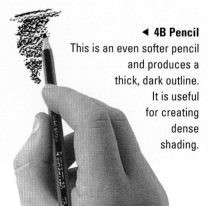

◄ 4B Pencil
This is an even softer pencil and produces a thick, dark outline. It is useful for creating dense shading.

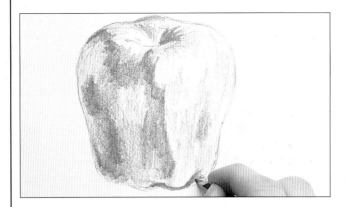

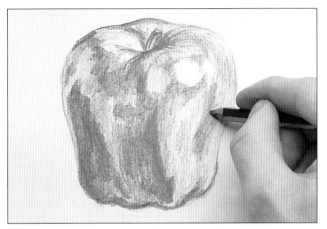

10 ◄ **Start adding the darker tones** Using darker, heavier strokes, shade the small area of depression to the right of the stalk. Then join the dark patches of shade which define the central and top left-hand areas of the fruit. Add some further shading to the apple's left side and sharpen the bottom with some heavy strokes.

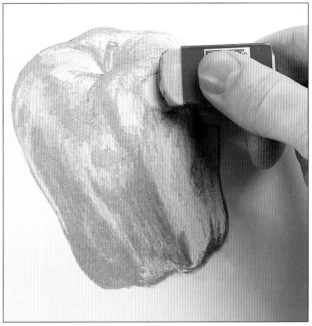

11 ▲ **Work up the dark tones some more** Build up the layers of darker tone, following the apple's contours and working round the two spots of bright highlight to the top right of the fruit. Apply the heaviest shading where there is no light falling on the apple, like the extreme left.

12 ▲ **Clean up the highlights** Clean up the sharpest areas of highlight – which by this time may have become smudged by your hand moving back and forth across the page – with a rubber. Make sure the tip of the rubber is clean by first rubbing it onto another sheet of paper.

DIFFERENT WAYS TO SHADE

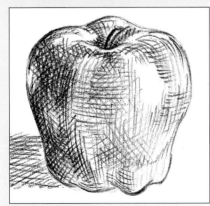

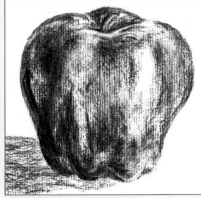

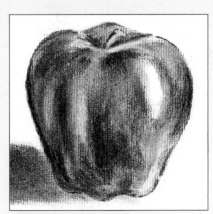

Crosshatching
Rather than using the flat side of the pencil to create shade and form, single strokes can instead be crosshatched and built up to form dense areas of tone.

Charcoal
Using the side of a short charcoal stick creates thick areas of textured tone. You can build on this, layer by layer, to create the darkest tonal areas.

Blending
Charcoal can easily be smudged using the fingertips to produce areas of shade and tone. This is a useful tip for creating a soft effect, with no hard lines.

13 ▶ Add the apple's shadow

Once you have built up the areas of tone to a point you feel happy with, you can add the apple's shadow. Use the flat side of the pencil and work in light, horizontal strokes, fading the shadow out around the edges by decreasing the pressure of the pencil on the page.

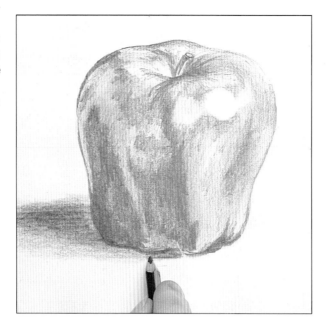

A grid is a useful way of plotting and drawing an object's outline, and comes into its own when drawing a group of objects. A piece of white cardboard with squares drawn onto it is placed behind the object or group, and then the artist plots the outline onto a similarly squared sheet of paper. Any part of an object's outline falling into a certain square on the upright grid is then drawn into the corresponding square on the sheet of paper. The artist who drew this apple did not use a grid, but you can see how the principle would have worked. More about using grids in the next project..

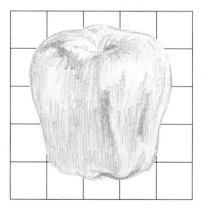

THE FINISHED PICTURE

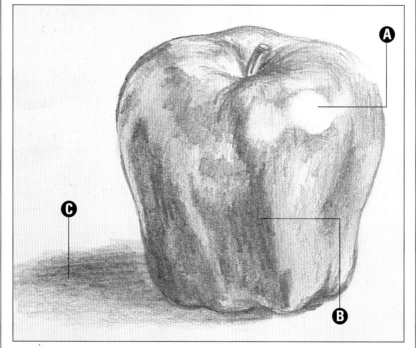

A Highlights
The areas where the light bounces off the skin of the apple – the highlights – were left unshaded. These areas became smudged as the drawing progressed, so were cleaned up with a rubber to give them extra sharpness.

B Darker tones
The darkest areas of shadow on the apple's surface are represented by the darkest areas of shading. The tones were built up in stages, until the artist felt that enough had been added to give the apple 3-D form.

C The shadow
The shadow, cast by the apple itself, was created using the flat side of the pencil. Less pressure was applied to the edges of the shadow, to give it the impression of fading back into natural light.

Drawing with a grid

Make a grid to help you position objects on paper and create a balanced outline. Then shade in the composition using a charcoal pencil for a bold effect.

There's no need to go anywhere special to find interesting subjects to draw. It is quite possible simply to stay at home and pick out some of the objects around you to create a worthwhile composition.

Mapping size and position

Even experienced artists can have difficulty in accurately mapping the size and proportion of objects. One solution is to stand a sheet of white card with squares drawn on it behind your still life, then to rule a corresponding grid on to your drawing paper. This makes it easier to plot the height and volume of different objects.

Another plus point is that the white backdrop encloses the objects, aiding concentration while making a clear surface for any shadows to fall on. In this project however, it is the outline of the objects, their place within the grid and their 3-D form that is important. Shadows will play a larger role in the next project.

Using a charcoal pencil

The outline is drawn using a 2B pencil, which is easy to rub out in case of mistakes; but the shading is done with a charcoal pencil to create strong, dark lines. In fact, because charcoal handles so differently to the graphite pencil you used to shade an apple last time, it's a good idea to get a feel for it first.

On a scrap piece of paper, move the pencil freely from side to side. Press lightly at first, then harder, and note the difference in the strength of the impression. Then go over your initial strokes with further strokes in different directions and check the varied textures you create. You will soon become familiar with the way charcoal pencils work.

▲ It is much easier to draw a still life if you plot the position of the objects in it against a grid.

HOW TO MAKE A GRID SCREEN

1 Mark a vertical line about 20cm (8in) from each end of the pliable white card. Cut along these lines, then tape the severed pieces of card back in place with masking tape. This creates the moveable side flaps that will allow the screen to stand upright. Then use a 2B pencil to mark out the limits of the grid, making sure its base is positioned as close as possible to the bottom of the card.

2 Continue ruling horizontal and vertical lines on the card to complete the grid. The version shown here has 16 squares, each 8 x 8cm (3 x 3in) in size. Then arrange your still life group at eye level and stand the grid screen behind it. You are now ready to start drawing.

HOW TO USE THE GRID METHOD

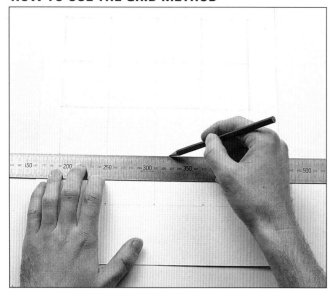

1 ▲ **Draw a corresponding grid on to your paper** Using the 2B pencil, draw another grid on to the drawing paper. You will need to divide it up into the same number of squares as appear on the card screen – although they do not have to be the same size as those you drew previously. The squares shown here measure 6 x 6cm (2.5 x 2.5in).

3 ▶ **Check as you draw** Continue drawing the bottle, including its stopper, referring frequently to the grid lines behind the object. Use a series of small strokes rather than a single line.

EXPERT ADVICE
Paper for charcoal

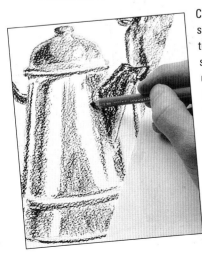

Charcoal, being a powdery substance, works best on slightly textured paper, which gives it something to 'grip' on to. If you use smooth or shiny paper, you will see the charcoal slide all over the place. Once you are familiar with how it handles, you can try using charcoal on paper with a highly textured surface. As the grain on this type of paper is prominent, it adds a distinctive character to the drawing.

2 ▲ **Start drawing the bottle outline** Start with the bottle because it is the tallest object in the group. Study where and how its outline crosses the squares on the grid behind it. Then start drawing in the bottle's outline using the 2B pencil. Make sure that you place each individual line in the corresponding grid square on your piece of paper as you draw.

ADD IN THE OTHER ITEMS IN THE GROUP

Once you have established the position of the first object in your still life – in this case, the bottle -- you can add the other items around it. By continuing to follow the grid lines, you will ensure that the objects relate to each other as in the original.

4 ▲ **Sketch the outline of the glass** Again using the grid lines for reference, draw in the outline of the glass. The glass is positioned just in front of the bottle, so it appears slightly 'lower' in relation to the bottle's rounded base.

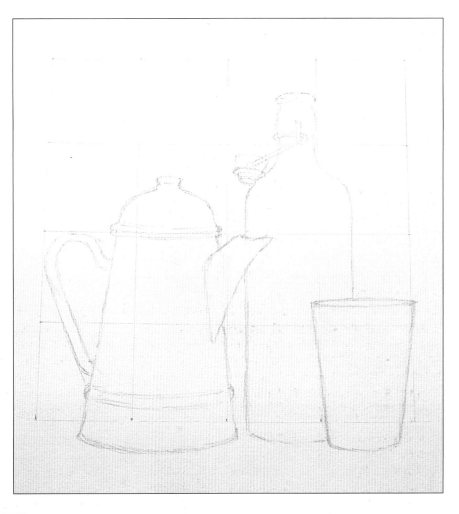

5 ▲ **Draw the coffee pot** Next, sketch the outline of the coffee pot, once again following the grid lines. Study the shape carefully and thicken up the lines slightly where the contours seem more intense – for example, on each side of the lid. If you use the rubber to correct any errors, you are likely to rub out the grid lines as well. Make sure to pencil these back in.

6 ▶ **Complete the pencil sketch** Add the details on the coffee pot. You have now achieved your initial sketch – a well-proportioned group of objects ready for developing with the charcoal pencil.

A FEW STEPS FURTHER

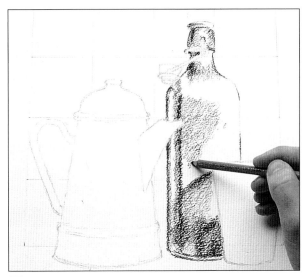

7 ▲ **Shade the bottle** Study how the light falls on the group of objects. Then use the sharp charcoal pencil and a combination of intense and lighter strokes to shade the bottle, leaving the highlights bare. Refer back to the first project for how to build up areas of light and dark tones.

8 ▶ **Give form to the glass** Use the sharp point of the pencil to give form to the bottle's stopper. Then turn to the glass. Use heavy strokes to create the shaded areas along its right-hand edge and around the lower half; then medium strokes to give form to the other areas. Leave the highlights on the left and near the top of the glass untouched so that the white paper shows through.

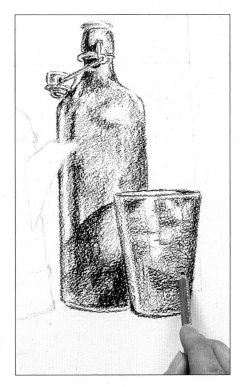

9 ▶ Work on the coffee pot

Place a sheet of paper over the finished parts of the drawing to prevent them smudging as you work. Then start to shade the coffee pot, leaving the main highlights as wide, vertical strips.

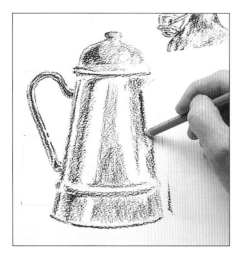

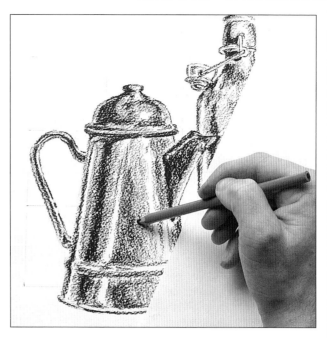

10 ▶ Build up the tones on the coffee pot
Gradually work up and darken the shading on the coffee pot. Reduce the main highlights to a few narrow bands, where the light bounces most intensely off the shiny, curved surface of the object.

THE FINISHED PICTURE

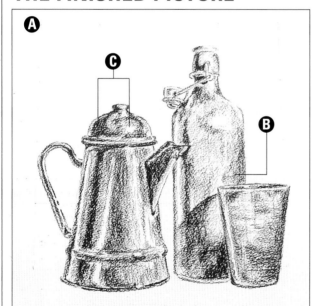

A The grid

The way the objects in the picture relate to their surrounding grid lines should mirror the way in which the original still life is positioned against the grid on the card screen. You can rub out the grid on the paper to complete the picture.

B Use of charcoal

The lines made with the 2B pencil, which was used to create the initial sketch in case of error, are completely hidden by the subsequent shading with the charcoal pencil. The charcoal produces darker tones and gives a softer finish.

C 3-D form

Once the shapes and arrangement of the three objects in the still life had been established on the grid, the artist then created the 3-D quality of their curved surfaces. This was achieved by the use of shading, and by creating highlights.

USING WATER SOLUBLE COLOURED PENCILS

If you would like to introduce colour into your still life, you can achieve a very different effect from a charcoal drawing by using water soluble coloured pencils. These are extremely versatile, as you can first draw your subject with them and then add water with a brush to soften the outlines and blend the colours. The final result is similar to a watercolour painting. You can then add more pencil strokes over the top of the blended areas once the paper is completely dry.

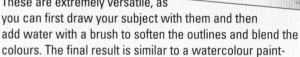

Shadows in still life

Shadows play an important part in any composition and can create fascinating shapes in their own right.

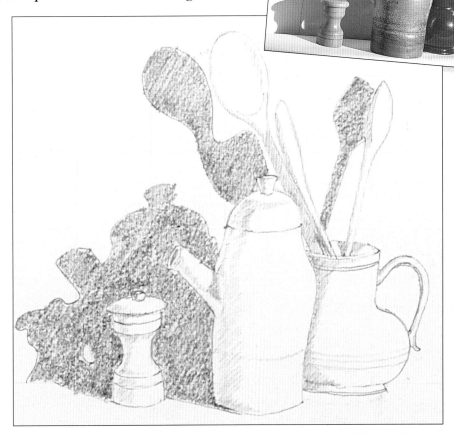

When drawing a still life, the tendency for beginners is to concentrate on the objects themselves rather than on the shadows they cast. However, the shadows play an important part in the composition and need to be observed just as carefully. In this exercise, we look at the shadows cast by setting up a group of objects in front of a screen, with a lamp providing a strong light source from the right.

Drawing with a grid

As in the project starting on page 17, the shapes in this composition are plotted with the aid of a grid. In this case the card backdrop had to be made anew however, as the one used previously proved too small to encompass all the shadows. Make sure you also buy a sheet of card large enough to include all the shadows within your chosen composition.

A grid of 8cm (3in) squares is then drawn onto the screen, and a corresponding grid of 4cm (1½in) squares is drawn lightly on a sheet of cartridge paper using a 2B pencil. These measurements ensure that the proportions on the drawing surface are exactly the same as on the screen.

Observing the shadows

Before you begin to draw, carefully observe where the shadows fall onto the screen. Because they are very dark, they are easily seen. Try to concentrate on the 'shadow shapes' in preference to the shapes of the objects themselves. In this exercise, the shadows will be seen as the 'positive' shapes, while the objects remain less important, 'negative' shapes. By focusing on the shadows in this way, you will begin to see how all the shapes in a picture work together to produce a balanced composition.

▲ It is much easier to draw a still life and shadows if you plot the position of the objects against a grid of squares.

YOU WILL NEED

Sheet of cartridge paper
Sheet of white card or mount board
Pencils: 2B; 6B
Rubber

HOW TO DRAW THE SHADOWS

1 ▶ Begin drawing the shadow outline
With a 2B pencil, draw the outline of the shadows cast on the extreme left. These are the shadows of the pepper mill and the wine jug. Observe where the outline crosses the grid in the photograph, so that you can reproduce the position on your paper grid. In your drawing, there might be a slight variation in the positions of shadows and objects – remember, you are not striving to become a photocopier!

2 ▲ **Continue the shadow outline** Move on to drawing the shadows of the wooden spoon and spatula. Combined, they form a very interesting single shape. This is the wonderful thing about drawing – interesting visual forms appear all the time, leading you to make continual discoveries about the world around you. Note the position of the two combined shapes: they appear to be growing out of the top of the wine jug.

3 ▲ **Complete the drawing of shadows** Draw the shadow of the other wooden spoon. Notice how it has a sharp corner, which, again, produces an interesting shape. The shape is not quite complete, because the actual spoon obscures a portion of the shadow. To complete the drawing of shadows, make sure you include the two that fall onto the horizontal surface, to the left of the pepper mill and wine jug. These travel at an angle over the horizontal surface.

4 ▲ **Gently erase some of the grid lines** Rub out the grid lines that are contained within your shadow shapes. Do not rub too hard, otherwise you can very easily damage the surface of your drawing paper. If this happens, it will be like applying your pencil to soft blotting paper when you continue with the picture.

HOW VARIATIONS IN LIGHTING AFFECT SHADOWS

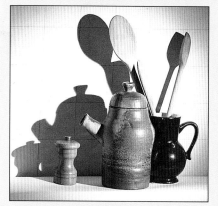

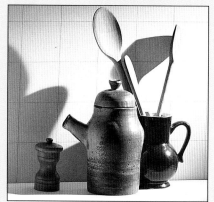

Sharp shadows
In this photograph of the still life group, the light source is positioned at an angle slightly above and to the right of the objects. This produces strong, sharp, clearly defined shadows, which are ideal for illustrating the point of this lesson.

Diffuse shadows
In this variation, the light source has been changed again. The lamp is set at a very oblique angle to the objects, causing their shadows to become extended and more diffused. This arrangement is less effective in illustrating the point of this lesson.

HOW TO GIVE DEPTH TO THE SHADOWS

Once you have completed the outlines of the shadows, you can fill in the dark tone within them. As you work across the picture, it is a good idea to rest your hand on a piece of paper, as soft pencil is easily smudged. Do remember the 'chink' of light between the pepper mill and the wine jug. This welcome break in the intensely hatched areas will provide that extra, important interest in the drawing.

5 ▶ Fill in the shadow outlines
With a 6B pencil, add dark tone into the shadow shapes on the left-hand side, using close hatching. Keep the pencil strokes close together at an angle of about 45 degrees to give unison within the shadow area. Take care you don't end up just 'scribbling' in any old direction, as this will tend to produce lighter and darker areas, which look less convincing.

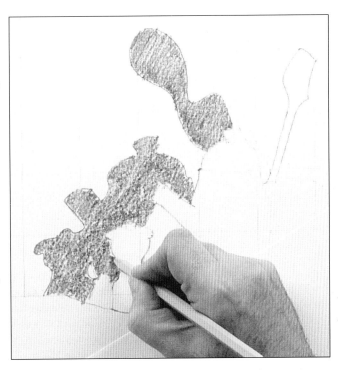

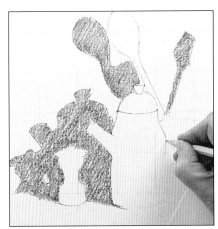

6 ▲ Outline the objects themselves Turn your attention to the foreground objects. Look at the grid and check their positions. Draw the outlines first with a 2B pencil. You should begin to see light negative shapes emerging. Take your time and draw carefully until you have completed all the outlines of the objects.

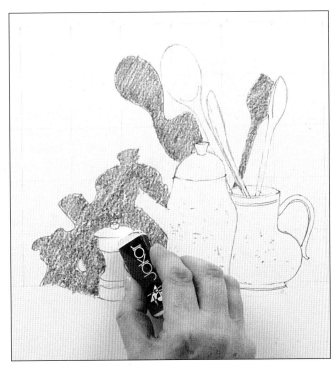

7 ▲ Rub out the grid lines within the shapes of the objects
Remember to do your erasing with care, so as not to damage the paper surface. By now you should have some very light shapes and some very dark ones; in other words, some strongly contrasting positives and negatives.

EXPERT ADVICE
Sharp pencils

It is important not to allow the pencil to wear down to its wooden casing. The wood can dig into your paper surface and score it. This produces ugly, unwanted lines in the form of 'channels'. If you subsequently want to shade over the damaged area, the scored channels will become even more apparent. The secret is to keep your pencils sharpened at all times.

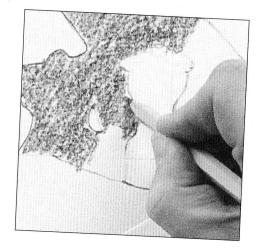

The objects themselves do not need to become very important – that would defeat the purpose of the exercise. Remember that the shadows are the positive subjects in this drawing. However, a little light shading serves to give the objects a minimum amount of form.

8 ▸ Work some light hatching

Use a 2B pencil and begin with some light hatching on the darker parts of the objects, such as the edge of the pepper mill. Keep this simple, avoiding too much detail – especially highlights.

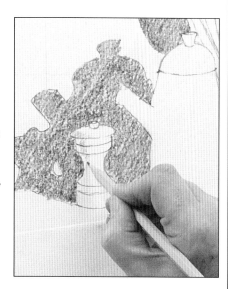

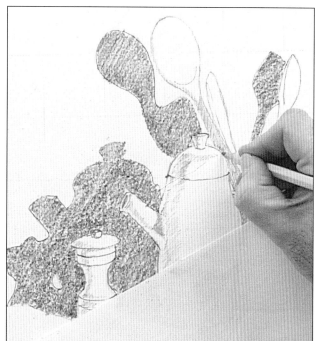

9 ▲ Complete the drawing

Continue with *light* shading in the form of hatching with a 2B pencil. Remember that 'light' is the operative word. If the shading becomes too dark, the objects could begin to merge with their shadows. Note that there are two distinct shadows on the objects themselves, which can be included now. These are on the spout of the wine jug and the handle of the left-hand spoon. Take care not to overshade; they should remain lighter than the background tones.

THE FINISHED PICTURE

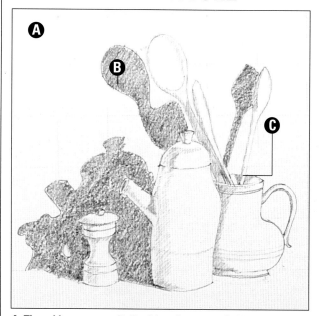

A The grid
Drawing a grid of squares onto the screen behind the still life group makes it easier to correctly plot the shapes and positions of the shadows on your drawing surface.

B Positive shapes
The shapes of the shadows are drawn first, as they are the dominant, 'positive' elements in this exercise. Notice how the contours of these shadows form a varied outline. This helps to break up the space behind the still life group in an interesting way.

C Negative shapes
For the purposes of this exercise, the objects themselves are not the main focus of interest, so they become 'negative' shapes. By concentrating on the shadows, you can see how important they are, not only in defining space but also in strengthening the composition by echoing the shapes of the objects.

Using patterned backgrounds

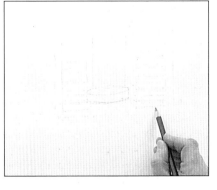

When you are faced with a blank sheet of paper, it is reassuring to have a reference point for your drawing.

In this exercise, you will find out how you can 'loosen up' your drawing. For the last two exercises, you used a screen with a squared 'grid' to help you plot the positions of objects in a still life group very precisely. Here, we are going to look at an alternative way of using a visual reference when drawing a group of objects.

Instead of a specially drawn grid, some striped wallpaper provides a helpful background to set behind a few simple objects. The regular vertical and horizontal stripes act as an excellent, informal grid reference. Choose objects with plain colours for your still life, so that they stand out clearly against the patterned background.

Positioning the light source

As for the previous drawing exercises, a light source in the form of a lamp is used here. This time, however, because of the nature of the composition, the light comes from the left as the objects would be in the shade if lit from the right. When you are setting up a group of objects for yourself, do bear in mind where the shadows fall, so that each object is clearly illuminated.

Adding water

Water soluble pencils, as mentioned on page 20, can add a new dimension to your drawing skills. But if the thought of using water scares you, don't worry. The pencils may be used dry – although in such a case it will not be possible to obtain the effects seen in the final stages of this drawing. Adding water is fun, so pluck up your courage and have a go!

YOU WILL NEED

Piece of cartridge paper

Water soluble graphite pencils: B and 2B

Rubber

Scalpel or pencil sharpener

Round brush with a point

FIRST STEPS

1 ▶ **Draw the wallpaper 'grid'**
With a water soluble B pencil, sketch in the vertical lines of the wallpaper. Add a few horizontals too. These lines will give you a reference point for

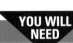

drawing the top of the flower pot. Once this shape is established, it will help you determine the positions of some of the other lines and shapes. Remember to keep looking at the wallpaper 'grid' while creating your initial sketch.

3 ▶ **Draw the garlic**
Complete the mortar and then add the large garlic bulb and the two garlic cloves. The mortar and the flower pot act as a reference for the position of the garlic.

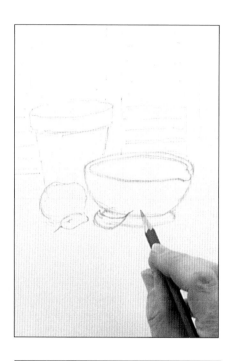

2 ▲ **Begin sketching the mortar** Start drawing the mortar (bowl), using the flower pot and background grid pattern as a reference. Remember that at this stage you can still work in a light, sketchy manner. You will be defining the outlines with a softer pencil later on...so take your time!

4 ▶ **Add the pestle** Now it's time to include the pestle (stick), erasing the lines of the mortar that cut through it. Determine the angle of the pestle by looking at the striped background and the flower pot. The pestle starts just to the right of a vertical line on the wallpaper and ends at a horizontal line just above the flower pot. Assessing the position in this way illustrates how the stripes on the wallpaper provide a constant useful background reference for your drawing.

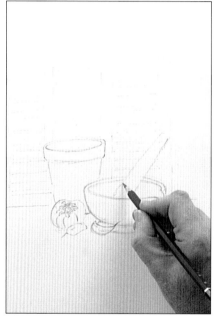

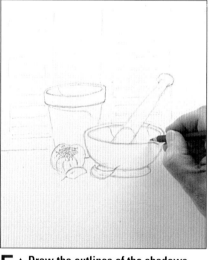

5 ▲ **Draw the outlines of the shadows** There are some shadows on the flower pot and the mortar. Lightly draw in their outlines at this stage.

HOW TO STRENGTHEN THE LINES AND TONES

Once your initial sketch is complete, change to a 2B water soluble pencil. This softer grade will strengthen the outlines and shaded areas, while its soluble nature will set you up for adding water, if you want to tackle the 'Few Steps Further'.

6 ▶ **Shade in the wallpaper** The background wallpaper needs some shading in order to explain its pattern more clearly. Still using the B pencil for this and holding it quite loosely, work hatching to show the darker areas of the background.

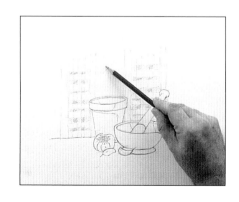

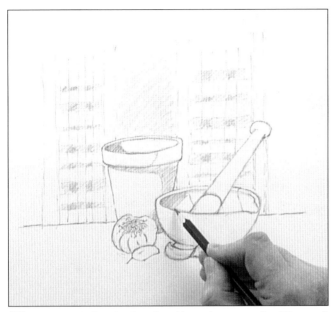

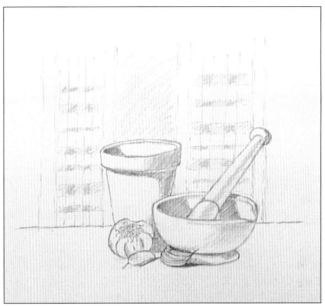

7 ▲ **Begin to define the drawing** Now change to the 2B pencil and draw over the existing lines if you are happy with their positions. Also at this stage, fill in the shadows that you outlined in step 5.

8 ▲ **Give form to the objects** Work shading on the objects, for example, along the pestle and on the right of the mortar, in order to give them some form. Light hatching will suffice for this, so that there will be a sufficient difference between shading and any shadows cast. The drawing could now be considered complete, but if you want to, you can add water to the drawing for a different effect.

A FEW STEPS FURTHER

Now that the still life group is complete, you can add some water and move the drawing on a stage. Rest your hand on a piece of kitchen towel as you work to prevent smudging; this can also be used for 'lifting off' if you apply too much water.

EXPERT ADVICE
Adding water

When adding water to a drawing produced with water soluble graphite pencils, there is no need to flood the paper – a small amount of water will be sufficient. You need just enough to activate the pigment in the pencil. If you use too much, the drawn areas will become very grey and will merge together, causing the finished work to look washed out and undefined.

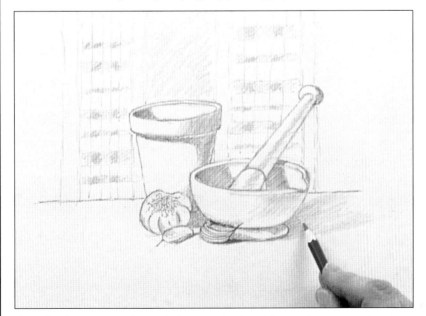

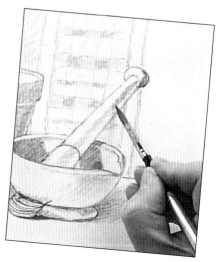

9 ▲ **Hatch in more shadows** Before you begin adding water to your drawing, you can give the composition greater depth by defining the shadows cast on the horizontal surface on which the still life is standing. Work these dark areas by hatching with a 2B pencil.

10 ▶ Brush water over the wallpaper pattern

Now load a round, pointed brush with clear water and begin to brush the water on to the patterned wallpaper. Now it should become apparent why the shading was added here in step 6. It has provided pigment, which intensifies when water is applied, creating a stronger version of the background pattern.

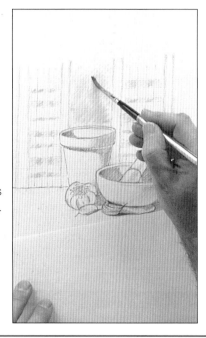

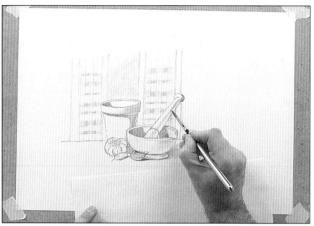

11 ▲ Add water to the whole drawing
Continue adding water to all parts of the drawing. A pointed brush will cope with fine lines as well as the broader areas such as the shadows and shading. Notice how the lines and shapes appear stronger as the water is added. After all the hard work of drawing, this is the fun part!

THE FINISHED PICTURE

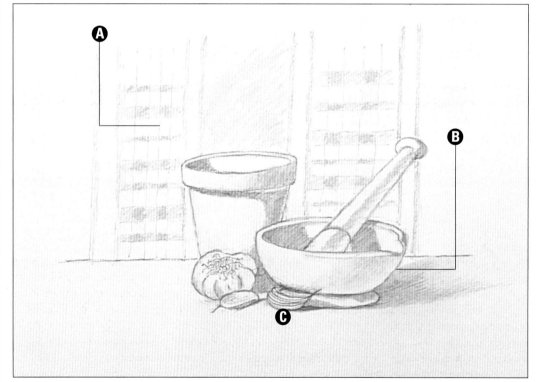

A Wallpaper 'grid'
The distinctive pattern of horizontal and vertical lines on the wallpaper was used to determine the positions of the objects in front of it. Unlike a specially drawn grid, the pattern of lines forms an integral part of the finished still life picture.

B Strong outlines
The light pencil marks used for the initial sketch of the objects were later strengthened with a softer pencil to define them. The still life stands out crisply from the more muted lines of the wallpaper in the background.

C Dark tones
When water was brushed over the dark areas of shadow, the tones here were deepened even further to form a stark contrast with the white paper and the more lightly shaded areas of the still life.

Drawing without outlines

Beginners at drawing are often tempted to give everything a hard outline. Try, instead, creating shapes with softly hatched lines.

In this exercise, we'll be looking at how you can achieve a drawing without relying too heavily on outlining everything you see with a hard pencil line. One way that this can be done is by using a 'soft' shading technique – that is, shading produced by the edge of the pencil lead rather than its point.

Subtle effects

By practising this technique, you will be able to make a key step in improving your observational and drawing skills. It will enable you to introduce subtle effects into your drawing and help you to understand that strong, harsh outlines are not always required in order to produce a drawing with a good range of tonal values, i.e. one that contains distinct light and dark areas.

Two-part exercise

For the first part of the exercise, you will be working with pencil on white paper. After this, you can try the same drawing again on a dark blue pastel paper, this time using a yellow soft pastel. This will give a different effect, as here the

▼ With this drawing, the artist has produced an accurate representation of the subject without using any hard outlines. Notice the softly hatched folds of the tea towel and how the shape of the tennis ball is formed by filling in the shaded area behind it.

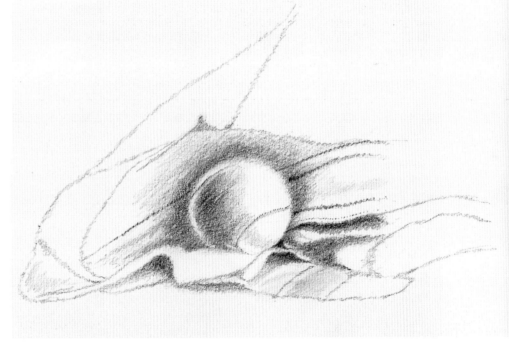

background will be darker than the drawing medium.

Drawing without a grid

Another progression you'll notice here is that the safety net of the background grid has been dispensed with. However, if you look at the still life shown here, you'll see that there are still guide lines that could help you. Note the border on the tea towel. This will provide a useful visual aid when you come to draw the folds in the fabric.

For this exercise, you will need to arrange a light object against a light background. Here, low sidelighting provides graduated shading, both on

the tennis ball and on the tea towel, providing the opportunity to see light against dark and dark against light. It is important to set up your lighting correctly, as the observation and representation of shading is the whole point of this exercise.

YOU WILL NEED

Piece of cartridge paper

Pencils: 2B and 4B

Rubber

Scalpel or pencil sharpener

HOW TO START THE PENCIL DRAWING

Begin the drawing by establishing the shape and position of the tennis ball. Keep in mind that you are trying to show shapes without using any hard outlines. In the case of the ball, the shape is indicated by shading around it.

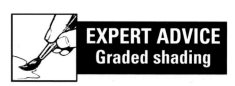

When attempting graded shading, do not hold the pencil too tightly. Begin with some light, loose strokes and gradually increase the pressure to produce darker tones. Soft pencils such as 2B and 4B will enable you to shade from light to very dark. By including a wide range of tonal values in this way, you will create more successful drawings.

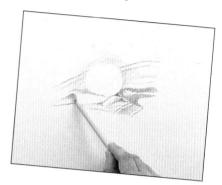

1 ▲ **Shade around the tennis ball** Look carefully at the subjects: you will notice graduated shading and some cast shadows. Start by holding a 2B pencil fairly loosely and apply light shading on to the tea towel immediately behind the tennis ball. Using the side of the pencil lead, work the shading around the ball. The shading forms almost a complete circle, apart from the bottom, which nestles in the folded tea towel.

2 ▶ **Complete the tennis ball shape** To the bottom right of the ball, there is a small triangle of very dark tone. Establish this to act as an excellent divider between the ball and the light area of tea towel at that point.

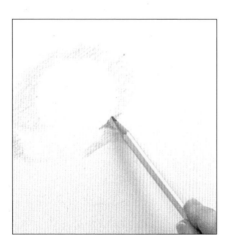

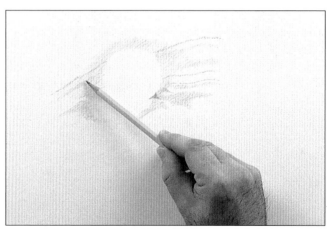

3 ▲ **Shade the tea towel** Work shading on the tea towel away from the ball. Apply a little more pressure at the bottom left, where the tone is much darker. The 'lines' of the border design can be indicated at this stage, still hatching with the side of the lead rather than making a drawn line. These lines will help you to determine where some of the folds in the cloth occur.

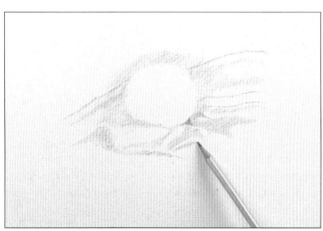

4 ◀ **Build up the front of the tea towel** Indicate the folds of the tea towel at the front of the composition with more soft shading. Notice how the underside of the towel, which does not catch the light, is darker than the top surface which reflects the light.

HOW TO ADD MORE SHADING

Once you have completed steps 1–4, you will be able to see the complete shape of the almost-round tennis ball and the folds of the tea towel around it. It is now time to develop the drawing by increasing the contrast between light and dark areas. Remember to use soft shading rather than hard outlines.

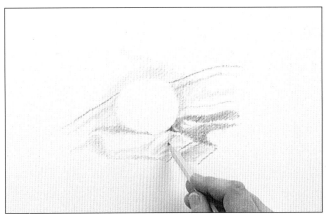

5 ▶ Deepen the shading on the tea towel Increase the pressure of the pencil to create darker areas where the folds change from light to dark. Remember that these light and dark areas produce forms that will explain the folds in the cloth. Notice that the pencil shading is still being applied in the same direction.

6 ▶ Begin adding form to the ball Lightly indicate the seams on the tennis ball. Even though these are fine lines, you should still use hatching to keep a soft effect. Next, start to introduce some shading on the left of the ball.

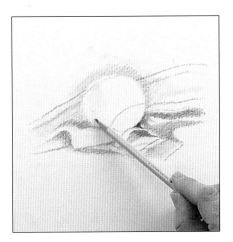

7 ▶ Increase the contrast Try to show the crescent of reflected light on the extreme left of the ball – it will help you form a sphere. The far right of the ball is also very light. Retain the white of the paper in both these places. Apply some heavier shading to the ball with a 4B pencil.

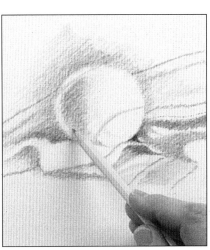

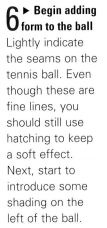
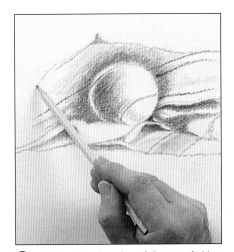

8 ▲ Extend the drawing of the towel Use hatched lines to explain the overall shape of the tea towel. You don't need to introduce any shading here. This is a simple way to portray the extremities of the drawing.

THE FINISHED PICTURE

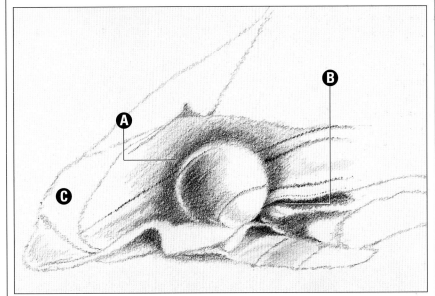

A Soft outline
Hatched lines around the tennis ball act as a visual boundary and create the edge of the ball without the use of a hard outline.

B Dark tones for contrast
The darkest tones are created with the 4B pencil, which blends into the lighter 2B shading to give the drawing more contrast and impact.

C Light tones
To represent the lightest tones in the drawing, the white paper is simply left showing through.

HOW TO MAKE THE PASTEL DRAWING

In the pencil drawing shown on the previous pages, the dark areas were shaded while the light areas were left as white paper showing through. Now you might like to try this exercise using different materials: a yellow soft pastel and a dark blue pastel paper that contrasts well with it. You will be working in reverse, i.e. the light tones will be shaded with pastel and the dark tones will remain as the paper colour. The pastel will work in an opaque manner over the dark colour underneath.

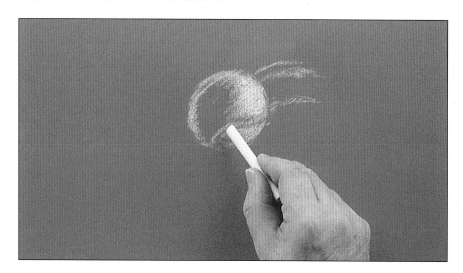

1 ◄ Draw the tennis ball Begin by hatching in the shape of the tennis ball. In contrast to the pencil drawing, you are actually outlining the ball itself this time but still not using any hard outlines. At this stage, also create a large block of colour on the right. This represents the light side of the ball. As a guide, include the seams. Now the shape of the ball is complete.

2 ► Begin forming the tea towel Hatch in the light-coloured triangles of cloth on the right of the tennis ball and immediately under it on the left. Whereas these pale tones were left as plain paper in the previous pencil drawing, here they are filled in with pastel, which creates light areas against the dark blue paper.

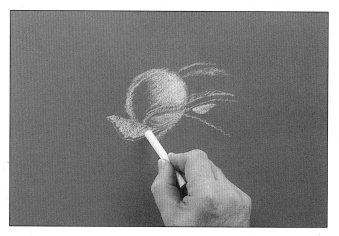

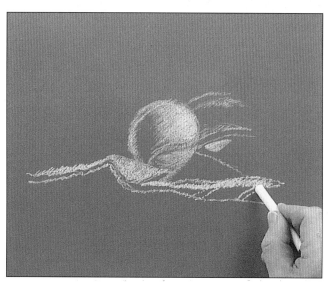

3 ◄ Draw more folds of cloth Continue by lightly hatching the border lines at the front of the tea towel. These will help you to position the folds, which can be hatched in quite boldly. Remember that 'lights' are the yellow pastel; 'darks' are the blue paper surface showing through.

TROUBLE SHOOTER

REMOVING SMUDGES

Pastel is very soft and is prone to creating dust when it is stroked across a surface. When working on your pastel drawing, constantly blow away excess dust, otherwise this will smudge the work in progress. If a smudge should appear, it can be removed by light rubbing with a piece of cotton wool. This is also an excellent remedy for taking off unwanted lines.

4 ▶ Develop the towel further

Hatch in the folds of the tea towel above the tennis ball. Strengthen the light areas such as the triangle of cloth under the ball with extra pastel colour. Protect the work with a piece of paper to prevent smudging.

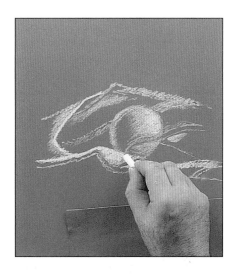

5 ▶ Continue adding pastel to the light areas

Increase the contrast between the light and dark areas by working over more of the light areas. Here, colour is being applied to the highlighted surface of the tennis ball.

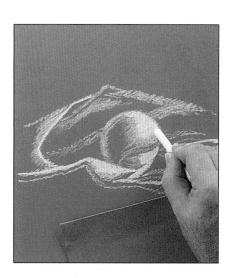

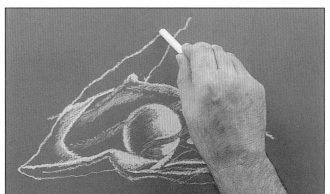

6 ◀ Complete the tea towel

Indicate the outlines of the tea towel with hatched lines. As with the previous pencil version, these will determine the edges of the drawing but need not be completed in great detail. Add further colour to the folds to complete them. Use spray fixative to prevent the pastel from smudging.

THE FINISHED PICTURE

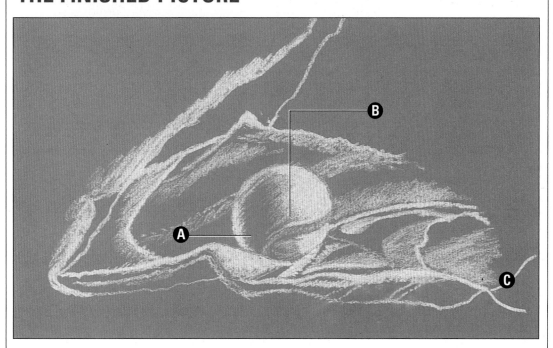

A Light and dark
The dark side of the tennis ball is left as blue paper, while the light side is heavily coloured with yellow pastel.

B Variable shading
Where the yellow pastel is applied more lightly, mid tones appear as some of the dark paper shows through.

C Simplified edges
The outer edges of the tea towel are left unfinished so that the eye is focused on the important central area.

Drawing flower heads

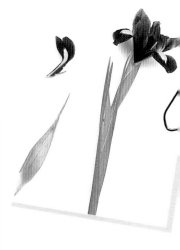

Before you can attempt to draw anything with a degree of accuracy, you need to spend vital time observing it closely.

Your aim in this drawing exercise is to combine the skills of soft shading, practised in the previous project, with careful line drawing. This involves some close-up observation of the subject. After all, observation is the key to good drawing; it is the foundation on which you build up your visual knowledge. Through careful observation, you can discover in depth how your subject matter is constructed. This in turn will help to improve your drawing skills, as you will be drawing what you understand.

Observing flowers

In order to develop your observational powers, it is a good idea to practise drawing all kinds of objects in detail. Flowers make ideal subjects as their shapes are varied, yet taken individually, their petals and leaves are not too complex. Choose a flower with an unusual shape, such as the iris shown here. If the petals or leaves have some patterning on them, this will make the exercise even more interesting. Start by removing one petal from a flower head and one leaf from the stem. Observe the petal and leaf closely for some time and then make pencil drawings of them. This will give you confidence, through knowledge of the subject matter, to move on to drawing the complete flower head and stem.

Coloured version

As an extension of this black-and-white exercise, you could try drawing the whole flower again, this time using water soluble coloured pencils to give a painterly effect. As you will already have observed the flower very closely for the pencil version, you should find that you can draw it with more ease and spontaneity the second time around.

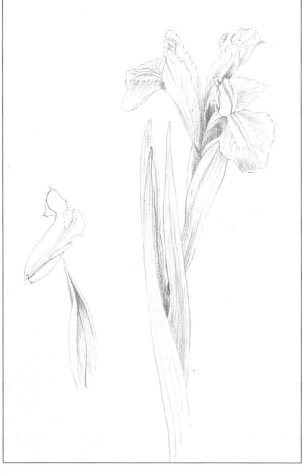

◄ **This realistic drawing of an iris was achieved only after careful observation of its various parts.**

HOW TO MAKE A PENCIL DRAWING

1 ◄ **Draw a single petal and leaf** Lay an iris petal and leaf onto your paper. Study them carefully and begin by drawing simple outlines with the B pencil. Then move on to include some soft shading strokes with the 2B pencil where you see darker patches. Take note, too, of the linear veins, both in the petal and the leaf, and add these.

2 ▲ Begin drawing a whole flower Now set an iris flower up beside your paper. Before you start, look carefully at the flower head, trying to simplify the formation of the petals in your mind. Then use the B pencil to draw straight lines to create various 'boxes' which will form the structure of the drawing. You can eventually draw the actual shapes of the petals and leaves into or around these. The 'construction' lines can be erased when the drawing has been completed.

3 ▶ Outline the petals Once the overall plan is established, draw the outlines of the petals and main veins, using your construction lines as a guide. Continue with the B pencil, but apply a little more pressure in order to produce a clarity of line.

4 ◀ Outline the leaves Then move on to the leaves, still making only outlines at this stage. Try to be as accurate as you can. 'Measure' the size of the leaves against the petals or stem visually, so that you get the shapes and proportions right.

HOW TO ADD SHADING

Once you are satisfied that you have depicted the linear structure of the flower head as accurately as possible, begin the process of giving depth to your picture by shading the petals and leaves.

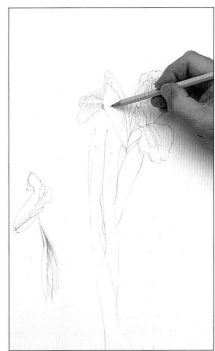

5 ◀ Start shading the drawing Use your 2B pencil to create lighter tones at first and then, by increasing the pressure, add some darker tones where necessary, for example in the crevices of the petal. You can also introduce the smaller veins at this stage.

EXPERT ADVICE
Observe and analyse

Spend a while analysing your subject carefully – it will be of great help when you begin to draw. You will notice details in even simple objects that you may have taken for granted. Start by looking at the basic proportions of the object – the relative sizes of its various elements. Then observe the way light falls on it and what this reveals about both the object's volume and its surface texture. Notice also how strong or slight the contrast is between light and dark areas.

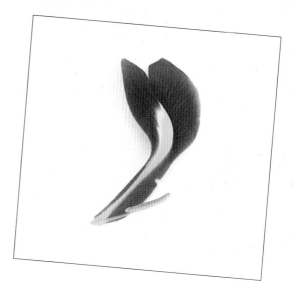

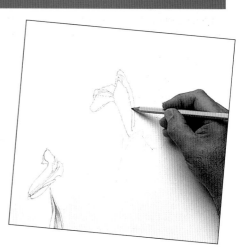

TROUBLE SHOOTER

When developing your drawing, try to work from left to right and from top to bottom. This will reduce the risk of your accidentally smudging the work, particularly if you are using a soft pencil for shading. If you are left-handed, work from right to left and top to bottom.

6 ▲ **Develop the petals** Continue shading and adding veins to the petals. Try to produce darker tones at the base of the flower head, particularly where it emerges from the stem and leaf shapes. This will suggest natural growth, and will have the effect of pushing the petal in the foreground towards you. Dark behind light will always help to project a shape forward in this manner.

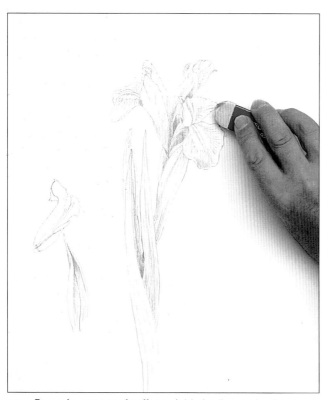

7 ▲ **Erase the construction lines** Add shading and veins to the iris leaves, in the same way as you did to the petals by building up dark and light tones. Finally, remove any unwanted construction lines with a clean rubber, taking care not to disturb your main outlines or the shading.

THE FINISHED PICTURE

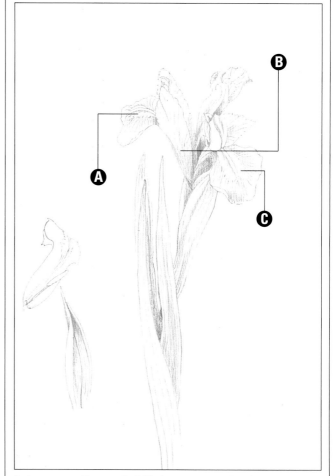

A Accurate outlines
Fine pencil lines were used to record precisely the outlines and details of the iris petals.

B Added tone
Degrees of shading from light to dark give a three-dimensional quality to the flower and leaves.

C Lifelike flower
Each vein on the petals was observed and drawn to make the picture as realistic as possible.

HOW TO MAKE A COLOUR DRAWING

As an extension of the graphite drawing, why not think about drawing the same flower in colour? To make the exercise even more interesting, use water soluble coloured pencils. The end result will be a piece of work that resembles a watercolour painting. So look at the same subject again and see what difference using colour makes.

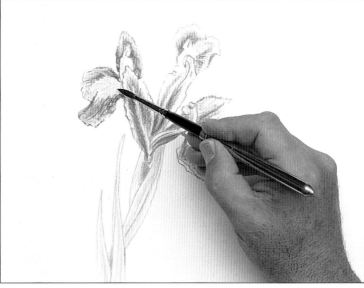

3 ▲ **Add water to the colour** Add a little clear water to the coloured pencil shading with a soft round brush. Do not use too much. If you flood the drawing, the colours will merge into a blur. Note how the pigment colour intensifies when the water is added.

YOU WILL NEED

Piece of cartridge paper

Water soluble coloured pencils: Deep violet; Indigo blue; Sap green; Mid yellow

Soft round brush with a point

Scalpel or pencil sharpener

1 ▲ **Draw a freestyle outline** The previous graphite drawing should have given you the confidence to draw completely freehand – just draw what you see. Without any pre-planning, draw the outlines of the flower head in deep violet and indigo blue water soluble coloured pencils. Use sap green to indicate the stem and parts of the leaves.

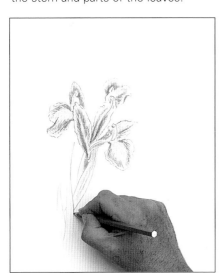

2 ▲ **Fill with colour** Shade the petals' edges with deep purple and indigo blue as shown, and use mid yellow for the central areas. Strengthen the colour, but do not fill every shape entirely. If you do, there will not be room for the pigment to move when water is added.

THE FINISHED PICTURE

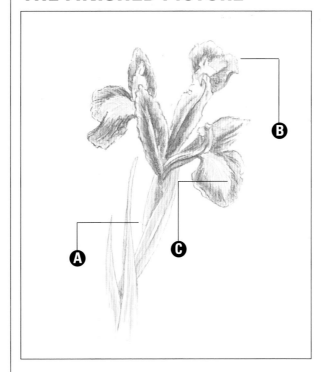

A Watercolour look
The addition of a little water softened the coloured pencil shading to give an effect similar to a watercolour painting.

B Defined outlines
The coloured outlines were defined clearly to emphasise the shapes of the petals and leaves and add more impact to the picture.

C Realistic detail
As in the graphite version of the iris, the smallest details of the flower head, such as the veins, have been carefully observed.

White on white

Drawing white objects against a white background will help you to develop your skill in using shading to render shape and volume.

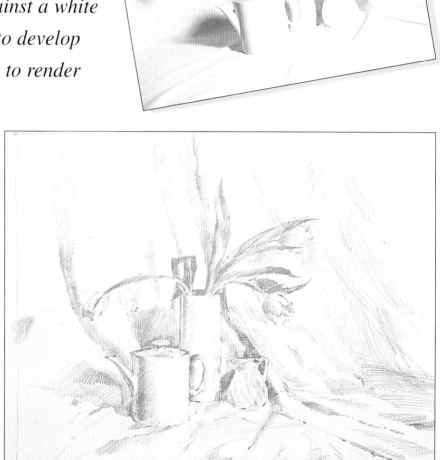

This all-white still life may seem a daunting prospect at first, but you will find it a worthwhile exercise in both observation and the use of tone. It is important that the objects are strongly lit from one side so that they cast dark shadows in a single direction only; this simplifies the composition and allows the white flowers and china objects to stand out against the background. Softer, subtler shadows on the rounded objects themselves convey their shape and also differentiate them from the white fabric backdrop.

Grading shadows

You will discover how to give a sense of depth to your picture by grading the shadows from dark – in the folds of the cloth behind the vase and on the leaves of the tulips – to light in the foreground. Accurately judging the density of the shading will help your composition by making the china objects 'sit' realistically on the horizontal surface. You will find darker shadows can be drawn most successfully with a soft 4B graphite pencil. You should switch to a B pencil for finer details, such as the tulip petals.

Negative shapes

This exercise will also build on the technique you learned previously, of drawing without outlines. By shading the background you create dark positive shapes, which form light negative ones in front of them. You will find the final effect is much more convincingly three-dimensional than if you give each object a hard black outline.

▲ **In this white-on-white still life the artist has used graduated shading to render the curved surfaces of the china objects and the soft folds of the draped fabric. The dramatic side lighting casts strong shadows against which the white objects stand out well.**

YOU WILL NEED

Sheet of cartridge paper

Graphite pencils: 4B and B

Putty rubber

▶ **It's worth making a couple of preliminary thumbnail sketches to decide on the best format for your picture. Here, the artist has chosen a landscape image to show more of the fabric folds, which help to balance the composition.**

FIRST STEPS

1 ▲ Sketch in the shapes Lightly sketch in outlines of the teapot, vase and jug to establish their positions in relation to each other. Use light lines to indicate the edges of the shadow areas and the shapes of the tulips. Use the 4B pencil, which is easy to rub out, as these lines will be removed later.

2 ▲ Start the shadows Next look carefully at the objects to see where the strongest shadows fall. Start blocking these in, using the side of the 4B pencil lead to give a dark, soft effect. Begin with the area behind the teapot, then render the shadows cast by the flowers and the fabric folds.

3 ▶ Fill in the shadows Continue filling in the background shadows. Using the tip of the pencil, draw the shadow made by the teapot with soft, even hatching strokes, then fill in the dark area between the vase and jug. Hold your pencil well away from the lead tip so that you can move your hand freely.

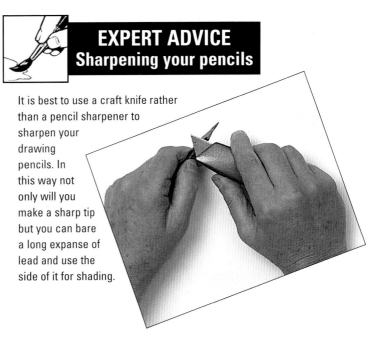
HOW TO DEVELOP THE DRAWING

Pause to look at your drawing so far: all the elements are in place and the relative areas of light and dark have been indicated. Notice how the background shadows have created the outlines of the china objects as negative shapes. Now you can go on to work on the details.

4 ▲ Shade the objects Start shading the objects themselves to render their rounded surfaces. Change to the B pencil, as you want this shading to be lighter and finer than the background shadows. To achieve a straight edge for the shadow on the vase, mask off the left edge with a piece of paper while shading. This will leave a narrow white strip of unmarked paper, representing the band of light (reflected from the white fabric) on the edge of the vase.

5 ▼ Strengthen the shadows Add shading to the teapot and jug, making this stronger on the left, furthest from the light source, to give the objects a realistically rounded appearance. Change back to the 4B pencil and continue defining the jug by strengthening the shadow around it.

6 ▶ Draw the leaves Now start working on the tulips. Begin with the leaves: parts of them are tonally darker than the background shadows, so shade these more heavily.

7 ▼ Adjust the balance of tones Strengthen the background shadow behind the teapot lid. Whenever you change one element in your picture, always stop to look at the whole composition, to make sure the relationship of tones and shapes is still harmonious.

8 ▲ Draw the flowers Draw the flower heads with the B pencil to achieve more delicate shading. Remember to keep your pencil well sharpened so that you have a fine point to work with.

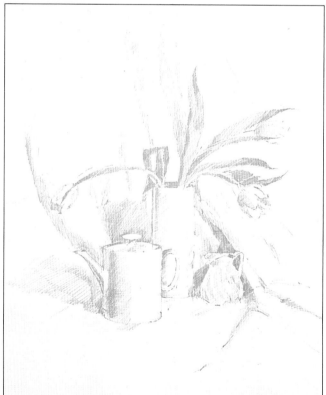

9 ▲ Shade in the folds Finally, add a little more shading to the shadows in the folds of the fabric to diffuse the edges and give them a gently rounded shape, remembering to use the edge of your pencil. This completes the picture, but if you feel you would like to develop it further, you could draw some more of the softly folded fabric.

You can extend your drawing by adding more folds to the foreground and to the right of the picture. This will help frame the objects and make a pleasing composition. It will also help to define the horizontal surface on which the china objects stand, locating them in space and giving them extra solidity.

10 ▲ **Add more folds** Add shading to represent the folds in the fabric in the foreground. Use the 4B pencil, but remember to keep the shading very light as the shadows are much paler in this area than in the background.

11 ▲ **Enlarge the picture area** Extend the picture to the right by adding shading to show where the folds of fabric 'break' from the vertical to the horizontal plane. This will help to develop the perspective of your picture.

TROUBLE SHOOTER

CORRECTING HIGHLIGHTS WITH A PUTTY RUBBER

The lightest tones in this drawing are created by letting the white paper show through. If you shade over an area and then decide it should have a highlight, use a putty rubber to erase the pencil marks. One of the advantages of this type of eraser is that it can be moulded to a fine point, enabling you to make adjustments very accurately.

12 ▲ **Indicate the table edge** Continue to develop the folds to the right of the picture. Next add a line of shading along the bottom of the picture to indicate where the fabric falls over the edge of the table. This will help define the edge of the picture and enhance its three-dimensional effect.

13 ◄ **'Frame' the picture** Use the putty rubber to remove any of the early construction lines that are still visible and clean up the paper. Now the picture is finished, you can 'frame' it by drawing a pencil line to confirm the composition and define the area you are including. This line would be the guide for a mount if you wanted to mount and frame your picture. Note that the artist has deliberately cut off the shadow of the flower-head on the left and some of the folds on the far right. You do not have to include every element of the picture; often you can improve the composition by cropping off details at the edges.

THE FINISHED PICTURE

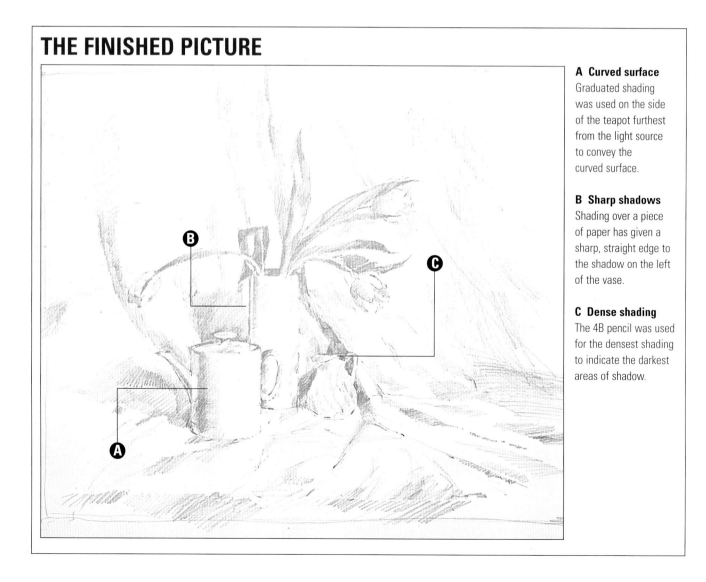

A Curved surface
Graduated shading was used on the side of the teapot furthest from the light source to convey the curved surface.

B Sharp shadows
Shading over a piece of paper has given a sharp, straight edge to the shadow on the left of the vase.

C Dense shading
The 4B pencil was used for the densest shading to indicate the darkest areas of shadow.

Surface pattern

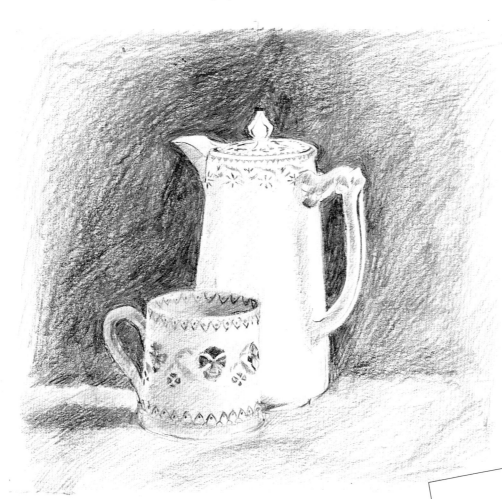

Patterned china adds a decorative element to a still life. Make it look realistic with a delicate touch and a sharp pencil point.

◄ **The fine detail on these pieces adds an extra dimension to the finished drawing, and will provide you with a challenge.**

▼ **Doing a loose thumbnail sketch like this before you start will help you establish the composition and 'cut-off' area of the drawing, and also to decide whether the colours you have chosen are suitable.**

This still life builds on the skills shown in the previous project, of using shading to render curved surfaces. This time we will be looking at drawing decoration on china objects, using coloured pencils to introduce a more illustrative element.

You can take your drawing to a finished stage using only two coloured pencils, indigo and sap green. However, you may choose to add two further colours, which will finish it off attractively.

The objects chosen for this still life, a coffee pot and a mug, both have simple shapes, as it is more difficult when you are starting out to draw decoration on more complicated items. The coffee pot and mug have been lit from the side to enhance the appearance of volume.

43

FIRST STROKES

1 ▼ **Establish the scale** Start by drawing a very faint outline of the objects, using the indigo pencil. Make sure you draw the curved lines (ellipses) accurately – see Expert Advice below for help. Part of the purpose of this exercise is to learn to draw directly in colour – it's not necessary to draw outlines in black pencil and then fill in colour. But do use very faint marks at this stage, as coloured pencil is more difficult to erase than ordinary graphite pencil.

YOU WILL NEED

Sheet of cartridge paper

Coloured pencils: Indigo, Sap green, Raw sienna, Magenta

Putty rubber

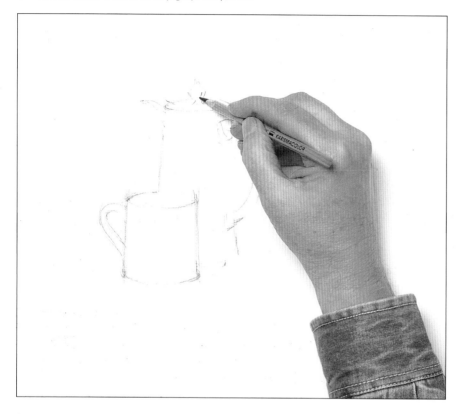

2 ▲ **Start the shading** Still using the indigo pencil, begin shading the mug and coffee pot to establish the roundness of the shapes. You can now apply a little more pressure, but do not press too hard or grip the pencil too tightly, as this will inhibit the free movement of your hand.

EXPERT ADVICE
Drawing ellipses

Take care when drawing ellipses – the curves you see at the rim of a rounded object. It is a good idea to sketch in lightly the imaginary back of the curve as a guide, even if this is not visible. The two sides of the ellipse should be symmetrical, both vertically and horizontally; to check this, either hold your drawing up to a mirror or turn it upside down, as shown here. Any mistakes will then be much more obvious.

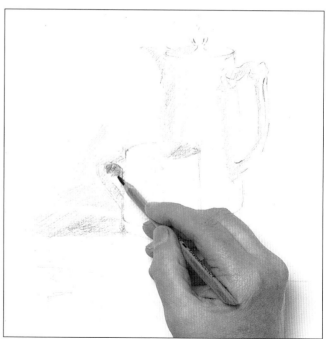

3 ▲ **Start the background** Now begin indicating the background and defining the negative shapes, for instance inside the handle of the mug. Lightly shade in the shadows thrown by the objects.

4 ▼ Darken the background You can now use a little more pressure to darken the areas of heaviest shadow in the background, but keep your strokes and movements free – think of your shoulder as being the pivot for your arm. Then, with the pencil sharpened to a point, delineate, or mark out the objects and draw up to them, carefully following the 'under-drawing' – your original faint outline.

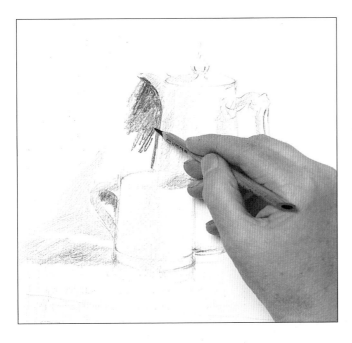

5 ▼ Continue in indigo Carry on adding the background with the indigo pencil. Do not make the shading too heavy as you will be adding sap green later on. (As coloured pencils are a relatively transparent medium, the blue will show through, creating a dark green shade.) Roughly establish the outside edges of the drawing.

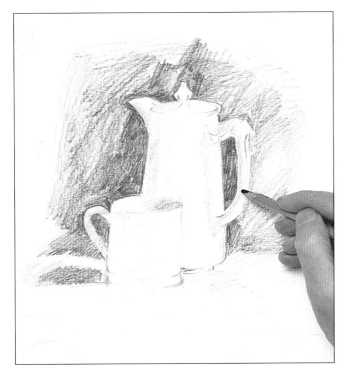

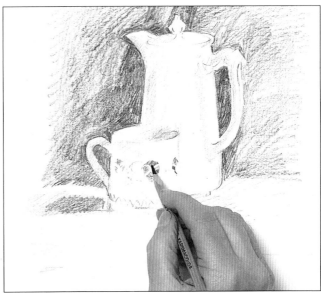

6 ▲ Add the decoration Still working in indigo, now begin drawing the pattern on the objects. Start with the pansies on the mug, then add the small zigzag pattern round the rim, remembering to follow the line of the ellipses with care. Continue by adding the decoration on the pot.

DEVELOP THE PICTURE

Up until now, you have been creating a **monochrome** drawing with the indigo pencil. You can give depth to the shading by working over the blue with the green coloured pencil. This can also be used to complete the patterns on the mug and coffee pot more realistically.

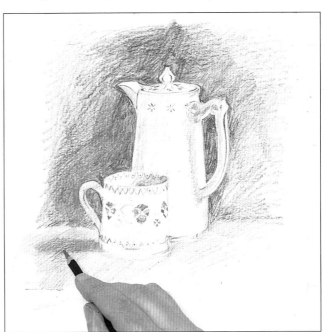

7 ▲ Start adding green Start using the sap green pencil to go over the blue shading in the background. This will produce a dark green very similar to the colour of the fabric. You do not need to produce an exact colour match – creating the correct tone is much more important. Pleasing tones, rather than accurate colours, will be noticeable in the picture.

8 ▶ Create the edges Carry on working in green, strengthening the existing shadows and moving outwards to give a soft edge to the picture. Work lightly in the foreground, as the light falling on the table surface makes the tone much lighter there than on the backdrop.

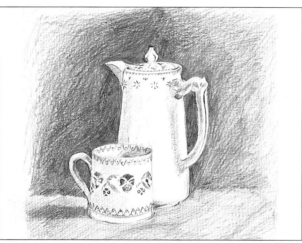

9 ◀ Finish the decoration Now you have finished the background, you can complete the details of the decoration. Make sure the tip of the pencil is still sharp, then draw in the leaves on the mug and the tiny green leaves on the coffee pot.

CORRECTING HIGHLIGHTS

TROUBLE SHOOTER

It is difficult to remove coloured pencil marks with a rubber. If, when drawing with coloured pencils, you have covered over an area you later wish to leave white, for instance a highlight, you can use a sharp craft knife or scalpel to gently scrape off the coloured surface of the paper. Be very careful, however, as it is easy to scuff the surface, especially of a poor-quality paper.

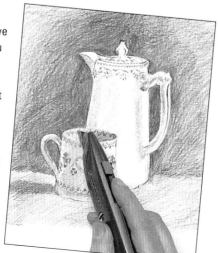

A FEW STEPS FURTHER

Some subtle shading will help to differentiate between the overall tone of the mug and that of the coffee pot. A few extra touches of colour will bring the decorative patterns to life.

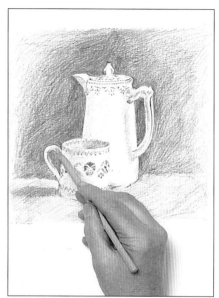

10 ▲ Add more colour To complete the picture and make the colours warmer and more realistic, you can use a raw sienna pencil to colour lightly over the mug.

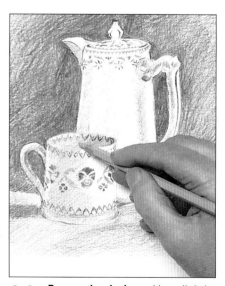

11 ▲ Deepen the shadows Use slightly more pressure to draw the inside of the mug and the base where the tone is deeper. This helps reinforce the appearance of roundness and also adds more warmth to the picture.

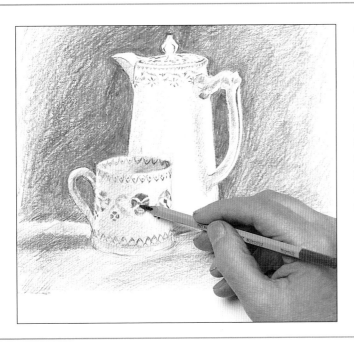

12 ◄ **Finishing touch** Finally, add the fine detail to the centre of the pansies on the mug with a magenta pencil. Shade over the shadows in magenta to warm up the tone a little more if you wish.

THE FINISHED PICTURE

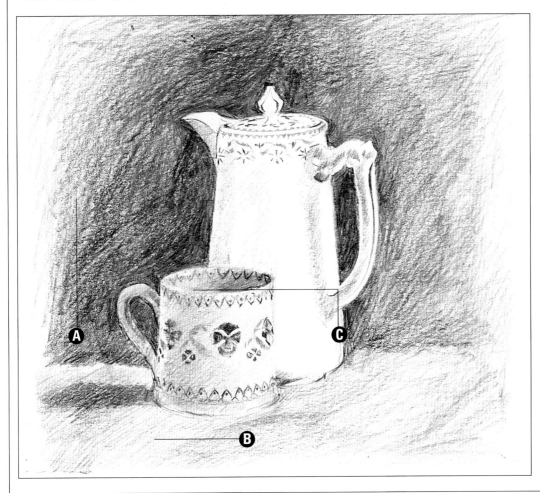

A Two-tone shadow
Blue and green pencils were used together for the darkest shadows.

B Light foreground
Green only, applied lightly, was used to help the sense of perspective by making the foreground much lighter than the backdrop.

C Added warmth
Shading in raw sienna helped to warm up the picture and emphasise the roundness of the mug.

Drawing patterned fabric

In this exercise you will be building on the skills you practised when drawing patterned china objects, but this time concentrating on fabric.

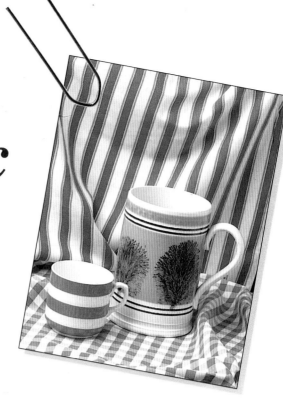

In this still life we introduce another element to extend your drawing skills: a background of patterned fabric. Drawing the fabric will involve not just shading, as in previous exercises, but also using the way the pattern on the fabric falls and changes direction to indicate the folds and creases.

Limited colours

In order to concentrate on drawing pattern, it is a good idea to limit the colour range for your still life to just a few different shades so that the composition doesn't become too fussy. This set-up has a simple blue-and-white striped background, and the china objects are placed on a checked table-cloth in the same colours. The small blue-and-white mug echoes the background fabric and the only additional colour is introduced by the large mug on the right of the drawing.

Soft lighting

In previous drawing exercises, you have lit your still life strongly from one side in order to cast deep shadows. This time you should arrange a softer light source, as the point of the exercise is to concentrate on how pattern rather than shadow renders the fabric folds.

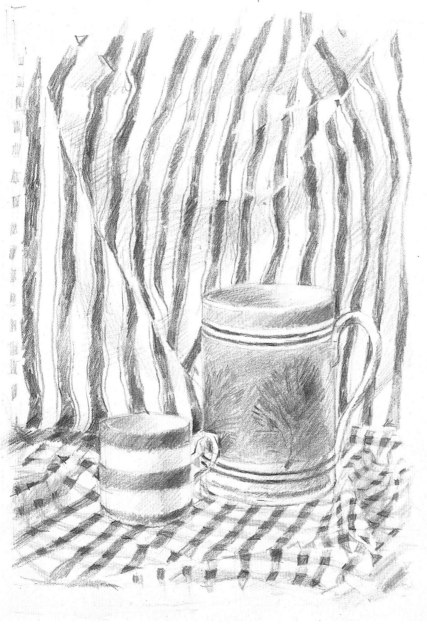

◀ **The distortions in the stripes and checks on the patterned backdrop and tablecloth make it clear where the folds in the fabric fall.**

HOW TO DRAW FOLDED PATTERNS

1 ▼ Make a pencil underdrawing Use a coloured pencil, in
this case cobalt blue, for the initial underdrawing as in the
last project. Define the edges of the picture lightly, then
sketch in the outlines of the mugs and start to indicate the
stripes on the fabric.

YOU WILL NEED

Piece of smooth white
cartridge paper

5 coloured pencils: Cobalt blue;
Cerulean blue; Prussian blue;
Burnt umber; Charcoal grey

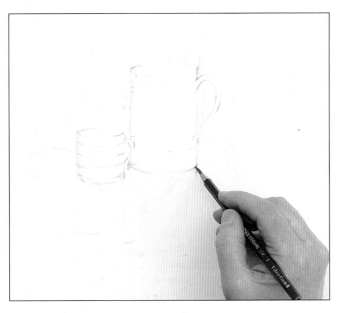

**3 ◄ Add more detail to the
folds** Continue
drawing the
stripes of the
background fabric,
strengthening the
blue colour where
the folds have
created areas of
shadow.

**2 ► Start work
on the striped
backdrop** Indicate
the main folds in
the backdrop,
then draw the
outlines of the
stripes and start
to shade them in.
The position of
the stripes
defines the shape
of the fold.

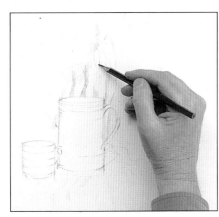

**4 ► Begin the
tablecloth**
Once you have
lightly indicated
the remaining
stripes on the left
of the backdrop,
roughly mark the
vertical stripes on
the tablecloth,
still using the
cobalt blue pencil.
Then fill them in.

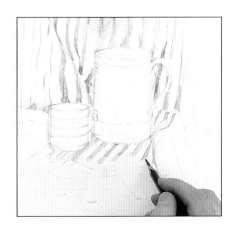

**EXPERT ADVICE
Checking the pattern**

Rather than just relying on
observation to get
the position
of the stripes
and checks
right, it is
worth actually
counting them.
Make marks at
the edges of the
mugs as a guide-
line for drawing
them in.

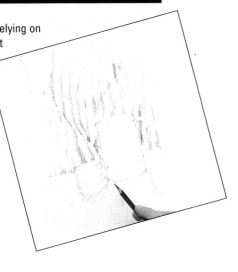

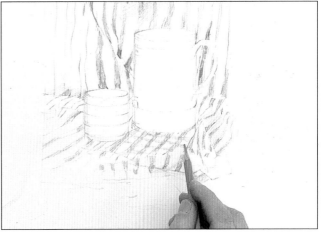

5 ▲ Change the direction of the stripes to show the folds
Indicate the fold where the fabric falls over the edge of
the table by showing the change of direction in the stripes.
Then switch to the lighter cerulean blue pencil and start
drawing in the crosswise stripes of the checked fabric.

6 ▶ Strengthen the backdrop
Return to the backdrop and, with the Prussian blue pencil, strengthen the vertical stripes. Still with Prussian blue, deepen the areas of shadow in the creases of the folded fabric, leaving a highlight on the ridge formed by the creases.

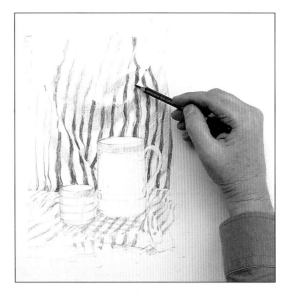

CORRECTING A LACK OF CONTRAST

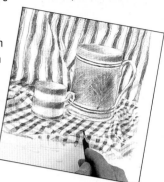

If you feel there isn't enough contrast in the foreground checks, where the lines cross over, go over the squares with the Prussian blue pencil to make them stand out better.

TROUBLE SHOOTER

7 ▼ Work on the striped mug Shade in the stripes with the cobalt blue pencil. Add shading to the right-hand side of the mug to define the shape.

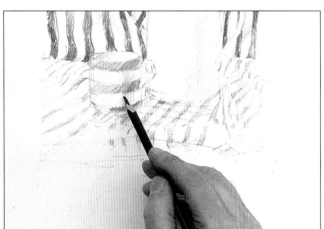

8 ▼ Shade in the background decoration on the mug Take the burnt umber pencil and use it to shade the centre panel of the large mug. Keep the pencil strokes long and even, and slant them to indicate the curve.

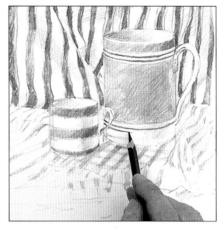

9 ◀ Add details to the large mug
With the charcoal grey pencil, add shading to the inside of the large mug. Draw in the curved decorative lines above and below the burnt umber panel, again using charcoal grey.

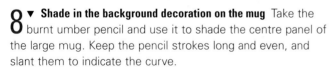

10 ▲ Finish the large mug Finally, sketch in the decoration on the mug panel, using charcoal grey. Add shading to the mug handle and around the top and bottom rims.

You still have scope to add fine detail to the patterned fabrics to strengthen them.

11 ▼ Emphasise the gingham fabric Use the cerulean blue pencil to outline the edges of the paler, horizontal stripes on the tablecloth to make them more positive.

12 ▼ Add detail to the backdrop Use the Prussian blue pencil to add fine lines to either side of the stripes on the backdrop fabric.

13 ◄ Refine the shading Use the burnt umber pencil to add warmth to the shading inside the small mug. This colour will also echo the decorated panel on the larger mug and link these two elements of the picture.

THE FINISHED PICTURE

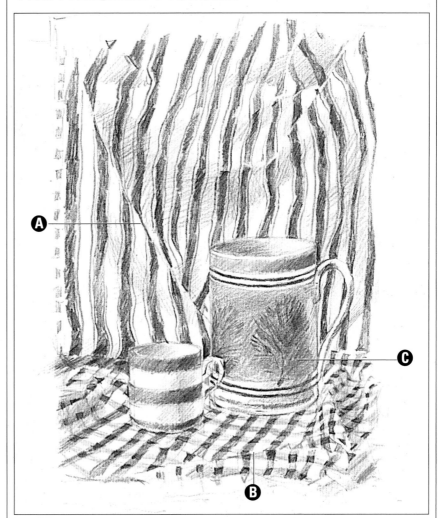

A Fabric folds
The irregularities in the striped pattern serve to depict the positions of the folds in the fabric backdrop.

B Gingham checks
In a similar way, the displacement of the gingham checks show how the tablecloth is folded.

C Colour contrast
The decorative brown panel on the larger mug adds the only element of colour contrast in the drawing.

Still life in coloured pencils

Practise a range of drawing skills with this still life combining patterned and plain objects.

▼ This still life shows a selection of objects with different textures and patterns.

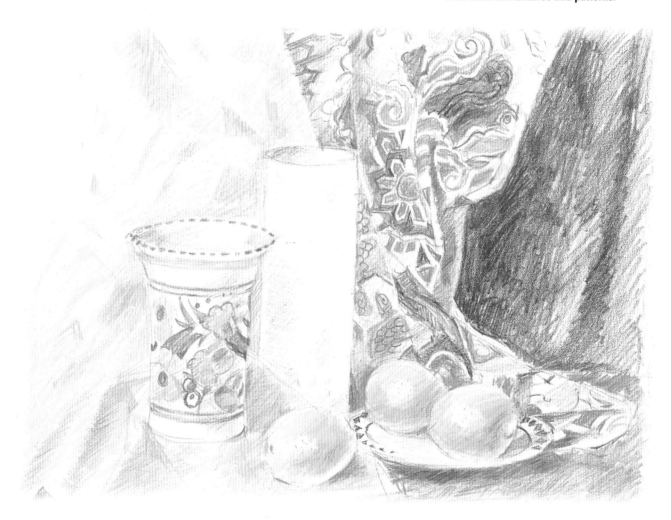

You will now be familiar with how to depict plain and patterned items, how to deal with a white subject, how to show curves on objects and how to tackle shadows. This exercise brings all these skills together into one composition.

This still life set-up combines the simplicity of a plain vase with the interest of decorative china and fabric. The lemons introduce a natural element to the arrangement. The overall composition, the contrasting surfaces of the objects, and the patterns and folds of the draped fabrics are the main points of study. If you set up a similar still life of your own, try various arrangements and make a few thumbnail sketches first to establish the best composition.

Coloured pencils

The still-life drawing was done in coloured pencils from a variety of sources. Manufacturers have different names for their colours – some use just numbers. A large set of pencils will probably include the colours used here, but most art shops sell loose pencils too. Coloured pencils can be mixed: softly blending two or three colours creates more subtle shades.

◄ In this composition, the patterned vase against the patterned fabric tends to complicate the picture. In addition, the lemons look detached from the rest of the composition.

▶ Here again, the two patterned items are set against each other, which detracts from each. However, the lemons are set in a more pleasing position in this composition, although they are grouped too closely together.

2 ▲ Complete the sketch Indicate the edges of the drawing, noting how the folds of fabric are arranged to draw the eye into the composition. Draw the patterns on the vase and fabric.

HOW TO START THE DRAWING

1 ▼ Sketch the composition Use the sepia pencil for the initial drawing to establish an underlying warm tone. Work lightly as coloured pencils are difficult to erase.

3 ▲ Introduce colour to the fabric Now use the raw sienna pencil to fill in the background of the patterned fabric. This will help to establish the design. Bring out the floral motif and other larger red areas of the patterned fabric using the madder carmine pencil. Use the darker alizarin crimson pencil for the second tone of red. This is the most intricate part of the drawing and requires patience to make sure that the pattern is accurate.

EXPERT ADVICE
Use a viewfinder

A viewfinder cut from black card is invaluable for investigating various compositions when setting up a still life. You can change from a landscape format to an upright, portrait format for a different viewpoint.

4 ▼ Build up the pattern Introduce mineral green into the floral pattern, then continue colouring the motifs and some of the fabric background using sepia, Vandyke brown and golden brown. As you build up the colour, keep checking how the pattern is broken up by the folds in the fabric. With the addition of smalt blue, the pattern is almost complete.

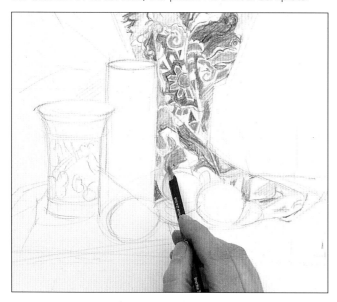

HOW TO DEVELOP THE STILL LIFE

With the complex fabric design now basically finished, turn your attention to the remaining areas of the still life – the plain fabric, the dark backdrop and the other objects in the composition. Observe each object carefully, noting its texture and tonal value.

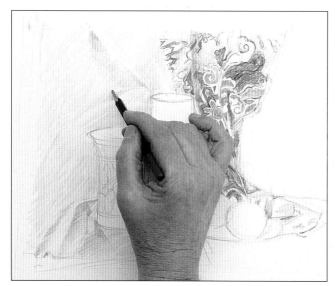

5 ▲ Introduce the yellows Use two yellow coloured pencils – lemon cadmium and Naples yellow – for the other main draped fabric. Apply them loosely to render the light marbled effect. To show the folds more strongly, use the raw sienna pencil. The more dramatic your light source, the darker the shadows created by the folds will be.

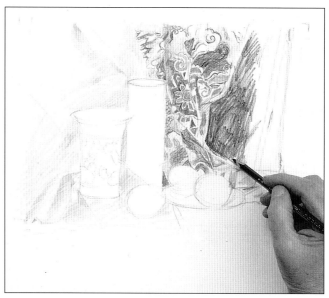

6 ▲ Fill in the darkest area As a contrast to the bright colours and patterns in the rest of the composition, the right-hand area is very dark. Fill it in with the charcoal grey pencil. This will 'throw forward' the patterned fabric, and will almost complete the outer parameters of the drawing.

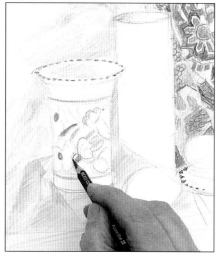

7 ◄ Add colour to the small vase You will need several colours for the design on the decorated vase. Begin with light violet, then use indigo for the dots around the top of the vase. Continue with the indigo for the dark areas of the pattern.

8 ► Complete the vase Add Naples yellow, alizarin crimson and mineral green to the vase pattern. Coloured pencils can be blended, so to make the green look a little more blue – on the curved bands, for example – just lightly pencil over it with smalt blue. Shade in some light violet on the right-hand side and inside the vase to show its round form.

9 ▲ **Finalise the composition** Depict the simple pattern on the plate rim with the charcoal grey pencil. The last area of the composition to fill in is the right-hand foreground. Use the olive green pencil to colour this.

10 ▲ **Give form to the lemons** Using lemon cadmium and Naples yellow, draw in the lemons. Work the soft shading in olive green and brown ochre, leaving highlights clear on each lemon. Indicate the rough texture of the peel using the dotted technique known as **pointillism**.

11 ▶ **Shade the white vase**
Enhance the form of the white vase by using smalt blue to indicate areas of shadow. Make the strokes of the coloured pencil follow the curve of the vase.

A FEW STEPS FURTHER

All the elements of the still life drawing are now in place. The contrast between the patterned and plain areas and the textured and smooth objects gives the picture vitality and interest. If you wish, you can work slightly more detail into some areas to accentuate their surface qualities.

13 ▼ **Add yellow to the marbling**
To emphasise the marbled effect on the plainer of the two fabrics, add more of the Naples yellow pencil so that the faint design shows more strongly.

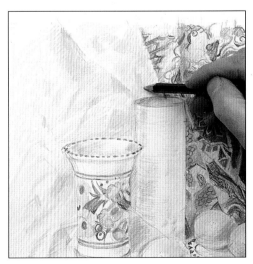

12 ▲ **Complete the areas of shadow** The rim of the plate casts a deep shadow on to the olive green cloth in the foreground of the still life. Indicate this dark shadow under the plate with the charcoal grey pencil.

14 ▼ Draw the reflection of the lemons

Use the Naples yellow pencil to add a very soft reflection of the lemons in the white vase. This will help to indicate the vase's shiny glaze.

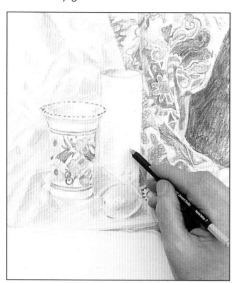

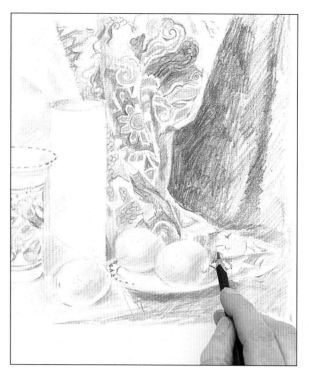

15 ◄ Complete the fabric in the foreground

Add the final touches to the pattern on the fabric in the foreground of the picture, accentuating the detail a little more.

THE FINISHED PICTURE

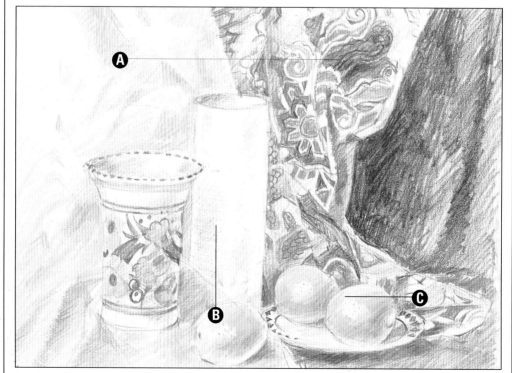

A Patterned fabric
The fabric design is depicted in intricate detail to provide an interesting backdrop to the plainer objects in the still life.

B White china
Although the vase is plain white, the shaded areas have a blueness to them, while the reflections of the lemons add a yellow tone.

C Rough texture
In contrast to the smoothness of the white china, the textured skin of the lemons is represented by dots of colour.

Studies of leeks

By drawing a single subject, you will learn about different shading techniques and how to get the best effects with coloured pencils.

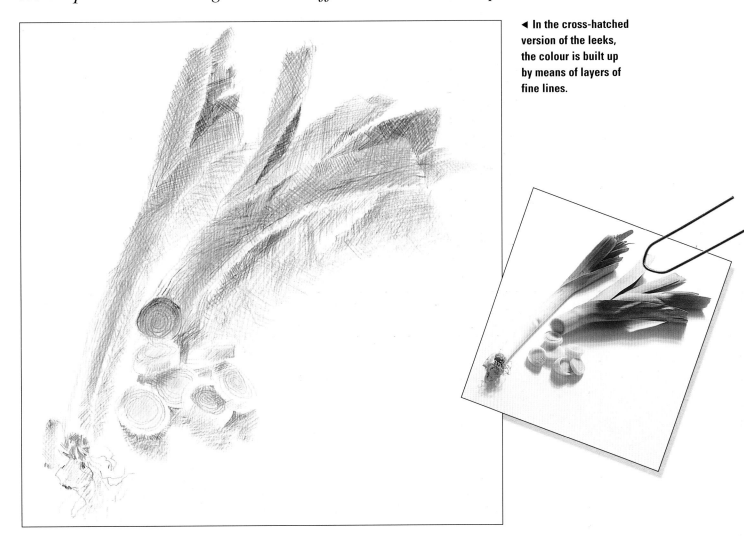

◄ In the cross-hatched version of the leeks, the colour is built up by means of layers of fine lines.

This drawing exercise returns to the study of a single subject – in this case, a pair of leeks. As in the project on page 34, when the subject was a single flower head, you will practise the close, intense observation needed to draw well, without the distraction of having to plan a whole composition.

You will also experiment with two different ways of building up colour and rendering shadows: cross-hatching and blending colours. Each method produces a very different effect and as you practise them in turn, you will discover which you prefer, both for the final look that the method achieves and how it suits your personal style of drawing.

Limited colour range

Only five coloured pencils have been selected for these drawings. Deliberately limiting the range of colours you use in a drawing is a useful exercise. It teaches you how to blend pencil colours to achieve the exact shade you want, rather than just choosing a ready-made colour from your pencil box.

Even if you already have a large selection of pencils, it is worth while spending some time practising layering and blending colours. By doing this, you will learn about the various proper-ties of different shades and the mixes you can achieve with them.

Choosing a subject

For this type of exercise, a simple, everyday object such as a common fruit or vegetable is ideal: because it is so familiar, you will probably never have examined it really carefully. Doing this will help you to analyse colour accurately. As you will see from these drawings, leeks are not just green and white; you will need to use shades of brown, blue and yellow as well as green.

HOW TO DRAW USING CROSS-HATCHING

1 ▶ Establish the outlines Using the olive green pencil, lightly sketch in the outlines of the leeks. It doesn't matter if you make a mistake or change your mind at this stage, as heavier marks made later on will hide these preliminary lines.

2 ▲ Start the shading Still using olive green, start hatching the dark areas of the leeks. Draw a succession of fine parallel lines, holding the pencil loosely and trying to work rhythmically. Remember to keep the tip of your pencil very sharp by rubbing it on a piece of sandpaper; in this way, the lines will remain fine and light.

3 ▲ Finish cross-hatching Finish hatching in olive green, then go back over your marks and cross-hatch by drawing further fine strokes over and at right angles to the first ones. Introduce apple green, a brighter colour than olive, to 'lift' and add depth to the green of the leaves.

4 ▶ Work on the lighter areas Still using the apple green pencil, draw in the centres of the chopped pieces of leek. Change to a lemon cadmium pencil to cross-hatch the light-coloured stems of the leeks and the sliced surfaces.

YOU WILL NEED

Sheet of cartridge paper

Coloured pencils: Olive green; Apple green; Lemon cadmium; Indigo; Brown ochre

Small piece of sandpaper

5 ▼ **Draw the shadows** Now switch to an indigo pencil and cross-hatch the shadowed areas beside the leeks and under the chopped pieces. Keep using light, free movements of your hand and wrist in order to achieve an even intensity of tone. Only where you want to make the colour darker do you need to press hard on the paper. Note how the dark colour is still not solid – it is produced by the accumulation of fine lines closer together than in the lighter areas.

6 ▶ **Darkening the leaves**
Continue working with the indigo pencil to darken the shaded areas of the leaves, increasing the pressure for the very darkest areas. Then go over the shadows in brown ochre to warm up the tone a little.

THE FINISHED PICTURE

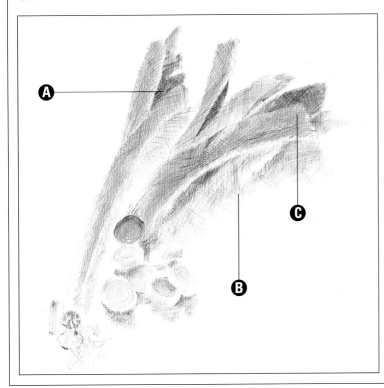

A Cross-hatching
The lines of cross-hatching were drawn closer together and with greater pressure for the darkest shadows.

B Indigo shadows
The shadows on the background were drawn in indigo rather than a more obvious grey in order to harmonise with the blue tone used on the leaves.

C Subtle colour
The green of the leaves was realistically rendered by building up layers of hatching in several different colours.

7 ▲ **Finishing touches**
Draw the fine veins on the leaves in indigo, and also use this colour to darken the base of the leek on the left and to add a little more detail to the circles on the cut surfaces. Change to the brown ochre pencil and draw the earthy base of the uncut leek and its hairy roots.

HOW TO DRAW WITH BLENDED COLOURS

As an alternative to cross-hatching, which produces an attractive effect but is quite time-consuming, you might prefer to try a study of the same subject, building up layers of colour from light to dark, but this time using solid shading.

1 ▲ Starting the drawing With the brown ochre pencil, establish the outlines. Either draw freehand as before, or paperclip the first drawing to a new sheet of paper and trace the outline against a window. Start colouring the leaves by shading smoothly in lemon cadmium – the lightest colour.

2 ▲ Adding more tone Shade over the darker areas in brown ochre pencil. Then add apple green to give volume and shape to the leeks and to draw the circles on the cut surfaces.

3 ▲ Adding the shadows Use the olive green pencil to darken the leaves and the rings on the cut slices. Define the slices with brown ochre. Finally, use the darkest colour in your palette – indigo – to draw the shadows on the background and to intensify the darkest green on the leaves.

THE FINISHED PICTURE

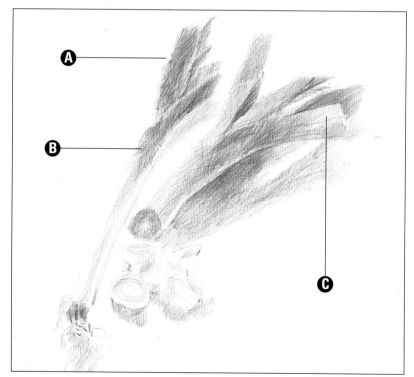

A Traced outline
The two compositions were made identical so that the shading techniques could be compared effectively.

B Blended colour
Using solid shading, a composite colour was built up in which the separate strokes are not visible.

C Light to dark
To build up the layers of colour on the leaves, the lightest shades were laid down first.

Colourful sweets

Arrange sweets and sweet wrappers to make a colourful pattern, and use your composition to explore ways to work with water-soluble pencils.

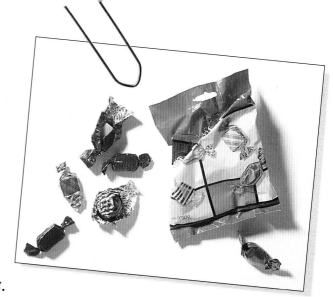

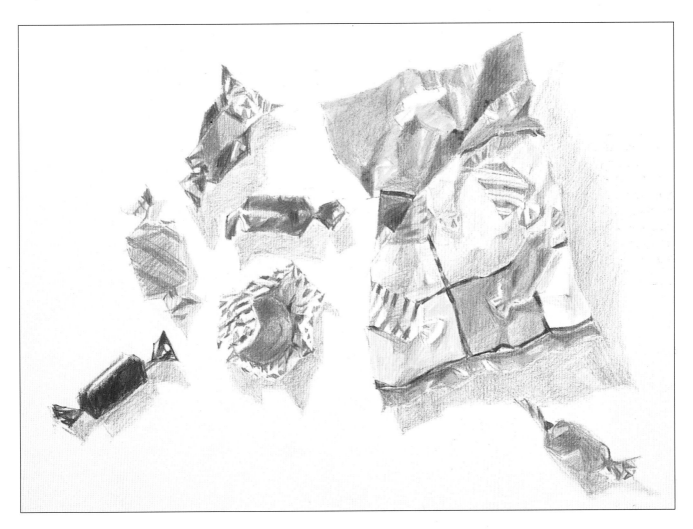

I n this exercise, you will lean how to make the most of a subject that involves a wide selection of bright, vibrant colours. You will also discover how to reproduce the sharp-edged shadows that appear when paper is crumpled, and the brilliant flashes of highlight that are characteristic of metallic foil.

Colour and detail

Previous exercises have concentrated mainly on depicting the shapes of objects. This time, you will be looking at the relationship between colours, and at surface detail. You therefore need to be able to look closely at your subject. Try arranging the sweets and their wrappers flat on a table or on the floor, and looking down on them. Or you could fix them to a piece of stiff white card, then prop the card up vertically. In either position, light your set-up strongly from one side for well-defined shadows. This picture uses 19 pencils, but you could choose sweets in fewer colours.

▲ **Water-soluble pencils, which blend very easily, are a good medium for rendering smooth surfaces, such as this sweet packet and the foil wrappers.**

FIRST STROKES

1 ▲ Draw the outlines Lightly sketch in the outlines of the sweet packet and the individual sweets, then indicate the main shadows, using a medium-grey water-soluble pencil.

2 ▲ Start the packet Shade in the top of the sweet packet in viridian, pressing harder in the shadowed area to obtain a darker tone. Leave the highlights blank so that the white paper shows through – a pale pencil will not show up over a darker colour.

YOU WILL NEED

Sheet of cartridge paper

19 water-soluble pencils: Medium grey; Viridian; Gold ochre; Raw umber; Lemon cadmium; Olive green; Hooker's green; Geranium lake; Dark carmine; Vandyke brown; True blue cobalt; Light blue; Blue violet; Dark orange; Venetian red; Prussian blue; Moss green; Apple green; Medium black

No.5 soft round brush

3 ▶ Blend the colour Finish drawing the top of the packet and the green band at the bottom. Then dip a No.5 soft round brush in water and brush out the pencil strokes to produce a smooth finish that covers the grain of the paper.

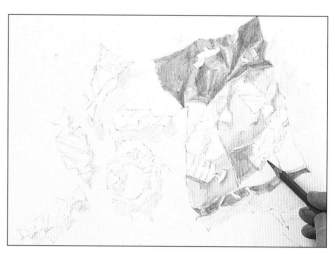

4 ▲ Go back to the pencils Use gold ochre for the light areas on the top right-hand square and raw umber for the shadows. Blend the colours with a damp brush. For the yellow square, use lemon cadmium, with olive green for the shadows. Then shade in the bottom right-hand area in Hooker's green.

5 ▶ Blend the shadow Complete the green square by strengthening the darker areas with the viridian pencil. Next, wash over the shadow under the packet with a damp brush to blend the pencil strokes smoothly.

6 ▶ Draw the red sweet Start drawing the bright red sweet. Use geranium lake for the main colour, then shade the darker areas with dark carmine. Use the same colours for the little patch of red on the left of the sweet packet.

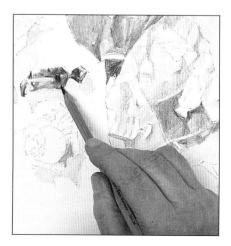

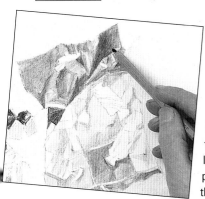

Water-soluble pencils are a very flexible medium: you can draw with a dry pencil, blend the drawn marks with a wet brush to get a water-colour effect, and then work over the same area again with a dry pencil to reinforce the colour or draw sharper lines. But be sure to let the paper dry thoroughly first, or the pencils will dig up and spoil the damp surface.

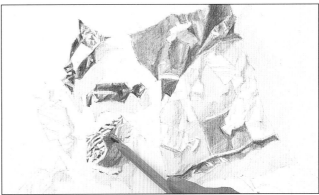

7 ▲ Continue drawing the sweets Add some Vandyke brown shading to the red sweet to darken the shadows. For the blue sweet wrapper, use true blue cobalt with light blue for the highlights and blue violet for the shadows. Draw the creases in the silver side of the wrapper in medium grey. To create the striped wrapper, draw the red stripes in dark orange and the folds in medium grey. Use Vandyke brown warmed up with Venetian red shading for the chocolate.

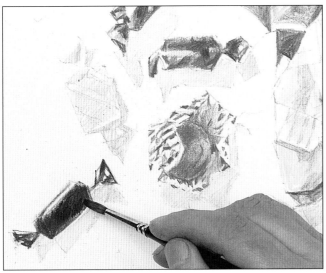

8 ▲ Blend the purple sweet Use gold ochre to shade in the background of the striped gold wrapper on the left. Then draw the purple sweet in blue violet, leaving a sharp white highlight and shading the dark side with Prussian blue. Go over this area with a wet brush to blend the colours smoothly.

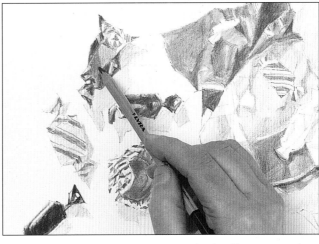

9 ▲ Draw the toffee Complete the striped toffee wrapper by drawing the green stripes with the moss green pencil. Use the same pencil to draw the stripes on the similar sweet printed on the packet. Draw the green sweet on the right in apple green and light blue, with viridian in the darker areas. For the toffee in the blue wrapper, use gold ochre with Vandyke brown.

10 ▶ Finish drawing the packet The final touch is to complete the printed sweets on the packet. The green sweet is similar in colour to the real sweet below, so use the same colours with a little more viridian to make a darker shade. Use medium black for the stripes on the black and white sweet, smudging it to indicate the shading in the centre. Shade the green striped sweet with gold ochre and raw umber. Finally, draw in the black lines on the packet with the medium black pencil; observe the folds and leave gaps and lighter areas for the highlights.

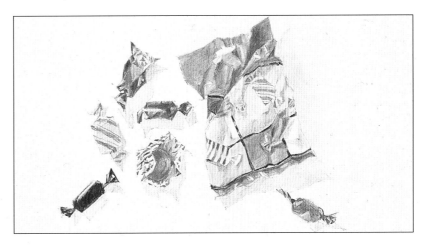

You now have an attractive and colourful finished drawing, but there are still a few refinements that you can make if you like.

 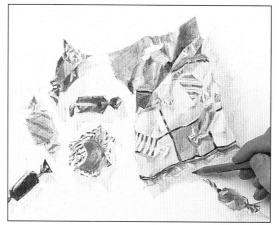

11 ▲ **Use a wet pencil** Drawing with a wetted pencil tip will produce a strong, solid line. Use the viridian pencil to make the edges of the folds in the top of the sweet packet darker and sharper.

12 ▲ **Darken the shadow under the packet** Finally, go over the shadow under the sweet packet with the dry medium grey pencil to make it a little darker. This will have the effect of making the packet stand out more vividly from the background.

THE FINISHED PICTURE

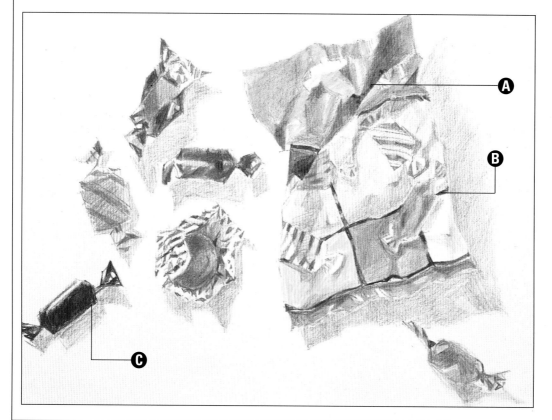

A Wet pencil
The darkest green areas at the top of the sweet packet were drawn with a wetted pencil tip to deepen the colour.

B Black lines
Black lines were added to the sweet packet to add emphasis and make the colours appear brighter.

C Blended colours
The colours used for the purple sweet were blended with a wet brush to give the impression of a smooth foil wrapper.

Still life of peppers

Red and green peppers create a visually striking image that is ideally suited to watercolour washes and water-soluble pencils.

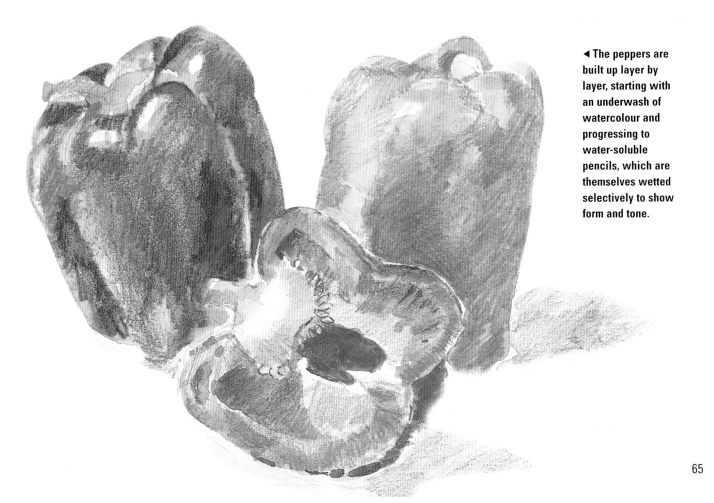

One way of creating a sense of depth in a still life is to work over a watercolour wash. To achieve the highly effective drawing of these peppers, for example, the artist first painted thin washes of red and green watercolour over the initial sketch to give a coloured surface on which to continue the drawing with water-soluble pencils.

Practical points

As you are using water with the paints and the coloured pencils, you will need to work on sturdy watercolour paper. Blocks of watercolour paper are useful for this kind of exercise, where you are not intending to wet the paper very much. You can paint directly on to the top sheet, which is still secured to the block, thus avoiding having to stretch the paper first.

When you lay down the washes, change your water frequently in order to keep the paint as clean as possible. If your wash spreads too far outside the lines of the sketch, you can easily mop it up with a piece of kitchen paper. Remember, though, that as a large part of the wash will eventually be covered by coloured pencil, you don't need to be too accurate.

Using water-soluble pencils

Water-soluble pencils are ideal to use in conjunction with watercolours, as they can be handled like ordinary coloured pencils but can also be dampened with a wet brush to blend and intensify their colours. You can build up the shapes of the peppers with shading, leaving the underlayer of paint showing where you want the tones to be light.

◄ The peppers are built up layer by layer, starting with an underwash of watercolour and progressing to water-soluble pencils, which are themselves wetted selectively to show form and tone.

FIRST STROKES

1 ▼ Draw the outlines Using a 4B pencil, draw the outlines of the peppers with loose strokes. Try not to make the pencil marks too strong, as you don't want them to show through the watercolour in the final picture. On the cut pepper, indicate the shape of the seed area and the pith.

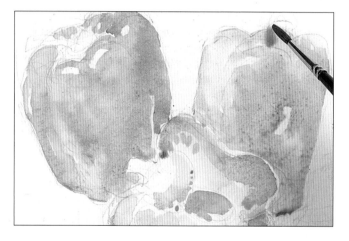

2 ▲ Apply a wet-on-wet wash Using a No.5 brush, first wash clear water over the parts of the peppers that you are going to paint. Avoid wetting the paper where the highlights will be, as you want to leave these white. Make a thin wash of **alizarin crimson** with a little cadmium red and paint over the wetted parts of the red peppers. Mix a little Payne's grey into the wash for the darker areas, and some sap green for the brown hollow in the cut pepper.

3 ▶ Begin the green pepper Wet the green pepper again if the paper has dried out, as you need to apply the washes wet-on-wet. Leave the highlights dry, as before. Make a thin sap green wash and add a little of the previous red wash to make an olive green colour. Paint the left side of the green pepper, then deepen the wash with more of the previous red to paint the right-hand side and the shaded part of the stalk.

4 ▶ Wash over the shadows Wet the shadow areas on the right of the green pepper and under the red peppers with clear water. Avoid the edges of the previous washes so that the colours won't run together. Then brush on a dilute wash of neutral tint, mixed from all the colours on the palette, to show the grey shadows.

5 ▶ Add a few details Leave the paint to dry. Change to a No.3 brush to add some detail. Paint the stalks on the red peppers with sap green. Then add sap green to the original red wash to make brown. Darken the hollow in the cut pepper, dab on more seeds and paint the stalk on the green pepper. Emphasise the edges and centre of the cut pepper with a strong mix of alizarin crimson and cadmium red.

DEVELOPING THE PICTURE

Now that the main shapes and tones of the peppers have been indicated with washes of watercolour, you can begin to define their forms more clearly with water-soluble pencils. Make sure the washes are dry before you begin – you can use a hair-dryer to speed up the process if you wish.

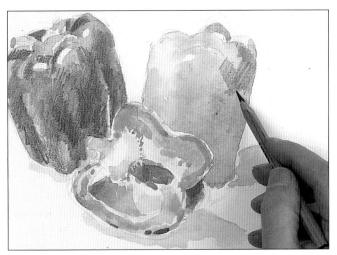

6 ▲ **Shade the red and green peppers** Using a rose carmine water-soluble pencil, shade over the wash on the red pepper with hatching marks until most of it is covered. Leave the highlights and some bands of lighter tone to create the pepper's ridges and curves. Change to a moss green water-soluble pencil to begin shading the green pepper. In the same way as for the red pepper, leave the pale wash showing where the tone is lighter.

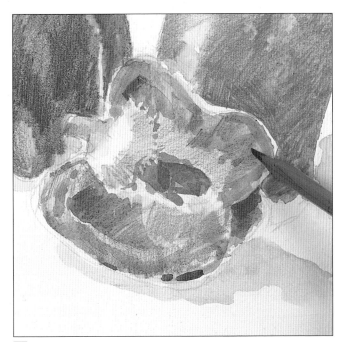

7 ▲ **Work on the cut pepper** Complete the shading on the green pepper, then shade the stalks with the moss green pencil. Darken the top corner of the cut pepper with a patch of rose carmine. Using a dark orange water-soluble pencil, colour across the lighter areas of the flesh and pith of this pepper with free strokes.

TROUBLE SHOOTER

SMOOTHING OUT PUDDLES

As you are laying down the washes, you might notice that an earlier wash has gathered in a small puddle on the paper, forming a dark patch like the one at the base of the green pepper shown here.
To remove this, tip your drawing board up so that the paint runs back into the main part of the wash.
In this way, the colour will be evened out.

8 ▲ **Darken the shadows** Warm up the shaded side of the red pepper with hatched lines made with an Indian red pencil. Use a medium grey pencil to deepen the colours of the cast shadows, keeping within their outlines.

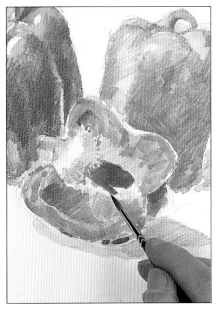

9 ◄ **Begin to wash over the pencil marks** Deepen the colour in the hollow of the cut pepper with the Indian red and dark orange pencils. Then, using the No.3 brush, wet this area to diffuse the colour.

10 ▼ **Add more lines and wash** Continue diffusing the colours of the pencils by washing clear water over the darker areas of the green pepper. Liven up the red pepper with the dark orange pencil, and again add a wash over these areas to intensify their colour. Add hard lines to the curves of the red pepper with the Indian red pencil, then soften them slightly with water.

The picture is now a pleasing combination of watercolour washes and pencil shading softened with added water. With additional colour, you can enhance the tones and make the peppers even more realistic.

11 ▶ **Add depth to the darkest areas** Using the medium grey pencil, deepen the darkest tones on the red pepper with just a little colour. The darker colour helps to throw the lighter colours forward in the picture.

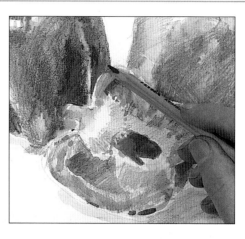

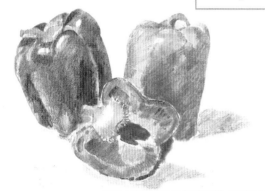

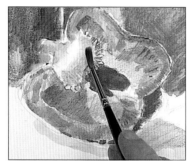

12 ◀ **Give the picture a final wash of water** Colour in the seed area and the tops of the stalks with ochre pencil. Outline some of the seeds with the Indian red pencil, and put in some lines of texture on the edge of the cut pepper. With the rose carmine pencil, deepen the outer edge of the cut pepper. Smooth out the colours once more with the No.3 brush.

THE FINISHED PICTURE

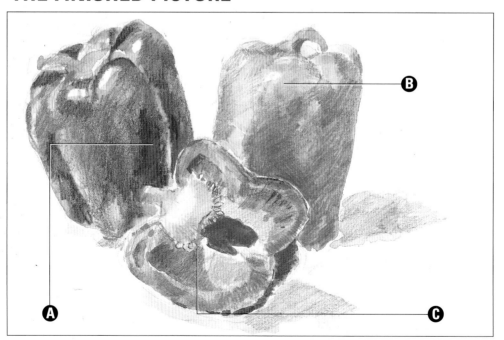

A Dark tones
Deeper tones were created with water-soluble pencil marks, which were then washed over to intensify the colour.

B Light tones
The initial pale watercolour wash shows through in places to form the light tones in the picture.

C Sharp details
The seeds in the cut pepper were drawn over the underlying washes with a well-sharpened water-soluble pencil.

A jar of humbugs

Childhood favourites, these striped humbugs jumbled together in a glass jar create fascinating, bold patterns which are challenging and fun to draw.

Objects seen through a glass jar offer a particular challenge to the artist. Even if the glass is clear, it tends to diffuse the tones of whatever lies behind it, and if it is curved, it will distort objects into unexpected shapes.

When drawing glass, remember that it has a thickness of its own which needs to be shown. In this exercise, for example, the sweets have not been drawn right up to the outer lines of the jar – they stop short of the edges so that the sides of the jar appear to have solidity.

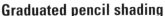

Graduated pencil shading

This monochrome set-up is ideal for practising drawing tones from light to the deepest black. Even though the stripes on the sweets are strongly contrasting, the diffusing effect of the glass creates intermediate shades of grey. You can achieve this range of tones by using two pencils with different levels of softness – a B and a softer 4B.

When you begin drawing the sweets, outline them very faintly so that you have a guide and then fill in the dark stripes, using the soft 4B pencil. The combination of stripes defines the outer limits of the sweets without any firmer outlines being necessary. To give the sweets form, shade them with a B pencil to imply their curved shape.

When the drawing is almost complete, work very light shading over most of the jar to suggest the glass.

Bright highlights

Where the light falls on the glass jar, it produces bright highlights. The white background is the lightest tone you can have in the drawing, so the paper should be left unshaded to show the highlights. If you want a highlight where you have already shaded the paper, it is a simple matter to erase the graphite in a small area with the tip of a putty rubber.

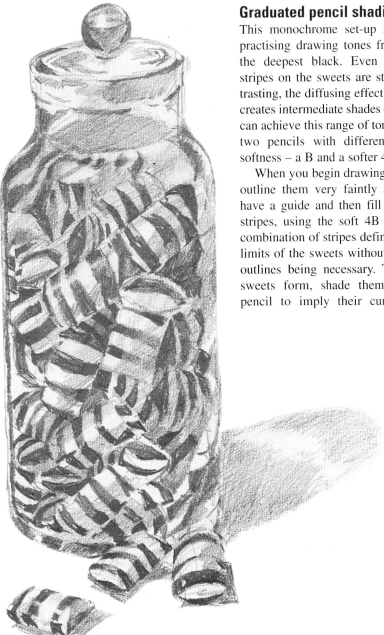

◄ **A monochrome still life, such as this jar of striped humbugs, will encourage you to observe tones and convey them on paper without being distracted by colour.**

YOU WILL NEED

Sheet of cartridge paper

Graphite pencils: B and 4B

Putty rubber

Sandpaper for sharpening pencils (optional)

HOW TO START THE PENCIL DRAWING

1 ▶ **Establish the outline of the jar**
Using a B pencil, begin to sketch the glass jar, assessing its proportions carefully. Take time over the ellipses that form the lid, neck and base of the jar – it helps to turn the sketch upside-down or look at it in a mirror if you want to make sure the ellipses are well formed. You can check the symmetry of the jar's sides by drawing a faint centre line from top to bottom; this can be rubbed out later.

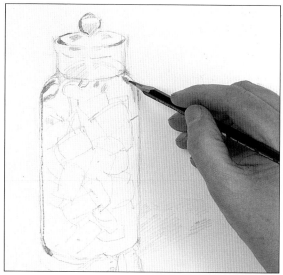

2 ▲ **Sketch the shadows and sweets** Indicate the thickness of the glass by drawing a double line at the sides. Then loosely draw the outlines of the sweets; those viewed through the curved glass at the neck of the jar will have distorted shapes. Still using the B pencil, indicate the medium tones at the top of the jar. Draw the jar's shadow with some lightly hatched lines. Change to a 4B pencil and work dark shading on the knob, lid and curved shoulders.

3 ▼ **Fill in some mid tones** Returning to the B pencil to give a medium tone, shade in the ellipse shape at the neck of the jar and also the vertical edge of the lid. To avoid smudging the pencil lines lower down, you can protect this area with a clean piece of paper.

HOW TO DEVELOP THE DRAWING

Once the jar and sweets are sketched in, you can have fun filling in all the black stripes. Carefully observe the directions of the stripes and notice how they curve, describing the shape of the sweets.

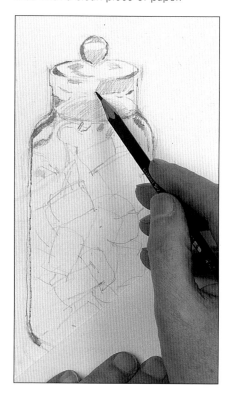

4 ▶ **Draw the stripes** Using the 4B pencil, begin filling in the stripes on the sweets, pressing hard with the pencil to achieve the very dark tones. Notice how the stripes are distorted and diffused by the curve of the glass at the top of the jar. Add medium tones to parts of each sweet so that they are not too starkly black and white. Shade the right-hand side of the jar with a medium tone.

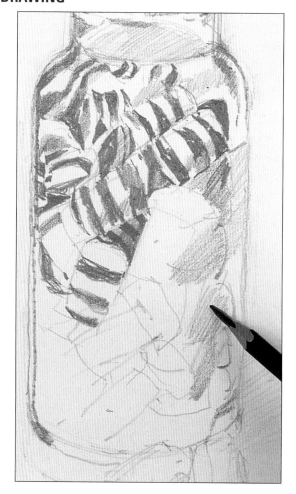

5 ▶ Create highlights with a rubber Continue filling in the stripes, using the B pencil for the mid tones and the 4B for the deep blacks. The mid tones help to define the shapes of the sweets. Shade the base of the jar with the 4B pencil. If you find that you've covered any bright reflections on the glass, remove the shading with the tip of a putty rubber.

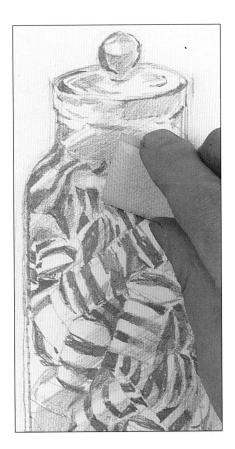

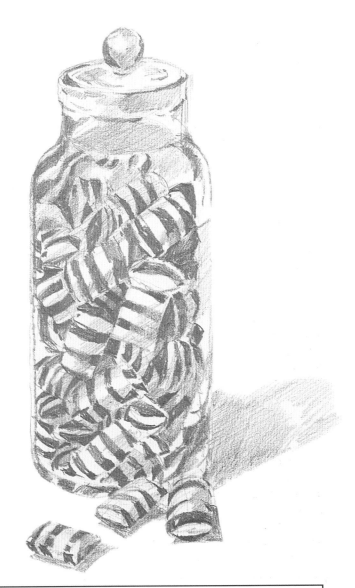

6 ▶ Emphasise tonal contrasts Go over all the sweets, firming up the tone. Shade the sweets outside the jar with the B pencil for the mid tone, putting in the stripes with the 4B pencil. Draw the shadows under these sweets in a medium tone, and develop the shadow of the jar with cross-hatching.

A FEW STEPS FURTHER

There are a few extra touches you can give the drawing to define the tones further, such as brightening the highlights and softening the edges of the shadows.

7 ▶ Brighten the highlights Using the 4B pencil, darken the areas around the highlights, such as on the glass knob. This will make the highlights appear brighter. If you have missed a highlight, on a sweet for example, erase it with the putty rubber, then draw dark marks on each side of it.

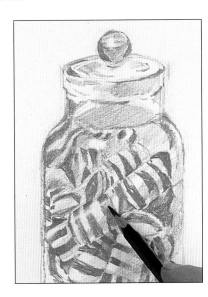

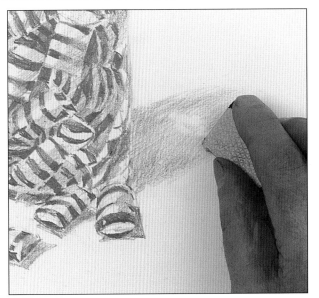

8 ▲ Add the final touches Darken the left-hand side of the jar to give a hard line. Deepen the shadow cast by the jar, then soften the edges and lighten the centre of the shadow with the putty rubber.

THE FINISHED PICTURE

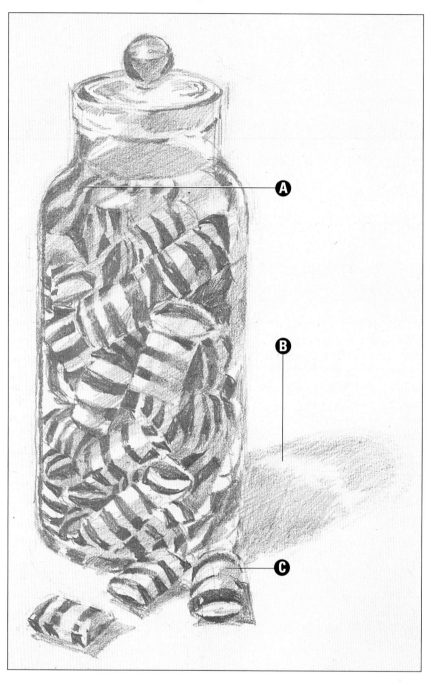

A Interesting distortions
The distorted stripes help to suggest the curved glass at the top of the jar and are interesting shapes in their own right.

B Soft shadow
The shadow cast by the glass jar was softened by erasing around the edges and at the centre with a putty rubber.

C Variety of tones
A range of tones from very light to very dark show the rounded form of the sweets and give them added visual interest.

Kitchen implements

Capture the well-defined reflections and highlights seen in the shiny surfaces of metal kitchen equipment using matt graphite pencils.

For an interesting arrangement of rounded shapes, combined with a wonderful variety of reflections and highlights, you need look no further than the kitchen. Put together a still life of shiny tools and implements, such as a saucepan and lid, a colander, a bottle and a ladle, and you will find a wealth of fascinating forms to study.

Before you begin drawing a group of metal objects, study them carefully to work out where the reflections are, as it is these that imply the shiny surfaces. You will see that many kitchen items are rounded in more than one direction, which has a distorting effect.

Light and shade

The reflections on dull metal, such as that of the colander, will be more diffused than those on highly polished items such as the saucepan lid. The lid is so shiny, in fact, that you can see the reflection of the window on the left.

Half-close your eyes to differentiate the light and dark tones, and remember that the highlights on the metal are the brightest areas, so plan ahead and leave the white paper untouched to represent them. You can use a putty rubber to add highlights later. Shade in the darker tones around the highlights, suggesting the rounded shapes with graduated shading.

◄ The shiny metal implements have mirror-like surfaces which produce a mass of reflections and highlights.

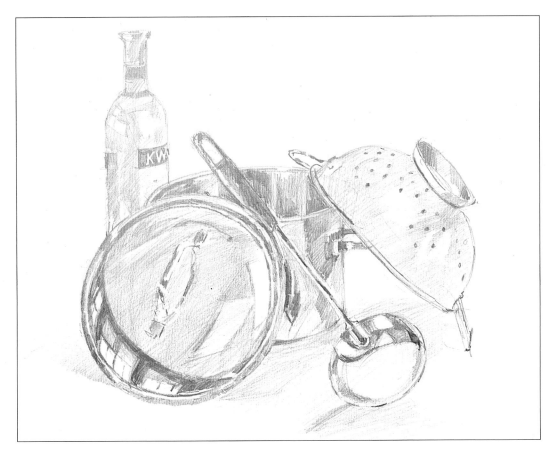

YOU WILL NEED

Large piece of cartridge paper

Graphite pencils: B and 4B

Putty rubber

FIRST STROKES

1 ▶ Sketch the outlines With a B pencil, draw in the basic shapes of the objects. As you progress, check the angles and proportions of the items with the pencil. As the objects are rounded, there are various elliptical shapes to be drawn (see page 44 for advice on drawing ellipses), so spend some time checking that these are even. Lightly indicate the outlines of the reflections on the lid, ladle and saucepan, and the holes on the colander. Draw the lid handle and its reflection.

2 ▼ Lightly fill in areas of mid tone Holding a 4B pencil as described in Expert Advice below, lightly shade around the highlights on the saucepan lid. Draw a stronger line around its rim and define the reflection of the windows at the base of the lid. Hatch in the mid tones on the saucepan, colander, bottle and ladle.

EXPERT ADVICE
Shading with a long pencil tip

When you are filling in initial areas of tone in a still life, use the side of your pencil lead to achieve an even effect.

Sharpen a 4B pencil with a craft knife to leave a long lead exposed, and hold the pencil almost horizontally to work the shading. To keep the point sharp, turn the pencil in your fingers as you work.

3 ▼ Gradually add darker tone Darken the base of the colander with the 4B pencil. Draw the bottle label, lightly indicating the other label seen through the glass from the back. Shade the bottle with a medium tone, defining the lip and neck more strongly. Firm up all the outlines and draw the top handle of the colander. Fill in the heavy, dark tone of the black handle on the ladle.

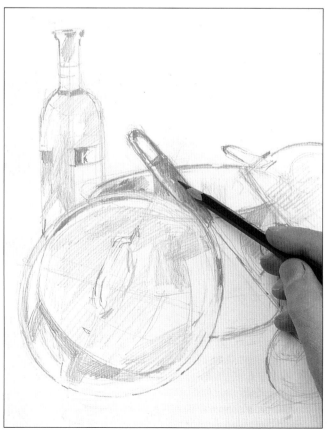

HOW TO DEVELOP THE REFLECTIONS

Once you have established the overall tonal values in the picture, you can concentrate on the all-important reflections and highlights in the metallic surfaces. The most interesting reflection is the one of the windows in the saucepan lid. Although the shapes are distorted, you can clearly see the dark window frames and the light panes of glass.

4 ▶ Work on the lid reflection
Add some very dark tone around the highlights on the lid created by the window panes to make them stand out more strongly. By creating distinct reflections, you can convey the shine of the metallic surface.

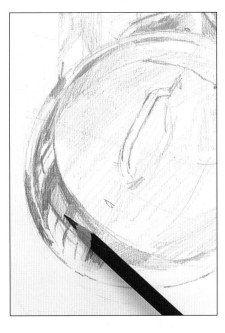

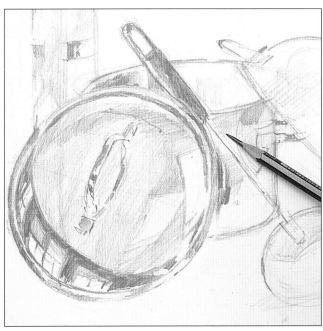

5 ▲ Develop the shading further Hatch areas of graduated shading over the lid, leaving the highlights pale. To give the highlights a crisp edge, shade over a piece of paper used as a mask. Strengthen the dark tone on the rim of the lid, as well as on the handle and its reflection. There is now a full range of tones on the lid. Begin to fill in medium tone on the side of the saucepan to show the reflection of the colander.

6 ▼ Work on the saucepan and ladle Show the dark area inside the saucepan with vertical hatching lines, graduating the tone to indicate the curved shape. Darken the reflection of the colander on the side of the saucepan with diagonal hatching. Draw a dark line down the handle of the ladle, then hatch medium tone over the bowl of the ladle, defining the edges with darker lines. Draw in the reflections at the top of the ladle. To help you simplify these shapes, half-close your eyes as you look at them.

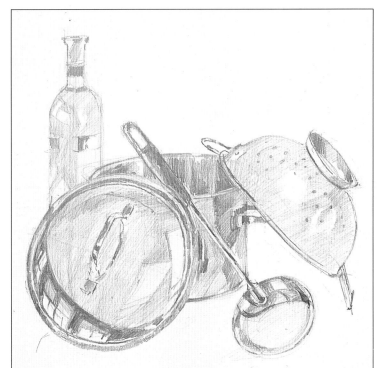

7 ▲ Complete the colander Draw the holes in the colander as dark spots, using the faint outlines you drew in step 1 to help position them. Define the handles and edges with dark, thin lines. Work long hatched lines all over the colander, changing direction to show the curves. Leave white paper for the highlight and the dent in the body. Finally, add reflections at the top of the bottle.

The tones are now well differentiated and the reflections clearly defined. To refine the picture a little further, add details such as the lettering on the bottle label and make sure the brightest highlights are clear of unwanted pencil marks.

8 ▶ Add detail to the bottle Shade around the lettering on the bottle label. so that the letters appear white. Hatch in some darker tone on the right of the bottle neck and body.

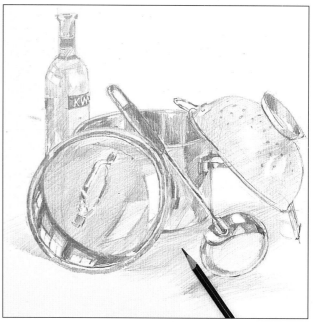

9 ▲ Hatch the shadows Define the edge of the label on the left of the bottle, hatching over a piece of paper for a crisp line. Render the cast shadows under the implements with long strokes. Use a putty rubber to clean up the highlights.

THE FINISHED PICTURE

A Interesting reflections
The rounded, shiny surfaces in the still life distort the reflections, producing some intriguing shapes.

B Strong highlights
The brightest highlights on the kitchen items were left as white paper showing through the shading.

C Dull surface
The colander was shaded with a more even tone than the other items to imply its less shiny surface.

'Painting' with graphite

With water-soluble graphite, you can combine the fluid finish of watercolour with controlled line work, as well as developing a range of tones.

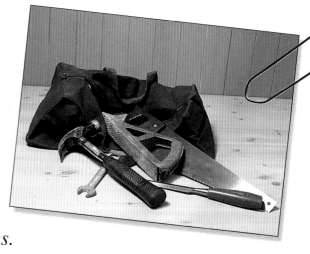

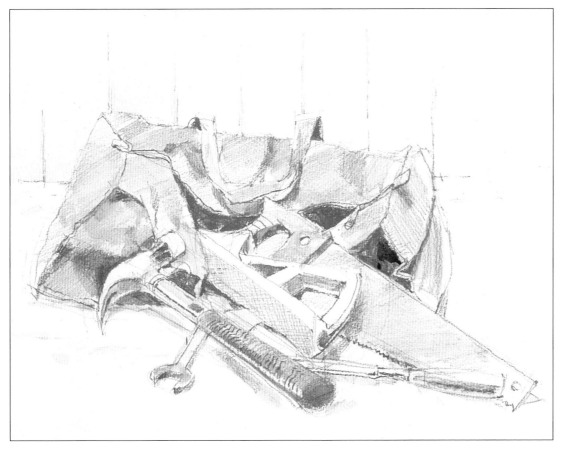

◀ Just a small amount of water will transform a graphite drawing into a monochrome painting with a watercolour look.

Water-soluble graphite pencils are very versatile drawing tools. When used dry for sketching and drawing, they behave exactly like ordinary graphite pencils. However, water-soluble pencils are capable of more than just straightforward mark-making on paper. If you brush a little water over an area shaded with soluble graphite, it dissolves to create a grey wash. Depending on the wash strength of the pencil (they are available in various grades), or on how much graphite was laid down in the first place, the wash can be very pale or velvety black. You'll find that your brush picks up a lot of graphite as you work, so keep rinsing it in water and wiping it clean.

Dark and light

Another way in which you can use a water-soluble pencil is to dip the lead into water and then draw with it. This makes very dark marks, ideal for emphasising details or filling in deep shadows. Hold the pencil almost upright so that the water can flow down more easily.

As with all watercolour painting, you should work from the light areas of the picture to the dark ones. If the brush picks up too much graphite and gives too dark a tone on the paper, you can rescue this by going over the same area with clear water to lift off excess graphite.

It is best to use watercolour paper with water-soluble pencils. Stretch the paper first to prevent it from cockling, or, if you don't intend to use lots of water, simply fix the paper to the drawing board with masking tape to keep it flat and smooth.

FIRST STEPS

1 ▶ Make an initial sketch Using a medium water-soluble pencil, draw in the line where the worksurface meets the tongue-and-groove background. You can then use the vertical boards as a measuring guide when you draw the folds of the soft tool bag and the angles and smooth curves of the tools.

2 ▼ Fill in tone on the bag Begin adding medium tone with hatched lines to define the folds of the bag. In the recesses of the folds, where the shadow is deepest, press harder with the pencil to give a darker tone.

3 ▼ Develop the tools Darken the shaded surfaces of the tools, such as the inside of the plane handle. Indicate the pattern on the hammer handle and begin to show the rough surface of the file with diagonal hatched lines.

4 ▲ Concentrate on details Complete the surface of the file with lines of cross-hatching. Shade in some very dark tone where the bag handle folds over. Define the zip and tag on the bag with hard, fine lines.

5 ▲ Tidy up the drawing Shade light tone over the saw and indicate some of the teeth. Follow the form of the hammer handle with curved lines and show its cast shadow. To complete the shading on the bag, hatch in medium tone and then change to a soft pencil to strengthen the darkest shadows. Firm up the hard lines of the tools.

ADDING WATER TO THE DRAWING

Once you feel that the overall tone of the drawing is correct, you have reached the exciting stage where you can begin to 'paint' with the graphite.

6 ▲ Begin using water Load a little water on to a soft round brush and use the side of the brush to wash over the bag, working from light areas to darker ones. The water smooths out the graphite shading to create a more uniform tone.

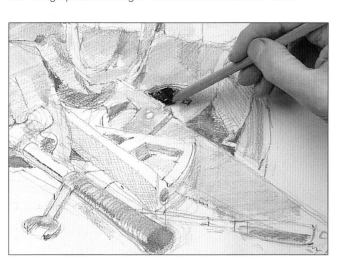

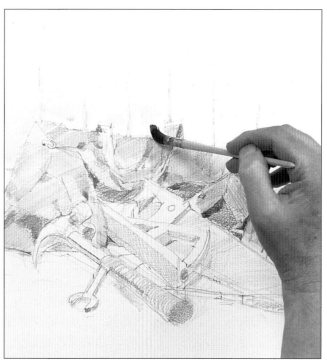

7 ▲ Shade the background boards Using the paper palette method described in Expert Advice below, brush a very pale wash of graphite over the tongue-and-groove boards behind the tool bag.

8 ◄ Develop the tone further Brush water over the saw and the hammer handle. Using the tip of the brush, paint water over the folds of the bag to give a dark watercolour effect. For the black interior of the bag, dip the lead of a very soft water-soluble pencil into water and shade with this.

EXPERT ADVICE
Using paper as a palette

Instead of brushing water directly over your drawing, you can pick up pigment from a patch of graphite shaded on to a spare piece of paper. In this way, you can control the depth of colour more easily, especially if you want a very pale wash.

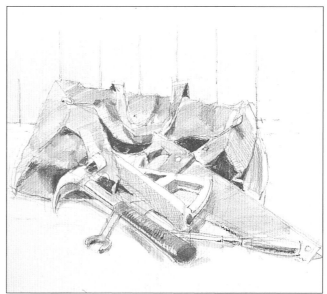

9 ▲ Continue with the wet pencil lead Emphasise all the darkest folds of the bag with the wetted tip of the very soft pencil. Returning to the brush, stroke water lightly over the rough surface of the file. Picking up graphite from a paper palette, develop the medium-toned shadows on the bag, and paint cast shadows under the chisel and hammer.

A FEW STEPS FURTHER

The drawing now shows various levels of tone, some achieved with a pencil used dry, some with a wash of water and the darkest with a wet pencil lead. You can add interest to the picture with some extra detail drawn with a wet pencil and brush.

10 ▶ Draw the fine lines Using the medium pencil dipped in water, draw fine, dark lines to strengthen the stitching on the bag, the edges of the zip and the edges of the handles. Accentuate the rivet on the saw handle and the pattern on the hammer handle.

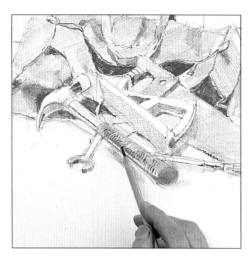

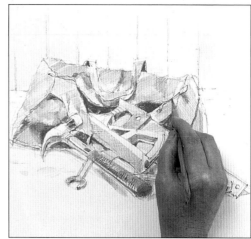

11 ▲ Add finishing touches Using a wet brush and a little graphite, very lightly show the knots in the wooden worksurface. Firm any edges, if necessary, with a wet pencil – for example, the top of the saw blade, the plane handle or the zip.

THE FINISHED PICTURE

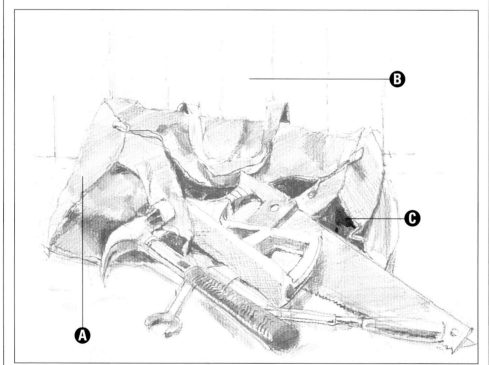

A Mid tones
The areas of medium tone, such as on the tool bag, were created by brushing water over dry graphite shading.

B Palest tone
The light wash on the tongue-and-groove background was achieved by using a wet brush tip to pick up graphite rubbed on to a piece of paper.

C Dark tone
Very black shadows in the creases of the bag were drawn in with the tip of a very soft water-soluble pencil dipped in water.

Drawing a perfect chair

Use a few simple tricks of perspective to help you to draw a realistic representation of a chair.

A chair might seem a perfectly straightforward object to draw, but unless you get the perspective right, it will not look convincing. If the angles of the seat and back are slightly wrong, or if the legs don't appear to sit firmly on the floor, the outline of the chair will look crooked and cannot be rescued by any amount of subtle shading.

Box construction

A simple device to help you with the initial drawing of the chair is to imagine it inside a box, or rather, two boxes – one for the legs and the other immediately above it for the seat and back. By following the simple rules of perspective, it is easy to draw the boxes at the correct angle. You can then fit the chair inside them, secure in the knowledge that it will look realistic when you come to rub out the construction lines.

A trial run

Try making a small sketch before you begin your drawing to see how the box construction method works. First, stretching your arm out in front of you and looking straight ahead, hold a pencil horizontally in front of you at your eye level to establish the horizon (eye level) line. Dot this in on the paper, as shown in the diagram on page 82.

Then, below the eye level line, draw two box shapes one on top of the other with the same proportions as the chair, taking the perspective lines off to two vanishing points on the eye level line. Draw the chair inside the boxes, using the outlines of the box as a guide to placing the legs, back and seat.

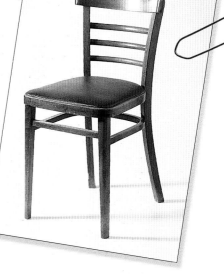

▼ **The solid, well-balanced shape of this chair was achieved by constructing the drawing within imaginary boxes.**

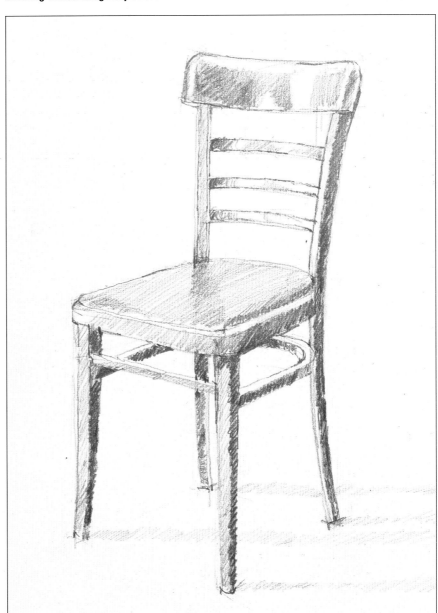

FIRST STEPS

1 ▼ Construct the boxes Study the chair carefully and measure its proportions with an outstretched pencil. Using a B pencil, draw two boxes in perspective, one on top of the other. The vanishing points will probably fall outside the edges of the paper, but you can follow the perspective lines through with a ruler on to extra pieces of paper on either side, if you feel this would be helpful.

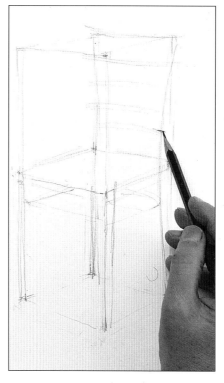

YOU WILL NEED

Large piece of cartridge paper

Graphite pencils: B and 2B

Putty rubber

2 ◄ Begin drawing the chair Sketch the chair legs, seat and back so that they fit the dimensions of the boxes. The chair has splayed legs and a curved back, so some lines will fall inside or outside the box shapes. Sketch the three crossbars on the chair back.

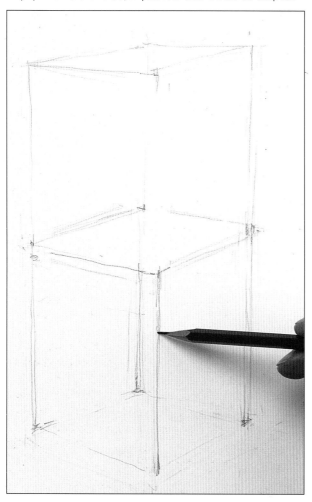

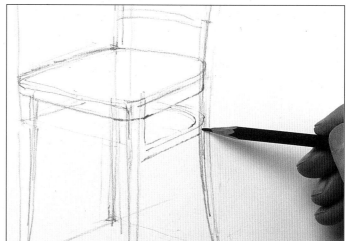

3 ▲ Develop the basic shape Define the outline of the chair more clearly, checking the negative shapes as well. Emphasise the shape of the very slightly splayed front legs and round off the seat and the struts underneath it.

EXPERT ADVICE
Constructing the perspective lines

A small diagrammatic sketch showing lines of perspective is useful to have beside you when you are working on your drawing of the chair. Use an outstretched pencil to help you compare lengths and angles as you construct the box shapes.

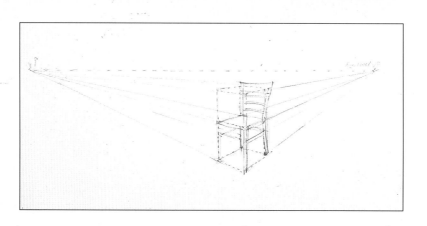

DEVELOPING THE TONE

When you are satisfied that the outline of the chair looks correct, you can start to develop the shading to give it solidity. Gradually erase the construction lines as you progress, leaving just a few as a guide.

4 ▶ Shade the chair back Change to a 2B pencil to begin adding tone. The chair is strongly lit from the left, so all the surfaces on the right are in shadow. With diagonal hatching lines, add dark tone along the upright bar of the chair back and indicate the dark patch on the edge of the seat.

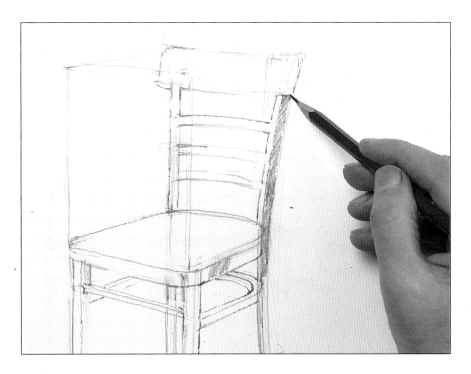

5 ▼ Continue adding dark tone Fill in dark tone on all the edges of the chair that are in shadow. At this point, you can erase most of the construction lines so that a clearer picture of the chair emerges. Using the edge of the 2B pencil, shade the chair seat with long lines of hatching.

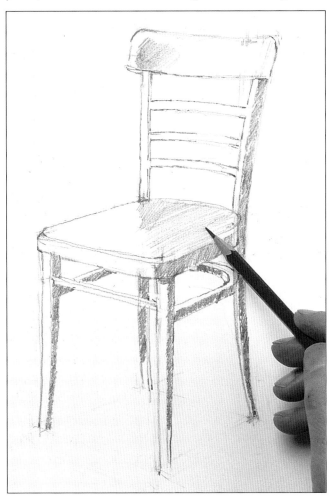

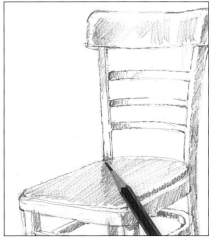

6 ◀ Show the reflection Complete the chair seat with some graduated shading. Notice how the upright bar of the chair back is reflected in the smooth fabric. Hatch dark tone on the chair back, using curved strokes for the crossbars.

7 ▶ Complete the shading Work over the whole drawing, building up the tone. Finish the shading on the crossbars, leaving highlights showing. Then strengthen the shading on the legs, so that the tone is dark on the shaded side and medium on the lit side.

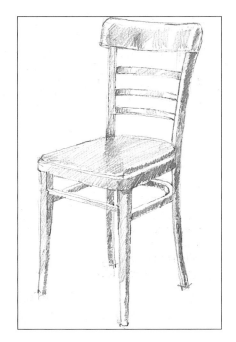

As the drawing of the chair is now finished, you can erase any remaining construction lines. To give the chair a feeling of standing firmly on the floor, indicate some cast shadows. You can also develop the tone a little further.

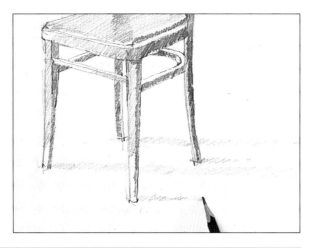

8 ◄ **Draw the shadows** The strong lighting means that the shadows from the chair's legs are clearly visible. Hatch these in with diagonal lines which start off narrow and become gradually wider.

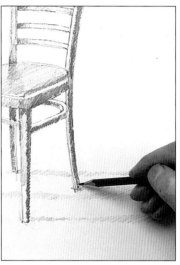

9 ▲ **Differentiate the tones** To strengthen the picture, you can define the various tonal areas more clearly. Increase the depth of tone on the shaded sides of the legs, the struts and the back, working over the edge of a spare piece of paper to keep the shading straight. Use a putty rubber to create any highlights.

THE FINISHED PICTURE

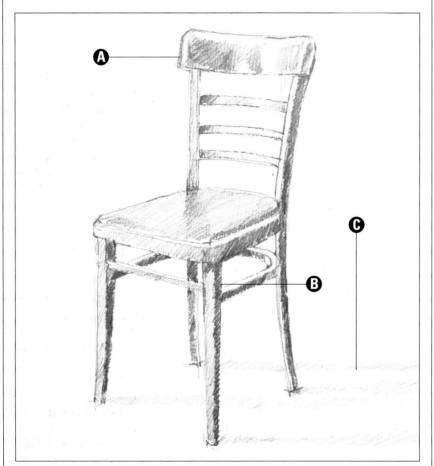

A Realistic shape
The chair was drawn with the help of construction lines, which means that its perspective is correct and it looks solid and convincing.

B Well-defined tones
The darkest tones were shaded with heavy strokes to contrast with the paler grey of the mid-tones.

C Cast shadows
The merest hint of hatching was used to show shadows cast by the chair legs – these help to anchor the chair to the floor.

Drawing with fibre-tipped pens

Interpret the fascinating geometric pattern and sharp, spiky leaves of a pineapple with the crisp, decisive lines produced by a fibre-tipped pen.

Drawing with a pen requires a different technique from drawing with a pencil, charcoal, pastel or other softer medium. A pen gives a well-defined line that cannot easily be erased or altered, so you need to be decisive in your approach from the beginning.

There are many different types of pen available to the artist, ranging from drawing pens with fine tips for graphic designers to dip pens hand-made from goose quills and bamboo. Turn back to pages 7-9 to see a wide selection of pens. Each has its own character, some being more suitable for precision work and others for freer interpretations of a subject.

The pineapple in this project was drawn with a fibre-tipped pen rather than a dip pen and ink. You'll find a wide range of fibre-tipped pens to choose from at any art shop. Ideal for line illustrations, cartoons and quick sketches, as well as finished drawings, these pens come in a variety of tip sizes, graded in numbers from the very fine 005 and 01 to the thicker 08 and 10. Versatile brush pens are also available if you want more flexibility. When working with a fibre-tipped pen, remember to replace the cap each time you finish using it, or it will dry out.

Use cartridge paper when drawing with a pen – you'll find the nib moves easily over its smooth surface.

Showing tone in pen

While you can show tone with a soft pencil or a stick of charcoal simply by shading with the edge or pressing hard, you'll need a different approach with a fibre-tipped pen as it creates lines which are all of a uniform thickness. One way to convey gradations of tone is to draw hatched lines either close together (for dark areas) or further apart (for paler areas). To create an even darker tone, add lines of cross-hatching as well. Alternatively, change to a pen with a thicker tip for areas of deep shadow.

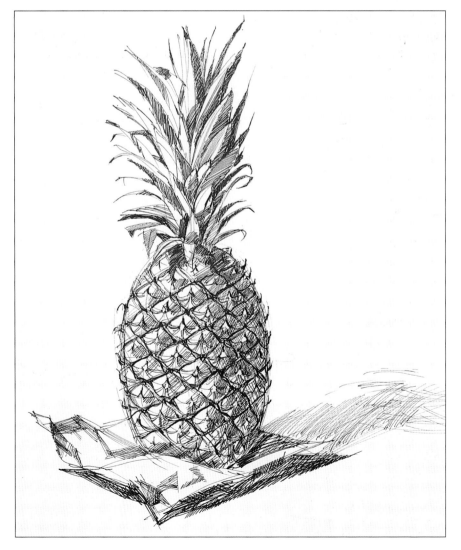

◀ **This pen drawing of a pineapple combines well-defined outlines with subtly drawn areas of tone to give a highly realistic finished image.**

Large sheet of cartridge paper

3 fibre-tipped pens: 01, 07, 05

Bleedproof Designer's White

No.5 round brush

FIRST STEPS

1 ▶ **Make a sketch** Holding one of the pens vertically, compare the height of the pineapple to the height of its leaves – the proportion is about half and half. Using an 01 pen, begin to sketch the pineapple, some of its leaves and the paper bag underneath it. Draw the body of the pineapple as a smooth oval, marking diagonal lines across it to help you interpret the regular growth pattern on the skin.

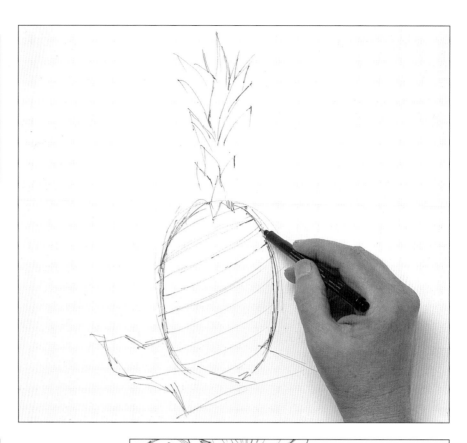

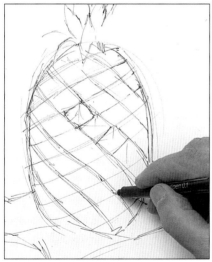

2 ◀ **Map out the pattern** Notice how the pattern on the pineapple forms a diagonal grid. Sketch in the crossing diagonals, curving the lines slightly to show the pineapple's rounded shape.

EXPERT ADVICE
Trying out the pattern

Practise sketching a small section of the pineapple's pattern before you begin the drawing. Each segment is based on a simple diamond shape. Build it up with a short, flat base, a point at the top and curves at the sides. Draw a horizontal line across the shape – the small spike sticks up from this with two lines below it.

3 ▲ **Develop the leaves and pattern** Draw more leaves, checking that they emerge symmetrically from the top of the pineapple by lightly marking a centre line through the fruit. Hatch in a little dark tone where the leaves are in shadow. Begin to draw some of the distinctive segments inside each diamond shape on the pineapple.

HOW TO DEVELOP TONE

As the pineapple is in shadow on the right, you will need to develop darker tones on this side of the fruit. With fibre-tipped pens, the most effective way to achieve gradations of tone is with hatching and cross-hatching.

4 ▶ **Shade with a thicker pen** Change to an 07 pen and fill in the darkest areas of shade on the leaves and where they cast shadows on the pineapple. Return to the 01 pen to hatch in light tone across the shaded right-hand side of the fruit. Create texture with cross-hatching and add the spikes visible along the right-hand edge.

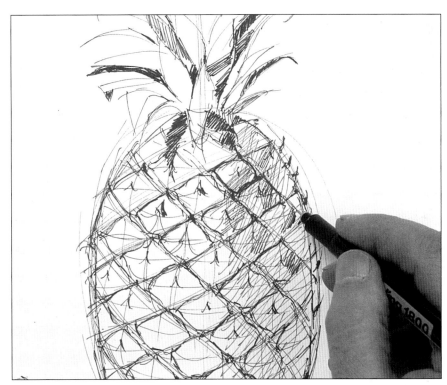

5 ◀ **Define the segments further** Use an 05 pen to work on each segment individually, emphasising its features. Then change back to the 01 pen to hatch in a little light shading on the left side of the pineapple.

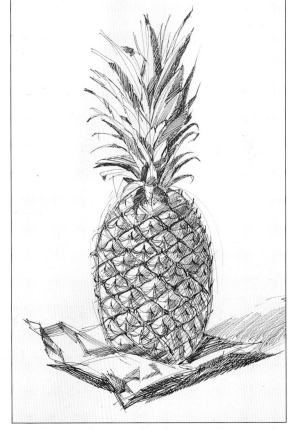

6 ▶ **Work on the shadows** Show the creases on the paper bag with directional lines and, changing to the 07 pen, fill in the dark tone with firm hatching lines. To depict the dark shadow under the bag, make long, feathered strokes with the 05 pen. Use the finest pen to build up the shadow of the pineapple with light, well-spaced hatching.

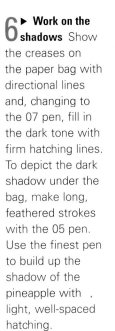

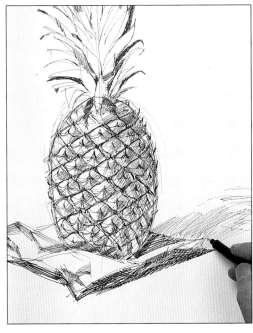

7 ▲ **Return to the leaves** Render areas of tone on the leaves with parallel marks made with the 05 pen, keeping the look crisp and well-defined. Work the lines close together for dark tones and further apart for medium tones. Add the softest tones to the leaves with the 01 pen. These hatched lines also suggest the fibrous nature of the leaves.

Apart from a few minor tonal adjustments, the illustration of the pineapple is finished. In spite of being built up entirely with line work and cross-hatching without any really solid shading, it is a very realistic image.

8 ▲ **Add highlights** If you want to add a few highlights to the drawing, you can blank out some of the pen lines with an opaque white liquid called Bleedproof Designer's White. Pick up a small amount on a No.5 round brush and dab it on to the tips of the spikes to make them catch the eye. You can also remove the early construction lines around the pineapple by painting over them with this liquid.

9 ▲ **Darken the overall tone** Outline the segments on the pineapple's skin with the 07 pen. Changing back to the 01 pen, darken the pineapple's right side, especially at the upper and lower edges, with more cross-hatching.

THE FINISHED PICTURE

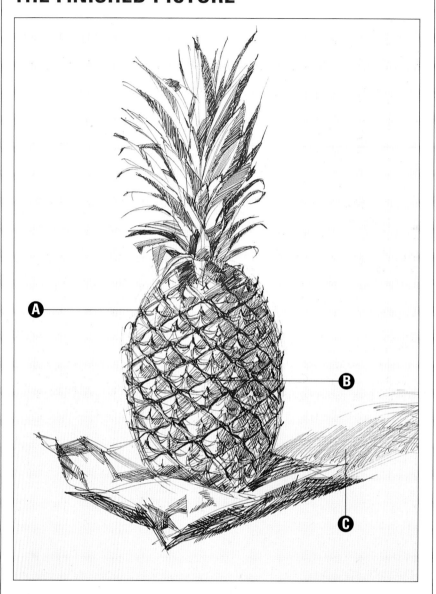

A Regular pattern
The distinctive pattern on the skin of the pineapple was built up gradually, using a diamond-shaped grid as a guide.

B Graded tone
Variations in tone on the surface of the pineapple were achieved with hatched and cross-hatched lines drawn either very close together or further apart.

C Light shadow
Long, fine lines made with a sweep of the wrist created a patch of light tone to represent the shadow cast by the pineapple on to the horizontal surface.

Chairs in tone

In this bold composition, tones of graphite pencil from pale grey to deepest black describe the forms of two chairs and emphasise the negative shapes that they create.

I f you've already tried the drawing excercise that begins on page 81, you will recognise the brown chair in this set-up. In that project, the aim was to draw the chair in perspective by fitting it inside an imaginary box or crate. In this step-by-step, however, the approach is quite different. The idea here is to use exactly the same chair, but to draw it freehand with minimal construction lines. As you have drawn it before, you will be familiar with its shape, so you should not find this too daunting.

Negative shapes

Set up the chair against a mainly dark background with a white curtain hung to one side for contrast. If you place it on a table, the chair will be at your eye level and it will be easier to see the negative shapes enclosed by the struts and slats. You could add another chair to make the composition more interesting.

Once you have sketched the chairs very roughly, look through the framework and fill in the negative shapes with dark shading. Then progress through the mid tones, leaving the lightest until last. By filling in the dark tones first, the chairs gradually emerge as forms in their own right. This is a good exercise in shading – against the dark background, the brown chair stands out as a light shape, whereas against the white curtain, it appears to have a darker tone.

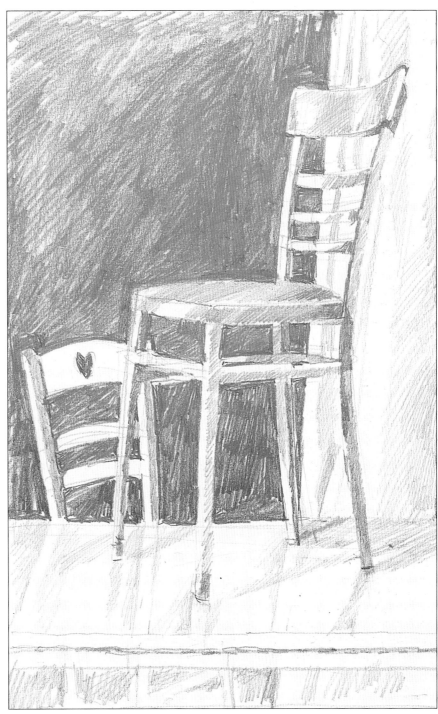

▶ **The negative spaces between the bars and struts of the two chairs show up well against the dark background.**

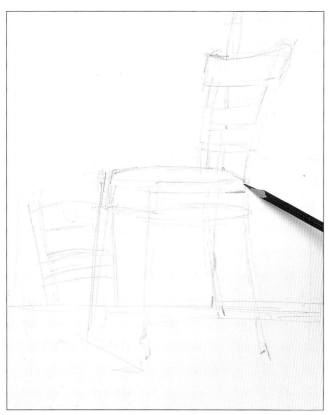

1 ▲ **Sketching the set-up** Using the 8B pencil, sketch the outlines of the two chairs quite roughly. Adopt a freehand approach, pencilling in just the bare bones of the chairs to help you when you come to fill in the dark shading in the next step. Show the horizontal line of the table top and the vertical line of the curtain.

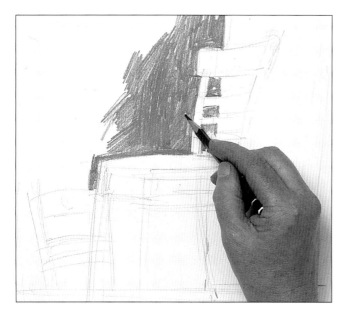

2 ▲ **Begin with the dark tones** Start by filling in the darkest tones in the set-up – these are provided by the black backdrop. Sharpen a long point on the 8B pencil so that you can shade with the side of the lead, then fill in the negative shapes between the slats of the brown chair. Shade the backdrop, changing direction now and then to create texture.

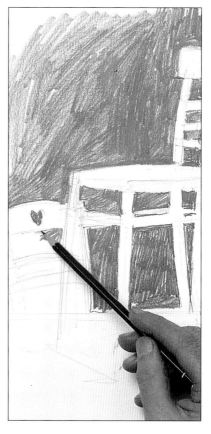

3 ◄ **Add more dark tone** As you continue shading the dark backdrop, look through and beyond the chairs, assessing the negative shapes between the structures. As you fill these shapes, you will firm up the rough outlines that you sketched in step 1. Shade the cut-out heart shape in the white chair.

HOW TO DEVELOP THE TONE

Once you have shaded in the dark-toned backdrop, the shapes of the chairs will stand out as pale images against the black. You can now begin to add modelling to them with medium and light tones.

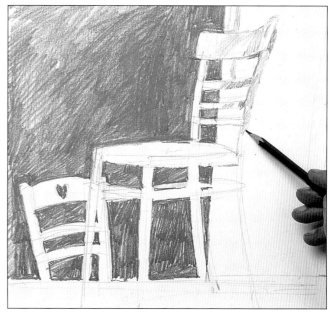

4 ▲ **Move on to the medium tones** Complete the dark tone between the slats of the white chair and fill in the shapes formed where the two chairs overlap. Change to a 4B pencil to sharpen up the edges of the negative shapes. Then, still using this pencil, begin adding medium tones with hatching lines on the white curtain and the back of the brown chair.

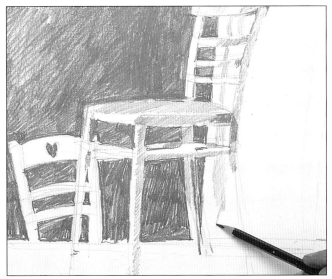

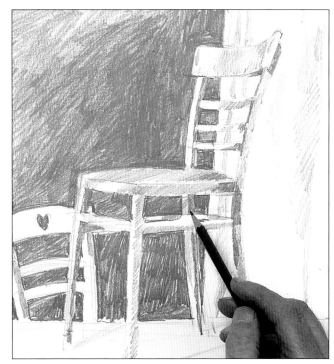

5 ▲ **Continue with the mid tones** Extend the medium tones to the chair legs and struts of the brown chair, shading over the edge of a piece of paper to keep the lines of hatching straight. Render the tone on the seat with long hatched strokes and then return to defining the curtain folds.

TRY AN ALTERNATIVE ARRANGEMENT

It is worth trying out a few different arrangements of this set-up to see what other negative shapes you can create by changing the positions of the chairs. Here, the brown chair is placed on its side, while the eye level is lowered so that more of the white chair is visible underneath the table. Sketch quickly, using the 8B and the 4B pencils. As before, lightly outline the chairs first, and then hatch in the negative shapes with bold strokes.

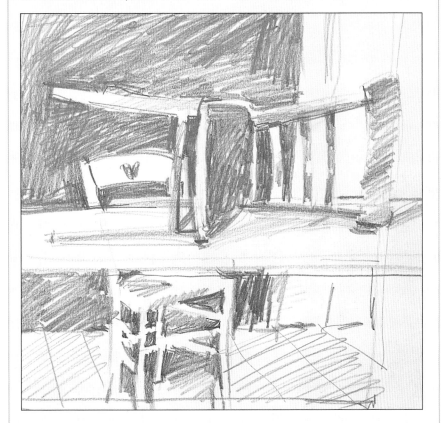

6 ▲ **Refine the tones** Check the whole picture, improving the tones where necessary. Show more curtain folds with loose hatching lines. Darken the far right of the chair seat and firm up its outline with a solid line. Define the flat sides of the chair legs and the uprights on the backs by hatching darker tone on the shaded sides.

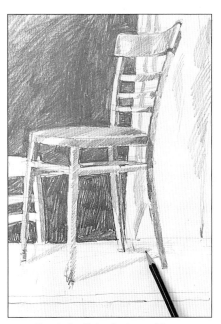

7 ▲ **Hatch the light shadows** The shadows cast on the table are some of the lightest grey tones in the picture: hatch these in with a B pencil. Draw the edge of the table to emphasise the foreground of the picture.

8 ▶ Complete the curtain folds

Using long, well-spaced hatching lines, fill in some more light shading on the right of the curtain, where the deep folds of fabric create shadows. Finish drawing the cast shadow of the brown chair on the table top.

9 ▼ Add table-top reflections

The reflections of the chairs are lighter than the table top itself, so the best way to show them is by outlining them with hatching. Then add more weight to the line showing the table edge. Finally, roughly sketch in the legs of the white chair visible under the table.

THE FINISHED PICTURE

A Range of tones
The black backdrop, the white curtain and the white and brown chairs in the set-up provided a complete range of tones from light to very dark.

B Negative shapes
The structure of the chairs and the way they were arranged created interesting spaces between struts, slats, seats and legs.

C Shadows and reflections
Lightly hatched lines were put in to show the cast shadows and the reflections in the shiny table top. They create an unexpected criss-cross pattern on the plain surface.

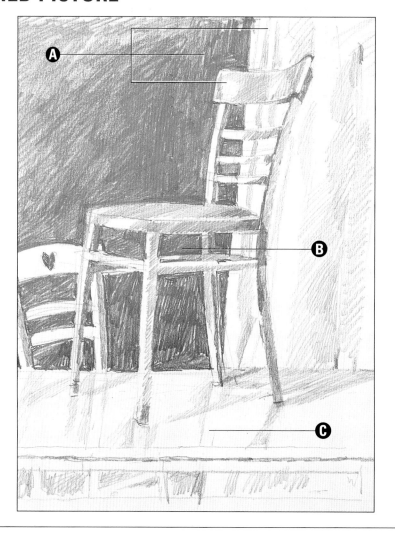

Holiday memories

Find out how perspective works on a small scale with this drawing of holiday guidebooks and postcards.

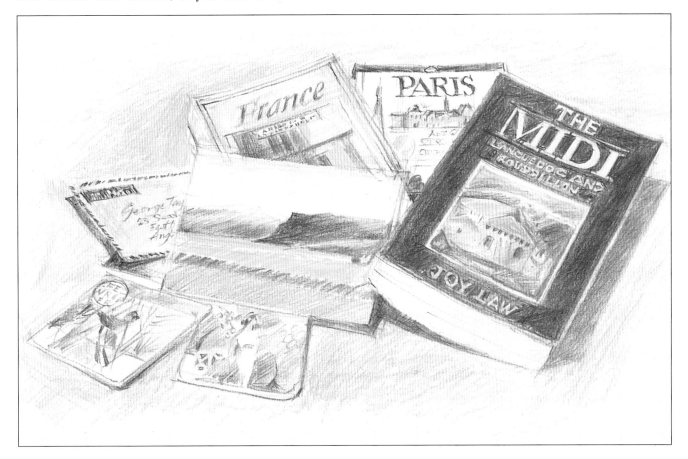

If seen from a bird's eye viewpoint, the books and other objects in this still life would simply look like rectangular shapes. However, when viewed from the front, the shapes look narrower as they recede – even into the immediate distance.

Introducing perspective

Although this effect is not as marked as it would be in a landscape, for example, perspective nevertheless needs to be introduced to record the shapes correctly. If you ignore the perspective, the drawn objects will not look as though they are laid flat on the table. When you start on your initial sketch, you might find it helpful to mark in the perspective lines and rub them out later, or you could do a rough drawing first to establish the correct shapes.

Colour and detail

You can obtain subtle effects with coloured pencils by blending two or more together. If you use light hatching lines, each layer will show through the next to give beautiful, lively colour with great depth.

It would be tedious to try to put the mass of detail in this still life into your drawing. However, it is worth taking time over the larger lettering on the books, so that it is reasonably accurate.

▼ **Coloured pencils give both precise lines and depth of colour – ideal for a drawing which needs a certain amount of detail.**

FIRST STEPS

1 ▶ Sketch in the shapes Use a light grey pencil to sketch the rectangular books and other objects, noticing how they appear to get narrower as they move away from you. Extend the perspective lines to make sure that you are achieving this effect. Indicate the main lettering on the books.

YOU WILL NEED

Large sheet of cartridge paper

21 coloured pencils: Light grey; Light cobalt blue; Medium grey; Light carmine; Prussian blue; Black; Naples yellow; Vermilion; Sky blue; Vandyke brown; Bright yellow; Olive; Yellow-green; Blue-violet; Moss green; Indian red; Canary yellow; Burnt ochre; Pale pink; Gold ochre; Raw umber

Craft knife

Sandpaper block

Putty rubber

2 ▶ Begin adding colour Fill in the background of the blue *Midi* book with light cobalt blue, knocked back with medium grey. Keep the tip very sharp with a craft knife and a sand-paper block as you work between the letters, so that they show up as crisp white shapes. Warm up the colour on the left of the book with light carmine. On the *Paris* guidebook, draw the large letters with a Prussian blue pencil, outlining them in black. Use black, too, to suggest the buildings and small letters. Fill in the background of the *France* guidebook with Naples yellow, adding the lettering on top with vermilion.

HOW TO CREATE MORE COLOURS

The pictures on the guidebooks, postcard and coasters need to be filled in with a certain degree of realism so that they look convincing, but it is not necessary to overdo the detail. One way to give depth to your work is by blending the coloured pencils to create a wider range of shades.

3 ▲ Draw the envelope Complete the *France* book with a border in vermilion and Prussian blue. Shade in the envelope with sky blue, using Prussian blue and vermilion for the markings. Indicate the address in medium grey.

4 ▲ Begin some colour blending Develop the photo on the *France* book, showing just the main shapes – use the black, Vandyke brown and light grey pencils for this. Begin on the postcard, blending bright yellow and olive for the foreground meadow. Use olive on its own for the dark band and yellow-green for the light band.

5 ▶ Continue the postcard

Complete the bands with a stripe of Naples yellow. Fill in the sky with sky blue. Blend colours for the hills, using sky blue, olive, blue-violet and light cobalt blue for the hill on the right and light cobalt blue and moss green on the left.

EXPERT ADVICE
Drawing white lettering

Letters that show up white against a dark background are described as 'reversed out'. To define them clearly in this drawing, mark lines at the top, bottom and sides of each letter to isolate it before filling in the background precisely.

6 ▲ Roughly sketch the picture areas Returning to the blue book, interpret the photo on the cover without putting in too much detail. Use sky blue blended with light cobalt blue for the sky, and olive for the hillside and houses. Similarly, sketch the main shapes on the coasters with olive, adding a little black and Indian red in places.

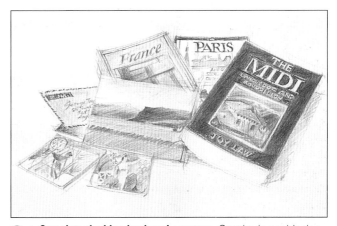

8 ▲ Complete the blue book and coasters Continuing with the blue book cover, warm up the roof with pale pink and darken the foreground with olive. Fill in the small letters in canary yellow and add the red lines and dots in vermilion. Half-shutting your eyes to filter out unnecessary detail, develop the coasters, using sky blue, yellow-green and Vandyke brown. The skin tone of the figures is Naples yellow. Then hatch a few black lines to darken the postcard lying underneath the letter.

7 ▶ Develop the books On the cover of the *Paris* book, blend Naples yellow and burnt ochre to fill in the building. Moving to the right, shade the building on the blue book with canary yellow and burnt ochre, defining the dark windows with Vandyke brown. Blend a touch of sky blue into the left-hand wall. Darken the hillside with more olive.

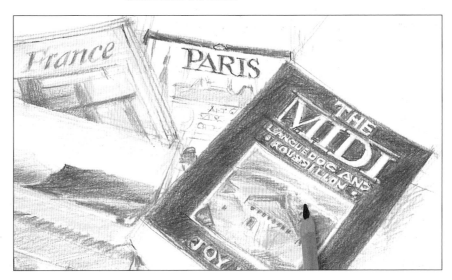

The pictures and the lettering in the still life have been rendered in enough detail to 'read' without labouring over every small detail. Rub out any construction lines at this stage. If you wish, you can now fill in a background colour to represent the table.

9 ▲ Shade in the table Using long strokes with a gold ochre pencil, fill in colour around the shapes of the items, but don't extend the background out too far. By adding this colour, you will achieve the effect of anchoring the still life group to the table.

10 ▲ Finish the details and create shadows Suggest the pages of the blue book with very light strokes of gold ochre and Vandyke brown. Work a little more detail into the book covers to add definition, if you feel it is necessary. Add colour to the shadow areas with raw umber, blended with some blue-violet. Blend a touch of raw umber into the background.

THE FINISHED PICTURE

A Subtle perspective
The edges of the items in this still life slant towards a vanishing point outside the picture box.

B Blended colour
The artist produced lively shades with depth and subtlety by blending coloured pencils.

C Effective lettering
The large letters on the books were rendered realistically, but smaller letters were just suggested.

Old trainer in pen and wash

Even a well-worn trainer takes on a certain charm when reproduced in fibre-tip pen with areas of wash.

You might think that old, battered trainers are only fit for the dustbin, but take another look at them and you will see that they have all kinds of interesting qualities which make them a good subject for a drawing. Trainers usually have a lot of linear details, such as logos and stitching, while maintaining a soft, supple character that improves with age.

In this project, a fibre-tip pen with a medium tip is used for the drawing. This type of pen makes marks of a uniform width and intensity, so shading has to be put in with hatching.

Adding a wash

To soften the effect of the hard lines of hatching and cross-hatching on the drawing, these areas can be selectively washed over with a damp brush, causing the ink to bleed and create smoother areas of tone. Further tones can be added by using a versatile technique that involves lifting ink with a brush from a patch drawn on to paper – this enables you to achieve subtle variations of light and dark.

Before you begin, it is a good idea to test your fibre-tip pen to check how water-soluble it is, as different brands behave in different ways. Practise washing over the ink lines on a few trial sketches before you embark on a final drawing.

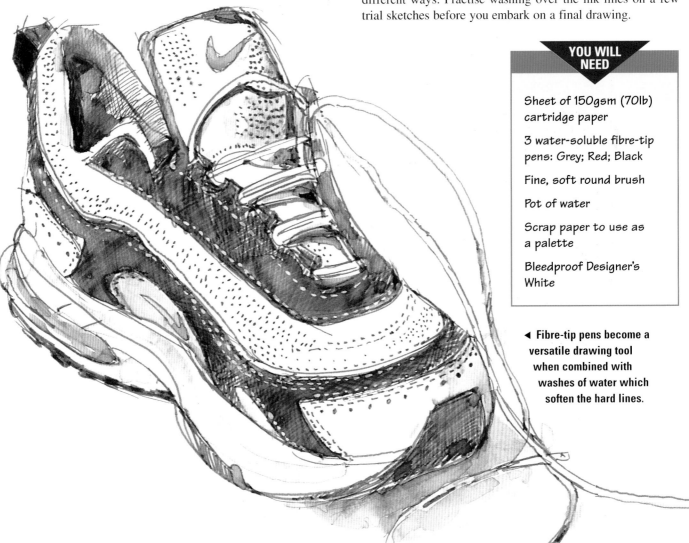

> **YOU WILL NEED**
>
> Sheet of 150gsm (70lb) cartridge paper
>
> 3 water-soluble fibre-tip pens: Grey; Red; Black
>
> Fine, soft round brush
>
> Pot of water
>
> Scrap paper to use as a palette
>
> Bleedproof Designer's White

◄ **Fibre-tip pens become a versatile drawing tool when combined with washes of water which soften the hard lines.**

97

FIRST STEPS

1 ▼ Sketch the outline Using a grey fibre-tip pen, sketch out the outline of the trainer, noticing its curved shape, its prominent heel and tongue, and its exaggerated sole. Begin marking in the construction lines.

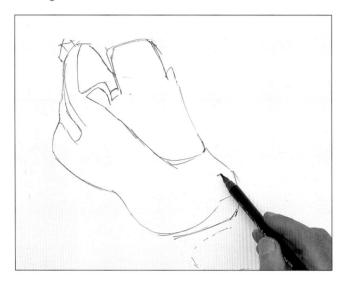

2 ▶ Build up the shape Indicate the panels of fabric and leather which make up the shoe and outline the plastic sole. Draw the shoelaces extending out to the side. Then start to dot in the punched holes and the stitching on the toe-cap and upper.

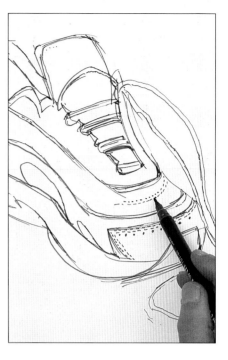

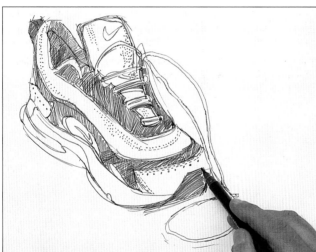

3 ◀ Fill in the dark areas Add the tick logos on the tongue and side of the trainer and mark some more dots to suggest the pattern of holes on the white fabric. To begin rendering the dark tone of the blue panels, the heel tab, the edge of the tongue and the sole, use closely hatched pen lines.

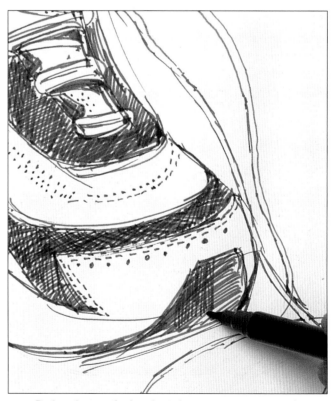

EXPERT ADVICE
Creating a range of tones

Don't restrict yourself to a single deep tone when drawing with a dark fibre-tip pen. A good method of showing the medium and light areas is by scribbling a patch of ink on to a piece of scrap paper and then washing over it with clean water and a soft brush until you have made the tone you need. You can then lift the wash off the paper with a clean brush and apply it to your drawing.

4 ▲ Darken the tone further In order to create an even deeper tone, go over the hatched areas with cross-hatched lines, keeping them even and close together. This is the last stage before you begin applying water to the drawing with a brush.

HOW TO WASH OVER THE PEN DRAWING

The drawing will acquire a softer appearance with more even tones if you wash water over some areas, dissolving the pen marks so that they run together. You can also use a paper palette technique (see Expert Advice, opposite page) to obtain medium and light grey tones.

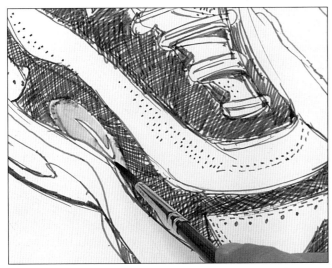

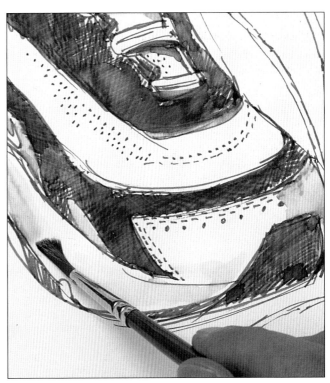

5▲ Begin adding water Still using the grey pen, darken the edge of the sole and tongue. Change to the soft round brush and, using the technique described in Expert Advice, create a lighter tone to paint the pale grey panel on the side of the trainer.

6▼ Wash over the dark areas With the brush, pick up some more medium tone from the paper palette and apply it to the tongue of the trainer. Dip the brush into clean water so that it is damp and wash over the cross-hatched ink marks on the dark leather panels and inside the heel.

7▲ Create more tonal washes Brush water over the dark flap of the sole curving up at the front. Create a light wash on some scrap paper and use it for the plastic base of the trainer, pulling the brush along the undulating shape. Add a little light tone to the shaded part of the white toe cap.

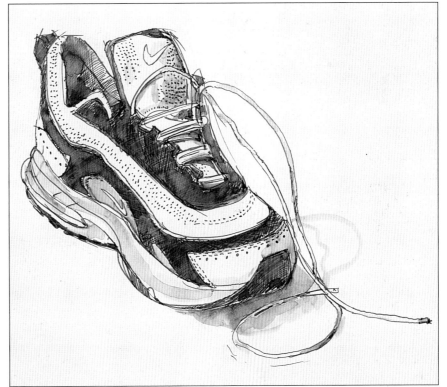

8▲ Indicate the shadows Complete the tonal washes on the trainer by painting the laces with the tip of the brush. Then pick up more medium and light tones from the paper palette to paint the shadow under the toe and the faint shadows of the laces. With the pen, put in more dots on the tongue and side panel and draw the ridges on the sole.

The combination of loose washes and fine detail gives an accurate representation of the trainer. To give it a lift, you could add a little contrasting red colour and white highlights.

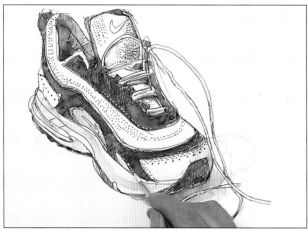

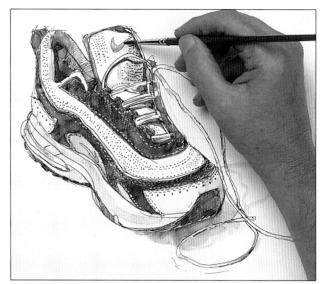

9 ▲ **Show the white stitching** The best way to show the white stitching on the background of the dark leather panels is to apply it over the pen wash with Bleedproof Designer's White, using the tip of the brush.

10 ▲ **Add a contrasting colour** Using a red fibre-tip pen, draw a patch of colour on to your scrap paper. Wet it with the clean brush and paint the two tick logos and the plastic panel set into the sole of the trainer. Change to a black fibre-tip pen to emphasise the very darkest tones – the tab on the back of the trainer and the shadow inside the heel. Outline the fabric panels in black, too.

THE FINISHED PICTURE

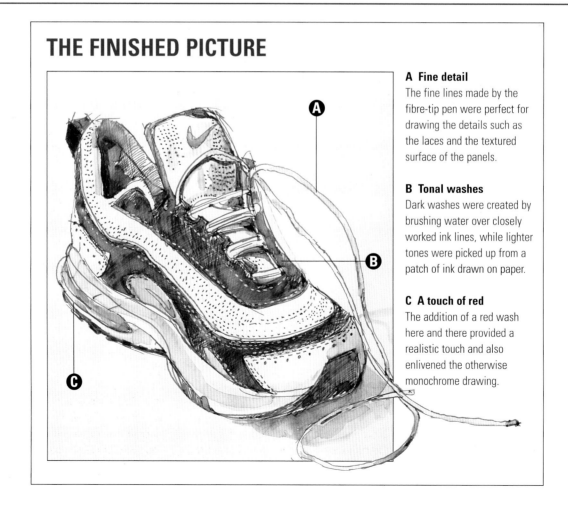

A Fine detail
The fine lines made by the fibre-tip pen were perfect for drawing the details such as the laces and the textured surface of the panels.

B Tonal washes
Dark washes were created by brushing water over closely worked ink lines, while lighter tones were picked up from a patch of ink drawn on paper.

C A touch of red
The addition of a red wash here and there provided a realistic touch and also enlivened the otherwise monochrome drawing.

Button tin in felt-tip pen

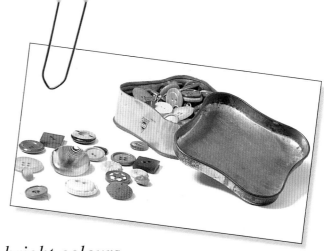

Felt-tip pens are not just for children – their bright colours and blendability make them ideal for quick, immediate sketching, such as this drawing of a selection of buttons.

▼ **Blending colours from felt-tip pens can create many new shades.**

Felt-tip pens are often regarded as nothing more than colouring tools for children, but they are ideal for recording vivid colours in an immediate and simple way in a drawing. Jars of sweets or tins of beads or buttons are ideal subjects, as they create lots of small 'flashes' of bright colour. If a more subtle treatment is needed, it is possible to blend shades – for example, light blue worked over yellow will give green. However, not all colours blend together effectively, so it is best to experiment on some scrap paper first.

Build up colour

Darker colours tend to cover lighter ones well, so patterns and details can be drawn over a pale base colour. The ink from felt-tip pens dries instantly, making this technique quick and easy. You can also achieve tonal variations with hatched and cross-hatched lines.

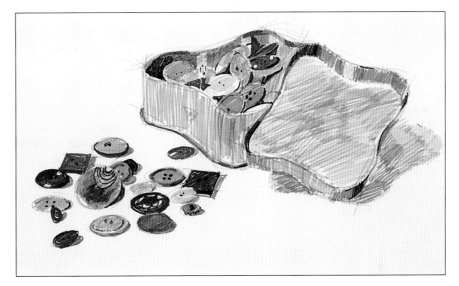

FIRST STEPS

1 ▲ **Draw the tin and buttons** Use a light grey felt-tip pen to indicate the curved outlines of the tin and lid. Draw the buttons inside the tin and scattered across the table – these form a variety of elliptical shapes.

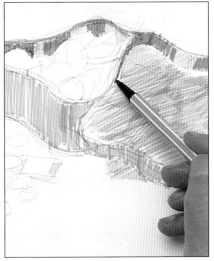

2 ▲ **Begin adding tone and colour** Hatch in the cast shadow of the lid and the medium tone inside the lid in light grey. Change to an ochre pen and shade the tin's sides. With a medium grey pen, darken the tone inside the tin and lid.

HOW TO COLOUR THE BUTTONS

Many of the buttons here are in vivid shades and can be coloured in with equally bright felt-tip pens. There are also a few duller colours, which need a softer treatment.

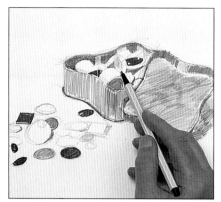

3 ▲ Start work on the buttons Shade in the negative shapes between the buttons in the tin with the medium grey pen. Use this colour, too, to deepen the cast shadow of the tin lid. Outline the tin base with medium brown. Now choose a variety of brightly coloured pens for the buttons – red, fuchsia, orange, purple, light pink and bright blue are used here. Leave any highlights as plain white paper.

4 ▶ Blend colours For the darker buttons, shade one colour over another – for example, purple and dark grey over medium grey, or medium grey and dark blue over bright blue. Show the pattern on the large button with dark brown and grey over ochre.

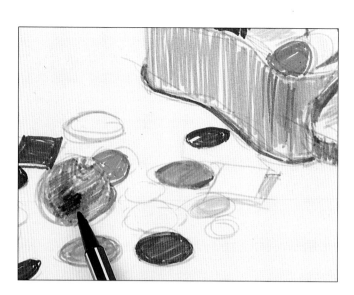

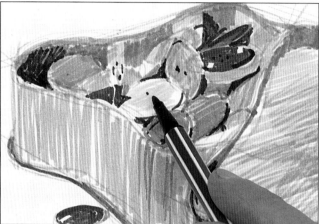

5 ◀ Finish the picture Draw shadows under the buttons in medium grey. Define the tin's lip with medium brown. Fill in the remaining buttons in ochre and green, then add holes and rims to the buttons with a dark grey pen.

THE FINISHED PICTURE

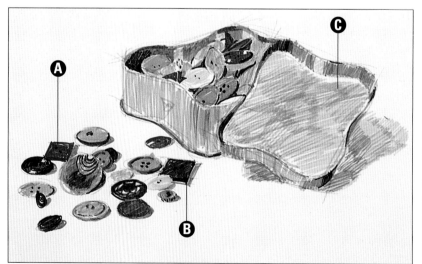

A Bright buttons
To capture the most vivid hues in the drawing, the brightest shades of felt-tip pens were used to create flashes of colour.

B Blended colours
Muted shades were made by working a dark colour over a lighter one, leaving streaks of the first colour showing to act as highlights.

C Tonal variation
The variation in tone on the tin lid was shown by cross-hatching lines of light grey in some places to make the grey shade appear deeper.

Corner of an artist's studio

An artist's studio usually contains a wealth of interesting materials, which can be arranged to form a still-life group.

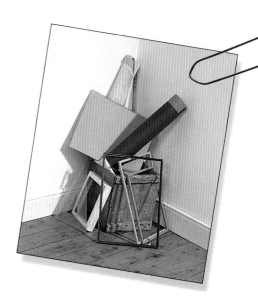

Setting up a still life composed mainly of rectangular and square objects, such as the frames and crate shown here, presents you with a good opportunity to practise showing perspective within a limited space. If the still life is positioned in the corner of a room, additional interest is created by the angles formed where the two walls meet.

Showing perspective

As this arrangement of objects is quite complex, you might find it helpful to mark in the eye level very lightly when you begin sketching. As you draw each rectangular object, you can extend the perspective lines out to their vanishing points to make sure you have got the angles right. Another useful method of checking the angles in your drawing is to make a simple device from two pivoting pieces of card (see Expert Advice, page 104).

Shadows in corners

With the light shining from the right, the left-hand wall in the picture is bright and has sharp shadows, whereas the adjoining wall looks grey with hazy shadows. The violet and orange coloured pencils given away with this issue are ideal for creating subtle shadow effects. These colours are layered for the shadow on the right, with the violet predominating. On the left-hand wall, the bright tone is represented with a little orange, overlaid with just a suggestion of grey.

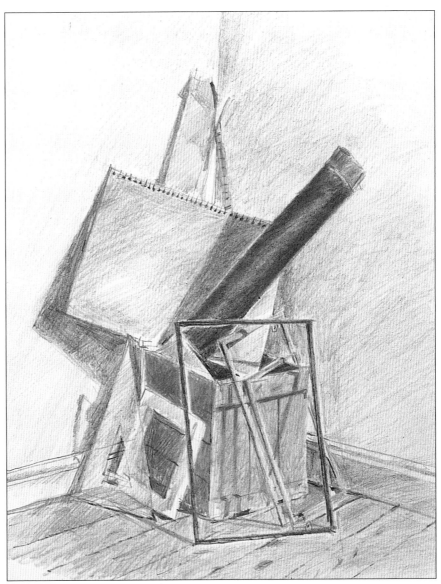

▲ The objects in this still life are propped up against each other so that they create a variety of interesting shapes and angles.

YOU WILL NEED

Piece of cartridge paper

14 coloured pencils: Medium grey; Blue violet; Black; Orange; Brown ochre; Yellow ochre; Dark brown; Sap green; Viridian; Dark carmine; Geranium lake; Light blue; Dark blue; Yellow

Putty rubber

Craft knife

FIRST STEPS

1 ▶ Make an accurate sketch Mark in the vertical corner and the skirting boards using the medium grey coloured pencil, then map out the other key points and lines. Use your pencil as a measuring guide and be aware of perspective – the floorboards show this very well.

2 ◀ Start work on the shadows Put in the strong cast shadows on the left-hand wall, on the sketch book and inside the crate. Still using the medium grey, colour the sketch pad lightly so that it shows up pale against the dark shadows. With long, diagonal strokes, lightly indicate the shadow on the right-hand wall, then emphasise its violet cast by shading over the grey with the blue violet pencil.

EXPERT ADVICE
Using card 'scissors'

With two strips of card joined at one end using a split pin, you have a simple device for checking angles. Hold these 'scissors' straight out in front of you, aligning the strips with two edges in the still life that form an angle. Then place the device on your paper and draw in the lines along the sides of the strips.

3 ▲ Colour the roll of paper Continuing with the blue violet pencil, add cross-hatched lines on the wall to darken the shadows around the still-life group. Begin to colour the roll of paper, pressing hard at the edges for a deep shade and lightly in the centre for a pale colour. This contrast helps to build up the curved form.

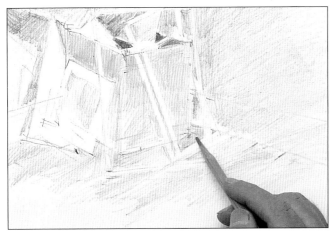

4 ▲ Warm up the picture Shade blue violet over the shadows on the left-hand wall and the sketch pad. Even out the sketch pad with more medium grey, then change to black to darken the negative shapes inside the crate. With an orange pencil, shade lightly over the walls to warm them up. Orange also forms the base colour of the crate, the floorboards, the roll of canvas propped up in the corner and the ruler.

5 ▶ Work on the crate and floor Outline the set square and shade it very lightly with black. To make the crate and floorboards look more realistic, work over the orange with brown ochre, deepening the colour on the shaded side of the crate.

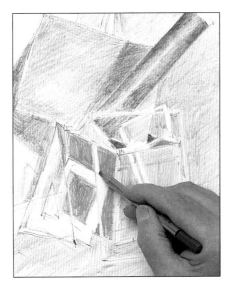

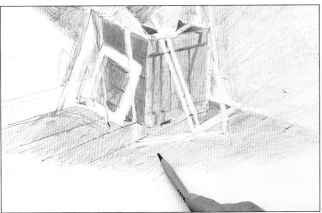

6 ▲ Add some detail Use a brown ochre pencil to indicate the crate's planks and the shadows of the frames. Change to yellow ochre to warm up the crate and floorboards, then show details, such as the knots, with a dark brown pencil.

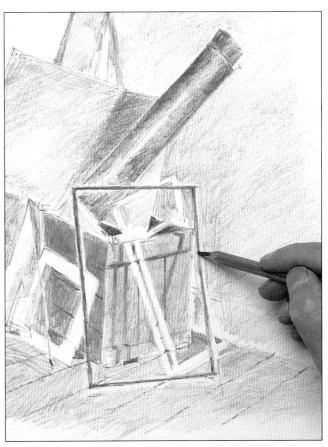

7 ▲ Introduce some other colours Give form to the roll of canvas with dark brown shading, and define the ruler with a little dark brown and yellow ochre. Now begin on the brighter colours: a mix of sap green and viridian for the green roll of paper, and dark carmine for the red picture frame.

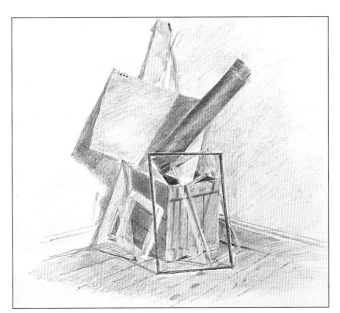

8 ▲ Shade the picture frames Blend yellow ochre with geranium lake for the mid-pink frame. Use light blue for the other thin frame, then work medium grey lightly over the white frame and set square. Darken the edges of the frames and set square with medium grey or black. With the black pencil, shade the skirting board and draw the moulding.

A FEW STEPS FURTHER

At this point, the drawing is almost complete. It has an overall warmth produced by the golden browns of the wood and the hint of orange in the shadows. A few more details will add realism.

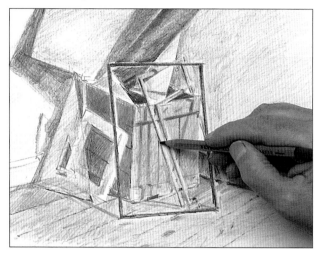

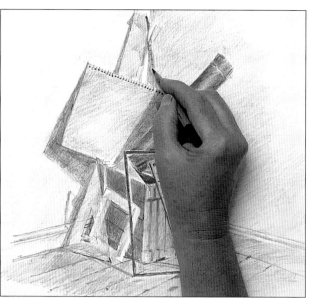

9 ▲ **Fill in some details** With the black pencil, draw the spiral binding of the sketch pad. Darken the shadow on the wall under the pad. Go over the shaded side of the blue frame with dark blue to give it more depth.

10 ▲ **Deepen the shadows** So that the left-hand wall is not pure white, shade it lightly with medium grey. Deepen the shadow on the right-hand wall with more blue violet. Put in a touch of yellow to show the paper emerging from the top of the roll. Finally, using black, add more detail to the skirting board and the ruler.

THE FINISHED PICTURE

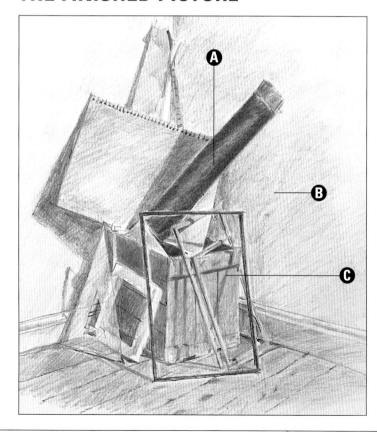

A Depth of tone
Light and dark areas of tone can be achieved by varying the pressure on the pencil. The curve of the purple roll of paper was modelled in this way.

B Colour in shadows
Shadows look livelier if they have colour in them rather than just being grey. Here, the cool violet was warmed up with a little orange.

C Sense of perspective
With so many rectangular objects in the drawing, special attention had to be paid to getting the perspective correct.

Hat collection

The varied shapes and textures of a few favourite hats make them an interesting subject for a pencil drawing.

Whether sporty or sophisticated, hats always have a certain charm and often become more appealing once they have taken on a comfortable, well-worn appearance. From the artist's point of view, they are ideal to draw, as there are so many variations in shape and texture.

Characterful hats

In this project, the four hats have quite different characters. The boater is rigid with an elliptical shape. It has a spiral construction that gives the effect of concentric rings on the brim and crown. The sun hat has a wide brim that is best drawn with a fluid sweep of the wrist. The panama has a far looser shape. The black cloth cap is also quite floppy, and provides a strong tonal contrast to the composition.

Straw texture

Straw hats have a finely woven pattern that would be tedious to draw in every detail. The challenge is to find a shorthand for each pattern, which will suggest the overall effect without actually copying it. This can be done in various ways: small hatched squares indicate the coarse weave on the sun hat, while cross-hatched lines show the finer weave of the panama. The stitched rings of straw on the boater are shown with dotted lines.

▼ Use a soft, well-sharpened pencil to achieve the wide range of tones and textures in this drawing of hats.

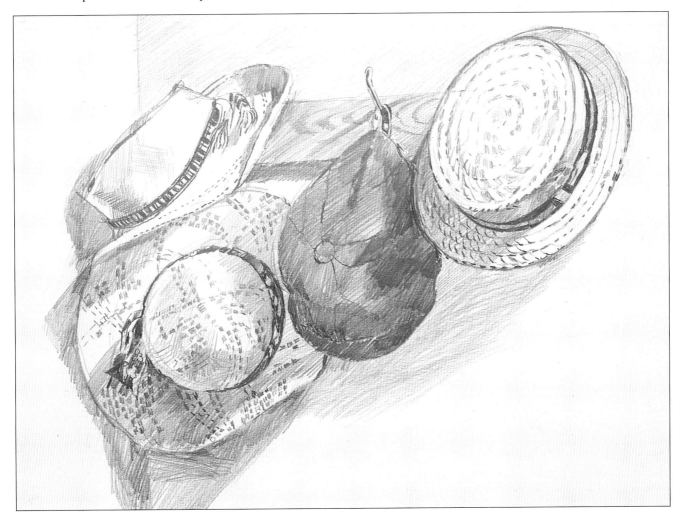

FIRST STROKES

1 ▶ Sketch the main shapes Use a 4B pencil to establish the lines of the hat rack and the corner of the wall. Sketch the outlines of the four hats, noting their different shapes. The top of the boater forms an ellipse – put in some construction lines to help you draw this correctly. Once you are happy with the initial sketch, go over the lines more firmly to redefine them.

2 ▼ Indicate light and shade Hatch in the dark shadows under the rack and on the left-hand wall. With lighter lines, shade in the rack itself. On the panama, work heavy shading in the crease of the crown and medium shading in the brim turn-up. Draw a fine, dark line along the brim edge. Moving on to the black cap, outline the button and the segments of the crown, then draw the dark shadows in the creases.

3 ▲ Give form to the black cap Fill in a light tone all over the cap, then add some firmer shading on the left to make a medium tone. Isolate the shadows on the brim and crown of the cap and use more pressure here to produce a heavy black. The cap now has light, medium and dark areas, all blending into one another.

CREATE SOME TEXTURES

Once you have put in the main areas of tone, you can start to concentrate on depicting the range of textures on the hats, especially the different types of straw weave.

4 ▶ Work on the panama hat Firm up the original lines of the hat band and tassels, marking in the woven pattern. Now begin to add a medium tone to the crown of the hat, indicating the weave with slanting lines that cross in places. Not much texture shows on the well-lit area at the top of the hat. Suggest the stitching on the brim with dotted lines.

5 ▶ Add shadow to the sun hat Put a suggestion of the woven straw pattern on the crown and brim of the sun hat (see Expert Advice below). Use long, straight shading lines to render the medium tone on the crown and wide brim, then extend this to the shadow under the hat. Leave the turn-up of the brim light, but darken the tone on the inner, shaded curve.

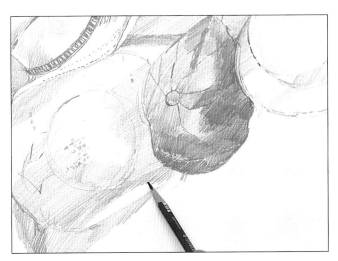

6 ▲ Describe the wood grain Extend the cast shadows on the right-hand wall by shading in the medium-tone under the boater. To achieve lively, flexible strokes, hold the pencil some way up from the tip. Fill in a little light hatching on the brim and band of the boater. Then indicate the wood grain on the hat rack by hatching a pattern of small curved shapes.

EXPERT ADVICE
Drawing woven straw

There is no need to imitate the fine, interwoven pattern of straw on the sun hat in great detail. Just suggest it with a few rows of small hatched squares here and there – this impression is enough to convey the character of the hat.

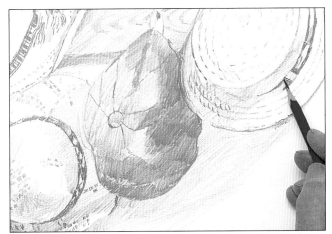

7 ▲ Work on the sun hat and boater Indicate the pattern on the band of the sun hat. Then add more little hatched squares to suggest the woven straw, placing them along the curves of the crown and brim. On the boater, use jagged lines to show the concentric rings formed by the stitching. Draw the stripes on the band and bow.

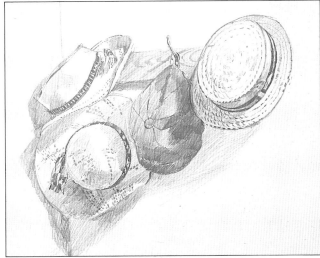

8 ▲ Show texture on the boater Emphasise the edge of the boater's flat top with short, dark marks, and show the straw texture along the rings of stitching with small blocks of shading and little slanting lines. Define the hook more clearly and show its cast shadow on the rack.

The drawing now has a good tonal balance and enough detail to suggest the different surfaces. Take a final, critical look at the hats to see if they could be improved by adding more texture.

10 ▼ **Complete the texture on the hats** Hatch in more small squares on the sun hat, positioning them along the direction of the weave. Add a few extra textural marks on the boater and panama. Finally, even out the dark tone on the black cap once more.

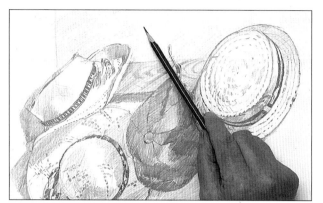

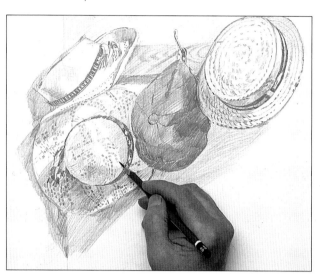

9 ▲ **Adjust a few tones** Work over the mid tones of the black cap to deepen them, so that they blend more evenly into the darker areas. As the right-hand wall has a slightly greyer tone than the brightly lit left-hand wall, hatch in some light tone here.

THE FINISHED PICTURE

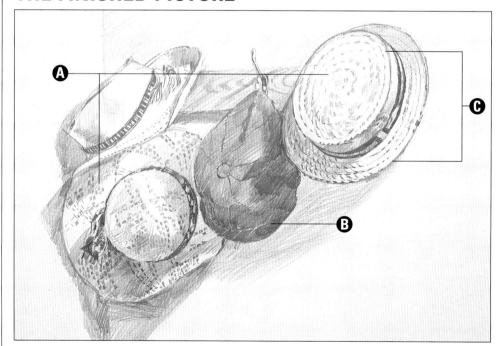

A Straw texture
Various textural marks were used to suggest the woven texture of the straw hats, including jagged lines, cross-hatching and small hatched squares.

B Tones within black
In spite of being deep black in colour, the cloth cap showed variations in tone depending on how the light caught it and where the creases fell.

C Elliptical shapes
In contrast to the floppy shapes of the other hats on the rack, the construction of the boater's crown and brim is rigid, forming perfect ellipses.

Reflections in a curved surface

Shiny convex objects, such as kettles, have reflective surfaces which create distorted images. These are challenging but great fun to draw in pencil.

Reflections are not always accurate mirror images. If the reflective surface is concave (curved inwards) or convex (curved outwards), the images you see in it will be distorted into surprising shapes. Even simple objects such as mugs or bottles will take on unexpected forms that will challenge your sense of visual perception. To draw reflections of this kind accurately, you will need to observe them closely, as you will not be able to rely on preconceived ideas about how the reflected objects should look.

Setting up a still life

The still life group in this project is set up around a metal kettle with a convex form. Another item you could use with a shiny convex surface is an old-fashioned iron, but even an old car hubcap would be appropriate for this exercise. Find a variety of objects to place around the shiny item – man-made objects with straight edges create the most obvious distortions, as they appear to bend around the curved form. Place the set-up on a plain white surface, as this will minimise distractions that might make your picture look fussy.

You might be able to see yourself reflected in the shiny object, as well as your surroundings. It can be fun to include your own image in the drawing, but you can leave out parts of the background such as windows or furniture if these spoil the effect. Alternatively, you could drape some white sheets behind you to hide any clutter.

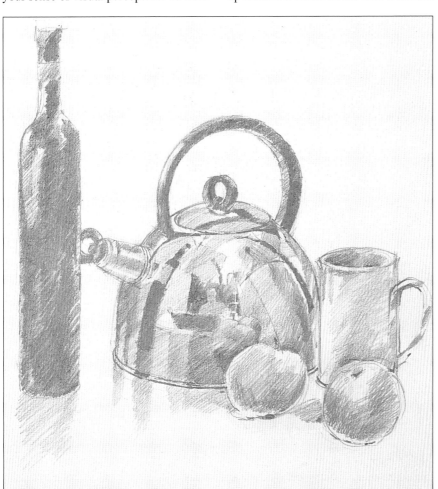

YOU WILL NEED

Piece of Hot Pressed watercolour paper

Graphite Pencils: 4B, 2B, 5B and 8B

Craft knife (for sharpening pencils)

Putty rubber (to correct mistakes)

◄ The scene captured in the smooth, shiny surface of the kettle includes the artist in the background, as well as the objects in the still life.

FIRST STEPS

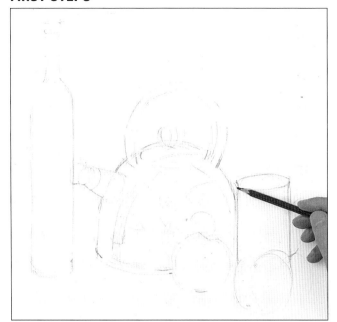

1 ▲ **Make an initial sketch** Using a 4B pencil, draw the curved outlines of the kettle, bottle, mug and apples, checking that the shapes of the man-made objects are regular. Take care over ellipses, such as the one formed by the top of the mug. Indicate the main reflections in the kettle, noting how they follow the curve of its surface.

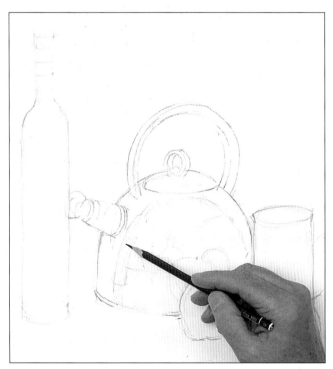

2 ▲ **Darken the lines of the sketch** Change to a 2B pencil and go over the lines of the sketch to make them darker and more precise. When you are strengthening the curves, hold the pencil near the end and draw freely. Put in a shadow underneath the reflection of the bottle.

HOW TO DEVELOP TONAL SHADING

To prevent the reflections in the kettle becoming a mass of conflicting details, it is important to develop the light, medium and dark tones gradually, looking for the lightest first, then progressing to the darkest.

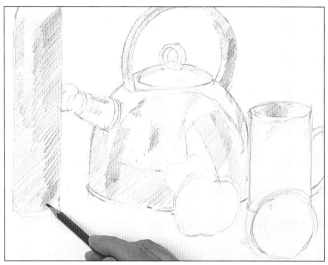

3 ▲ **Create light and mid tones** Begin adding tone to the reflections, using a 5B pencil. Lightly shade the reflected mug and the white surface, then hatch in mid tones on the reflected bottle, the shaded side of the mug and parts of the background. Leave the brightest reflections as unshaded white paper. Render the light and mid tones on the actual bottle, kettle handle and mug with diagonal hatching lines.

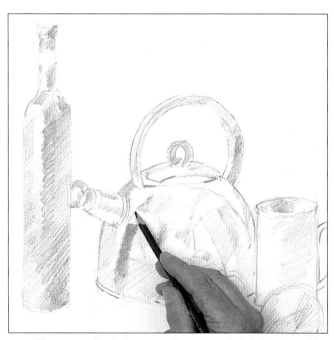

4 ▲ **Move on to the darker tones** Pressing slightly harder with the 5B pencil, create a band of dark tone down the centre front of the bottle, leaving a pale highlight to its left. Shade in the black plastic handles of the whistle and lid of the kettle. Begin indicating the form of the apples and the mug with loose hatching lines. Returning to the reflections in the kettle, darken the tone of the bottle and put in the dark line of the handle reflected in the kettle lid.

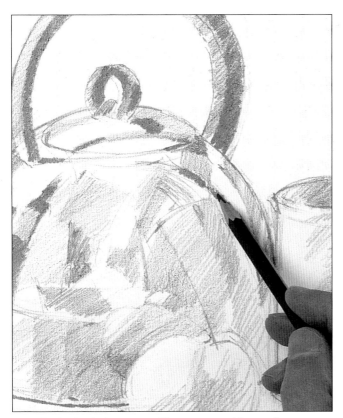

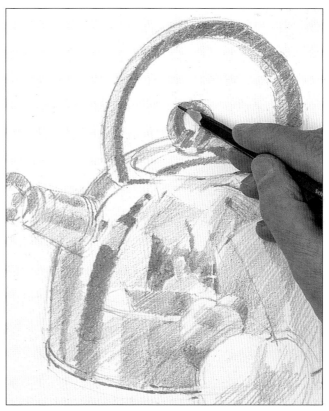

5 ▲ **Put in the darkest tones** Change to an 8B pencil, sharpening a long point so you can shade with the edge of the lead. Now darken the reflected bottle. Define the lines at the base of the kettle, then darken its main handle and lid handle.

6 ▲ **Draw your reflection** If you want to suggest yourself reflected in the kettle, as here, shade around the outline of your head and body. Check all the reflections, adjusting tones as necessary. Hatch light tone around the kettle spout, then strengthen the lid handle and its reflection in the lid.

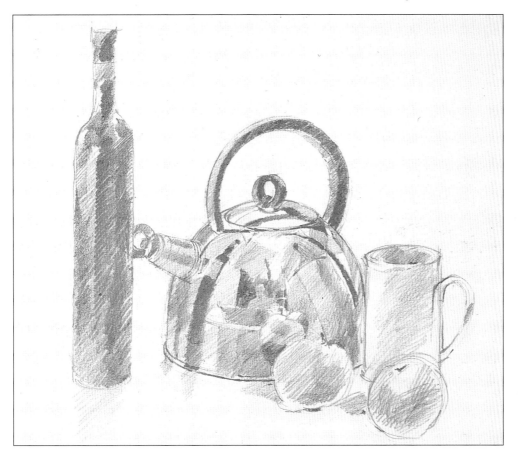

7 ◄ **Work over the whole picture** Firm up the hard edges, such as those on the kettle spout. Develop the rounded forms of the apples by applying hatched and cross-hatched lines. Deepen the shadow inside the mug. To emphasise the blackness of the bottle, go over the dark band down the centre once more. Lightly indicate the reflections and cast shadows of the objects on the white surface.

The reflections in the kettle progressed from a pattern of abstract shapes to discernable objects. You just need to add more shadows, and check that none of the reflections have been omitted.

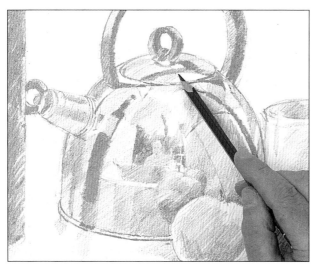

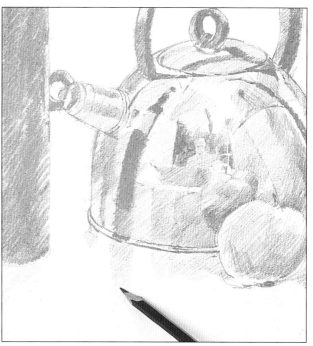

8 ▲ Refine the shading Return to the 4B pencil to continue darkening the bottle edges. Deepen the reflections of the apples with more hatching lines. Shade the top edge of the kettle handle and lid, using the side of the lead.

9 ▲ Complete the white surface Although the reflections of the objects in the white surface are quite faint, hatch them in clearly, as they prevent the objects from looking as though they are floating on the picture surface.

THE FINISHED PICTURE

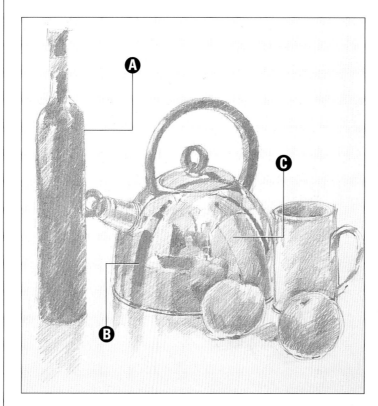

A Rounded shapes
The rounded, smooth items in the still life add unity to the composition. The curved bottle also has high, straight sides, which introduce contrast.

B Dark bottle
The reflection of the bottle is also interesting in terms of tone. Its dark form stands out sharply from all the other reflections in the kettle.

C Curved reflections
The effect of the convex surface of the kettle was to make all the lines of the objects curve up towards the lid.

Lettering on curved surfaces

A still life of bottles with interesting labels is ideal for improving your skills at drawing lettering and small graphic details.

Bottles make versatile subjects for a still life. Not only do they come in pleasing shapes and colours and have a surface that produces fascinating reflections, their labels also offer a wealth of detail that is fun to explore in a drawing.

Drawing lettering

It requires a fair degree of precision to draw printed letters that look convincing. Once you start observing drinks labels, you will be surprised at how many different styles of lettering, or typeface, they feature. Modern letters are bold and plain, such as in the words 'Pimm's' and 'Chardonnay' on the labels shown here, whereas the classical typefaces are more complex and have an elegant appearance. Other letters, such as those in signatures, have flowing curves. If you ignore these differences in style, your drawing will not look sharp and accurate.

Unlike the lettering on a flat object, such as a book, the letters on a bottle label will follow the curve of the bottle shape and therefore need to be drawn to show this. You will find it helpful to mark some faint, curved guide lines on your drawing first, into which you can then fit the letters.

If some of the letters on a label are very small, it might be impossible to render them accurately. In this case, replace them with little symbolic marks, which will represent them convincingly.

▶ Reproduce the lettering and graphics on the bottle labels with great clarity using a set of sharpened coloured pencils.

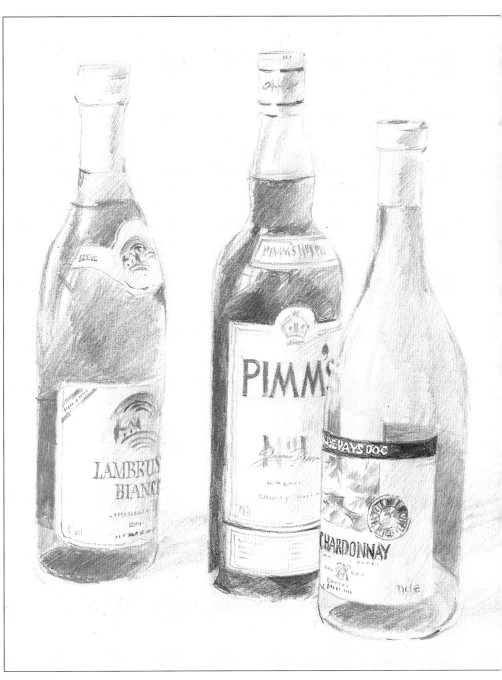

Piece of Hot Pressed water-colour paper

17 coloured pencils: Mid-grey; Black; Pale grey; Magenta; Scarlet; Yellow; Ochre; Dark brown; Dark green; Purple; Orange; Bright green; Olive green; Violet; Mid brown; Light green; Dark blue

Craft knife (for sharpening pencils)

FIRST STROKES

1 ▶ Sketch the bottles Using a mid-grey coloured pencil, outline the bottles, making sure that the sides are balanced. Indicate the labels – some show through from the back of the bottles. Put in a little shading on the right-hand side of the bottles and labels. Begin to sketch in some of the letters lightly.

2 ▼ Draw the reversed-out letters Change to the black pencil and work around the shapes of the white, 'reversed-out' letters (see page 95) at the top of the label on the olive green bottle. If you feel unsure about doing this just by eye, sketch in the outlines before filling in the background.

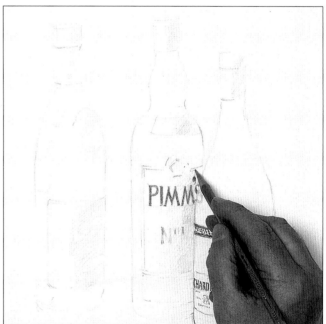

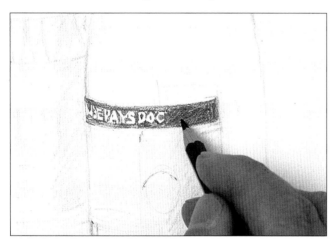

3 ▶ Continue the Chardonnay label Indicate the small circle, the crest and the tiny lettering on the label with the black pencil. Then put in curved guidelines and plot the outlines of the black capital letters. As the letters come towards you, the spacing between them appears to become slightly wider.

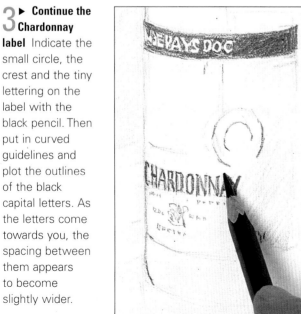

4 ▲ Work on the Pimm's label Deepen the shading on all the labels and bottle tops with pale grey and mid-grey pencils. Change to magenta and scarlet to fill in the letters on the Pimm's label. For the gold lettering and border, use a mixture of yellow and ochre, with a little dark brown and black.

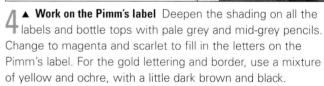

In a classical typeface, the letters are finished off with little triangular devices known as 'serifs'. Put these in with a sharp pencil once you have drawn each letter. Notice, too, how some of the letters are made up of a combination of narrow and wider strokes.

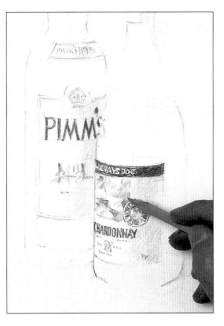

5 ◀ Develop the labels Draw mid grey and dark green letters on the Lambrusco label. Darken the Pimm's letters in the shadow area with purple, then put in the letters on the small label. On the Chardonnay label, sketch the illustration in orange, bright green and olive green.

6 ▶ Add more label details Draw the two small illustrations on the Lambrusco labels with violet, black, dark green, yellow and scarlet pencils. Going back to the Pimm's bottle, work the lettering on the cap in orange and black, and draw the red stripes.

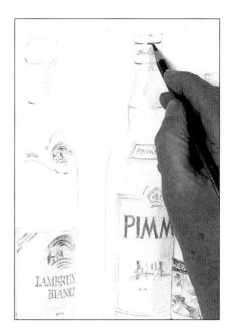

HOW TO ADD COLOUR TO THE BOTTLES

When the labels are developed to your satisfaction, you can begin to fill the bottles with colour. Use several shades for each one to reproduce their rich, glowing tones, leaving the white paper for highlights.

7 ▶ Colour the dark green bottle With the dark green pencil, fill in the colour with long hatched lines. Make the tone darker on the left of the label. Use olive green at the base and go over some areas with bright green.

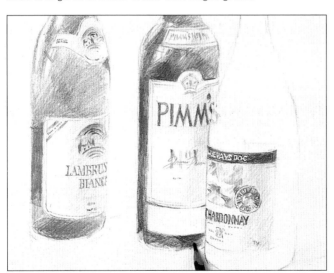

8 ▲ Fill in the Pimm's bottle To show the tawny colour of the Pimm's bottle, blend dark brown, orange, mid brown, scarlet and magenta. Add a little black for the tone around the label and down the left side, where the dark green bottle is reflected.

9 ▶ Complete the third bottle Hatch strokes of light green and ochre over the bottle, using olive green and dark brown to indicate the label and the edge of the Pimm's bottle showing through from the back. Suggest the tiny lettering on the lower Pimm's label with short lines in ochre.

A FEW STEPS FURTHER

The drawing is now almost complete, the glowing colours of the bottles setting off the intricate labels beautifully. Just a few shadows and reflections need to be added now.

10 ▲ **Put in the cast shadows** Use long, loose hatched strokes of mid grey to indicate the shadows thrown by the bottles on to the white surface. Darken the Lambrusco label on the shaded side in the same way. Use a little dark blue on the shaded letters here.

11. ▲ **Show the bright reflections** Look closely for the brightest greens – you'll see these at the bottom of the bottle where the light shines through the glass and on the white surface adjacent to this area. Indicate these reflections with the bright green pencil.

THE FINISHED PICTURE

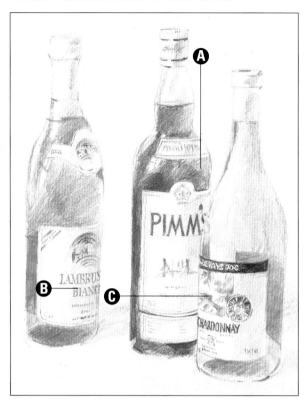

A Glowing colours
The jewel-like colours of the glass bottles were rendered by combining several different coloured pencils.

B Curved labels
The lettering follows the curve of the labels around the bottles. Guidelines were drawn to help position the letters correctly.

C Simplified detailing
Rather than try to depict the illustration on the label in detail, the artist simplified it into basic blocks of colour.

Classical wall plaque

This relief wall plaque demands a subtle touch to render the fine facial features and delicate shading. Coloured pencils are the ideal medium.

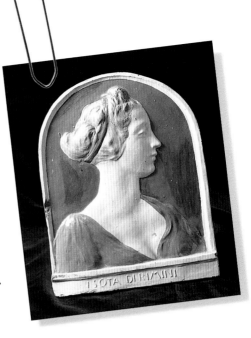

The beautiful relief plaque that was used as the inspiration for this drawing project is in the style of the Florentine artist Luca della Robbia (*c.* 1400-82), who developed coloured, glazed terracotta as a medium for sculpture. The head and shoulders are meticulously modelled and give a realistic, three-dimensional portrayal of a woman in the classical style.

If you would like to practise this project with a different object of your own, reproduction relief wall plaques are sometimes sold by museum shops.

Also, some decorative plates have relief surfaces, as do traditional German beer steins (tankards). Alternatively, you could use an intricately carved wooden box.

Lighting a relief surface

It is very important to plan your lighting carefully when you set up a relief object for drawing. If it is lit from the front, the undulations on the surface will appear completely flattened. However, if you light the object strongly from one side, all the features will be picked out and, even on a shallow relief, you will see subtle gradations of tone. To emphasise the relief effect, build up the colour gradually from light to dark.

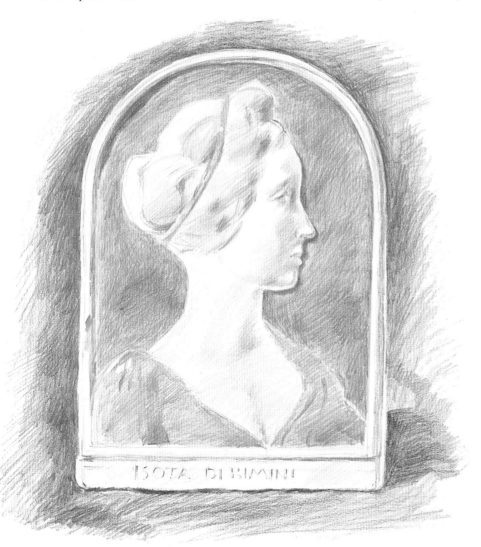

◄ Subtle gradations of tone show the relief effect on this wall plaque. Side lighting makes the most of the undulations on the surface.

YOU WILL NEED

Piece of Hot-pressed watercolour paper

11 coloured pencils: Mid-grey; Light blue; Dark blue; Kingfisher blue; Olive green; Pale Naples yellow; Pale green; Light grey; Dark grey; Ochre; Black

Craft knife for sharpening pencils

Putty rubber

FIRST STEPS

1 ▶ Sketch the plaque First establish the shape of the plaque's frame, using a mid-grey coloured pencil. Roughly mark in the lettering. Then outline the woman's head and shoulders. Begin lightly shading the cheek and chin.

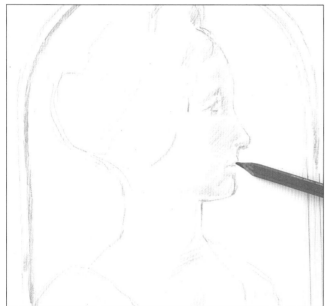

2 ▲ Add light and medium shading Lightly shade the front of the face, darkening the eye and eyebrow. With looser lines, hatch some light tone on to the front of the neck, hair and breast. Press harder with the mid-grey pencil along the left-hand inner edge of the frame and, in the same way, show the shadow cast by the profile on to the background.

EXPERT ADVICE
Drawing a rounded arch

There are two devices that you can use to help you establish a pleasing arch shape for the frame of the plaque. You can check its symmetry by marking a vertical centre line from top to bottom. Also, you can produce a smoothly rounded top by lightly continuing the curved line to make sure it forms a circle (left).

HOW TO INTRODUCE COLOUR

Having completed an accurate sketch and indicated the main shading on the woman's face and breast, move on to filling in the different areas of colour, beginning with the intense blue of the background.

3 ▲ Fill in the background Using a light blue coloured pencil, start filling in the background with long hatching lines. Change direction occasionally so that the shading looks lively rather than smooth and bland.

4 ▲ Define the profile Change to a dark blue pencil and shade this over the light blue, working carefully around the head. Emphasise the profile by redefining the narrow line of its shadow – this lifts the head from the background and helps to suggest the relief effect. Shade a little kingfisher blue on the left of the plaque to brighten this area.

5 ▲ **Work on the dress and face** Use olive green for the dress bodice, leaving a bright highlight on the shoulder on the left. Follow the drape of the fabric with the hatched lines. Lightly and delicately shade the face and neck with pale Naples yellow, also working over the grey shadows.

6 ▲ **Model the hair** Use olive green on the hairband and to emphasise the sleeve folds. Vary the colour of the dress by adding pale green. Use pale Naples yellow as the basic hair colour, then model the waves with light, mid- and dark grey. Deepen the facial shadows with dark grey.

7 ▲ **Begin the lettering** Shade pale Naples yellow over the lettering area and up the sides of the frame. With mid-grey, indicate the shadow under the narrow ledge just above the lettering. Sharpen the dark grey pencil and go over the sketched letters, defining them clearly but not too heavily.

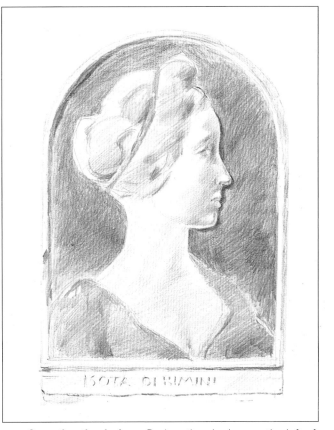

8 ▲ **Strengthen the shadows** Darken the shadow on the left of the frame with dark grey and dark blue, and on the right with mid-grey. If the shadows on the face, hair and dress need to be strengthened, go over them with dark grey. Use this colour to emphasise the shadow at the base of the plaque, too. Work a little ochre over the breast and throat.

A FEW STEPS FURTHER

The relief effect on the sculpted head is now clearly evident. However, the wall plaque will stand out more clearly if you suggest some of the black velvet drape behind it.

9 ▲ Begin shading the background fabric Use long hatched lines of dark grey to indicate the background fabric around the arch. Build up the tone with multi-directional strokes, curving them around the top of the arch with a sweep of the wrist.

10 ▲ Put in the deepest tones Finish off the shading with a black coloured pencil, feathering off the strokes at the outer edges. To keep the sides of the frame straight, you could shade over the edge of a piece of paper. Strengthen the tone of the dark shadow under the plaque.

THE FINISHED PICTURE

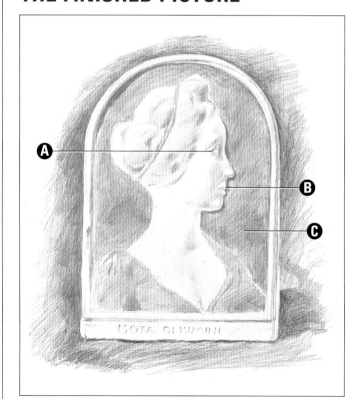

A Delicate features
The woman's fine features were built up gradually, using three shades of grey.

B Relief effect
To emphasise that the face is in relief, a dark shadow was drawn around the profile, making the face stand out from the background.

C Blue background
The vibrant background was achieved by blending light and dark blue, then adding a bright patch of kingfisher blue.

Leaves in close-up

Take a close-up look at the abstract shapes formed by a random collection of leaves. Use water-soluble coloured pencils to create both subtle washes of colour and sharp, realistic detail.

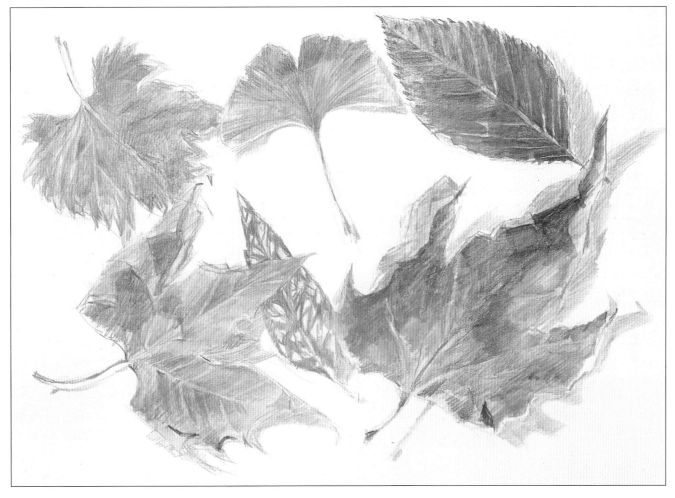

A still life of leaves can be treated in different ways. You could make a botanical drawing, arranging a sprig of leaves in a conventional way and concentrating on making them look as realistic as possible. Alternatively, you could let the leaves fall into a random design, and then focus closely on the shapes and textures within it.

The second of the two methods has been chosen for this exercise. The leaves are varied in size, shape and colour, and where they overlap, they create some interesting negative spaces.

A piece of plain white paper makes the best background for the leaf design, as the delicate serrated outlines will show up clearly, as will any cast shadows. A good tip is to fix the leaves to the paper with small pieces of double-sided sticky tape. You can then pin the paper to an upright board, so that you can look at the pattern face on.

Using water-soluble pencils

Water-soluble coloured pencils are ideal for delicate work, such as studies from nature. You can use them to draw

▲ **Water-soluble coloured pencils give a painterly effect to these richly coloured leaves, but also show plenty of detail.**

all the intricate details and to render soft, realistic shading, and then you can add a little clean water on a paint brush to blend the colours.

For this picture, a range of browns, greens, reds and yellows has been used to represent the variety of colours in the leaves.

FIRST STEPS

1 ▶ **Outline the leaves**
Using chocolate brown, olive green or red brown, as appropriate, sketch in the rough outlines of the leaves. On the red hydrangea leaf (top right), define the serrated edge and the veins with chocolate brown and magenta. Change to raw sienna to draw the main veins on the large plane leaves at the bottom.

YOU WILL NEED

Piece of 300gsm (140lb) Hot-pressed watercolour paper

15 water-soluble coloured pencils: Chocolate brown; Olive green; Red brown; Magenta; Raw sienna; Mid-grey; Pale Naples yellow; Lemon yellow;

Bright green; Apple green; Emerald green; Lime green; Orange; Moss green; Burnt sienna

Craft knife for sharpening pencils

Medium-sized, round squirrel-hair brush

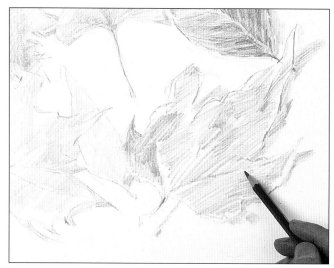

3 ▲ **Continue with the colour** Shade pale Naples yellow over the left-hand plane leaf and lemon yellow over the variegated laurel leaf (centre bottom). Moving on to the right-hand plane leaf, fill half of it with olive green and half with red brown, adding bright green highlights.

2 ▲ **Begin colouring the leaves** Use olive green to fill in the vine leaf (top left) and the fan shape of the gingko leaf (centre top). Put in the shadows in mid-grey (see Expert Advice). Shade the hydrangea leaf with chocolate hatching lines, cross-hatched with magenta.

EXPERT ADVICE
Drawing the cast shadows

When leaves are used in a still life, they have a tendency to curl up as they dry out, especially if they are placed under a strong light. Because of this, it is a good idea to shade in the cast shadows early on. They will then exactly match the original leaf shapes you have drawn.

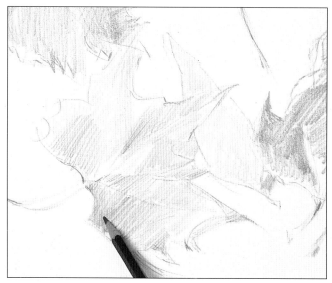

4 ▲ **Blend colours with the pencil** Prior to wetting the water-soluble pigment, you will need to blend the colours of the leaves to achieve the mottled shades. On the left-hand plane leaf, blend in some red brown over the pale Naples yellow that you applied in the last step.

HOW TO ADD WATER TO THE DRAWING

As you complete the colour blending using the dry pencils, begin adding a little water to even out the pigment. Rinse your brush frequently to keep it clean. When the washes are dry, you can use more dry pencil for shading and details.

5 ▲ Begin using water Dip a medium-sized, round squirrel-hair brush into water to dampen it and then paint over the gingko leaf, smoothing out the hatched lines as you go. Work in the direction of the fan shape.

6 ▶ Continue adding water Turn to the red hydrangea leaf, painting water over the blended magenta and chocolate brown. Work carefully into the serrations. In the same way, add water to the vine leaf and the plane leaves, cleaning your brush between colours. Leave the washes to dry for a while.

8 ▲ Work on the lower leaves On the laurel leaf, use olive and emerald green to fill in the pattern around the yellow spots. Change to chocolate brown to shade the plane leaves, leaving pale veins. Brighten these leaves with orange, then wet them to blend the colours.

9 ▼ Bring out more colours By adding several layers of different colour, you'll bring out the richness of the original leaves. Darken the vine and gingko leaves with moss green, and lighten the plane leaves with bright green, adding touches of burnt sienna and raw sienna here and there.

7 ◀ Go back to dry pencil shading Shade bright green over the left-hand plane leaf. Add bright green and apple green to the gingko leaf, drawing its veins with emerald green. Carefully shade chocolate brown, lime green and magenta between the veins of the hydrangea leaf, and emerald green between the veins on the vine leaf.

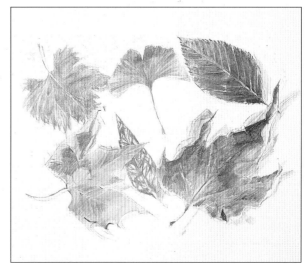

As well as being accurately drawn, the leaves also form a pleasing design in harmonious colours. To sharpen up the drawing, add more definition to the shadows and leaf veins with a dry pencil.

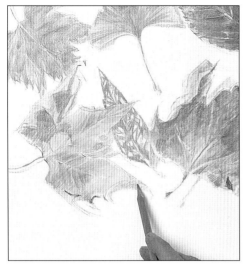

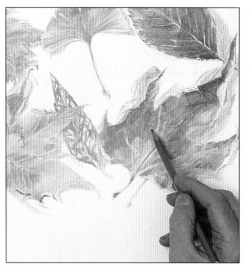

10 ▲ **Darken the shadows** Using the mid-grey pencil, go over the cast shadows that you marked in earlier. Press more firmly to deepen the tone. Draw the narrow shadow of the gingko stalk.

11 ▲ **Define the veins** Check the pattern of veins on the vine leaf, re-defining them with moss green if necessary. In the same way, work a little moss green around the veins on the right-hand plane leaf.

THE FINISHED PICTURE

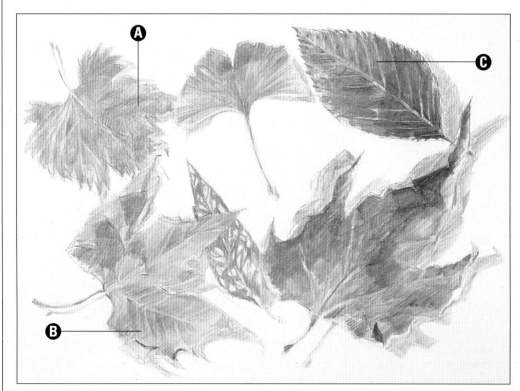

A Random pattern
Leaves of different types were arranged to create a dynamic design rather than a natural-looking one.

B Blended colour
To emulate the rich colours of the leaves, layers of dry pencil shading were blended with a little water on a brush.

C Light veins
To represent the light-coloured leaf veins, darker colours were worked carefully around them, leaving a pale underlayer showing through.

Fabric textures in charcoal

The soft feel of fabric can be convincingly rendered by drawing in charcoal and blending tones with a stump.

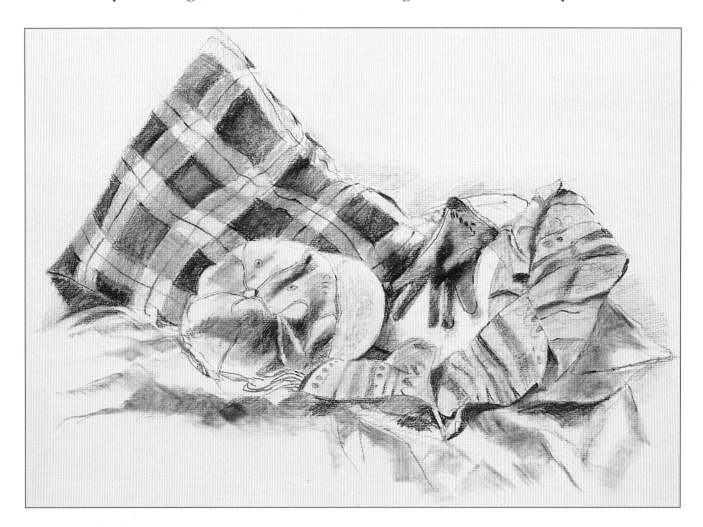

When drawing fabric, you need to adopt a technique that will suggest its tactile surface and gentle folds convincingly. Charcoal or charcoal pencils are excellent to work with, as they create appropriate textures on the paper, yet can be sharpened to a fine point for drawing details.

An Ingres pastel paper, which has a textured surface, was used for this still life to provide a tooth for the charcoal. As you progress with the picture, it is a good idea to rest your hand on some spare paper to avoid smudging the lines you have already drawn.

Using a stump

If you use charcoal in conjunction with a stump, you can achieve an even more realistic fabric effect. Stumps, or tortillons, are small tubes of tightly rolled paper. They come in various thicknesses and can have either a pointed or flat end. By rubbing a stump over an area of

▲ **The softly blended look in the picture is achieved by rubbing a stump, or tortillon, over charcoal pencil shading.**

charcoal, you can blend it to a smooth tone. With a pointed stump, you can work into small corners easily.

You can also use a stump to pick up charcoal pigment and transfer it to your drawing (see Expert Advice on page 129). Vary the tone by changing the pressure you apply.

FIRST STEPS

1 ▶ Make a charcoal sketch

Using a hard charcoal pencil, sketch in the main lines of the still life, showing the curves and folds of the soft objects. Indicate the tartan pattern on the cushion.

YOU WILL NEED

Piece of buff Ingres paper

3 charcoal pencils: Hard; Medium; Soft

2 stumps: Medium with pointed end; Fine with flat end

Craft knife to sharpen charcoal pencils

Putty rubber

Fixative

2 ▼ Establish dark and medium tones

Change to a medium charcoal pencil to put in the darkest tones in the folds of the cap. Block in the dark squares on the tartan cushion and shade in the medium tone on the glove.

3 ▲ Develop the tartan cushion

Shade in the mid and light toned green bands on the tartan pattern, working carefully around the edge of the cap as you do so. Leave the lightest squares of the tartan unshaded for the moment.

HOW TO SHADE WITH A STUMP

Now that you have developed some of the dark and medium tones, you can begin using the stumps to blend and smudge the charcoal. This technique will give the shaded areas a soft appearance reminiscent of the surface of the fabrics you are portraying.

4 ▶ Blend the darkest tones

With a soft charcoal pencil, suggest the very dark tone where the tartan cushion is in shadow. Then blend the charcoal by rubbing over it with the pointed medium-sized stump.

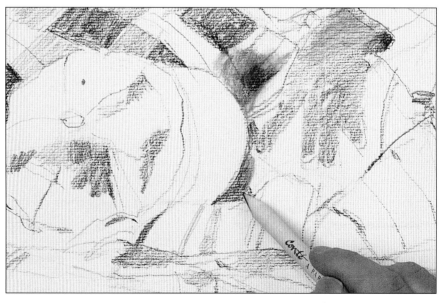

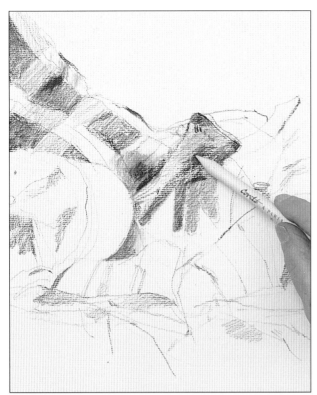

For subtle shading, apply charcoal to your drawing with a stump. To do this, scribble the soft charcoal pencil aggressively over a spare piece of paper so you create some charcoal powder. Then rub the tip of a stump in the powder and use this to render the light and mid tones in your picture.

5 ▲ Smooth the tartan pattern Rub the medium stump over the dark squares and medium-toned bands of the tartan cushion, smudging the charcoal into an even tone. Build up the folds and shadows in the glove, using the charcoal and stump alternately to develop the form.

6 ▶ Develop the cap Using the method described in Expert Advice above, suggest the drapes of fabric in the foreground with the medium stump. Draw the shadows on the cap with the medium and soft charcoals, then rub over them with a fine stump. Change to the hard charcoal to put in the stitching, strap and eyelets.

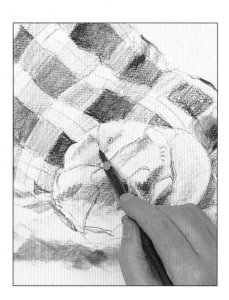

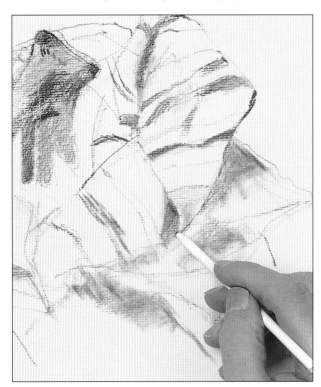

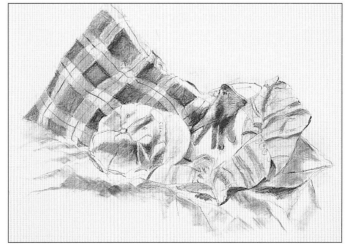

7 ▲ Work on the scarf With the medium charcoal pencil, begin to indicate the striped pattern on the scarf. The curves of these lines will help to show how the scarf is folded and draped. Rub over the shadow areas on the scarf with the fine stump.

8 ▲ Adjust the tones Fill in the pale stripes on the scarf with charcoal applied with the medium stump. Use this method to also add light tone to the green tartan squares, then draw the fine lines with the medium charcoal pencil. Deepen and blend the tones of the glove, as well as the tip of the yellow cushion.

The surfaces in the still life now have a pleasing soft feel to them that suggests the texture of fabric. All that remains is to add a little contrast in the form of some sharp detail.

9 ▶ **Create a highlight** Put in a suggestion of the background by rubbing on charcoal with the medium stump. To emphasise the light falling on the glove, lift out a light patch along one side, using the tip of a putty rubber. Define the pattern on the scarf in more detail.

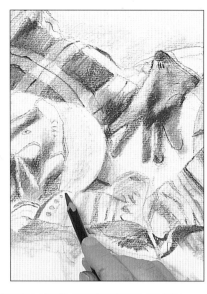

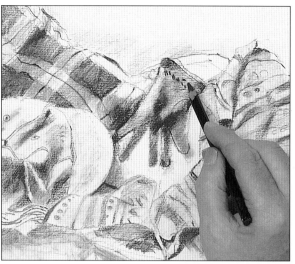

10 ▲ **Check the last details** Darken the shaded folds of the foreground fabric, leaving the buff paper to represent the ridges of fabric that are catching the light. Add any details that you might have missed, such as the pattern on the wrist of the glove and the tassels on the scarf. Spray the picture with fixative.

THE FINISHED PICTURE

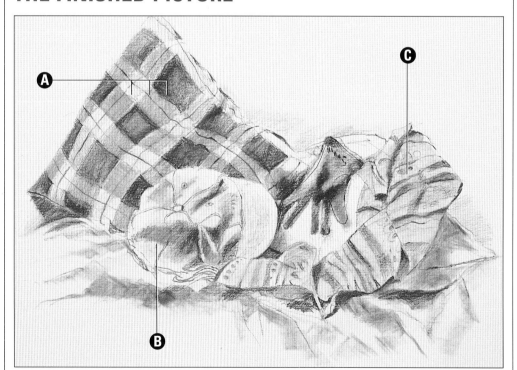

A Tonal contrast
By using a variety of hard, medium and soft charcoal pencils, a range of light, mid and dark tones is established in the drawing.

B Smudged effect
Blending shaded areas of charcoal with a stump gives a soft, hazy look that suggests the texture of woven or knitted fabric.

C Fine lines
To contrast with the softly blended tones in the drawing, the fine, distinct lines show pattern and details such as stitching.

Reflections in glass

Glasses and decanters really test your observation skills – each object reflects whatever is around it and distorts whatever is behind it.

I
f you look closely at a group of glass objects, you will see some fascinating reflections and distortions. Curved glass appears to displace the edges of objects behind it, producing unexpected outlines, while cut glass throws back the light in different directions so that its facets form surprising patterns.

In order to create the most effective highlights and shadows, take time to experiment with the lighting for your still life. The set-up shown here was lit from behind so that shadows were thrown forwards on to the white surface.

Move the objects in the group around until you have found the best reflections and distortions and built up a pleasing composition. Be aware that the reflections in the glass will change if you move your head even slightly as you are drawing, so try to keep to one position as much as possible.

▼ **Two grades of graphite pencil were used to depict the various tones visible in the curves and facets of the glassware.**

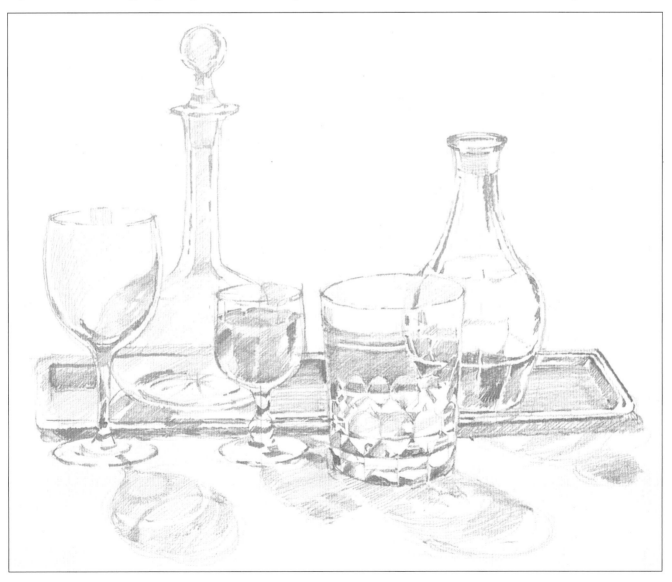

FIRST STEPS

1 ▶ **Make an initial sketch** Use a 2B pencil to draw the shapes of the glasses and decanters, making sure they look symmetrical. Pay particular attention to the ellipses formed by the tops and bases of the items. Looking through the glass, note and mark in any distortions, such as the edge of the tray showing through the tumbler.

2 ▶ **Firm up the lines** Changing to a 4B pencil, go over the lines of the sketch. You could check the symmetry of the items, if you wish, by lightly indicating their vertical centre lines. Draw the cut-glass pattern on the tumbler and the ribbed lines along the necks of the decanters. Outline the distorted curves of the decanters, which are visible through the glasses in front of them.

HOW TO DEVELOP THE GLASS OBJECTS

Continue to observe the still life closely, searching for the multitude of small reflections and distortions created by the glassware. Remember to look right through the glass objects, as well as noticing the light and dark tones on its surfaces.

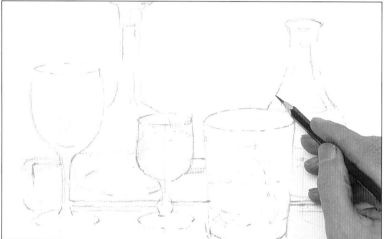

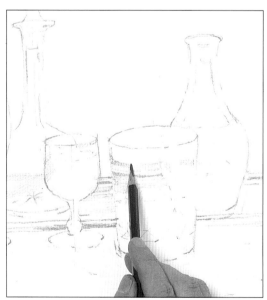

3 ▲ **Shade in the tray** Draw the star design in the base of the tall decanter. Shade in a mid tone on the tray, pressing harder for the dark tones along the edges. As you do this, look through the tumbler and decanters to see how they distort the far side of the tray – the curved glass has the effect of raising the level of the edge.

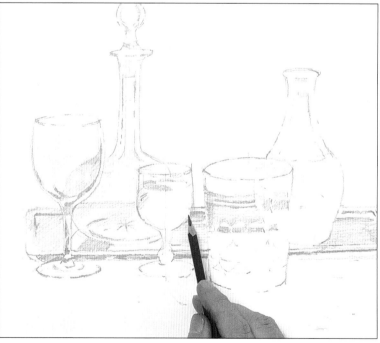

4 ▲ **Build up tone across the picture** Begin to show the facets on the tumbler with dark and medium tones. Lightly shade the left-hand decanter and tall wine glass, increasing the pressure on the pencil to show the distorted shape of the decanter as seen through the glass. Draw the dark reflections in the glass stems, decanter stopper and surface of the tray.

5 ▶ Work on the small wine glass In the glass of wine, mark the reflections of other objects with patches of dark shading. Continue adding reflections, working down the stem to the base. The cast shadows are a distinctive feature of the still life. Indicate these in outline first.

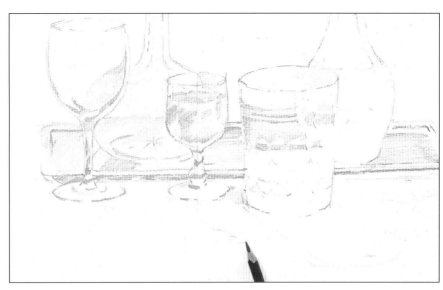

6 ▼ Develop the tumbler With a good point on the 4B pencil, complete the faceted design on the tumbler down to the base. Take your time over this, looking carefully at all the complex reflections and trying to show the pattern of light and dark shapes as accurately as possible.

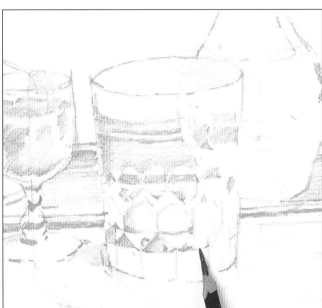

7 ▼ Show the facets on the small decanter The flat facets on the body of the small decanter are most visible where the tray shows through. Define these with dark shading, leaving the white paper to represent the edges of the glass. Hatch in the shaded area under the tray, then lightly shade in the cast shadows.

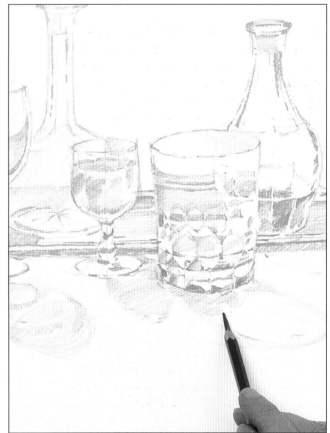

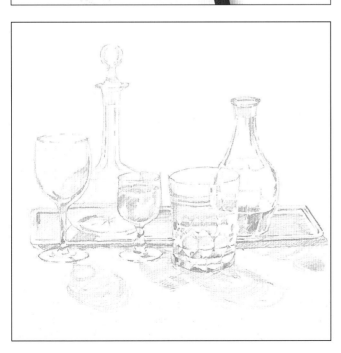

8 ◀ Continue with the cast shadows As the shadows are simplified versions of the glasses themselves, use curved lines to suggest the rounded shapes. Fill in the shadow of the small decanter, too. Define the back edge of the tray showing through the tumbler and tall decanter.

All that remains to be done at this stage is to add a little definition and give some sparkle to the picture by lifting out a few highlights.

9 ▶ Create highlights
With a sharp pencil lead, add definition to the tumbler and small glass. Lightly shade the left side of the tall wine glass and the stopper in the decanter. Using a putty rubber, lift out highlights on the stopper and the edge of the decanter visible through the glass.

10 ▲ Check final details Define one of the facets on the neck of the tall decanter with light diagonal hatching lines. Emphasise the edges of the tray with heavy, dark lines. Check the shapes of the cast shadows and work on these in a little more detail.

THE FINISHED PICTURE

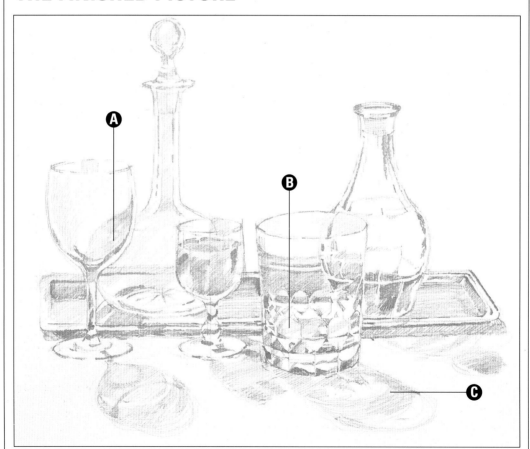

A Distorted shapes
The distortions seen when viewing objects through curved glass are clearly visible in these glasses and decanters.

B Complex reflections
Each facet of the cut-glass design on the tumbler shows different reflections, producing a fascinating tonal pattern.

C Curved shadows
The shadows are an important part of the composition and were drawn with a combination of curved and straight hatched lines.

Kitchen stools in charcoal

Draw the chunky lines and negative shapes in this uncluttered composition with the expressive medium of charcoal.

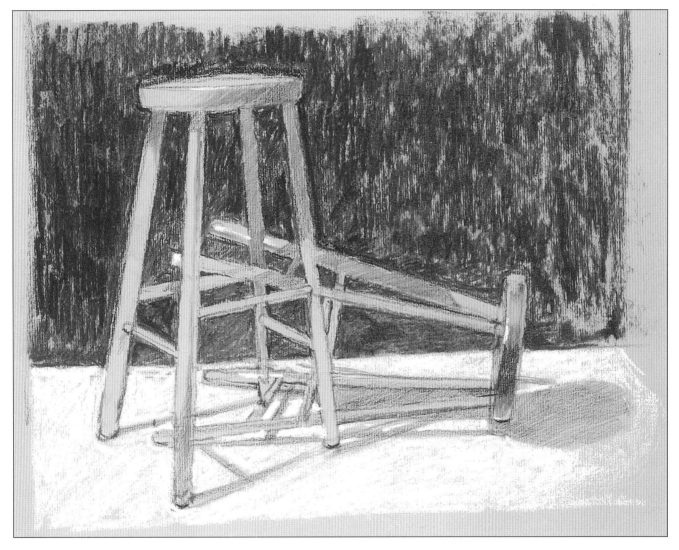

When you arrange a pair of kitchen stools against a plain background and then look through the spaces between them, you will see all kinds of shapes formed by the interlocking legs.

These 'negative' spaces, ranging from tiny triangles to irregular four-sided shapes, are just as vital to the drawing as the lines of the structure itself. If you observe them carefully as you draw, they will help you to establish the outlines of the stools correctly.

Sympathetic materials

A grey Ingres pastel paper was chosen as the support for this drawing. The colour provides a useful mid-tone between the black of the charcoal and the white of the soft pastel used in the

▲ A pleasing composition in neutral shades, this drawing is worked with a spontaneous, direct style.

still life. Charcoal and soft pastel work well together, as they both have a slightly crumbly texture that produces positive and lively marks suitable for the bold, simple nature of this set-up.

FIRST STEPS

1 ▶ Sketch the stool

Use a thin stick of charcoal to draw the outlines of the upright stool. Then draw the stool lying on its side, observing how its legs cross the other stool's legs. Put in the cast shadows.

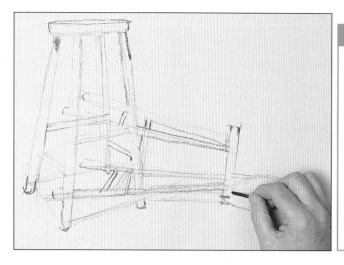

YOU WILL NEED

Piece of mid-grey Ingres paper

Thin stick of charcoal

White soft pastel

Medium charcoal pencil

Thick stick of charcoal

Putty rubber

Medium stump

Spray fixative

2 ▼ Start on the dark negative shapes

Look through the legs of the stools and isolate the dark shapes you can see. Begin filling these in, pressing the charcoal stick quite firmly to give a rich, dark tone. Keep the lines of the legs straight as you work.

INTRODUCING A LIGHT TONE

A white surface was chosen for the stools to stand on so that there would be a strong contrast between the dark and light negative shapes visible through the legs. As you continue shading in the negative shapes, correct the outlines of the stools if necessary.

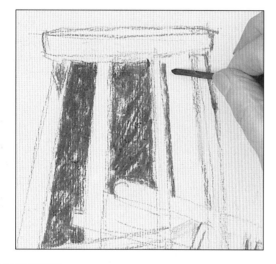

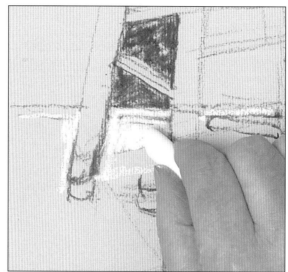

3 ◀ Work on the white surface

Indicate the far edge of the white surface with a charcoal line. Then change to a white soft pastel to begin filling in the light tone visible through the stools.

EXPERT ADVICE
Doing a rough sketch

Making a quick sketch before you begin your drawing is very useful to check how well your composition works on paper. It also helps you decide how much of the background to include, and enables you to get a feel for looking for negative shapes.

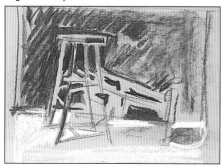

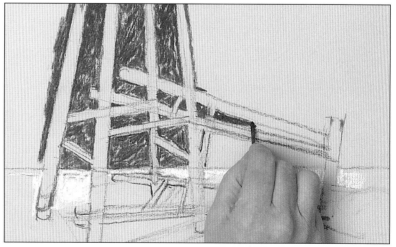

4 ▲ Continue with the black shapes
Returning to the thin stick of charcoal, shade in more of the negative shapes – some of these are very small or narrow. Leave flecks of the grey paper showing through to create texture and prevent the tone becoming too dense.

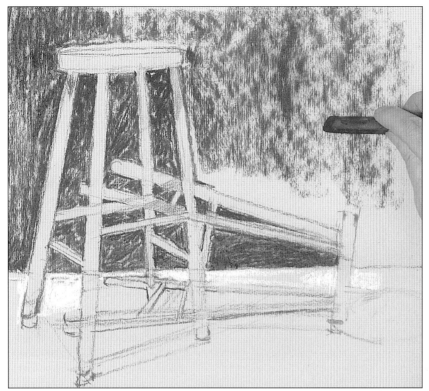
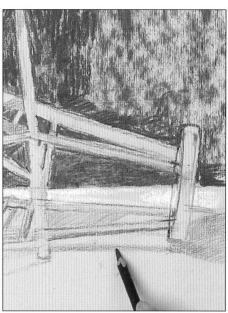

5 ▲ Shade in the background Look for mid-tones where the cast shadows fall on the stools' legs and begin shading these using a medium charcoal pencil. Then, using a thick stick of charcoal on its side, block in the background with broad, vertical strokes.

6 ▲ Develop the mid-tones With the thin stick of charcoal, darken and neaten the black negative shapes, working carefully around the stools' outlines. Change to the medium charcoal pencil to hatch in a mid-tone where the shadows of the legs and seat fall on to the white surface. Then put in further mid-tones on the shaded parts of the stools.

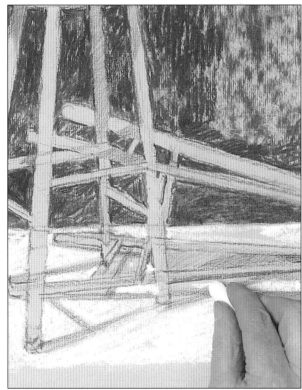
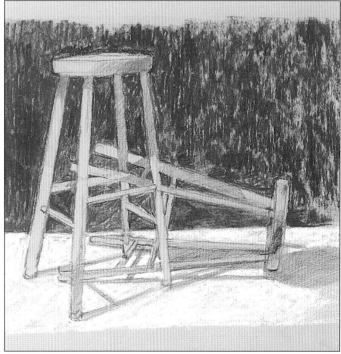

7 ▲ Complete the light foreground With the white pastel, continue blocking in the pale surface. Fill in the small negative shapes, as you did earlier with the charcoal. Notice how the grey paper provides a mid-tone for the stools in contrast to both the black and the white areas.

8 ▲ Refine the drawing Use the thick stick of charcoal to darken the black background on the right, allowing some of the paper to show through to retain an interesting texture here. With the charcoal pencil, work up the mid-toned shading on the legs of the stools. Correct any mistakes and clean up any unwanted marks around the edge of the picture area with a putty rubber.

The use of a stump will soften parts of the shading and a few white highlights will liven up the mid-tones.

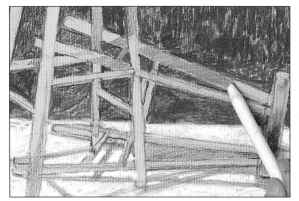

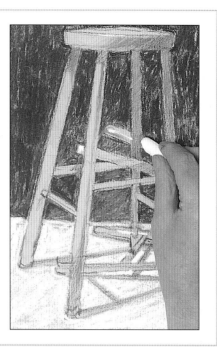

10 ▶ **Add white highlights** With the tip of the white pastel, draw some fine highlights on the stools. Check that you have put in all the shadows and that the lines of the legs are straight – use the charcoal pencil to make any adjustments that are necessary. Finally, spray on fixative to prevent smudging.

9 ▲ **Soften the mid-tones** With a medium-sized stump, gently rub over the charcoal shading on the legs of the stools. This will have the effect of blending the hatched lines to a smooth mid-tone.

THE FINISHED PICTURE

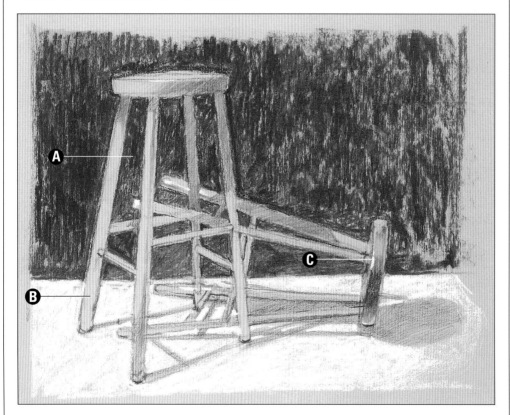

A Negative shapes
The arrangement of stools has produced all kinds of interesting negative shapes, which make the composition fascinating to draw.

B Useful mid-tone
Once the black and white negative shapes have been filled in, the stools emerge from the untouched grey pastel paper.

C White highlights
The use of a few, carefully chosen, sharp white highlights prevents the stools from being a uniform mid-tone.

Study of a skull

Whether you choose to draw an animal skull because you are interested in its anatomy or simply because it is a fascinating form, you will find it an absorbing subject.

Drawing an animal skull requires the precision of an anatomical study – you need to observe the bone structure closely and draw it clearly and sharply.

Water-soluble coloured pencils are ideal tools for this type of subject, as you can use them for fine lines and details, but you can also brush over your marks with water to create areas of flat colour that suggest the smoothness of the bone. And hot-pressed watercolour paper is a good choice of support, as it allows you to register detail precisely on its smooth surface.

Study the structure

Before you concentrate on the intricacies of the bone structure, you need to establish the basic shape of the animal skull – the sheep's skull in the step-by-step forms an inverted triangle, so keep this in mind as you sketch the outlines. To help you relate the different parts of the skull to each other, feel free to lightly draw a few 'structural' lines such as a centre line along the length of the skull.

▼ **Yellow ochre shading on the skull gives it an aged appearance. This colour is echoed in the background.**

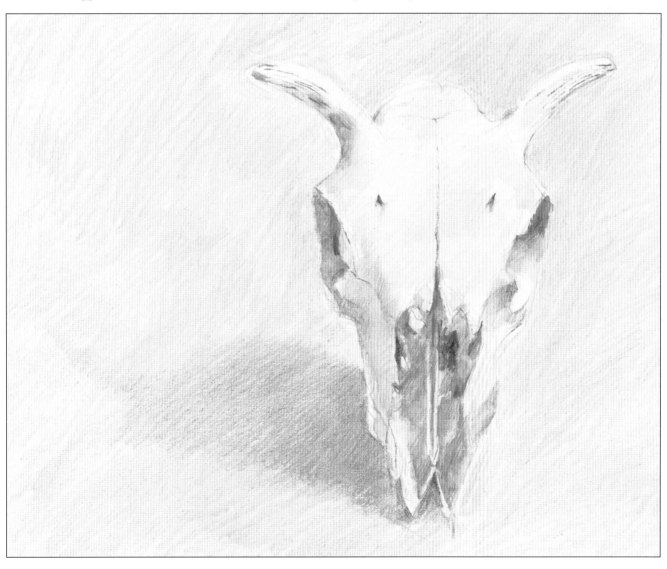

1 ◄ **Sketch the skull** Observe the sheep's skull closely and, using a blue-grey water-soluble coloured pencil, lightly draw the main lines, including the curved horns. Indicate the cast shadow on the left.

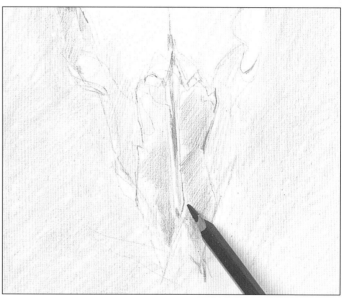

2 ▲ **Begin the ochre shading** Firm up the sketched lines with the blue-grey pencil, then change to a yellow ochre pencil to shade inside the nasal cavity and along the nasal bone. Lightly render the ochre background around the skull, occasionally varying the angle of shading.

3 ▲ **Build up the shadow areas** Complete the background, then very lightly put some yellow ochre across the top of the skull. Returning to the blue-grey pencil, create medium-toned shadows in the eye sockets and nasal cavity with neat, closely worked shading. Draw a dark line down the nasal bone.

EXPERT ADVICE
Assessing tonal values

As you draw, assess one tone against another constantly. For example, the cast shadow is darker in tone than the shaded side of the skull, but the area nearest the jaw is darkest of all. Half-close your eyes to eliminate detail – you will see the tonal gradations better.

4 ▲ **Define the cast shadow** Work over the cast shadow with the blue-grey pencil. Give it a soft, diffused edge, so that it contrasts with the sharper lines within the skull.

HOW TO EVEN OUT THE TONE

The advantage of using water-soluble coloured pencils for the drawing is that you can even out the shading with a brush dipped in clean water. Once these areas are dry, you can draw over the top with a dry pencil again.

5 ▲ Begin adding water Dip a No.3 round brush in water and paint over the blue-grey shading in the nasal cavity to even out the texture and create smooth tones. Brush water over the eye sockets and the nasal bone, too.

6 ▲ Work over the rest of the skull Change to a No.10 round brush and paint water over some of the yellow ochre on the forehead. Leave a few areas dry here to allow patches of white paper to show through. Darken the left side of the lower skull with more blue-grey pencil shading, then brush water over this.

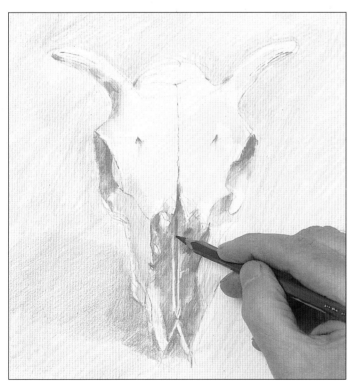

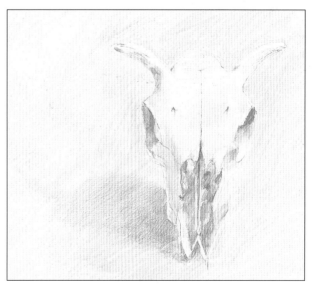

7 ▲ Put in darker tones Leave the drawing to dry. Sharpen the blue-grey pencil, then use harder pressure to define the eye sockets, horns and indentations in the forehead. Emphasise the vertical bone fissure and draw another fissure from the left eye socket. Darken the complex shapes in the nasal cavity.

8 ▲ Strengthen all the tones Using the blue-grey pencil, work over the cast shadow and the shaded side of the skull once more, deepening the tones here. Put in more linear texture on the horns. Changing to the yellow ochre, darken the background around the skull.

If you need to deepen the tones further, continue to work over the drawing with a dry pencil and then even out the shading with a wetted brush. Also pay attention to telling details at this stage.

9 ▶ Create black details With a medium black water-soluble pencil, sharpen up the indentations in the forehead. Deepen the darkest tone of the eye sockets and nasal cavity further, then even out the tone with the wetted No.3 brush.

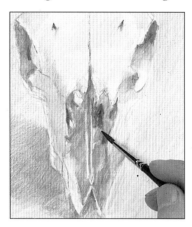

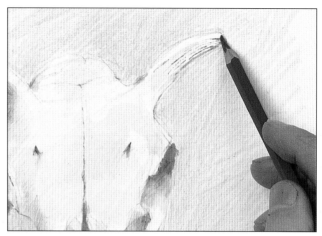

10 ▲ Intensify the background Shade more yellow ochre across the background, working carefully around the skull. With the blue-grey pencil, draw a few extra lines on the horns to suggest their scored surface.

THE FINISHED PICTURE

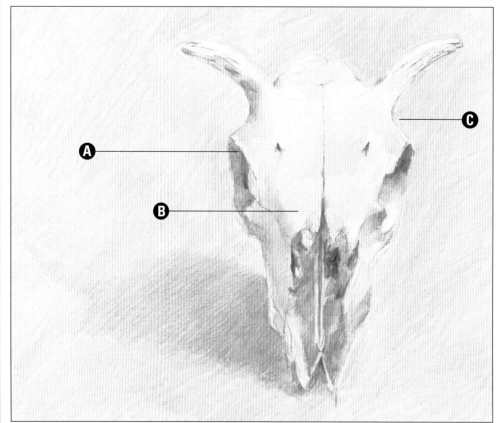

A Fine detail
The intricate bone structure was reproduced by drawing with a well-sharpened coloured pencil.

B Even tones
Smooth areas of tone were achieved by working over the coloured pencil shading with a damp brush.

C Lively shading
The plain, flat background was enlivened by varying the direction of the shading and deepening its colour around the skull.

Drawing a building

If you have not drawn buildings before, this attractive French shop makes an ideal first subject.

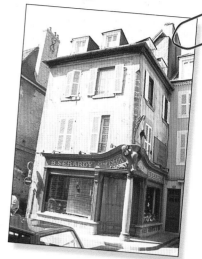

In most towns, you are likely to come across a variety of buildings that would be suitable for an initial attempt at drawing an architectural subject.

Look out for simply constructed buildings, perhaps embellished with a few lively decorative details. In the drawing shown here, the shop front with its elaborate lettering and its unusual curved corner decoration adds extra interest to a typical French town house.

As it is not always convenient to work on a finished drawing on the spot, you could make a few sketches of your chosen building instead, showing the main construction lines, the basic light, medium and dark tones and any unusual features. Touches of watercolour or coloured pencil will remind you of the predominant colours. In addition, take a few photographs of the building from different angles.

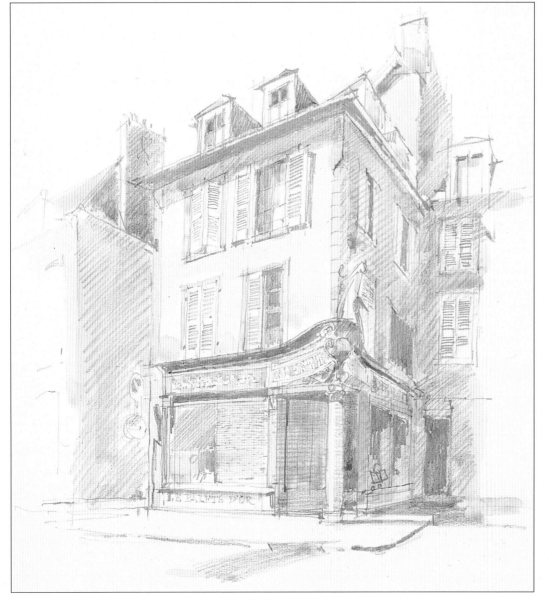

◀ **This drawing of a small French shop is full of character. Subtle watercolour washes help enliven the pencil work.**

YOU WILL NEED

Piece of smooth water-colour paper

Graphite pencils: 4B and HB

Putty rubber (to correct mistakes)

5 watercolour paints:
Winsor blue;
Ultramarine;
Cerulean; Raw sienna; Naples yellow

Brushes: No.10 and No.3 rounds

PREPARATORY STUDIES

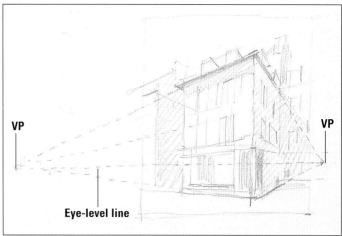

VP **VP**

Eye-level line

A few reference sketches showing architectural details and colour (above) will help you to produce an accurate and lively drawing once you get home. Also try establishing the perspective in an initial rough (above right) using the following steps:

● Dot in a line on your eye level. Then draw an upright line to show the corner of the building.

● Assess the angle of the roof on each side of the corner and continue these lines to vanishing points (VP) on the eye-level line.
● Draw the base lines of the walls so that they extend to the same vanishing points, and put in the windows in the same way.

Notice that the vanishing points might fall outside the picture area, and on a large drawing, might fall outside the paper itself.

FIRST STEPS

1 ▶ **Establish the main lines**
Use a 4B pencil to sketch the main lines of the building, referring to your perspective rough (see above) to check angles and proportions. Lightly mark the eye-level line, as in your rough, and visualise the lines of the roof, walls and windows receding to their vanishing points. Suggest the pavement with faint lines.

2 ▲ **Develop the windows** Go over the sketched lines more firmly and begin to rough in architectural details. Outline the window shutters, then develop the dormer windows, marking the frames and glazing bars. Shade the sides of the dormers and their glass panes.

3 ▲ **Continue with the windows** Put in the glazing bars and the slats of the shutters on the front windows. Indicate the curve of the shop front at the corner and the wrought-iron work above it. Shade some of the glass panes. Strengthen the lines of the shop's display window and the column at its entrance, then indicate the traffic signs on the left. Roughly sketch the building on the right, including its windows.

HOW TO DEVELOP THE DETAIL

Once the main building and its windows are established, you can begin to draw the details that make the shop front unique. Use a harder, HB pencil for the fine lettering.

4 ▼ Draw the lettering Change to a well-sharpened HB pencil to put in the lettering above the shop window. To make sure the words fit the space, rough the letters in very lightly to begin with. Notice how the lettering curves upwards towards the corner of the shop.

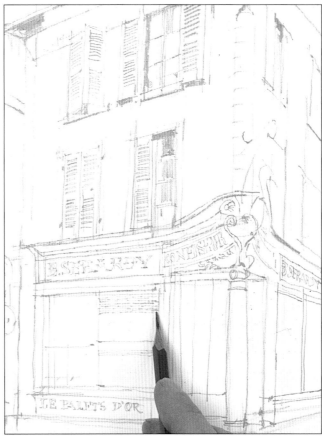

5 ▲ Put in more details Complete the lettering below the shop window and along the side wall, then put in the decorative scrollwork above the column at the corner. The cane blind in the shop window can be suggested with closely worked horizontal lines.

6 ▶ Develop the darker tones To give the drawing depth, you need to indicate the shadow areas. Return to the 4B pencil to fill in the darkest tones – under the eaves and the porch, bordering the shop name, and on the door on the right. Working with lighter, looser strokes, shade in the medium tone of the shop window and the top of the front wall under the eaves. Add more medium tone to the side walls, the left-hand chimney stack and the cast shadow on the road.

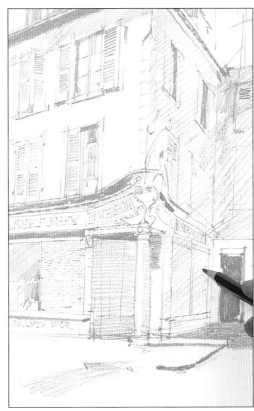

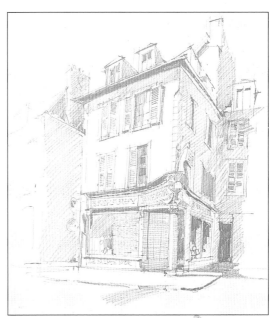

7 ▲ Complete the pencil drawing Put dark shading on the hanging shop sign and the scroll below it. Complete the shutters on the far right building and shade the narrow wall above it. In the side shop window, suggest the goods and fill in the deep shadows. Develop the traffic signs.

The drawing of the building is now complete, but you can give it more depth by adding a few discreet watercolour washes.

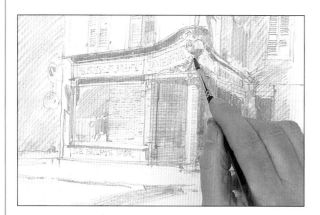

8 ◄ Add some blue Make a wash of Winsor blue and ultramarine. Apply this with a No.10 round brush on the shadow areas of the buildings and road. Wash cerulean over the shop windows, the scrollwork and the door shutter.

9 ▲ Introduce warm golds Warm up the colour on the front of the building, and on the wall to its left with a wash of raw sienna. For the side wall and the building on the right, paint on a darker wash of Naples yellow. Put a stronger shade of this colour on the side edges of the building, the window frames and the chimneys. Change to the No.3 brush to fill in Naples yellow around the lettering.

THE FINISHED PICTURE

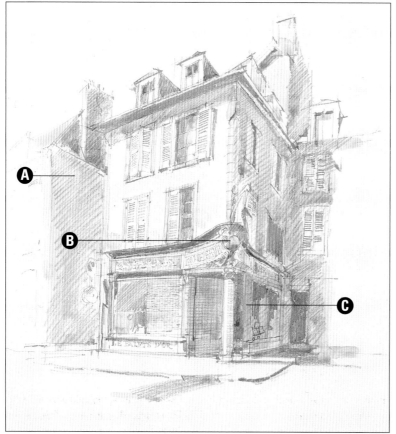

A Sense of the street
Including parts of nearby architecture helped to establish the building in the context of the surrounding street.

B Architectural details
A fascinating aspect of drawing a building is observing its unique architectural features, such as the decorative scrollwork on the shop.

C Hint of colour
The various tones in the drawing were enhanced by the addition of subtle washes of colour, using just a few shades of watercolour.

Flowers in line and wash

Capture the delicate beauty of these exotic, colourful bird-of-paradise flowers using pen and wash.

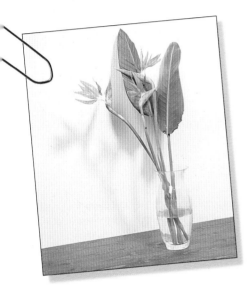

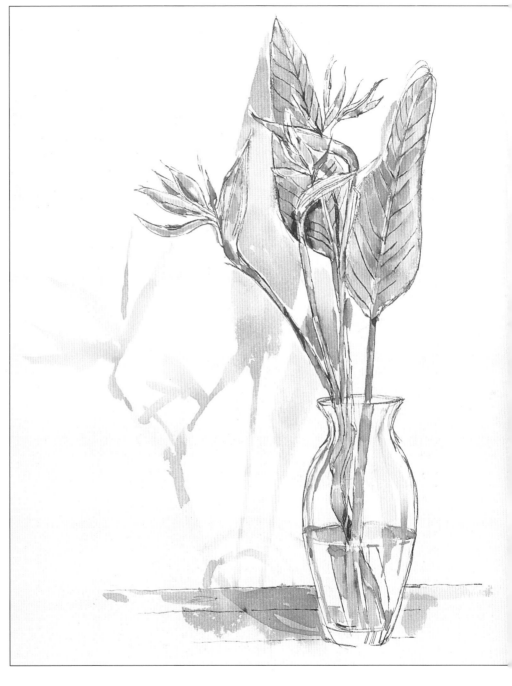

While pure line drawings have a clarity and beauty of their own, they can be given an extra dimension with washes of tone or colour. With a monochrome wash, you can build up tone more freely than with hatching or other forms of mark-making, while washes of colour will enliven your drawings. These looser areas also provide an effective contrast to the crispness of the line work.

Pen and wash

You can experiment with a variety of media for this line-and-wash technique. For this still life of exotic flowers, the artist drew with water-soluble ink using a fountain pen. You can also try using a dip pen with various widths of nib.

Water-soluble ink will give you all kinds of exciting effects and 'happy accidents'. For example, if you brush over the ink lines with clear water, they begin to dissolve, producing a marbled grey wash with hints of rusty brown and orange where the ink has separated.

Permanent ink, on the other hand, will retain its sharpness of line.

The excitement of colour

For a monochrome drawing, you can create the washes with the same ink used for the line work. With watercolour washes, however, you can bring the realism and excitement of colour to a drawing – the vivid flowers here almost cry out for a touch of cadmium orange.

▲ **The crisp linear work in water-soluble ink is enhanced by tonal washes and lively areas of watercolour.**

Once you have added a few washes, you can draw more detail over the top or redraw any ink lines that have been washed out. For soft detail, draw over the washes while they are still damp, but for crisp lines, make sure that the washes are completely dry.

FIRST STEPS

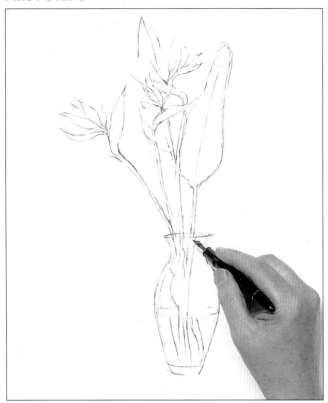

Piece of Not watercolour paper

Fountain pen with reservoir

Black water-soluble ink

Brushes: Nos.10 and 4 soft rounds

Paper tissue

Mixing palette or dish

3 watercolours: Cadmium orange; Hooker's green; Cadmium lemon

Jar of water

1 ▲ Begin a line drawing Fill a fountain pen with black water-soluble ink. Draw the flowers and leaves in outline, working carefully as you can't erase mistakes. Outline the vase, putting in a faint vertical centre line to help you achieve a symmetrical shape. Indicate the water level and the stalks, which look distorted where they show through the glass.

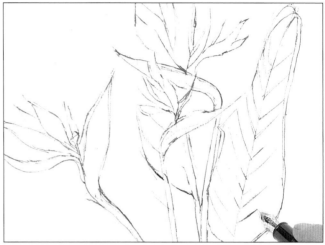

2 ▲ Complete the line drawing Check the symmetry of the vase by turning the drawing upside down. Adjust the lines if necessary. Put in a little more detail on the flower heads, then draw the veins on the leaves.

PUT WASHES ON THE LINE WORK

Now comes the exciting part where you will be adding washes to the line drawing. You can achieve tonal effects with diluted ink or by painting over the lines with clear water. Use watercolour paint for splashes of colour.

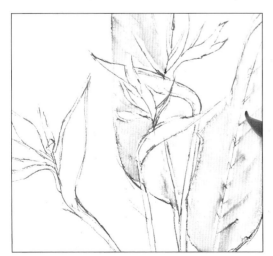

3 ▲ Put on the first wash Dip a No.10 soft round brush in clear water, then dab it on to a paper tissue to absorb excess water. Brush over the leaves – where the veins are moistened, the ink separates, giving a mottled orange/grey effect.

4 ▶ Paint the cast shadows Moving on from the leaves, continue the grey wash down the stems. Then put a small pool of ink on to a mixing palette and add a little water. Using the No.10 brush, paint the dramatic shadows of the leaves on the wall with this watery mix. Wash this mid tone over the table top as well.

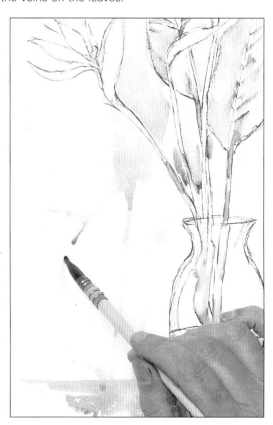

5 ▼ Continue the shadows Now put in the shadows of the flowers on the wall. You can make use of the shape of the brush head to help you do this – simply push the bristles down on to the paper and drag the brush along a short way to create a perfect petal.

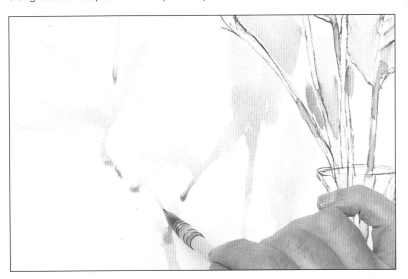

If you want to keep your colours true when adding watercolour to a drawing made in water-soluble ink, avoid painting over the lines. Wherever the wet paint touches the lines, the ink will mix with the watercolour and spoil its clarity.

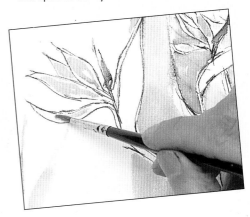

6 ▶ Add some watercolour Using the tip of a No.4 brush, paint the petals with cadmium orange watercolour. Where the washes touch the ink, they run together to form a greenish-grey (if you want to avoid these colour mixes, see Expert Advice, top right). To strengthen the leaves, change back to the No.10 brush and loosely paint a wash of Hooker's green over the grey ink wash.

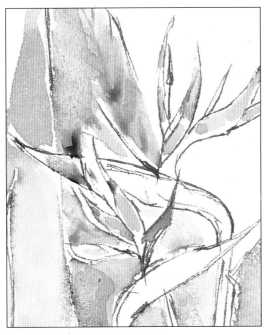

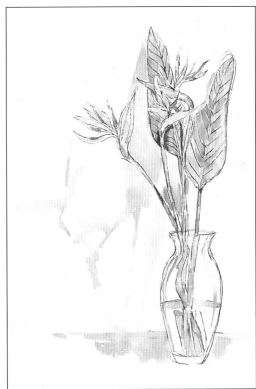

7 ◀ Mix a bright green Mix some cadmium lemon into the Hooker's green wash. Paint this lighter, brighter green over the grey wash on the stems. Also use it to colour the pod shape on the flowers from which the petals emerge. Leave to dry.

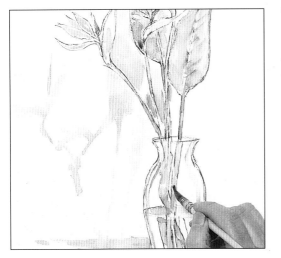

8 ▲ Do more linear work Once the paint is dry, go over the washed areas with more line work making sure the ink doesn't run. Redraw the leaf veins and stems and add detail to the left-hand flower. Now return to your watercolours. With a strong wash of cadmium orange, put darker areas on the petals and the tops of the stems. Paint over the shadow areas on the leaves with a strong wash of Hooker's green.

Check that you have enough tonal variety and detail in your drawing. Put in more linear marks and overlay further washes of colour if necessary.

9 ▶ Paint more shadows With the pen, draw a horizontal line to mark the table edge. With a No.4 brush and a wash of black water-soluble ink, suggest the shadow of the vase on the wall with subtle, curved lines. Change to the No.10 brush to render the dark tone of the vase's shadow on the table.

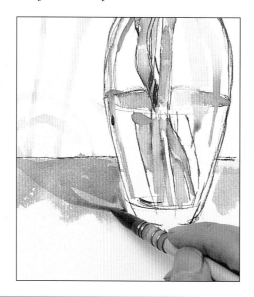

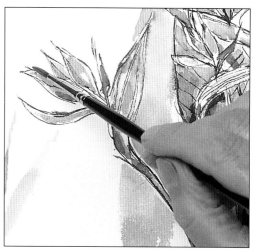

10 ▲ Put in the final touches Using the No.4 brush, strengthen the colour of the stems by adding more of the bright green wash used in step 7. Brush a little more strong cadmium orange on to the flower petals and the tops of the stems.

THE FINISHED PICTURE

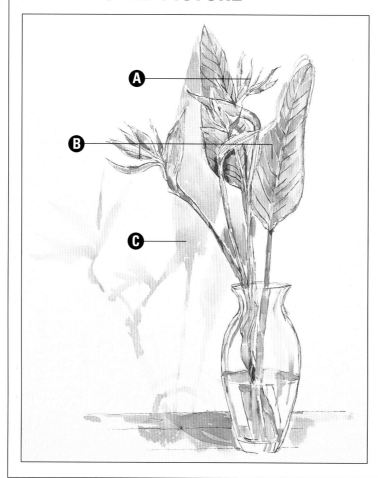

A Delicate lines
The fine lines produced by a pen nib are ideal to convey the delicacy and fragile beauty of the exotic flowers.

B Watercolour washes
Subtle washes of watercolour add life to the flowers and leaves. Some were painted directly on to white paper and some over grey washes of ink.

C Soft shadows
The shadows were painted with a wash of ink without any linear work. They provide a soft contrast to the harder-edged flowers, leaves and vase.

Foreshortening the figure

If you view a body from an unusual angle, you will find that its proportions change dramatically.

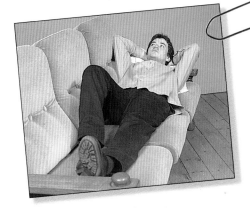

The effect of perspective on a building, a street scene or a land-scape is probably familiar to you by now, but you might be surprised to find that the appearance of a figure alters in much the same way, depending on your viewpoint.

For example, because of perspective, a figure in a reclining pose, like the one shown here, exhibits an effect known as 'foreshortening'. The proportions of the body look very different from how they are in reality. The parts that are furthest away from you (the upper body in this case) appear shorter than they really are, while those closest to you look surprisingly long in comparison.

Draw what you see

When looking at poses from unusual angles, you need to observe the figure very carefully and make a conscious effort to draw what you see rather than what you know to be the case. Look at the photographs on page 152 of a figure standing and lying down to see how dramatically the proportions of the body alter from one viewpoint to the other.

To help you to draw a convincing reclining figure, measure proportions and angles using an outstretched pencil. You might also like to make a few roughs before you begin your drawing.

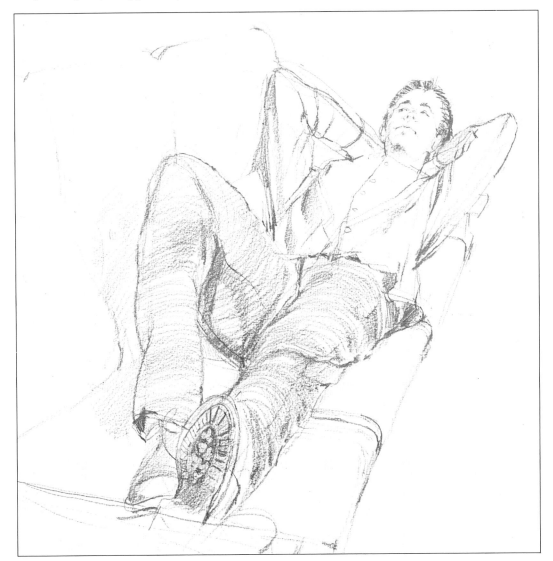

◄ As the model is lying down at an angle to the viewer, his upper body is foreshortened in comparison to his legs in the foreground.

FIRST STEPS

1 ▼ **Make a rough sketch** First, establish the angle of the figure by indicating its centre line. Begin to feel your way around the main forms, but keep your pencil marks light at this stage. Put in further construction lines if you wish – for example, a curved line across the face will help you position the features; another line across the elbows will show the position of the top of the head.

2 ▼ **Firm up the lines** Once you are happy with the basic pose of the figure, go over the outlines with firmer lines and indicate the position of the eyes, nose and mouth. Draw the sofa, remembering to show it in perspective – to check that you have got this right, rough in your eye-level line and take the lines of the sofa to a vanishing point. (To do this, see Preparatory sketches in drawing a building, page 144.)

CHANGING YOUR VIEWPOINT

With unusual poses drawn from unusual angles, pay attention to the way the proportions of the body change. If you were drawing the figure standing up (right), the torso (A-B) would be about half the length of the legs (B-C). But in the reclining pose (below), the torso is about a quarter the length of the legs. Also check the relationship of all the body parts – for example, see below how the bent knee aligns with the neck (along the line of A).

HOW TO BUILD UP THREE-DIMENSIONAL FORM

Once the proportions of the body are correct, start to suggest its form by showing the drape of the clothing and by adding tone.

3 ▲ **Build up the form of the body** Indicate the folded fabric on the shirt and the creases and seam of the inner leg on the trousers. Begin to convey a sense of the solidity of the limbs by working around the legs with sweeping, curved lines.

4 ▼ **Work on the face** Refine the facial features, noticing how the eyebrows follow the curve of the head and how the nose is foreshortened. Outline the ears, put in the shadow under the chin and work the black hair with short hatched lines.

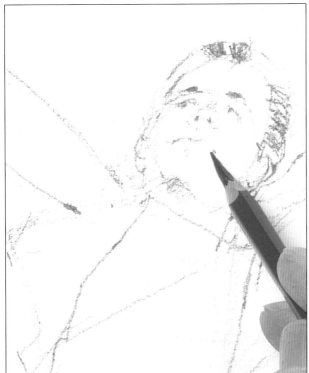

5 ▲ **Begin adding tone** The diagonal folds on the shirt front show how the fabric is being pulled by the upstretched arms; shade in the shadows formed by the folds. On the trousers, draw the seam on the left leg and the fold across the knee. Hatch in some light shading on the trouser legs.

EXPERT ADVICE
Simplifying a figure

When drawing a complex pose, you might find it easier to envisage the body as a collection of cylinders joined together. This will help you to sketch the outlines of the limbs and show their rounded forms.

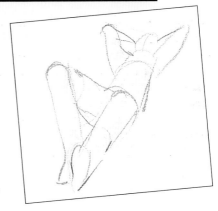

7 ▶ **Complete the sofa** Make the sofa look more solid by strengthening the lines of the cushions. To anchor the figure to the sofa, hatch in the cast shadow of the model's bent leg. Put in any remaining dark tones, such as the underside of the fabric at the bottom of the shirt.

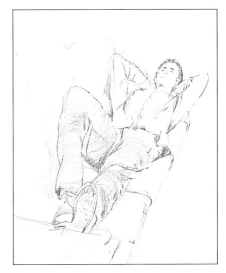

6 ▲ **Shade the trousers** Render the dark tone of the trousers with firm, curved pencil strokes, following the form of the legs. The tone is darkest under the thigh of the bent leg. Create a little foreground detail by drawing the pattern on the sole of the left shoe and the laces on the right shoe. Shade the front of the right shoe – notice how this part of the shoe is foreshortened.

The reclining figure should now look realistic, with the correct proportions for the angle of the pose. Just add a few more details to bring out the personality of the model.

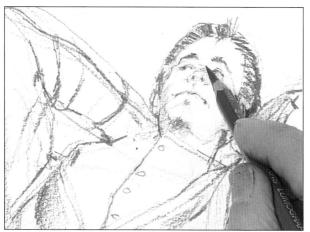

9 ▼ Build up the dark tone Emphasise the tension folds on the sleeves of the shirt where the arms are pulling the fabric taut. To heighten the contrast between the light sofa and the dark trousers, put in more shading around the trouser legs.

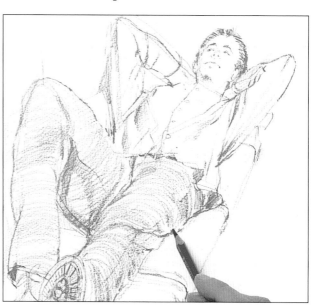

8 ▲ Work on the face Although the main point of interest in the drawing is the foreshortened figure, you can enhance the character of the face by working into the features in more detail. Using a very sharp pencil, add subtle shading to the lips, and feather the eyebrows.

THE FINISHED PICTURE

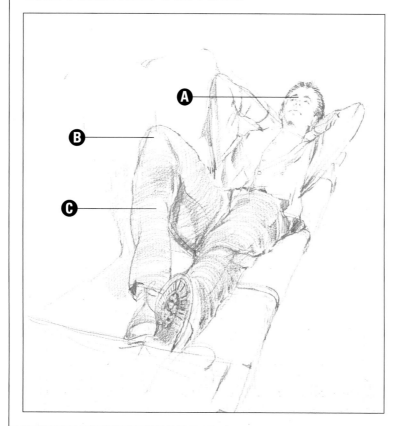

A Facial features
Although tilted up, the face shows the effect of foreshortening, just as the body does. The features are closer together than they would be if viewed straight on.

B Long legs
The effect of perspective becomes very clear when you study the length and thickness of the legs in comparison to the arms.

C Rounded forms
The cylindrical shapes of the legs were suggested by using curved shading lines to render the dark tone on the trousers.

Drawing round the form

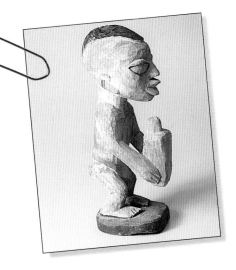

Bring out the three-dimensional quality of this wooden carving by suggesting rounded forms with your line work.

How do you give the illusion of three dimensions on a two-dimensional piece of paper? This is one of the first questions every artist has to ask when embarking on a drawing.

One very helpful technique is known as 'drawing round the form'. This involves using line work to follow the curves of the subject. These lines do not necessarily exist in reality, they simply serve to indicate volume.

Sculptural lines

In this project, the subject is a carved wooden figure from Nigeria in West Africa. When you draw, it might help to actually think in terms of making a sculpture as you build up the form with line work. This will encourage you to think in three dimensions.

The best way to begin is to map out the overall shape, using delicate marks and lines, especially if you are working in pen and ink as here. Rather than making a continuous line, use ticks and dots to feel your way round the outline.

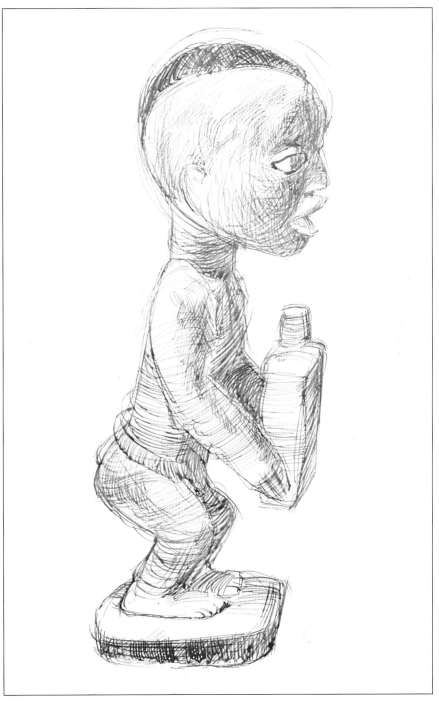

Then begin to suggest the rounded forms of the figure with strokes that follow the curves of the head, body and limbs. In your imagination, you could work right round the volumes, but only actually show the surfaces you can see.

The forms of this carved figure are relatively simple and therefore useful for practising this technique. Once you

▲ **The drawing looks almost as solid and tactile as the carving itself, thanks to its informative line work.**

have tried it, you could move on to drawing a live model in the same way. The forms will be more complex, but their contours can be described with similar curving line work.

HOW TO FOLLOW FORM

1 ▼ **Rough out the shape** Using brown ink and a dip pen, lightly plot the outline of the carving with fine lines. On the head, indicate the position of the eye, ear and hairline, as well as the nose and prominent lips. Lightly mark the fingers.

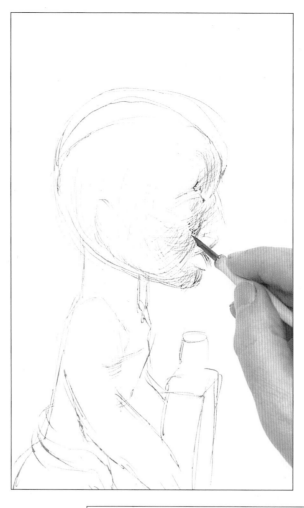

YOU WILL NEED

Piece of hot-pressed watercolour paper

Dip pen

2 waterproof inks: Brown; Black

2 ◄ **Begin to show the form** Start to build up the rounded form of the head with long curved lines, working with loose sweeps of the wrist. Observe how the planes change direction on the cheek, forehead and nose, and alter the direction of your strokes accordingly. Use denser cross-hatching for the front of the face, which is in shadow.

EXPERT ADVICE
Drawing a head

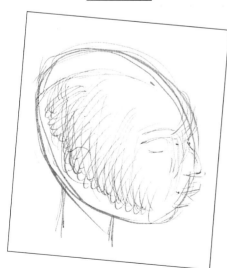

When you are drawing a figure, whether from life or, as here, using a carving, a useful trick is to base the shape of the head on that of an egg at an angle of about 45°. This establishes the basic outline and helps you to visualise where to put areas of tonal shading.

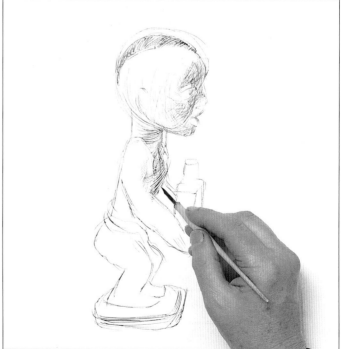

3 ▲ **Render the dark tones** For the dark hair, make thicker ink marks by putting more pressure on the pen nib. Still using heavy pressure, render the dark tone on the throat with curved strokes that follow its cylindrical shape. For the flatter plane of the chest, change your marks to straight lines.

4 ▼ Add more dark tone Build up the rounded form and dark tone of the left arm with closely worked curved hatching. Similarly, cross-hatch the top plane of the right arm, where it turns away from the light. Strengthen the fingers, and work around the curve of the hand. Use straight lines to render light and dark tones on the flat sides of the bottle, curving them at the neck.

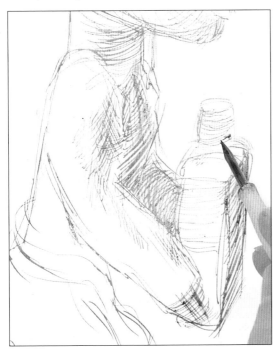

5 ▼ Work on the lighter tones Continue working down the torso and legs with loose, curved lines, feeling your way around the body shape. Where light falls on the side of the carving, keep the lines more delicate and further apart to give a paler tone.

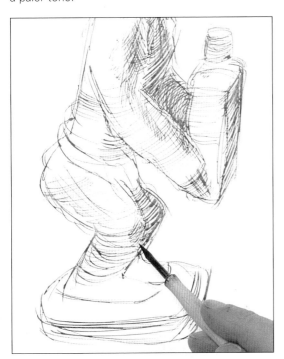

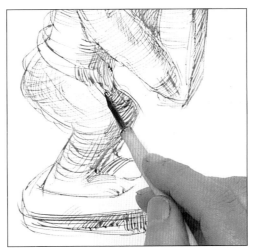

6 ◄ Build up the lower part of the figure Work hatched lines across the shaded parts of the feet and also on the side of the painted stand. Add dark tone to the front of the loincloth with straight, parallel lines, changing to short, upright lines as you move around the waistband.

7 ▶ Define the features Darken the shadow at the base of the neck with heavy marks. Build up the shape of the head with more curved hatching lines, suggesting the rough-hewn nature of the carving on the side and back of the head with areas of cross-hatching. Work into the dark tone on the forehead, nose and cheek with short strokes.

8 ◄ Complete the modelling Add bold cross-hatched lines to darken the hair. Outline the eye with heavy lines. Cross-hatch the sides of the stand and add a little shading to the top. To complete the sculpted effect of the figure, work over the whole body once more with sweeping curved pen strokes.

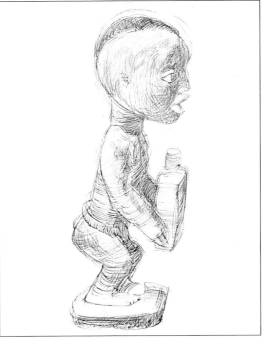

The figure has now taken on a very convincing three-dimensional appearance. With a little black ink, you can emphasise the painted parts of the carving.

9 ▶ Darken the hair and eyes

Dip the pen into black ink and add more hatched lines to the hair. Go over the brown outlines of the eyes to give the same bold effect as on the carving itself.

THE FINISHED PICTURE

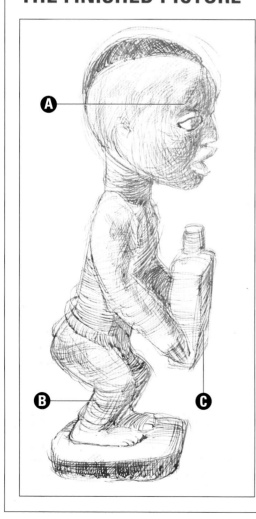

A Cross-hatching
On the most complex part of the carving – the head – the sculpted forms and gradated tones are worked up with layers of cross-hatching.

B Rounded forms
The curves of the hatched lines follow the shapes of the limbs and suggest their full, rounded forms.

C Flat shading
In contrast to the curved forms of the body, flat planes, such as the sides of the bottle, are shaded with straight lines.

10 ▲ Put in the last few details

Still using black ink, hatch a few short strokes on the side of the stand. Draw the dark shadow down the side of the bottle's neck. Finally, mark the shadow under the toes of the right foot.

Drawing light out of dark

An eraser can form an effective part of your drawing equipment – use it to create the palest tones in a charcoal or graphite picture.

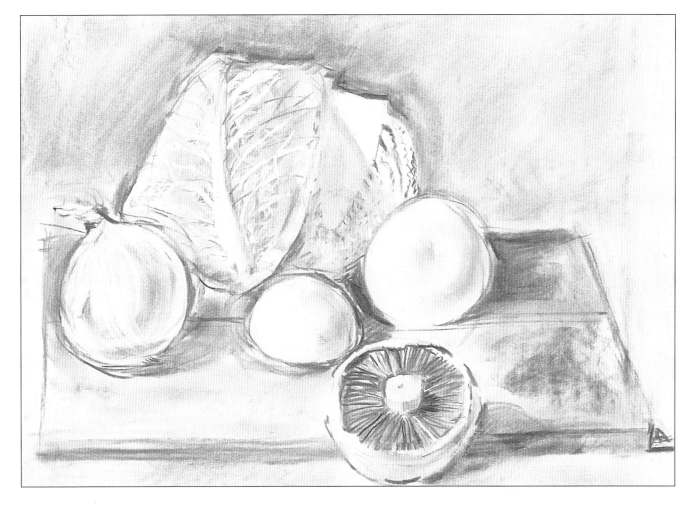

When you draw in graphite or charcoal, you normally build up the medium and dark tones with hatched lines or solid shading, leaving the white paper to stand for the lightest tones. There is another way of creating the light areas, however – you can 'draw' into the dark shading by using a rubber. With this technique, you can achieve delicate white lines as well as pale areas that blend softly into the surrounding grey tones. Choose a smooth paper, as the marks can more easily be removed from the surface.

Choice of media

For a bold drawing like this still life, you can have some messy fun applying graphite powder to the paper with your fingers for the main outlines. For details, use stick charcoal, a charcoal pencil or a soft graphite pencil.

Vary the type of rubber you use to create the white areas. Work with the

▲ **In this still life, dark marks made with charcoal and graphite powder contrast with highlights rubbed out with an eraser.**

edge of a plastic rubber to make pale curves, or rub with one corner to create sharp, bright highlights. Mould the tip of a putty rubber into a point to 'draw' fine lines, such as the veins on the cabbage.

159

Piece of Hot-pressed watercolour paper

Graphite powder

Thin and medium sticks of charcoal

Plastic rubber

Putty rubber

4B pencil

Paper tissue

Hard charcoal pencil

Spray fixative

FIRST STEPS

1 ▶ Draw outlines in graphite powder
Pour a small pile of graphite powder next to your drawing board and then dip your finger into it. Use this finger directly on the paper to sketch the outlines of the still life. Make bold, sweeping lines to show the rounded forms of the vegetables. Return to the graphite whenever necessary.

2 ◀ Add definition with charcoal Blow away any excess graphite powder. Then, with a thin stick of charcoal, draw the outlines of the vegetables. Fill in the darker tone on the chopping board and background with the side of the charcoal stick, then smudge these areas with your finger.

3 ▼ Develop the drawing Start to put in a little detail, such as the gills on the upturned mushroom, the onion's base and stalk, and the spine and veins on the outer cabbage leaf. Shade and smudge the background around the cabbage.

4 ◀ Put in darker tones Change to a medium stick of charcoal and, using it on its side, put in the shadows of the vegetables on the board. Press firmly on the stick to make the dark tone behind the cabbage. Square up the outer edges of the picture.

HOW TO DRAW WITH A RUBBER

Look for the lightest parts of your still life – the mushrooms, the cabbage veins and the highlights on the onion. These are the areas that you will erase with a rubber. The darker the background, the clearer these erased areas will look.

Begin work with a rubber With the medium charcoal stick, work heavier lines around the vegetables and draw the texture inside the cabbage. Smudge charcoal from these marks over the vegetables to make a mid tone. Now run the corner of a plastic rubber down the spine of the outer cabbage leaf, creating a band of white. With a sweep of the rubber, remove tone from the onion and mushrooms.

6 ▲ **Rub out details** Using the moulded point of a putty rubber (see Expert Advice, right), erase fine lines to show the main veins on the cabbage. Draw the point of the rubber down the onion in curved lines that bring out its form and texture. Changing back to the plastic rubber, lift out more tone from the lighter areas of the mushrooms.

7 ▲ **Use a pencil for fine work** Sharpen a 4B pencil and draw fine lines on the onion stalk to emphasise its papery texture. Shade in some of the tiny indentations on the outer cabbage leaf. Don't attempt to draw all of them – an indication here and there is enough to suggest the crinkly texture.

EXPERT ADVICE
Using a putty rubber

As a putty rubber has a kneadable consistency, you can mould one corner into a point and use this for erasing fine lines or for creating a dotted texture. If the point gets dirty, rub it on scrap paper or mould another point.

8 ▼ **Work on the textures** Still using the 4B pencil, continue filling in the texture on the outer cabbage leaf. On the inside of the cabbage, make small, tight pencil marks to suggest the crisp texture here. Draw more gills on the upturned mushroom.

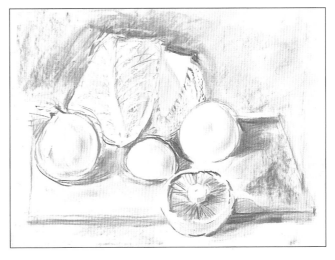

Your drawing now has a full range of tones. The white, erased parts of the vegetables blend gently into the mid tones. You just need to add a little more sharp detail to contrast with the smooth, velvety areas.

9 ▶ Add detail to the mushroom
Use the medium stick of charcoal to draw more gills on the upturned mushroom. Make firm, straight strokes to capture the texture.

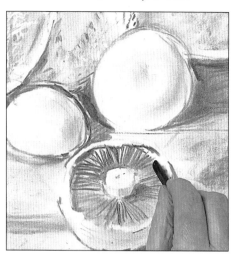

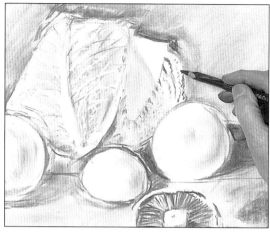

10 ▲ Put in the final touches Smooth the tone on the background with a crumpled paper tissue. Using a well-sharpened, hard charcoal pencil, draw the final strong details – the finest mushroom gills and the frilly leaves on the inside of the cabbage. Spray the drawing with fixative.

THE FINISHED PICTURE

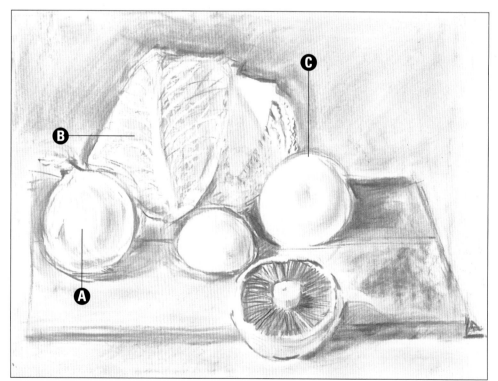

A Lines showing form
To suggest the rounded form of the onion, as well as the texture of its skin, curved lines were erased from its stalk to its base.

B Intricate details
Rather than trying to draw painstakingly around the pale vein structure of the cabbage leaf, the artist lifted the light lines out with a putty rubber.

C Soft effects
The soft, white surface of the mushrooms was created by rubbing out areas of lightly applied charcoal. The transition from light to mid tones is very subtle.

One subject, two styles

Compare the results of interpreting a figure in two different ways – first as an outline drawing and then as a tonal drawing.

There is no one definitive technique for drawing a figure – the human form can be represented in many ways, depending on your personal style and the method of drawing that you choose. In this project, two drawing methods are compared – an outline drawing and a tonal study. Try them both, noticing how you focus on different aspects of the figure with each interpretation.

The model held the same pose for both drawings, but the lighting set-up was changed. For the outline drawing, the model was lit with general, frontal lighting, which did not create very distinct areas of light and shade on the figure.

For the tonal version, strong side lighting threw one side of the model's face and body into shadow.

Using pen and ink

Pen and ink were used for both drawings. Ink marks give a crisp, clean quality to a picture and, even though you can't remove incorrect lines with a rubber as you can when working with pencil, you can alter and strengthen outlines and areas of hatching, especially if you work lightly to begin with. In any case, a few looser lines will give your drawing a lively quality, so don't worry about being too precise.

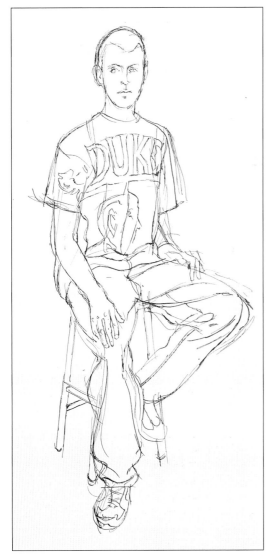

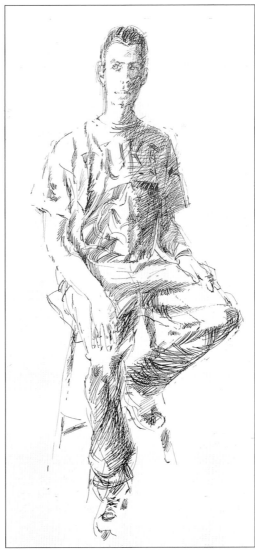

◄ The line drawing on the far left gives an accurate representation of the figure, but lacks the depth of the tonal version next to it.

163

PROJECT 1

OUTLINE DRAWING

With an outline drawing, your initial lines describe the shape of the figure, but do not give any clues to its three-dimensional form. You can achieve this by working inside the main outlines, with what are often called 'contour lines'. These will show how the clothes drape over the body to hint at the volumes beneath.

2 ▼ **Complete the outline** Continue outlining the body down to the feet, indicating the fingers of the model's left hand. Mark in the legs of the stool to show how the figure is supported, then draw the outline of the baggy trousers crumpling over his right shoe.

MAKING ALTERATIONS

If you decide to alter the angle or position of any of the limbs after your initial pen-and-ink sketch, don't worry about drawing a few new lines. Although the original ink marks cannot be erased, they will not spoil the image – in fact, in the outline of the bent knee shown here, the extra lines suggest the bending action.

TROUBLE SHOOTER

FIRST STEPS

1 ▶ **Begin tentatively** Outline the head and shoulders. Then, checking the proportions as you go, begin to plot the position of the limbs and torso. Use light, sketchy lines in case you make a mistake.

PROVIDING MORE INFORMATION

Now that you have completed the basic outlines, you need to build up the three-dimensional quality of the figure by drawing the 'contour lines' inside these perimeters. Remember, you are restricting yourself to line work rather than shading.

3 ▲ **Suggest the body shape** The way in which clothing folds gives a good indication of the form of the body inside. As you are not using shading in this drawing, you will have to indicate the folds in the T-shirt with lines rather than tone.

4 ▼ Give character to the face Spend time on the facial features to achieve a good likeness. Firm up the hairline and outline of the chin, then draw the eyebrows, eyes and nose with delicate, sensitive lines. Rather than drawing a complete outline of the mouth, just show the line where the lips close and suggest the top and bottom of the mouth with faint marks.

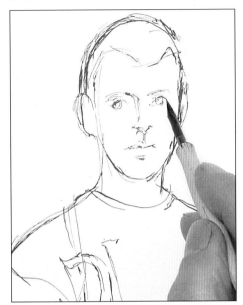

5 ▼ Work on the clothes Outline the letters on the T-shirt, noticing how they curve to follow the shape of the chest and fall of the shoulders. Indicate the design as well. Draw the fingers in more detail, then build up the deep folds on the right trouser leg.

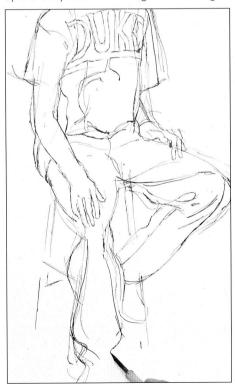

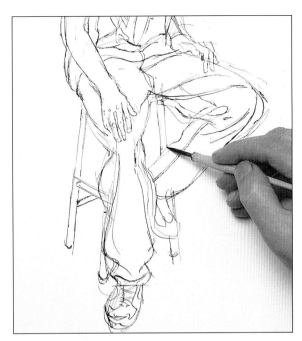

6 ◀ Put in the last details Finally, give some more attention to the detailed areas of the drawing – the training shoes and the design on the T-shirt front and sleeve. Add definition to the folds on the trousers by pressing hard to make darker marks. Finish drawing the stool.

THE FINISHED STUDY

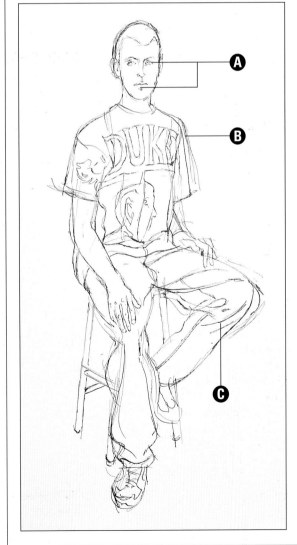

A Facial features
The eyes, nose and mouth were drawn with the minimum of line work – just enough to convey the character of the model.

B Strong outline
Following the initial tentative marks, which plotted the proportions of the figure, the body was redrawn with firm lines to give a clear, positive outline.

C Fabric folds
The impression of folded fabric on the trousers was achieved with vigorous, curving lines rather than tonal shading.

PROJECT 2

TONAL DRAWING

For the second drawing, the light source is on the model's right, throwing his left side into shadow. This time, you need to concentrate on the tones in the figure – half-closing your eyes will eliminate detail and enable you to see the tonal differences more clearly.

FIRST STEPS

1 ▶ Rough in the figure Plot the shape of the figure, checking the proportions as for the previous drawing. This time, the defining lines are just a guide to the tonal work rather than the main descriptive element, so you can use sketchier lines to indicate the main shapes.

2 ▼ Model the face Lightly mark in the facial features and the hair line. Notice how half the model's head is in the light and half in the shade – begin working hatched lines to show the shadow down the left-hand side of his face and neck.

SHOWING FORM THROUGH TONE

As you shade the dark tones on the model, the volume of his body and clothing will gradually take shape. The figure will take on a three-dimensional appearance, as opposed to the flatter look of the previous line drawing.

3 ▲ Work up the dark tone Add more definition to the facial features and hair line. To make the tone darker on the shaded side of the face and neck, work areas of cross-hatching here. Continue the hatching lines down the model's left shoulder and the sleeve of his T-shirt. Begin to show the lettering on the T-shirt with short, dark strokes.

Master Strokes

Rembrandt van Rijn (1606-69)
An Actor Standing

In this characterful study of an actor, worked in chalk on tinted paper, the Dutch artist Rembrandt has built up tone with lively and assured strokes to convey the volumes of the figure. Notice the strong contrast between light and shade on the face and legs.

Fine chalk lines are used to hatch the medium tone on the actor's hat.

Applied more vigorously, the chalk produces darker tones on the cloak.

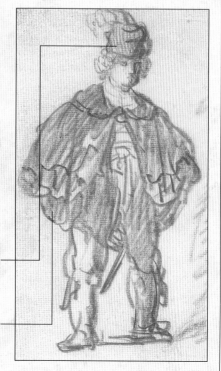

4 ▼ Work on the T-shirt Render dark tone over the left side of the T-shirt with long, slanting pen strokes, cross-hatching wherever you want to deepen the tone further. You can also make darker marks by pressing harder with the pen nib. Complete the lettering and start filling in some of the background around the design.

5 ▲ Define the logo Begin to define the logo by filling in the dark shapes around it – notice how the fabric folds distort its shape slightly. Put a little shading in the crook of the right elbow – the rest of the arm is in the light. Using curved hatching lines, describe the rounded form of the left arm.

EXPERT ADVICE
Vary your nib width

Feel free to experiment with different pens and nibs. With a fountain pen you can use the front of the nib (A) to create a bold line or the back (B) for lighter shading. For pronounced and somewhat irregular marks, use a broad-nibbed dip pen (C). Alternatively try out one of the many felt-tip pens available (D).

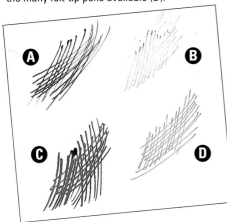

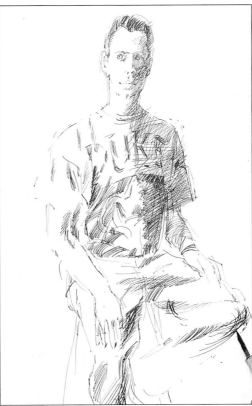

6 ◄ Start shading the trousers Complete the dark background to the logo and strengthen the shading on the T-shirt even more. Now identify the darkest areas of the trousers, where the folds of fabric create deep shadows. Hatch in deep tone here, using firm pressure on the pen to make the heaviest marks.

7 ► Continue the heavy shading Put in some lively cross-hatching on the left shoe and trouser leg, using sweeping, curved lines. Boldly worked areas such as this contrast with the more delicate hatching on the face and limbs. Shade the hands lightly.

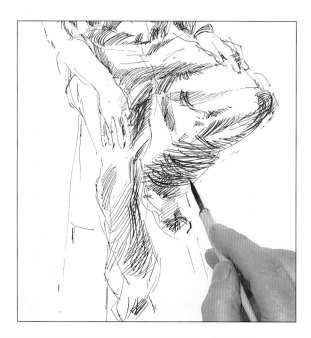

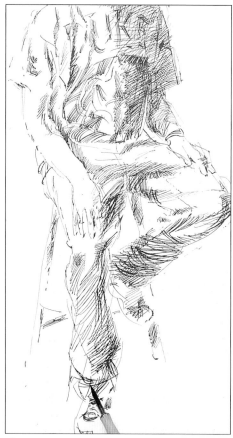

THE FINISHED STUDY

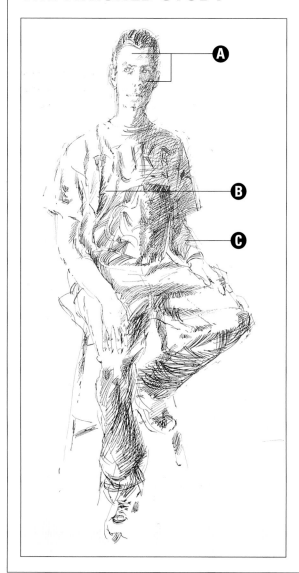

A Tonal contrast
The areas of tone are clearly demarcated on the face – there is no intermediate grey tone between the light and the dark sides.

B Fabric folds
Hatched shading makes the folds in the fabric look more tactile and three-dimensional than in the previous outline version.

C Rounded forms
By using tonal shading in this drawing, it is easier to describe the forms of the limbs convincingly than it is with linear work.

8 ▲ Check the tonal balance Put in the seam on the left trouser leg. With more hatching, work down the deep folds of the right trouser leg to the shoe. Define the laces and toe cap. Returning to the T-shirt, put in more vertical lines of shading to show the gentle folds across the chest. Render tone on the stool to give it solidity.

Choosing the best format

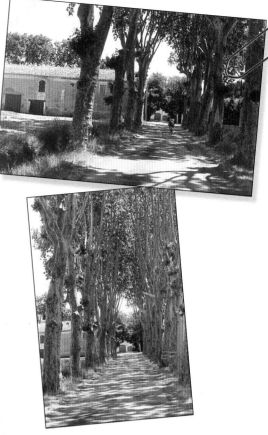

There are many ways to frame a scene – make sure you choose the best one before you start drawing.

One of the first decisions to make when planning a drawing is whether it should have a horizontal (landscape) format or vertical (portrait) one. In this scene of a tree-lined road in France, the artist saw the possibilities of both formats (right).

The vertical format was ideally suited to capturing the height and grandeur of the trees. These strong verticals help to create a rather dramatic mood. The artist, however, decided to use the horizontal format. This enlarges the scope of the view and the inclusion of the farm building helps to provide a balanced composition. The strong horizontals of this building make for a more serene, peaceful mood.

Whether you choose a horizontal or a vertical format, plan to offset the centre of interest in the composition. A useful rule of thumb is to divide your paper into thirds each way, either by eye or by marking it lightly in pencil, and then place the focal point at the crossing point of two of the dividing lines. The focal point of the drawing below – the distant hut with the cyclist in front of it – is positioned in this way.

▼ In the horizontal format, the farmhouse on the left balances the verticals of the trees, helping to create a tranquil, rural image.

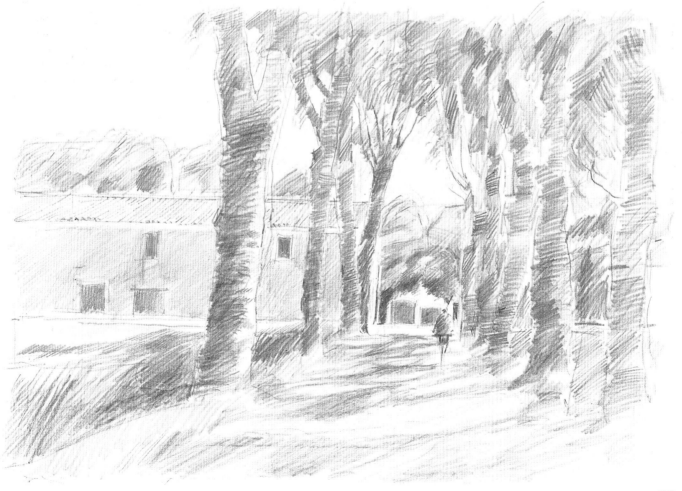

Piece of Hot-pressed watercolour paper

7B pencil

15 coloured pencils: Light turquoise; Apple green; Lemon yellow;

Olive green; Sap green; Pale grey; Venetian red; Yellow ochre; Dark grey; Prussian blue; Aubergine; Burnt sienna; Viridian; Vandyke brown; Burnt orange

FIRST STROKES

1 ▼ Sketch the composition Using a 7B pencil, sketch the main elements of the scene – the trees, buildings, road and cyclist. Notice how the negative sky shapes formed between the trees are roughly triangular. Also, look at how different parts of the scene relate to each other – the roof of the long building lines up with the distant tree-tops, for example.

2 ▶ Establish dark and light tones Add more spiky branches to the tree at the end of the avenue, tapering them off from the trunk towards the top of the paper. Hatch in the shaded parts of the trunks and also the shadows cast on the grass and road.

3 ▶ Begin with the light colours Complete the tonal pencil shading on the trunks and vegetation on the right of the picture. Now, using a light turquoise coloured pencil, fill in the sky, including all the shapes between the trees. Move on to the sunlit areas of foliage, using an apple green pencil. As with watercolour painting, you are working from light to dark, so that you gradually build up depth of colour.

CHANGING THE EMPHASIS

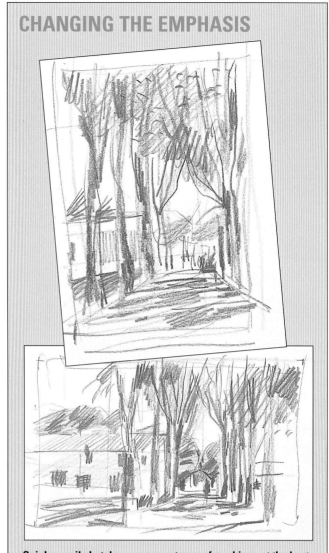

Quick pencil sketches are a great way of working out the best format and composition for your drawing. The vertical format emphasises the height of the avenue of trees, conjuring up a cathedral-like image. The horizontal format provides a 'quieter' image – the eye is still pulled down the road but it also has a place to rest on the farm building on the left.

ADDING COLOUR TO THE SCENE

Once you have roughed in the main shapes and tonal areas, work up the rest of the drawing in coloured pencil. Blend shades if necessary to capture the essence of the colours.

4 ▲ **Introduce darker greens** Put more apple green on the tree-tops and highlight the distant trees with a touch of lemon yellow. Now look for the areas of darker green in the distant trees and colour these with olive green and sap green, working over some of the graphite pencil tone.

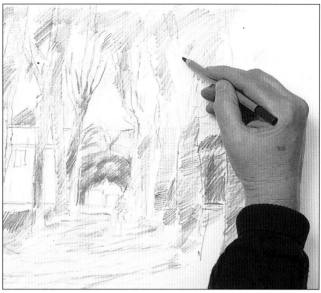

5 ▲ **Continue with dark greens** Using vigorous strokes of sap green, hatch in the shadows on the grass and foliage to the left and right of the road. Changing to the olive green, hatch across the tree-tops and trunks. Block in a mid tone across the road with a pale grey pencil.

EXPERT ADVICE
Giving form to the trees

Shade in the tree trunks using mainly horizontal hatching lines. The eye reads them as curving around the trunks, which helps to suggest the cylindrical shapes. By leaving one side of the trunks pale where they catch the light, you can convey their form and solidity.

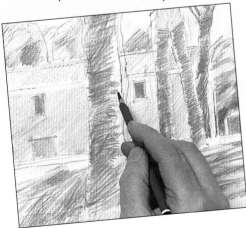

6 ▶ **Work on the building and road** Hatch the roof on the building with diagonal strokes of Venetian red and work loosely over the wall below it with yellow ochre and dark grey. Use Prussian blue for the figure on the bicycle, then strengthen the cast shadows on the road with Prussian blue, aubergine and dark grey.

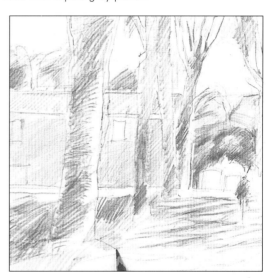

7 ▶ **Colour doors and windows** Shade the hut doors in burnt sienna, dark grey and viridian, and the doors and windows of the building in Vandyke brown and burnt orange. Hatch over the trees with the 7B and olive green pencils, suggesting leaf texture with dashes of olive green. Use dark grey to put tone down the ochre wall and to strengthen the far left tree.

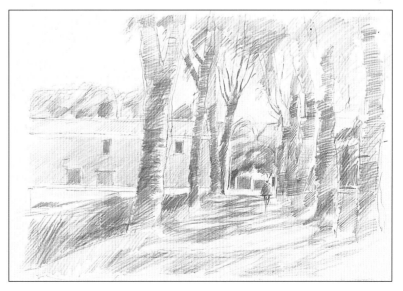

The drawing now successfully evokes the atmosphere of a sunny and tranquil rural scene. A touch of detail on the roof and tree-tops will add texture and interest.

8 ▼ **Complete the roof** A suggestion of terracotta roof tiles will give the left-hand building more character. Using the 7B pencil and Vandyke brown, draw the lines of tiles and their rounded ends.

9 ▲ **Hatch in more leaves** To enhance the effect of mottled colour in the tree-tops, use the olive green pencil to hatch dark clumps of leaves amidst the foliage. Press firmly to achieve a deep, rich shade.

THE FINISHED PICTURE

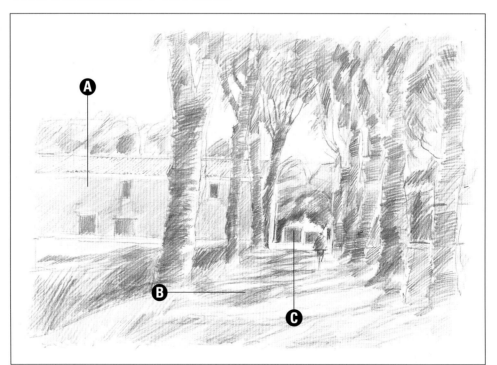

A Blended colours
To find the correct shade for the wall of the building, a darker colour was worked over a lighter one to tone down the brightness.

B Dappled effect
The shadows falling across the road create an interesting pattern on what would otherwise be a broad area of plain colour.

C Focal point
The eye is drawn down the avenue of trees towards the focal point – the brightly coloured doors in the distant building.

London street in perspective

A row of flat-fronted houses makes an ideal subject for practising perspective.

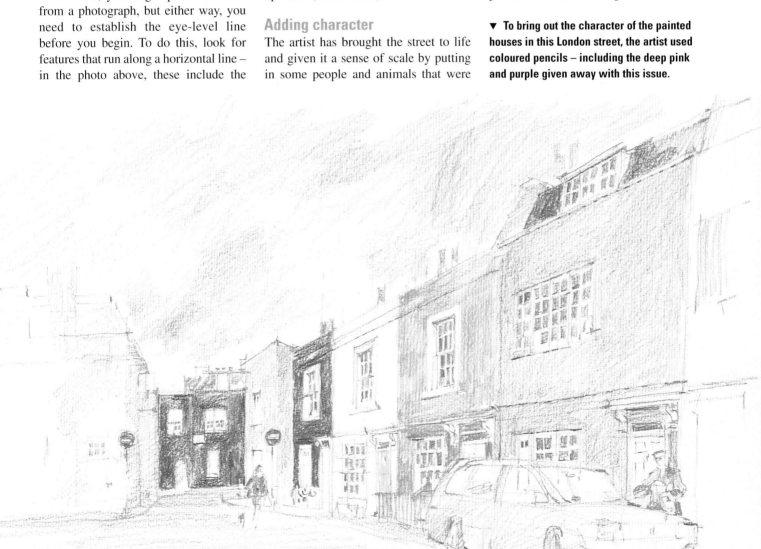

In this London terrace, the houses have a simple, uniform style. It is clear to see how the roofs and windows recede into the distance, and therefore easier to work out the lines of perspective.

Rather than sketching on the spot in a town street, you might prefer to work from a photograph, but either way, you need to establish the eye-level line before you begin. To do this, look for features that run along a horizontal line – in the photo above, these include the heads of the two figures and top of the car. Notice how the lines above it, such as the roof line, are angled downwards as they move off to the vanishing point on the horizon, while lines below it, such as the edge of the pavement, are angled upwards (see overleaf).

Adding character

The artist has brought the street to life and given it a sense of scale by putting in some people and animals that were not there in the original photograph – the traffic warden, the pigeons and even a cat on the window sill of the pink house. Feel free to add human or animal life to your scenes, or conversely, to take out any features that spoil the picture, such as traffic signs or dustbins.

▼ **To bring out the character of the painted houses in this London street, the artist used coloured pencils – including the deep pink and purple given away with this issue.**

Piece of smooth cartridge paper

4B pencil

Craft knife and glasspaper block (for sharpening pencils)

Putty rubber (for erasing mistakes)

8 coloured pencils: Light blue; Purple; Cobalt blue; Black; Deep pink; Burnt ochre; Vermilion; Lemon yellow

TO PUT IT INTO PERSPECTIVE

Where perspective is important in a scene, it is worth making a quick sketch before you begin your actual drawing. To check perspective, first mark in your eye level. Then look for lines that you know to be parallel – on the right side of the street these include the top of the terrace, the first-floor line and the edge of the pavement. These lines, if extended, should all converge at a vanishing point (VP) on the eye-level line. If they do not, adjust the sketch until they do. Do the same for the building on the left – note how it recedes to an auxiliary vanishing point (AVP). Use the sketch as a guide for your drawing.

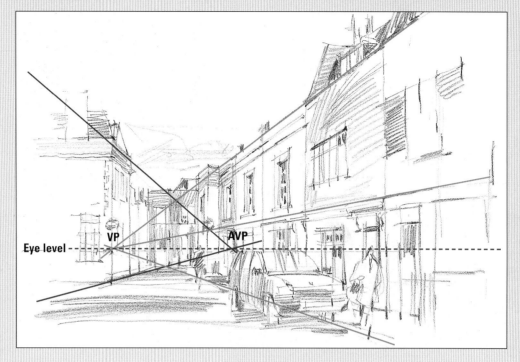

FIRST STEPS

1 ▼ **Make a perspective drawing** Using a 4B pencil, plot the main lines of the buildings, referring to your rough sketch to check the perspective. Remember that the lines of the terrace of houses on the right recede to a different vanishing point than the lines of the brown house (see above). Lightly indicate the car and the figure standing next to it.

2 ▲ **Firm up the lines** Keeping your pencil well sharpened, begin to work more emphatic pencil lines over the main features of the houses, such as the roof line, doors, windows, chimneys and aerials. Put in the figure with the dog and the two traffic signs at the end of the street.

3 ▼ **Define the windows** Draw the railings outside the pink house. Then put in the recessed frames and horizontal bars of the sash windows. The small panes of glass in the windows look dark in tone – begin shading these in on the pink house, first lightly marking the position of the glazing bars. Once the panes are filled in, the glazing bars between them appear as a white grid.

4 ▼ **Continue with the window panes** Work along the top row of windows, shading in more dark blocks to represent the panes. As the windows are recessed, some of the panes further down the terrace are hidden from view, so draw fewer in these windows. The panes also look narrower here owing to the effects of perspective. Shade in the shadows under the window recesses and the glass over the doors.

5 ▲ **Work on the car** The parked car in the foreground helps to lead the eye into the picture. Add some detail to it, but not so much that it detracts from the houses. Sketch the traffic warden behind the car with simple lines and shading.

6 ▲ **Put in more window detail** On the nearest house, fill in more of the glass panes between the glazing bars. Remember to keep sharpening your pencil as you draw – by using a craft knife and a glasspaper block, you can achieve a very fine tip, which gives good definition to the hard-edged architectural features.

7 ▲ **Shade in some medium tone** Continue shading the panes of glass on the ground-floor windows and draw the decorative features above the doors. Using the side of the pencil lead, shade some medium tone across the sky and road, adding a shadow under the car. For some foreground interest, draw a group of pigeons in the road.

8 ▼ **Put on underlayers of tone** On the houses at the end of the street, shade over the walls in pencil to form an underlayer of medium tone – this will give depth to the colours you will be adding in the next step. Shade very light tone over the car and the light blue house in the foreground.

ADDING COLOUR TO THE PICTURE

The main architectural details and the lights and darks in the scene are now established. Make the most of the gaily painted houses by adding some bright colour to the walls.

9 ▲ **Begin using colour** Shade freely over the sky and over the nearest house with a light blue coloured pencil. Blend purple over the top of these areas. Begin colouring the house at the end of the street, shading light blue and cobalt blue pencil over the pencil tone previously applied.

10 ▼ Continue with the blue houses Complete the dark blue houses, blending light blue and cobalt blue as before. Work carefully around the doors and windows. On the light blue house, shade cobalt blue on the roof around the dormer window, and put a light layer of purple over the walls.

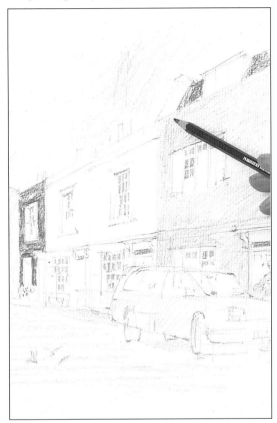

11 ▼ Begin on the pink house Add a touch of purple to brighten the dark blue house at the end of the street. Use a black coloured pencil to darken some of the window panes and to put in some sharp detail, such as the bands below the parapet of the nearer dark blue house. Shade the walls of the pink house with a deep pink pencil.

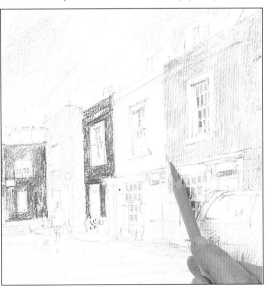

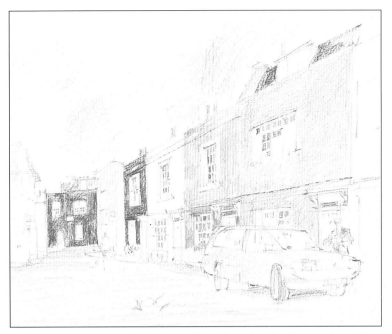

12 ▲ Work over the whole picture Complete the shading on the pink house. With the black coloured pencil, emphasise the tone and detail on the car and deepen the shadow underneath it. Neaten the edges of the glazing bars on the windows with a very sharp 4B pencil. Finally, use burnt ochre to colour the chimneys, the sloping roofs and the side of the left-hand house.

A FEW STEPS FURTHER

The blues, pink and mauve in the picture harmonise well. However, to make the scene more arresting you could put in one or two dashes of contrasting colours.

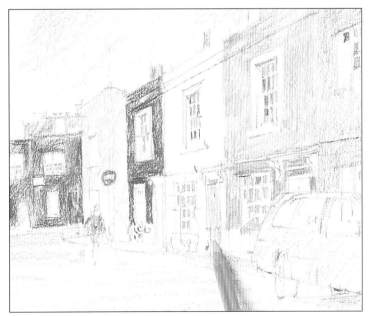

13 ▲ Add bright colours Using a vermilion pencil, colour the road signs and the figure walking the dog. Brighten the door of the white house with lemon yellow. These splashes of vivid colour attract the eye to the end of the street.

177

14 ▶ **Put in the last details** Cast your eye over the drawing to see if you have missed anything. Using the 4B pencil, fill in the last few window panes on the light blue house and darken the hair of the figure and the dog. Finish off the sky with a little more loosely shaded purple.

THE FINISHED PICTURE

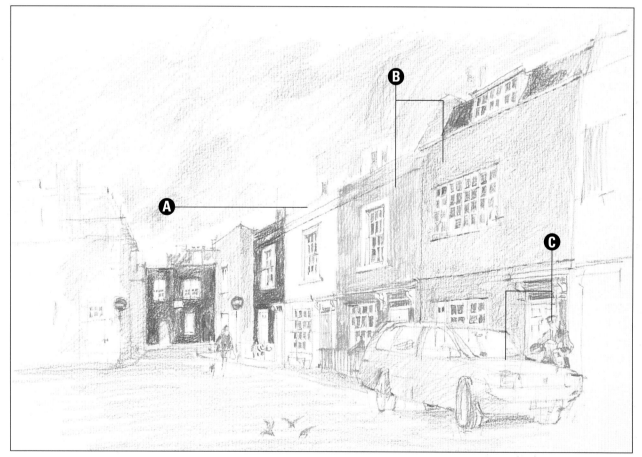

A Sense of perspective
As the houses are flat-fronted and adjacent to one another, the effect of perspective is clear. Take more care when drawing a road of different-shaped, detached houses.

B Colourful houses
Colour was introduced into the drawing to emphasise the characterful painted houses, which are a particular feature of the Chelsea area of London.

C Street life
A street with no figures or cars could run the risk of looking lifeless and unrealistic. Here, they provide interest without detracting from the architecture of the houses.

Looking at anatomy

Combine your talent for art with a little knowledge of science and you'll find that your figure-drawing skills will improve immensely.

▼ The muscles on the plaster cast are well defined and produce a drawing which shows clearly how they are grouped together. The most important muscles for the artist are indicated on the cast.

To draw the figure convincingly, it really pays to have some knowledge of anatomy. After all, if you are familiar with the body's internal structure, you are much more likely to get its external form right. Of course, you don't have to visit mortuaries and operating theatres, as the likes of Leonardo da Vinci and Rembrandt did. Instead, simply practise drawing this anatomical plaster cast.

For the beginner, this type of cast is ideal. First and foremost, unlike a real person, it stays still. Furthermore, it can be a bit intimidating to ask someone to sit nude until you are confident about your figure-drawing skills. (If you're thinking of buying one of these casts, take note: they are costly and only available at specialist art shops.)

Visible form

The basis of anatomy is that, while the skeleton provides the basic framework of the body and determines its proportions, the muscles, which overlay the bones, create the visible form of the figure. The skeleton and muscles work together to produce the vast variety of movements that humans are able to make.

When you move on to a life model, the muscles are unlikely to be quite as pronounced as this cast. However, in most slim, strong models, the muscles will create discernible forms. And with practice, you will soon be able to see exactly how the muscles change in form as the body moves. This, in turn, will help you analyse and capture the overall pose of your model.

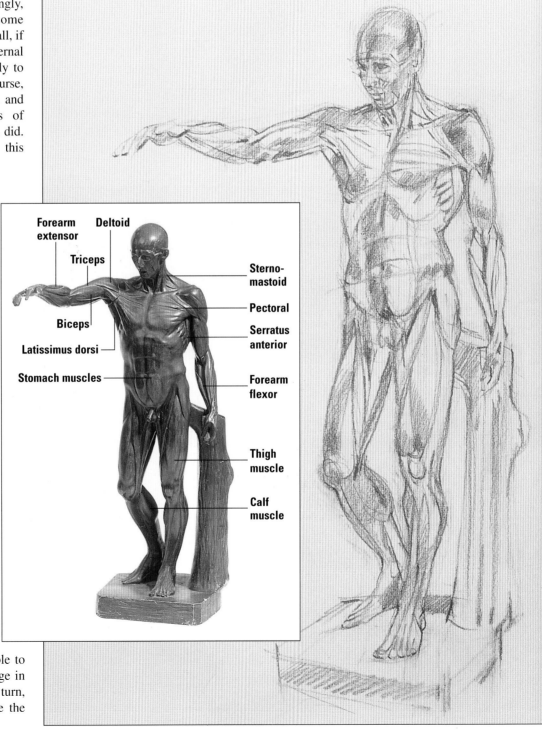

Forearm extensor
Deltoid
Triceps
Sterno-mastoid
Pectoral
Biceps
Serratus anterior
Latissimus dorsi
Stomach muscles
Forearm flexor
Thigh muscle
Calf muscle

Piece of cream pastel paper

Sepia Conté pencil

Craft knife and glasspaper
(for sharpening pencil)

FIRST STEPS

1 ▲ Sketch the figure Using a sepia Conté pencil, sketch the main lines of the figure. As you work, check the proportions of the figure and the angles of the head, torso and limbs. A few guidelines – across the chest and running down the length of the torso and legs – will help you get the stance correct. Indicate the tree stump and stand.

EXPERT ADVICE
Checking the pose

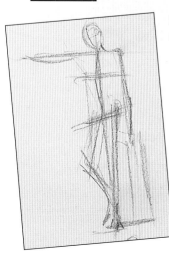

Before beginning your anatomical drawing, make sure you get the stance of the figure right by making a quick sketch of the main lines of the body. Here, the weight is taken by the left leg and the pelvis is tilted at an angle towards the bent right leg.

LOOKING AT BONE STRUCTURE

It is important to bear in mind the structure of the skeleton when you work on a figure drawing. The pose of a figure depends on the position of the head, spine, shoulders, pelvis and limbs in relation to each other, and this is easier to ascertain if you can visualise the skeleton beneath the flesh.

As you work through the steps in this project, refer to the skeleton shown here and try to relate the muscles on the anatomical model to the bones they cover. And note that some bones, such as the kneecap, will be visible through the skin.

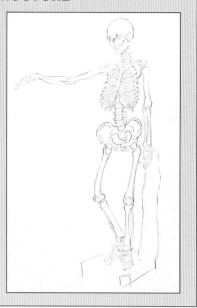

2 ▶ Work on the head Indicate the facial features, the jaw-line and the indented line above the brow. Emphasise the prominent muscle – known as the sterno-mastoid – that runs down the side of the neck, from the base of the skull behind the ear to the inner end of each collarbone.

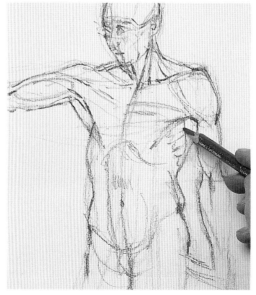

3 ◀ Develop the upper body Just below the armpits, show the ends of the latissimus dorsi muscles, extending around the back from the spine. On each arm, draw the oval biceps, the triceps behind them and the triangular deltoid above. Mark the pectoral muscles on the chest and, below them and to the side, the strap-like serratus anterior muscles.

4 ▶ Describe the limb muscles On the hanging forearm, draw the muscles running from the elbow to the wrist. These comprise the flexor on the inside, which bends the arm, and the extensor on the outside, which straightens it. Define the powerful muscles at the front of the thighs – these connect the pelvis to the shinbone. Indicate the position of the kneecaps with tentative circles. Then draw the calf muscles – note how one calf muscle is seen side-on and one protrudes from behind the shin.

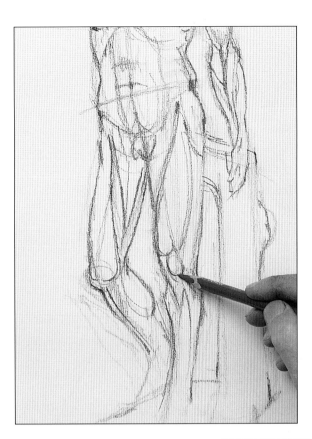

5 ▼ Draw the feet Indicate the bony structure of the feet with lines radiating out from ankle to toes. Bring the tree stump into focus by firming up its outline.

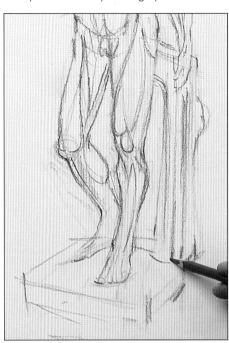

ADDING TONE TO THE BODY

The main muscles on the body are now clearly visible in outline. To help show the contours of the muscle groups, add tone to your drawing by shading with the Conté pencil.

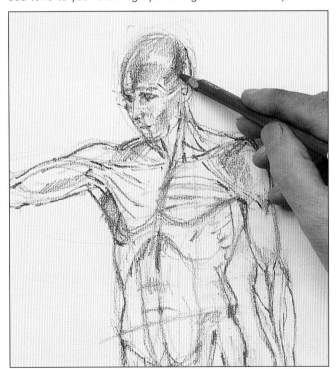

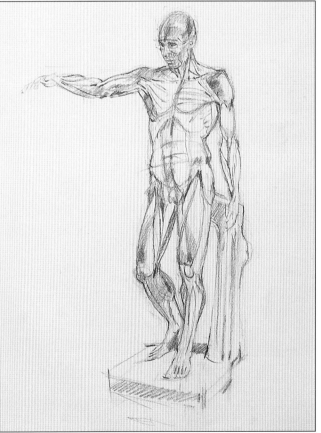

6 ▲ Shade the upper body On the figure's right side, render the dark tones under the biceps and in the armpit. Shade the front of the left shoulder. Darken the shadows under the pectoral muscles and below the rib cage. Then shade mid and dark tones over the face and cranium.

7 ▲ Shade the lower body Complete the flexor and extensor muscles on the right arm. Add definition to the stomach muscles and darken the shadow at the groin. Render a mid tone under the outstretched arm and on the leg muscles. Hatch in some shading on the stand and tree stump.

A FEW STEPS FURTHER

If you want to use your drawing as a reference for future figure studies, define the muscles a little more strongly in places, so that each muscle group will show up clearly.

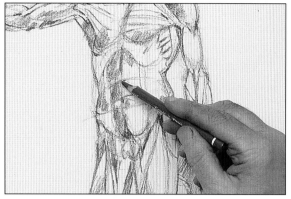

8 ▲ Add tone to the stomach Work over the serratus anterior muscles to emphasise the serrated effect at their edges. Shade more tone on to the regular blocks of muscles down one side of the stomach.

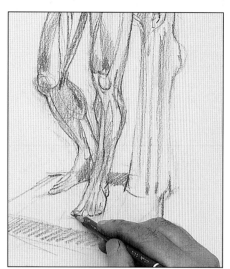

9 ▲ Define the feet Give the structure of the feet a little more detail, defining the toe nails, the heels and the ankle bones. Shade the shin of the left leg.

THE FINISHED STUDY

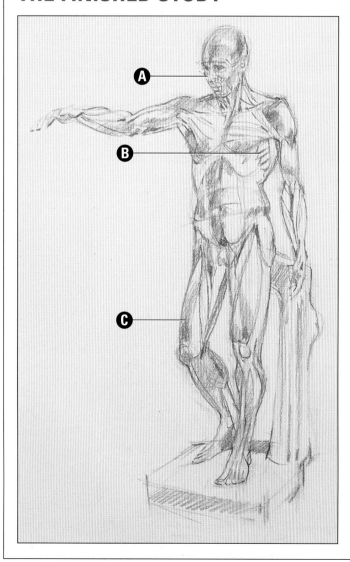

A Head proportions
As the cast has no hair, you can clearly see that facial features occupy only a small area in the bottom half of the skull.

B Muscle shapes
The outlines of the muscles have been clearly defined, so that it is easy to see how they overlap to build up the structure of the body.

C Body contours
Through subtle shading, the muscles take on a three-dimensional appearance, which helps to suggest the rippling contours of the body.

Drawing a nude figure

When working with a life model, spend some time finding a pose that looks graceful and makes an interesting composition.

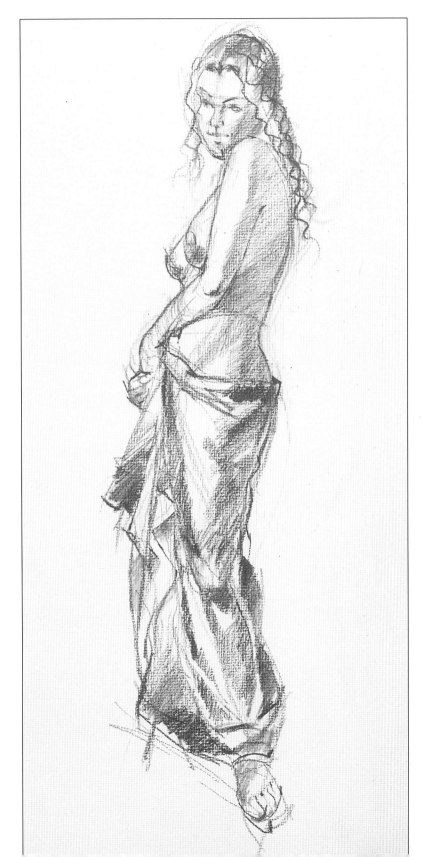

Drawing from a life model is invaluable, as there is no better way to observe the human body and the multitude of poses it can hold. If you are able to work with an individual model, it is well worth spending some time looking for a pose that both you and the model are happy with. Avoid trying to arrange the model's body into a position that doesn't feel natural, as the result will look stiff and awkward, and the model will not be able to hold the pose for long. An experienced model will interpret an artist's ideas to produce a pose that looks graceful and feels comfortable.

An alternative way of working with a model is in a group, perhaps at an art college or an adult education centre. In this situation, the artists will be sitting around the studio viewing the model from different angles, so it is particularly important to ensure that the pose is fluid and looks interesting from all sides.

Blending effects

Use a 6B pencil to do a few preliminary sketches. Then execute the finished drawing with a sepia Conté pencil. This will give the image a warm, antique look – similar to the chalk drawings of the Old Masters such as Leonardo and Rubens.

The Conté's soft, chalky marks are easy to smudge and blend to give tonal shading effects. A stump, or torchon is ideal for controlled blending, as it has a pointed tip that you can rub over small areas of pigment. It works equally well with the 6B pencil.

◄ **In this Conté pencil drawing, the model is holding a pleasing, supple pose. The sumptuous drape gives the drawing a classical feel.**

CHOOSING A POSE

Using the 6B pencil, make a few rough sketches of possible poses before you decide on the final one. In this project, the pose on the far right was chosen because of its flattering arrangement of the body and the draped fabric.

BODY FRONT-ON, FACE SIDE-ON (near right)
This pose with one arm akimbo is angular and awkward, and lacks the sense of rhythm that is characteristic of more graceful poses. Also, the position of the head – twisted to one side – would be very hard to hold for any length of time.

FACE FRONT-ON, BODY FRONT-ON (centre right)
A straight-on pose, although useful for practising proportion in figure drawing, is too symmetrical to provide an exciting image. The figure looks rigid and unnatural, with no sense of animation.

BODY SIDE-ON, FACE FRONT-ON (far right)
The attractive pose that was chosen for the project is one that the model took up naturally and found comfortable. The interesting angles of the torso and limbs produce fluid lines that run from the body through to the draped fabric.

YOU WILL NEED

Pad of white pastel paper

6B pencil (for trial sketches)

Sepia Conté pencil

Craft knife and glasspaper (for sharpening pencils)

Stump

FIRST STEPS

1 ▶ Sketch the model Using a sepia Conté pencil, first draw the head, putting in guidelines for the features. Next, sketch the body and draped fabric – notice how the model's weight rests on her right leg, while her left leg is bent. She is twisting her body from the waist, bringing her left shoulder up.

2 ▶ Firm up the outlines Pressing harder with the pencil, go over the curves of the figure. Indicate the position of the bent left knee to help you work out how the fabric drapes over this leg, and show the ruffles of fabric falling from the model's hand. Draw the facial features, positioning them on your guidelines.

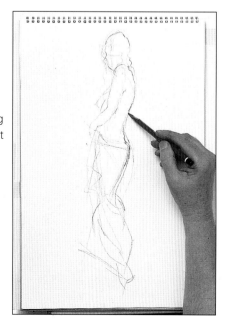

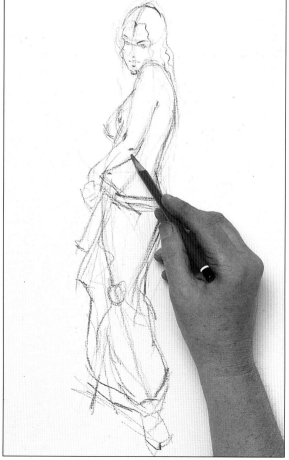

INTRODUCING TONE

Suggest the softly rounded forms of the upper body with subtle shading – keep your Conté pencil well-sharpened with a craft knife, then rub it on glasspaper to achieve a fine point. For the shading on the fabric, work more emphatically to emphasise the darkest tones.

3 ▼ **Model the body** Use loose wavy lines to suggest the long strands of hair and shade over the dark hair at the top of the head. Work the Conté pencil across the back and on the underside of the left arm and breasts to show the shadows here. Then add tone to the shaded side of the face.

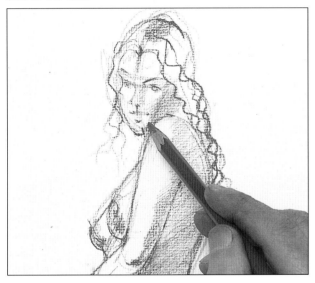

4 ▼ **Develop the drape** Show the deep creases in the draped velvet fabric with mid and dark Conté shading. Concentrate particularly on the fold running from the hand to the knee, as this follows the line of the bent leg and therefore gives information about the model's pose.

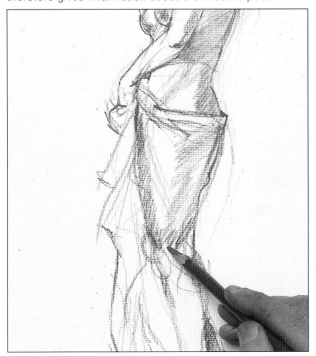

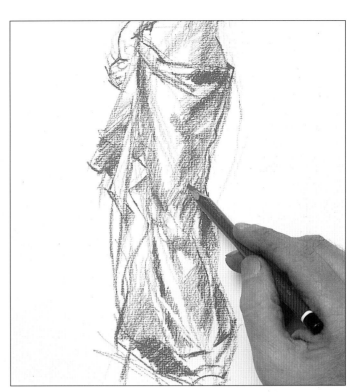

5 ▲ **Continue defining the drape** Make the most of the graceful fall of the fabric by using tonal shading to describe its rippling surface. Press hard with the Conté pencil to achieve the deepest shadow where the fabric folds around the hips and crumples near the floor.

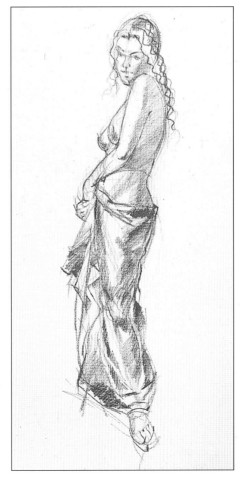

6 ◄ **Complete the details** Draw the foot in more detail, putting in the lines of the toes. Work into the facial features, adding a little more definition but keeping them light and delicate. Put in the patch of shadow on the side of the hair.

As Conté pencil is easy to smudge, you can soften some of the line work and smooth out tonal areas in the drawing by rubbing over the pigment. By using the pointed end of a stump, you can work in a controlled, delicate way.

7 ▶ Start using a stump Rubbing quite hard with the tip of a stump, smooth out the shadow on the hair, at the same time softening some of the wavy lines. Take a little of the colour you have picked up on the stump over the rest of the hair – this creates light, soft smudges of colour.

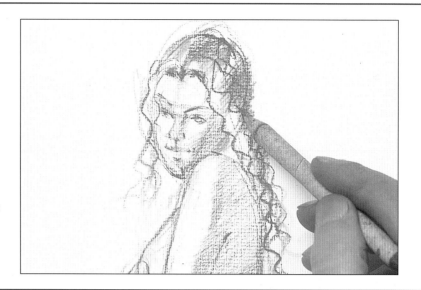

Master Strokes

Edgar Degas (1834-1917)
The Toilet

Degas was particularly drawn towards painting nude figures during the later part of his life, when he produced many intimate pastel studies of women washing. This example, worked in 1883, is typical of Degas's superb draughtsmanship. The figure is caught in mid-action and creates a strong diagonal shape across the paper. Although Degas's compositions look spontaneous, they were, in fact, very carefully composed.

Degas lets the paper show through on the lit side of the body, making no marks to indicate volume. However, the viewer 'reads' this area as rounded because of the precise shading on the shadowed side of the figure.

The triangle created by the bent leg echoes the one above it formed by the thigh, arm and torso. Note also how the figure, basin and chair make an even larger triangle.

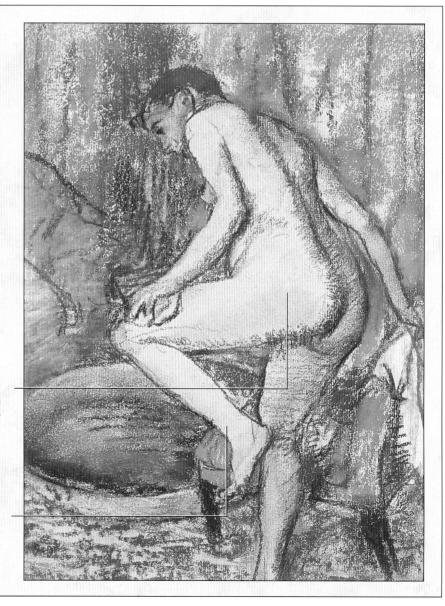

8 ▲ **Move on to the drape** Work the stump over the darkest areas of shadow on the drape. As you blend the textured marks together and hide the light paper, a heightened sepia colour results. Rub some of the pigment from the stump over the side of the foot.

EXPERT ADVICE
Sketching with a stump

When you are doing your initial sketches for a life study, suggest the hair and features simply and lightly by using a stump as a drawing tool. Pick up some pigment from a dark area of your sketch on the tip of the stump and draw with this. Try this technique on your Conté pencil drawing, too.

THE FINISHED PICTURE

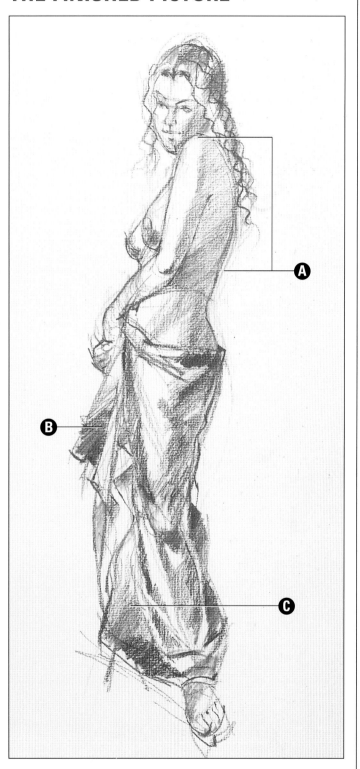

A Fluid lines
The model's graceful pose gives pleasing lines, such as the curve of her raised shoulder and the sweep of her back into her hips.

B Dark and light
There are strong tonal contrasts on the draped velvet fabric where the folds create areas of deep shadow next to pale, highlit areas.

C Blended pigment
The textured effect produced by shading Conté pencil on pastel paper was smoothed out in places by rubbing with a stump.

Citrus fruits and melons

Sharp greens and yellows complement each other perfectly in this vibrant still life of Mediterranean fruit.

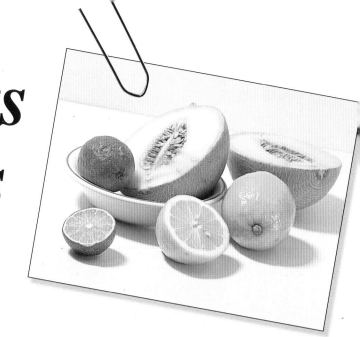

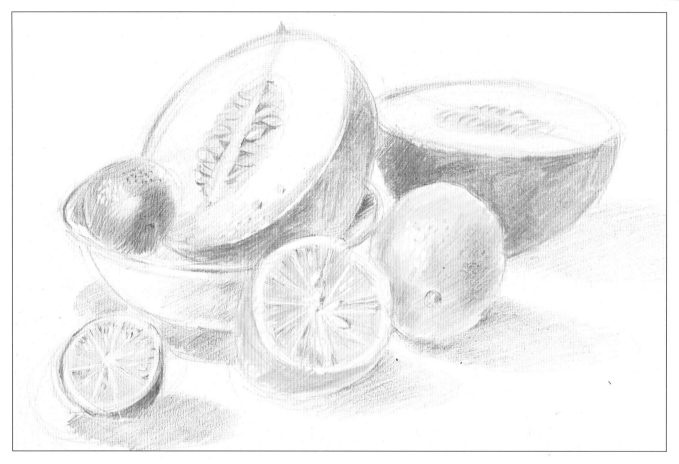

When drawing citrus fruits, you need to use strong colours that really sing out from the paper.

Colour and texture

A useful way to make colours appear vibrant is to set darker shades against them so that they look even brighter by contrast. Here, for example, the tones of the lemons stand out vividly against the darker background of the melon rinds.

Another consideration when drawing fruit is texture. The lemons and limes have a waxy, pitted surface, suggested with heavy shading and dotted marks. The flesh of the cut melons, on the other hand, is smooth and shiny with moisture. Use light shading, which allows the white paper to show through, for this effect.

Highlights can be difficult to deal with when using coloured pencils. The lightest tone you can achieve is the white of the paper, but once you have coloured over it, the white is lost. If you

▲ **Draw with coloured pencils to capture the bright colours and varied textures in this still life of luscious fruit.**

want to show reflections here and there, scrape away the colour with a craft knife. Choose a smooth, heavyweight drawing paper for this technique, as this type of surface will not scuff when it is scraped.

FIRST STROKES

1 ▶ Make an initial sketch Using a brown ochre coloured pencil, draw the outlines of the fruit and bowl. Notice how they form a series of circles and ovals. Lightly indicate the seed areas on the melon halves and shade their rinds with long, loose hatching lines.

2 ▼ Start to add colour Sketch in the melon seeds. Shade the lemon rinds with a mid yellow pencil, then with buttercup yellow. Show the flesh on the cut lemon with lines of gold ochre and mid yellow. Hatch gold ochre over the melon rind.

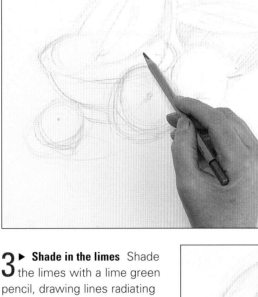

YOU WILL NEED

Piece of smooth, heavyweight drawing paper

7 coloured pencils: Brown ochre; Mid yellow; Buttercup yellow; Gold ochre; Lime green; Black; Prussian blue

Craft knife

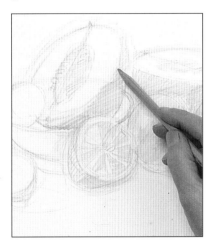

3 ▶ Shade in the limes Shade the limes with a lime green pencil, drawing lines radiating from the centre of the cut fruit. Lightly apply lime green over the flesh of the half-melons, making them darker around the rim. Deepen the brown ochre hatching on the rind, livening it up with a little lime green. Using brown ochre, define the shadow on the half-melon in the bowl.

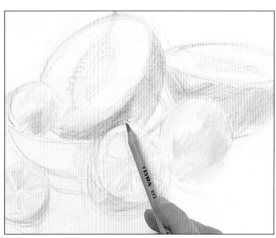

4 ▼ Work on the lemons and limes Warm up the rind of the lemons with buttercup yellow, adding shadow with gold ochre and brown ochre. Hatch brown ochre on to the melon rind behind the uncut lemon to emphasise the lemon's bright colour. Strengthen the lime rind with the lime green pencil, knocking it back with hatching in black and Prussian blue.

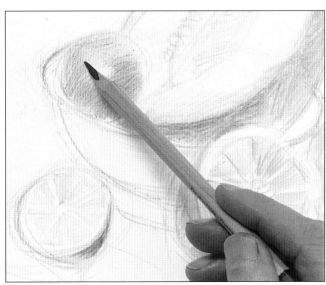

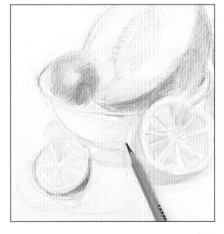

5 ◀ Use blue for the shadows Indicate the cast shadows with Prussian blue and a little black. Use black, too, for the shadow on the right-hand melon rind. Shade the bowl lightly with Prussian blue, outlining its rim.

EXPERT ADVICE
Keeping surfaces fresh

When you are working on a still life that includes sliced fruit, keep the cut surfaces damp by spraying with a fine mist of water from time to time. This will prevent the flesh from drying out and losing its fresh, juicy appearance.

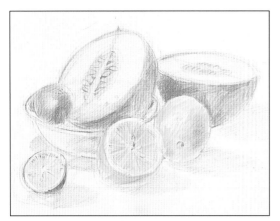

6 ▲ **Draw the seeds** Shade the seed area on the melon halves with gold ochre. Then outline the seeds with brown ochre, filling in some of the negative shapes around them with this colour and some black. Add a little detail to the lemon flesh with a well-sharpened brown ochre pencil, and to the lime flesh with Prussian blue and black. Define the edges of the melon flesh with a little blue.

A FEW STEPS FURTHER

The still life could now be considered complete. However, you might like to develop the textured surfaces even more by using a craft knife to scrape away the colour and reveal the white paper underneath.

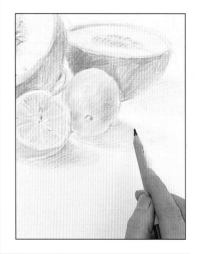

7 ◄ **Add some more details** Using the black pencil, fill in more negative shapes around the melon seeds. Add to the texture on the lime and lemon rinds with dots and hatching in black and brown ochre. Lightly hatch more black over the cast shadows.

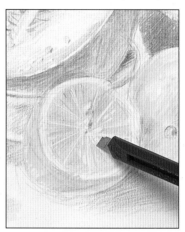

8 ▲ **Scrape away highlights** With a craft knife, scratch away some of the colour around the melon rind and across the flesh. Fill some of these areas with a little brown ochre. Scrape away some lines, pips and reflected light on the cut lemon, and some highlights on the uncut lime.

THE FINISHED PICTURE

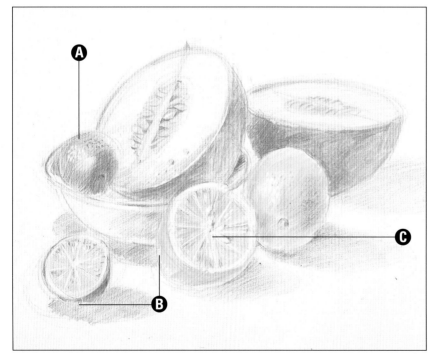

A Textured rind
The pitted texture on the lemon and lime rinds were suggested with just a few dotted marks.

B Citrus colours
The bright greens and yellows of the limes and lemons were thrown into relief by the dark shades used behind them.

C Scraped highlights
By scraping back the coloured pigment, the white paper was revealed to give the impression of reflected light.

Using graphite sticks

The bold, expressive marks of chunky graphite sticks are perfect for capturing the hustle and bustle of this quayside fish market.

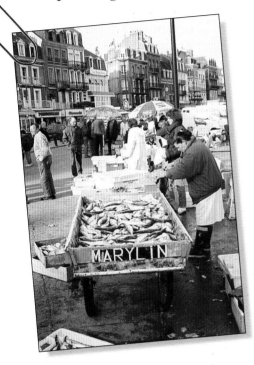

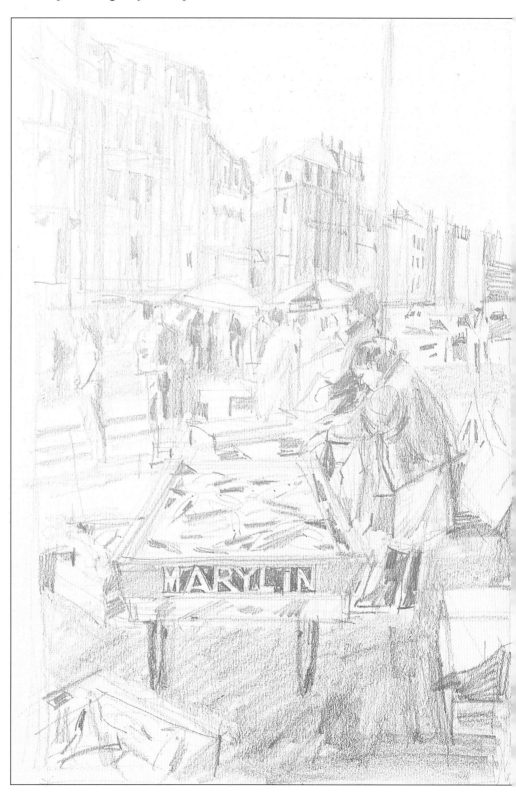

Markets are always full of life, with interesting characters manning the stalls and a variety of produce on display, making them an inspiring subject for a drawing. As there is constant movement in a market, make a few sketches on the spot first or take some photographs to capture the scene, then work from these later at home.

A broad medium

Graphite sticks are useful drawing tools for this type of subject, in which an over-all impression of the hustle and bustle is more important than fine detail. These chunky sticks are made of compressed and bonded graphite and produce broad lines and bold shading, ideal for sketching the shapes of figures in a crowd or suggesting the features of distant buildings. If they are well-sharpened, they can also be used to add the odd detail.

▶ **Lively marks and loose blocks of tone made with graphite sticks give this drawing a spontaneous, sketchy quality.**

USING THE PUSH-DOWN LEAD PENCIL

Graphite sticks can be rather messy to take with you when you are sketching outdoors. For preliminary sketches, try using a push-down lead pencil (right) The lead can be retracted when not in use and the clip allows you to simply pop it into your pocket. Try to get into the habit of carrying it around so you can practise your drawing in free moments.

▶ Graphite sticks come in various grades and shapes. Some have a casing to protect your hands. They can be sharpened with a pencil sharpener or by rubbing the tip on glasspaper.

FIRST STEPS

1 ▶ Set the scene Using a 9B graphite stick, draw the verticals of the buildings in the background and the tall lamp-post in front of them. Then put in the roof-line. Sketch in the main activity in the mid and foreground – the woman and her stall, some of the passers-by and the parasols. Outline the boxes of fish on the road.

2 ▲ Fill in some tone Change to a 4B graphite stick and block in some medium tone on the stallholder's jacket. Very loosely, scribble in a little tone to indicate the dark clothing of the passers-by. Use long, light strokes to shade the walls of the buildings.

3 ▲ Continue shading Block in the shadows cast on the road by the stall and by the figures on the left. With the 9B graphite stick, work across all the figures, shading in dark tones on their clothing and hair. Use heavy strokes to draw the legs of the stall, then rough in the lettering on the side.

4 ◀ Work across the picture Using the tip of the 4B graphite stick side-on, block in the dark area of road on the right (see Expert Advice). Begin shading some of the roofs and windows of the buildings, and suggest the windows on the left with a grid of lines. Fill in light tone on either side of the lettering on the stall, then shade in the dark stripes on the parasol.

GIVING THE SCENE CHARACTER

Once the main outlines and tonal areas have been established, start adding character to the scene. Develop the people and the buildings with loose strokes, keeping any slightly more detailed work for the fish stall and traders in the foreground.

5 ▶ Put in some detail Build up tone on the hair and clothing of the figures in the middle ground. Darken the stallholder's boots and jacket with heavy black tone. Suggest the fish on the stall and in the box with dashes of the 4B graphite stick – this is a shorthand way of describing the pattern they form.

6 ▲ Develop the buildings Pick out the architectural features of the buildings in slightly more detail, but keep the overall effect simple so that you don't detract from the action in the foreground. Outline more windows with simple crossing lines and shade in the dark areas on the roofs. Draw the canopies over the windows of the hotel in the centre.

7 ◀ Work on the lettering Change to the narrow 9B graphite stick for this detailed work. Fill in around the outlines of the letters, so that they show up as white against a dark background – press hard with the stick to make a good, dense black.

EXPERT ADVICE
Blocking in large areas

The chunky tip of a graphite stick used side-on is ideal for filling in large areas of tone quickly. Each sweep of the stick will make a broad rectangular mark, and you can layer these to build up texture and tone in the drawing.

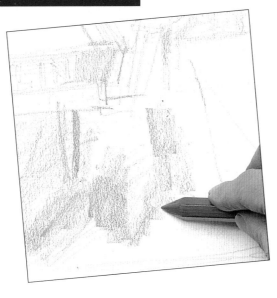

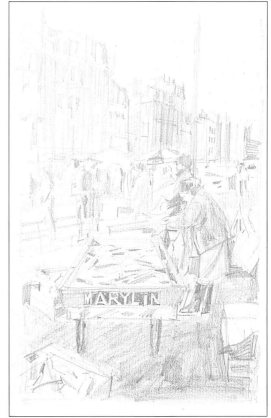

8 ▲ Add overall definition Sharpen the profile of the stallholder by darkening the clothing of the woman behind her, then add some linear details to her jacket. Dash in short vertical lines for the windows on the distant buildings, then indicate some of the balconies. Check the tones of the buildings, darkening them where necessary. Add more fish to the left-hand box and draw the plastic sheet in the box on the right.

There is always room for a little more detail in a busy scene such as this – the thinner graphite stick will produce quite fine lines.

9 ▶ Refine the details Give more character to the two figures in the foreground by outlining their profiles with a well-sharpened 9B graphite stick. Darken a few of the windows with heavy strokes.

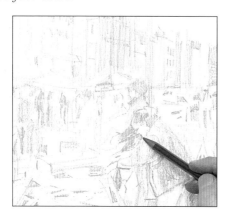

10 ▲ Lift out tone Check the tones over the whole drawing. If you want to lighten any previously shaded areas – for example, the white coat – you can lift off the graphite by using a putty rubber.

THE FINISHED PICTURE

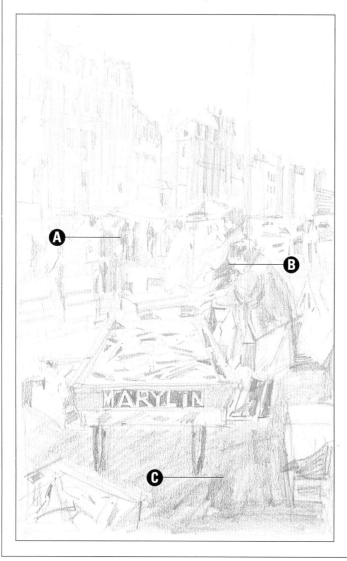

A Groups of people
The clusters of figures in the middle ground were suggested with simple, sketchy marks that indicated just the rough shapes of the bodies.

B Facial detail
Although basically a broad medium, a graphite stick was sharpened finely enough here to give a precise outline to the woman's profile.

C Quick shading
Large areas of tone, such as the dark road in the foreground, were quickly and easily rendered with a graphite stick by using the tip on its side.

Scraperboard harbour scene

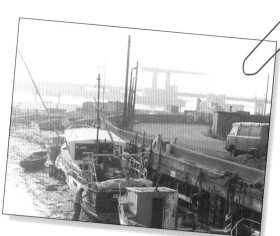

Scraperboard work has a distinctive, finely etched quality and gives dramatic results in black and white.

Instead of reaching for pencil and paper next time you want to draw, why not give scraperboard a try? This technique has a look reminiscent of woodblock printing, and is equally suitable for broad areas of tone and intricate details.

The traditional scraper surface consists of a backing board, a layer of white china clay and a black top coating. By scratching away the black surface with special cutting tools, the white layer beneath is revealed.

Scraperboard tools are available in sets consisting of holders with interchangeable metal cutters rather like pen nibs. (Both the board and tools are available at good art stores). Practise with the cutters before you embark on a drawing to discover the range of strokes they make. Be adventurous, trying the tip and the sides of the blades. Draw outlines or scatter freely worked dots, circles and other shapes on the board. Keep your cutters needle-sharp with fine emery paper or an oilstone, as this will ensure quicker, cleaner work.

As with any drawing, it is important to establish a realistic tonal range. With scraperboard, you are actually 'drawing' the light tones, so you need to look at the dark tones as negative shapes.

▼ **A variety of strokes – including fine crosshatching in the distance and broad, scribbled strokes for the water – add to the liveliness of the image.**

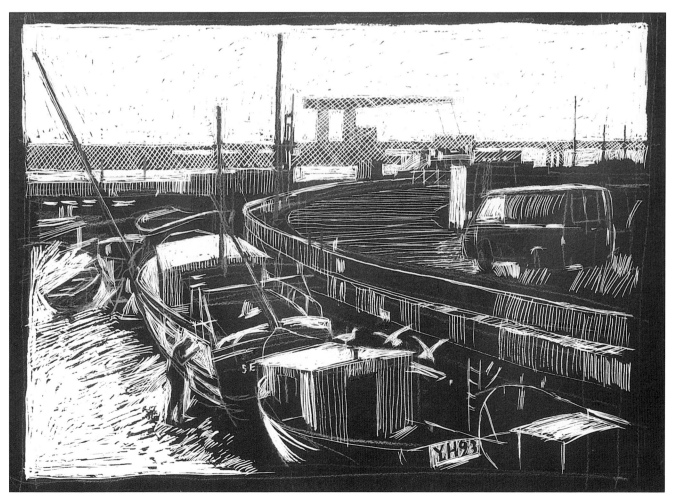

Piece of black
scraperboard 40 x
30cm (16 x 12in)

White coloured
pencil

Curved cutter

Pointed cutter

No.1 soft round
brush

Indian ink

ISOLATING THE TONES

Making a quick tonal sketch of the scene in pencil before you start on the scraperboard will help you to work out the main areas of light and dark. Alternatively, you could work directly from a black-and-white photograph, as the tonal variety will be more obvious in this than in a colour one. If your only reference is in colour, you can simply photocopy it to reproduce it in black and white.

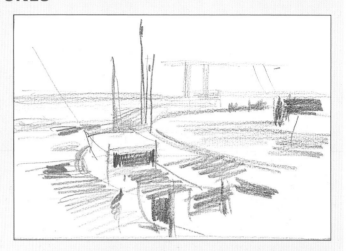

FIRST STEPS

1 ▼ **Sketch the scene** Before you use the scraperboard cutters, sketch the horizon and the curve of the harbour wall of the scene with a white coloured pencil. Then put in the boats, the figure and the van. Indicate the light areas, such as the sky, the water, the top of the main boat and the van's window, with loose strokes of the white pencil.

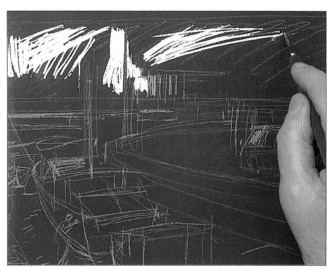

2 ▲ **Start scraping the sky** A cutter with a curved blade is best for clearing away the large expanse of sky. Make long, positive strokes in any direction that feels comfortable. As you progress, work carefully around the fine lines of the masts and telegraph poles silhouetted against the sky, as these should remain black.

▲ **Scraperboard cutters have a variety of interchangeable blades for different effects.** The pointed blade at the top is ideal for fine detail. The blade in the centre gives medium to broad lines, while the curved blade at the bottom is suitable for clearing large areas of the black surface.

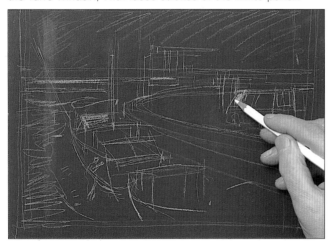

3 ◄ **Create more light tones** Scrape away the sky until nearly all the black has been removed. Change to a pointed cutter to outline the bridge and buildings before scraping close up to them. Scrape away the distant river with horizontal lines, then change back to the curved cutter to scrape off the top of the boat's cabin.

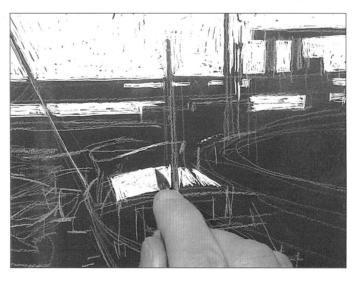

HOW TO VARY THE TONE

By clearing broad areas of light tone, you have built up strong contrasts between black and white in the scene. To give the picture more subtlety, you now need to create diversity of tone by varying your cutting technique.

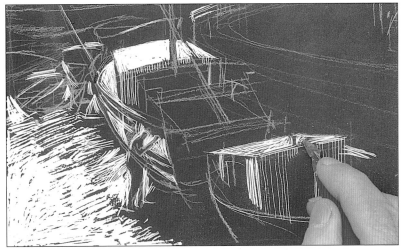

4 ▲ Introduce some mid tones Scrape the pale water on the left, using dense strokes with the curved cutter. For the mud, space your strokes further apart to convey a darker tone. Create a mid tone on the cabin walls with fine vertical lines made with the pointed cutter. Draw the boat hulls, the figure and the rowing boat. Scrape off the foreground cabin roof with the curved cutter.

5 ▶ Create distant mist The silhouettes of the distant harbour wall and the bridge are softened by mist. Recreate this hazy effect by drawing a series of slanting parallel lines with the pointed cutter to give a mid tone.

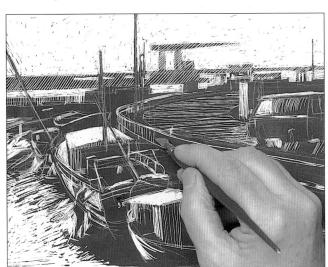

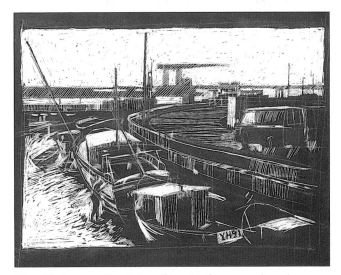

6 ▲ Fill in more tones With the pointed tool, draw the van, spacing the strokes close together for its light window and further apart for its mid toned side. Mark in the boat details, such as masts, rails and lettering. Define the small boats and mud bank in the middle distance. Using the curved cutter, scrape away the end wall of the shed. Draw the curve of the quay, hatching a mid tone on the wall and road.

7 ▲ Work across the picture Give the foreground mud some texture with dashes of white scraped with the pointed cutter. Create a mid tone on the distant buildings. Add more details to the boats. Finally, if you have missed any posts or masts, brush these in with Indian ink and a No.1 round brush (see Trouble Shooter).

A FEW STEPS FURTHER

Check your picture to see if you have left out any details. Assess the range of tones and, if necessary, adjust the light tones with further scraping.

8 ▲ Fill in more foreground detail Straighten up any ragged edges on the buildings or boats with the pointed cutter. Hatch more lines on the quayside wall to indicate patches of light and draw the ladder leading up from the boats.

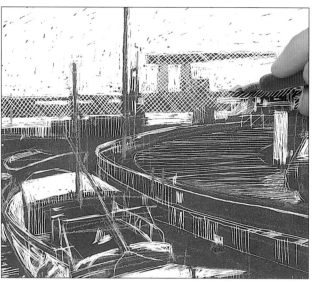

9 ▲ Soften the misty effect The tone on the distant harbour wall and bridge is still rather strong. Soften it further by using the pointed cutter to hatch diagonal lines that cross the previous ones.

THE FINISHED PICTURE

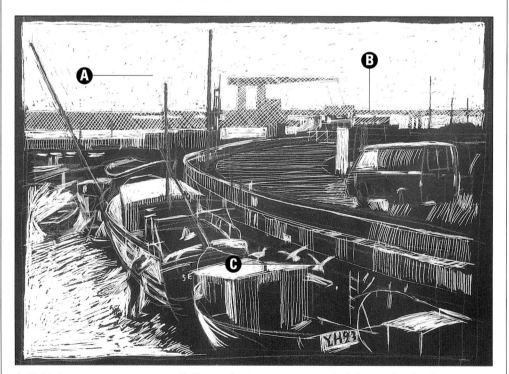

A Light sky
Most of the black scraperboard was removed to create the pale sky, but a few flecks were left to prevent the area from looking bland and uninteresting.

B Range of tones
Subtle gradations of tone can be achieved with hatching and cross-hatching. The distant bridge is lighter in tone than the road, but darker than the sky.

C Interesting detail
With a little artistic licence, lively touches, such as these seagulls flying around the boat, can be added to the scene, using a fine, pointed cutter.

Adding colour to scraperboard

Combine strong tonal contrasts and bright hues in a garden scene, using scraperboard with coloured inks.

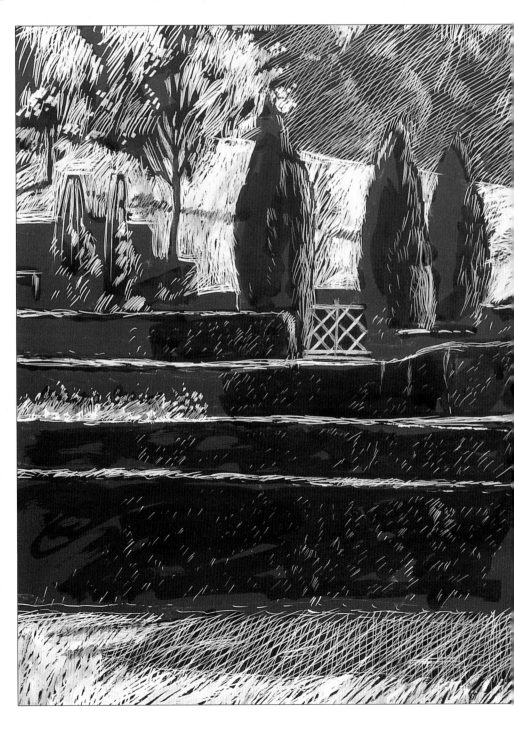

This view across a beautifully tended garden calls out to be drawn on scraperboard. The photograph has strong tonal contrasts – for example, between the hedges and their sunlit tops, and between the dark, clipped conifers and the light lawn behind them. This dramatic lighting effect is ideal for scraperboard work, which is most effective when used for compositions that have black areas close to pale ones, without too many mid tones in between.

If you tried the scraperboard harbour scene, you will be familiar with using a pointed tool (for fine lines) and a curved tool (for broad areas). In this project, an asymmetrical pointed tool is added – with this you can make fine lines and, by turning the blade on its side, wider ones, too, without needing to change from one blade to another.

A touch of colour

Scraperboard work does not have to be just black and white. It looks very effective with the addition of a little colour on the white areas. Here, a few touches of coloured ink enliven the view and give the garden a more summery feel.

Don't flood the board with ink – keep your brush fairly dry and work within the white areas you want to colour rather than brushing too much ink over the surrounding black.

▶ **Coloured inks enhance this country garden view with the tints of nature.**

FIRST STEPS

1 ▼ Make a Conté sketch Your initial sketch needs to show clearly on the black surface of the scraperboard, so use a white Conté pencil to outline the main features of the landscape. Indicate the rounded trees and the conifers, the horizontal lines of the hedges and the pale foreground. Position the climbing plants on the left and the ornamental fence in the centre.

EXPERT ADVICE
Mask your composition

While you are building up your scraperboard picture, it is useful to have straight edges to work up to. A paper mask is a good way of isolating the picture area. Mark the picture size on a large sheet of white paper and cut out the centre. Then place the cut paper over the scraperboard and tape down the edges with masking tape.

2 ▲ Create a light lawn Begin by scraping away the black surface of the board to create the distant sunlit field. Use the wide blade of a curved cutter to remove solid white areas, and a pointed cutter for fine hatched lines. Work around the conifers, varying the direction of the hatching.

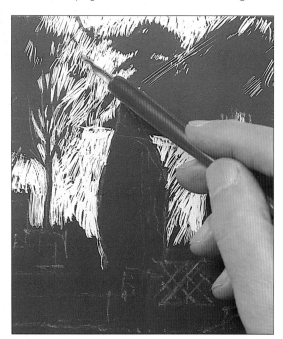

3 ▲ Work on the trees Continue scraping the field, leaving the thin tree trunk as a black shape against the white. Change back to the curved cutter to remove broad chunks across the sky, then return to the pointed cutter to draw the left-hand tree foliage with groups of hatched lines. The dark shapes left behind represent the tree's branches. Hatch some well-spaced lines on the right to suggest trees in the distant wood.

4 ▶ **Continue the top part of the picture**
Build up the foliage on the remaining trees on the left with more hatched lines. With fine lines, mark the light tone on the sides of the conifers where they catch the sun. Describe the trees in the distant wood with more well-spaced hatching.

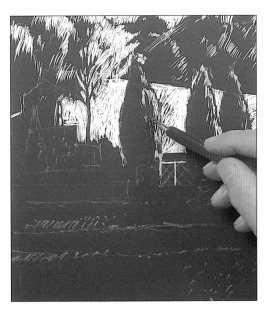

BUILD UP THE MID TONES

Now that you have scraped away some of the main light-toned areas, it is time to work on the mid tones. Use widely spaced hatched lines so that the black background shows through – the optical effect of the alternate bands of white and black is to create a mid toned grey.

5 ▼ **Draw the fence and hedges** Using the tip of an asymmetrical pointed cutter, carefully draw the criss-cross lines of the fence, keeping them straight and parallel. Tilt the cutter on to its wider edge to draw the thicker line of the seat. Using the tip of the cutter once more, mark the sunlit tops of the hedges with a series of short lines.

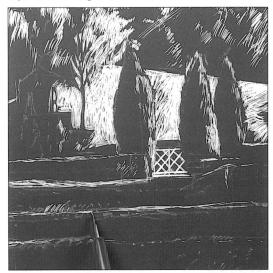

6 ▶ **Make a mid tone**
Using the pointed cutter, draw long hatched lines diagonally across the trees in the wood, keeping the lines quite far apart. Where the long lines cross the shorter ones that you drew in step 4, lighter areas are built up, giving an effect of sunlight catching the tree-tops.

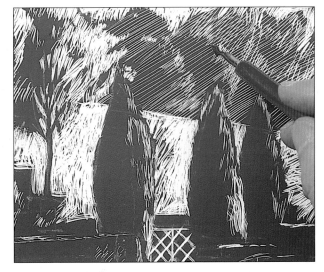

7 ▶ **Add some texture**
Slightly lighten the tone on the trees in the wood with fine cross-hatching. Using the broad side of the asymmetrical cutter, make wider lines on the left of the field, working around the climbing plants. Then change to the tip of the blade to put textural marks on the plants. With the curved cutter, make a leafy texture in the trees with dots and dashes of white.

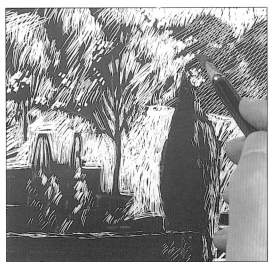

8 ▲ **Move to the foreground** Continuing with the curved cutter, scrape over the lawn in the foreground, working around the cast shadow. Create texture by working in different directions. Change to the pointed cutter and make a mid toned shadow with well-spaced cross-hatched lines, then add some finer texture to the lawn.

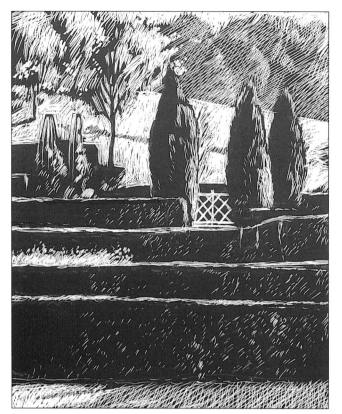

9 ▲ **Put in final details** Using a No.4 soft round brush, paint a shadow across the far field with Indian ink (see Trouble Shooter, below). Then, when the ink has dried, scrape fine lines across it to lighten its tone. Using the pointed cutter, break up the black hedges with a speckled texture. Draw the group of flowers behind the hedge on the left. Changing back to the curved cutter, scrape away more broad marks from the sky and the field.

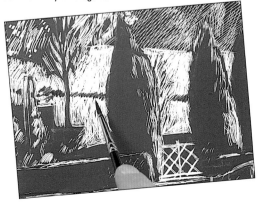
A FEW STEPS FURTHER

Although scraperboard work looks dramatic in its original black and white tonal form, it can also look very effective if you add a little colour. Here, brightly coloured inks give a sunny glow to the garden scene.

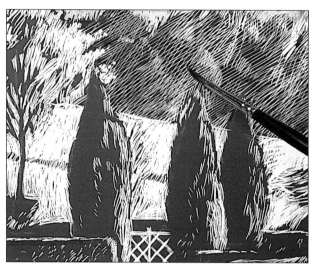

10 ▲ **Begin painting with blue ink** Thin some cobalt coloured ink with distilled water. Using the No.4 round brush, paint this blue shade over the sky. Brush cobalt across parts of the distant trees, too, leaving some areas unpainted so that yellow can be added later.

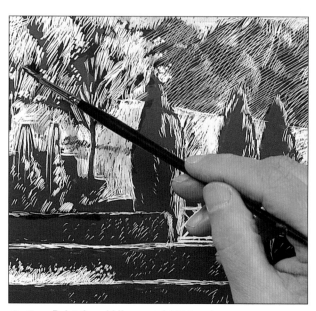

11 ▲ **Paint the middle ground** Water down some canary yellow ink and paint it over the field. Paint the trees on the left with undiluted yellow. Don't feel that you have to fill in every white mark with colour. The picture will look more lively if you leave patches of white showing here and there.

12 ▶ **Introduce some greens**

Paint a little diluted canary yellow over the remaining white areas of the blue trees, and dab in some cobalt among the yellow trees. Add a touch of cobalt and nut brown ink to viridian ink to create a deep bluish green. Paint this across the dotted texture on the hedges and down the sides of the conifers.

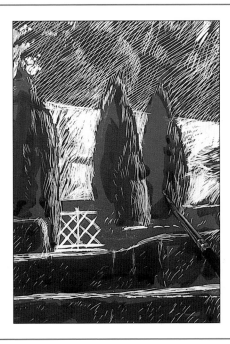

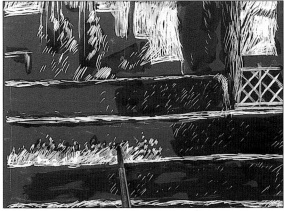

13 ▲ **Complete the picture** Brush canary yellow over the hedge tops and the foreground lawn, using the ink more diluted in some areas than others. Put a touch of apple green on the climbing plants. Paint cobalt over the fence and the flowers. Finally, add a splash of brick red to the flowers.

THE FINISHED PICTURE

A Vertical lines
Black conifers stand out starkly against the light-coloured lawn, giving a strong vertical element to the composition, in contrast to the horizontal lines of the hedges.

B Hedge texture
Tiny dotted and dashed marks were used to convey the texture of the privet hedges, but were scattered well apart so as not to lighten the deep tone.

C Shades of yellow
The lawn was painted with both diluted and undiluted yellow ink. This varies the tone and colour across this broad band of the picture.

Capturing personality

As well as aiming for a good likeness, a portrait should hint at the sitter's character.

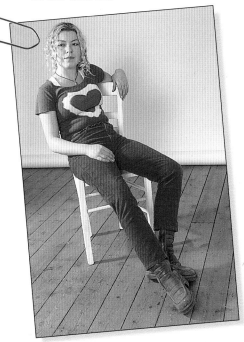

An important aspect of figure drawing is capturing the personality of your sitter. Personality is a more elusive quality to convey than the sitter's physical characteristics, but you can incorporate clues into your drawing that will help to build up a rounded view of the individual.

Natural pose

For example, you can suggest your model's character by his or her pose, facial expression and clothing. In addition, you can put your model in familiar surroundings or show them with a favourite possession. A person's general attitude can also be very telling. Look at whether they usually stand confidently or slouch, whether they gaze out boldly or keep their eyes downcast, whether they smile or remain passive.

If you are using a model or a friend to sit for you, ask them to wear clothes that

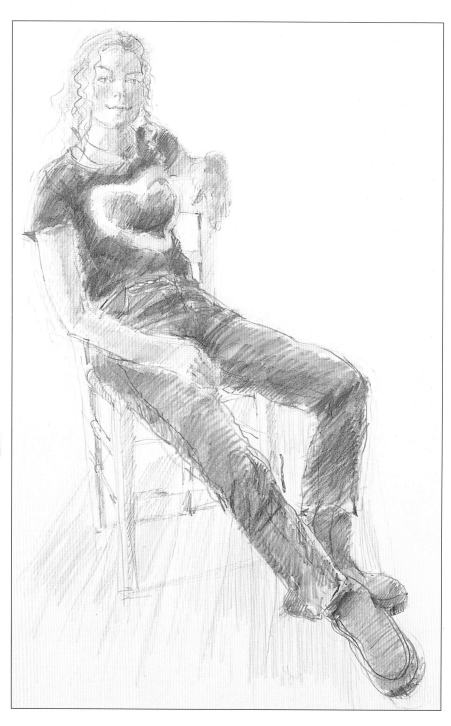

they feel comfortable in and let them adopt a pose that feels natural. In the drawing here, the young woman favours casual jeans and a T-shirt and is leaning back in her chair in a relaxed fashion.

Colour is another means by which you can convey personality, so the drawing was worked in water-soluble

▲ **The casual pose of the model reflects her youth and relaxed personality.**

coloured pencils. The bold red of this sitter's clothes suggests that she has a confident and outgoing nature. The dynamic diagonal created by the outstretched pose has a similar effect.

FIRST STEPS

1 ▼ Make a sketch Using a medium black water-soluble coloured pencil, sketch the figure. Establish the slight tilt of the head and the position of the eyes with crossing guidelines. Use another guideline down the front of the torso to show the angle of the upper body leaning back against the chair. Indicate the fabric creases on the trousers. To show how the body is supported, put in the chair legs and back.

3 ◄ Colour the red clothes Change to a pale geranium lake pencil to shade in the bright red T-shirt; make bold, textural marks, pressing quite hard. Fill in the heart motif with medium black. Continue the red colour on to the jeans, using looser hatching lines here. Let your marks follow the stretch of the fabric as it creases across the model's stomach and folds around her legs.

2 ▲ Introduce a flesh tone With a burnt ochre coloured pencil, shade the left side of the model's face and neck, adding a little extra shading on the right cheek and eye socket. More loosely, shade the burnt ochre on the model's left hand and the top of her right arm. Sharpen the pencil to define the facial features.

4 ▲ Develop the picture overall Use yellow ochre as a base colour for the hair, suggesting the wavy strands with raw umber (see Expert Advice overleaf). Mark in the darker hair at the front with medium black. Develop the shadow on the flesh tones of the face and arms with a Pompeian red pencil, blending it over the burnt ochre. Using medium black, hatch in some tone on the legs and back of the chair. Shade the right boot with a little burnt ochre.

ADDING WATER

The advantage of using water-soluble pencils is that you can smooth out the colour with a little water on a soft brush to give a painterly look to your drawing. Extra shading and details can be added over the colour washes with dry pencil marks.

5 ▶ Add water to the clothes Dip a No.10 soft round brush into clean water. Brush it over the pale geranium lake of the T-shirt and jeans to blend the previous shading into a soft wash. Rinse the brush before blending the black shading on the T-shirt heart.

6 ▲ Build up shadows To suggest how the light falls across the clothing, work up some darker tone on top of the washed-over pale geranium lake. Use an Indian red coloured pencil for this, rendering the shadows on the T-shirt, the lower part of the legs and the inside of the left thigh. Use bold linear marks to represent the pull of the fabric folds across the stomach.

7 ◀ Develop the face Brush a little water over the flesh tones on the face and neck to smooth out the skin colour. When this has dried, warm up the cheeks and lips with dark carmine. Sharpen a Vandyke brown pencil and define the eyebrows, eyes and jawline.

**EXPERT ADVICE
Making waves**

To suggest the waves in the model's hair, hold the coloured pencil lightly about halfway down its length and make loose zigzag lines. By working in this way, you will avoid drawing too tightly and spoiling the effect of the casual hair style.

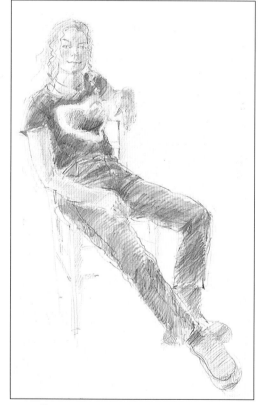

8 ▲ Sharpen up the drawing Work up the heart on the T-shirt with medium black. Still using black, outline the fingers, draw the necklace and add dark shadow to the chair back. Strengthen the pale geranium lake shading on the jeans. With loose lines, hatch brown ochre, then Vandyke brown and a little Indian red over the boots. Strengthen their outlines with sketchy lines in these colours.

The drawing of the model is now complete, but it is worth paying some attention to the floor to give the composition a firm base.

9 ▲ **Put in cast shadows** To help 'anchor' the chair to the floor, introduce the shadows cast by the chair legs, using medium black. Darken the tone of the chair with more hatching on its legs. Add colour to the woven straw chair seat with a little gold ochre hatching.

10 ▲ **Draw the floorboards** Wash a little water over the boots to blend the drawn lines together. With the well-sharpened Vandyke brown pencil, emphasise the outlines of the boots and darken their soles. Shade the floorboards with long hatched lines in gold ochre, then edge them with black.

THE FINISHED PICTURE

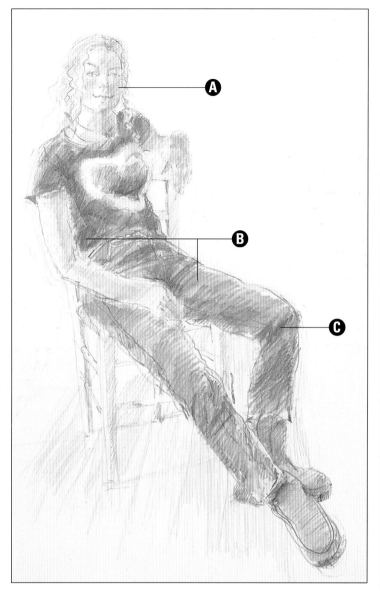

A Character study
The facial features were drawn in enough detail to convey the youth and relaxed expression of the model.

B Light to dark
On the jeans and T-shirt, the lighter red was shaded in first, then the darker red was hatched in over the top.

C Colour blending
Washing over hatched lines made with water-soluble coloured pencil softens them and blends the colours together.

Drawing the head

Although each person's head is unique, there are certain fundamental principles of figure drawing that can help you improve your portrait skills.

There are many aspects to consider when you are drawing a portrait – how to establish the shape of the head, how to convey an individual's facial features and how to build up a sense of form through shading. If you master these concepts, you will find it easier to create a good likeness.

Skull structure

A knowledge of how the underlying bone structure of the skull determines the shape of the head and facial features is extremely helpful when you are drawing from life and trying to analyse your model's main characteristics. The form of the skull is initially evident on the surface of the face in the appearance of the cheekbones, the jaw and chin, the ridge of the nose and the dome of the cranium. The skull's structure also determines the relative positions of the facial features.

Certain proportions tend to be similar in most people. For example, the distance from the top of the head to the eyes is roughly equal to the distance from the eyes to the chin. The distance from the eyebrows to the bottom of the nose is more or less the same as from the bottom of the nose to the chin. The gap between the eyes is approximately the width of an eye. However, you should always check an individual's proportions by measuring with your pencil.

▶ **Where the form of the head can be seen clearly, as on this model with a shaven head, it is easier to relate the visible features to the underlying structure of the skull.**

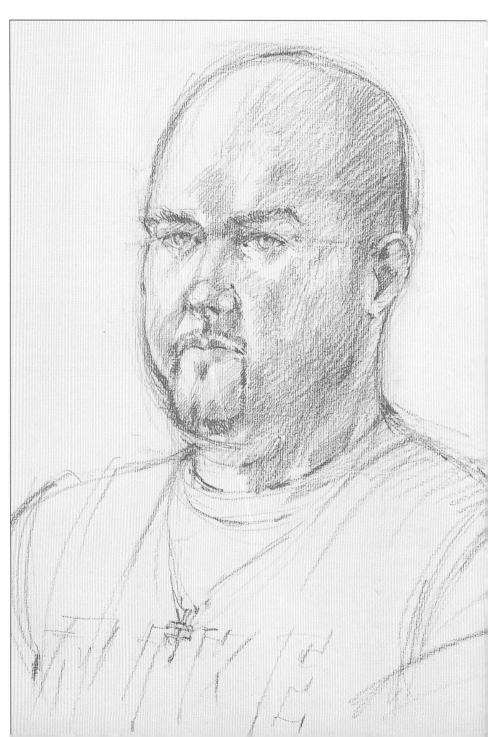

DRAWING FACIAL FEATURES

Although everybody's features are unique, there are common characteristics to look out for when you are drawing them. The classical features represented in these plaster models are based on the sculpture *David* by Michelangelo (1475-1564). The models are available from the British Museum in London.

EYE
The eye is simply a ball set inside a bony socket in the skull. Shading above the eye suggests the protruding brow bone. Lids are shown by pairs of curved lines around the iris.

 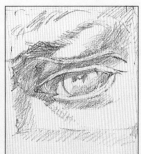

NOSE
A simple but helpful way of visualising the nose is as a cylinder emerging from a sphere with a quarter sphere on each side for the nostrils. Shade around the nose and inside the nostrils to define them.

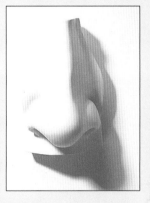 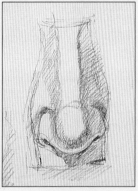

MOUTH
The mouth is made up of lobes: three on the upper lip (a circular central area and a lobe on either side), and two on the lower lip. The chin forms a circular form below it. Emphasise the line where the lips close together.

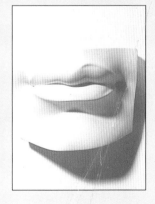 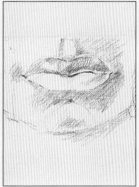

EAR
The ear can be broken down into an outer rim of cartilage ending in the large lobe and, inside this, a protruding semi-circular piece of cartilage. Add shadows in and around the ear to define these features.

 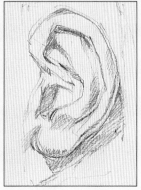

YOU WILL NEED

Piece of cream pastel paper	(for erasing mistakes)
Sanguine Conté pencil	Scalpel or craft knife (for sharpening Conté pencil)
Putty rubber	

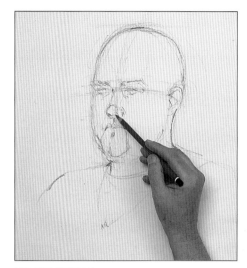

FIRST STEPS

1 ▲ Establish the proportions Using a sanguine Conté pencil, draw the outline of the head and shoulders. Measure proportions with your pencil and lightly mark in a curved line at the level of the eyes and another down the centre of the face to help place the nose. Sketch in the features and begin to develop them (see left).

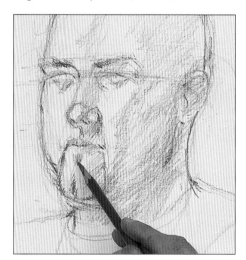

2 ▲ Work up some details Begin modelling the head with long, light hatching lines on the right of the head, neck and jaw. Lightly shade in the lips, marking a heavier line where they meet. Darken the beard and eyebrows, and the shadows under the nose.

209

MODELLING THE HEAD

Give the head a more solid feel by adding and refining areas of tone. Remember the head is lit from the left, so most of the shading will be on the right-hand side.

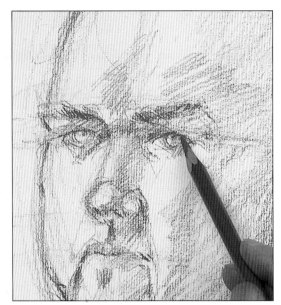

3 ▲ **Work on the eyes** As you develop the eyes, check that they still sit well on the curved guideline you drew in step 1. Emphasise the upper lids and hatch a little shading above them to indicate the shadow under the jutting brow-bone. Draw the irises and put in the pupils.

SENSITIVE LIPS

Avoid the temptation to draw lips with strong outlines and then shade them in afterwards. They will look more sensitively drawn if you use shading alone to define them. The top lip is shaded more heavily than the upturned lower lip, which catches the light.

The underlying structure

Underpinning the soft flesh of the face is the bony structure of the skull. Keep the shape of the skull in mind when you are drawing a portrait, as it helps you make sense of the features of the head. In both the three-quarter view and the side view shown here, you can see how the skull is based on a sphere and an egg-shaped oval. The facial area is quite small compared to the whole skull.

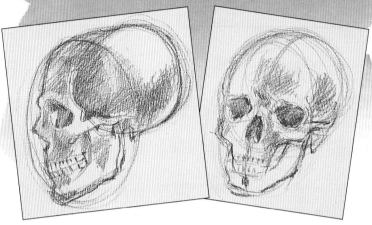

4 ▶ **Develop the mouth and ear** Work up some dark tone on the far right of the head, which is in the deepest shadow. Define the lips more clearly, but don't give them heavy outlines (see Trouble Shooter). Using a combination of shading and line work, define the outer areas and recesses of the ear.

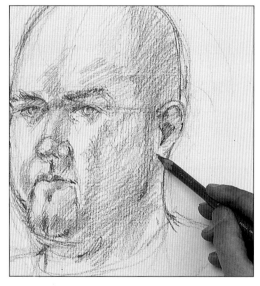

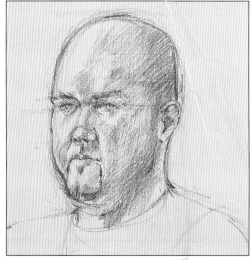

5 ◀ **Work on final details** Go over the outline of the head once more to firm up the shape. Make two emphatic marks for the nostrils and darken the beard. Lightly extend the shading on the right of the head and face, covering the whole cheek area except for a highlight under the eye.

A FEW STEPS FURTHER

Now that the head is worked in a lot of detail, a little more definition on the upper body will give a better balance to the portrait. Don't overdo it, though – the main point of interest is the head.

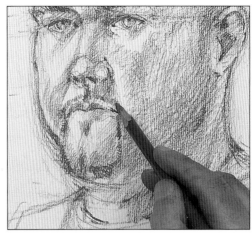

6 ▶ Sketch the T-shirt Lightly suggest the logo on the T-shirt and draw the silver chain and cross. Add light tone to the shoulder on the right with some well-spaced hatching lines.

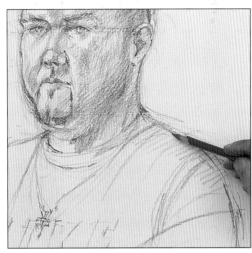

7 ▲ Put in the last facial details Sharpen the Conté pencil well and work over all the features, putting in details that you might have missed, such as the dots at the inner corners of the eyes. Complete the moustache and beard with short hatched lines.

THE FINISHED PICTURE

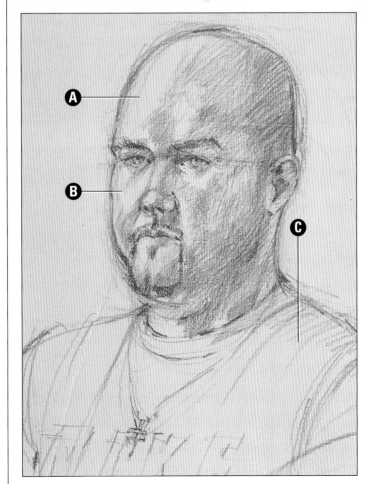

A Egghead
The distinctive egg-shaped form of the head can be seen quite clearly in this portrait, reflecting the underlying structure of the skull.

B Informative pose
The three-quarter view of the head, with strong lighting from the left, gives good contrasts of tone and shows the shapes of the features distinctly.

C Head and shoulders
The upper body, though only sketchily drawn, is necessary to anchor the head and put it in context, adding to the character of the portrait.

Shells in pen and wash

Bring out the wonderfully diverse shapes, textures and colours of shells with pen and wash.

S ea shells are fascinating in their variety. They come in all kinds of shapes, sizes, textures and colours. Some shells have a smooth, polished surface, others are rough or ridged. Shells such as the scallop are beautifully symmetrical, while others have irregular spikes or gradually widening spirals.

An ideal technique

A dip pen and ink are the ideal tools for capturing the complex shapes of shells, as you can achieve precise linear work with a fine metal nib. By changing the pressure you put on the nib, you can vary the thickness of your lines, and you can also build up textural effects by making marks such as hatching, cross-hatching and stippling.

Choose a smooth paper to work on, as the nib will move across it more freely than with a textured paper. Keep the ink flowing evenly as you work by frequently dipping the pen into the ink bottle. You can thin the ink if necessary by diluting it with distilled water.

A little colour brings pen and ink drawings to life. Here, watercolour washes were brushed over the finished shells to enhance the delicate hues.

◀ **An arrangement of different shells makes an interesting and harmonious still life.**

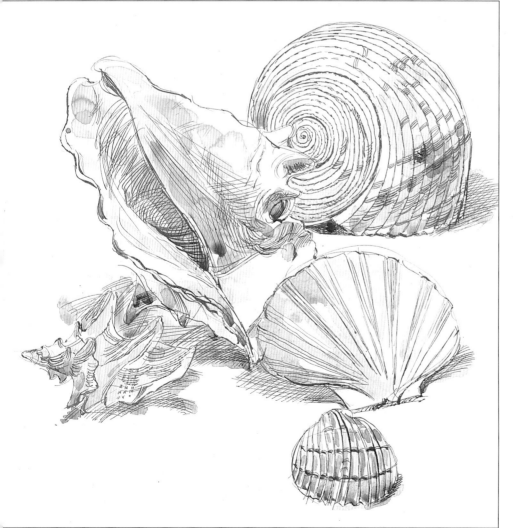

FIRST STEPS

1 ▼ Sketch the shells Using an 8B pencil, make a light sketch of the shells to guide your ink lines at the next step. Plot the main features, such as the curves of the spiral shell and the fan shape of the scallop.

2 ▼ Begin with pen and ink Dip a fine-nibbed pen into black Indian ink and start to go over the pencil outlines. Draw the conch shell, changing the pressure on the pen nib to produce both fine and thicker lines. Describe some of its curves with a little shading. Then begin outlining the smaller, spiky shell.

3 ▶ Add tone and detail On the small spiky shell on the left, describe the little 'horns'. Do this by building up the shadowed sides of the horns with parallel lines that follow the form.

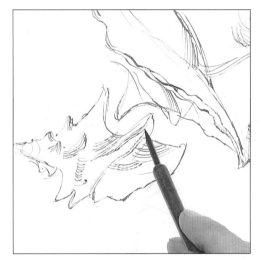

EXPERT ADVICE
Textural line work

At first glance, the large spiral shell looks smooth, but it actually has quite a rough texture. Indicate this by drawing the spiral with slightly jagged ink lines, using a tentative motion with the pen. Make sure that you maintain the curvature of the spiral as you work round the shell.

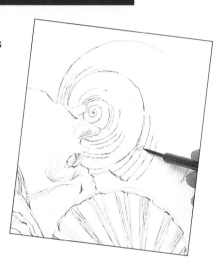

BUILD UP TEXTURE AND TONE

Once you have drawn over the pencil outlines in ink, build up the textural qualities of the individual shells and show their form through tonal shading.

4 ▶ Draw a spiral Outline the scallop shell and the small foreground shell, and put in their fanned-out ridges. On the small shell, draw rows of short curved lines to define the raised ridges. Using jagged lines (see Expert Advice), draw the spiral of the large shell. Narrow the gap between the lines at the centre.

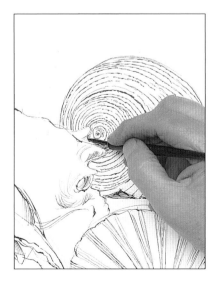

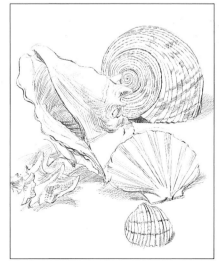

5 ◀ Draw shadows Cross-hatch a mid tone on the pink area inside the conch and a lighter tone on the outside of the shell. On the spiral shell, build up texture with short diagonal lines along each ridge. Cross-hatch the shadows cast by the shells, then erase the initial pencil lines with a putty rubber.

So far, the character of the shells has been built up through tone and texture, but you might like to add some subtle touches of colour with watercolour washes. Keep your drawing board horizontal while you are applying the paint to prevent runs.

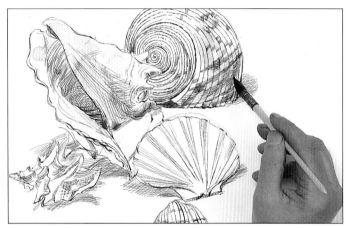

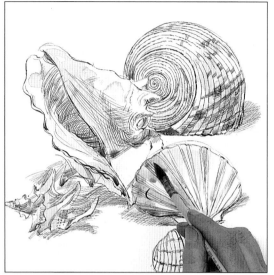

6 ▲ **Add colour wet-on-wet** Using a No.2 squirrel brush, mix alizarin crimson with cadmium red and wash over the pink part of the conch. Brush cadmium yellow across the top of the shell, letting the colours run together. Make a mix of burnt umber and a little raw sienna and loosely paint the spiral shell.

7 ▲ **Paint the smaller shells** Paint the spiky shell in yellow ochre, adding a little burnt umber for the darker areas. Mix alizarin crimson and Payne's grey to suggest the dark tone on the underside of the conch. Wash Payne's grey over the scallop shell. Complete the painting by working down the ridges of the small curved shell with burnt umber mixed with touches of Payne's grey and cadmium red.

THE FINISHED PICTURE

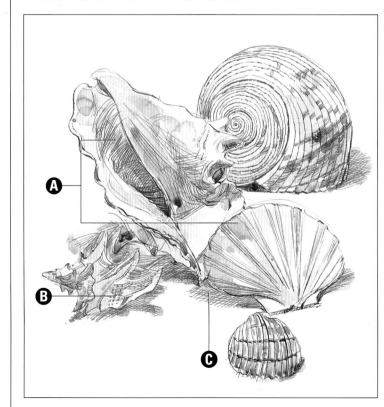

A Natural colours
Subtle washes of watercolour, loosely applied, were perfect to bring out the gentle pink, beige and grey hues in the shells.

B Making marks
The textures and patterns on the shells were built up with linear pen marks, including hatched lines and dotted patterns.

C Soft shadows
The cross-hatched lines forming the cast shadows were softened with loose washes of Payne's grey.

Hilly street in France

Apricot and carmine coloured pencils are ideal for rendering the warm shades of houses in the south of France.

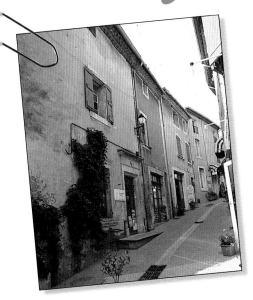

Although this steep road is mainly in the shade, the pale terracottas, pinks and peachy colours of the houses still catch the eye. The artist has captured the combined effect of shadow on warm colours by working the house walls in warm hues first, then superimposing shading using a purple pencil.

Dealing with angles

Because of the hill, it is important to check the angles created by the buildings and road to give a convincing impression of the upward slope. The artist is standing at the foot of the slope, with the street extending uphill away from him, so his eye-level is low. The perspective lines on the upper windows and tops of the lower windows therefore slant downwards, while the bases of the lower windows look almost horizontal.

At the same time, the hill has a slant of its own. The bases of the house walls follow this angle, as does the ramp outside the nearest house.

To heighten the impression of distance, the foreground is worked in more detail than the background. For example, the nearby window panes and door frames are more highly developed than those further away.

▶ **Coloured pencils were used both for the initial sketch and for rendering the lively shading in this atmospheric drawing.**

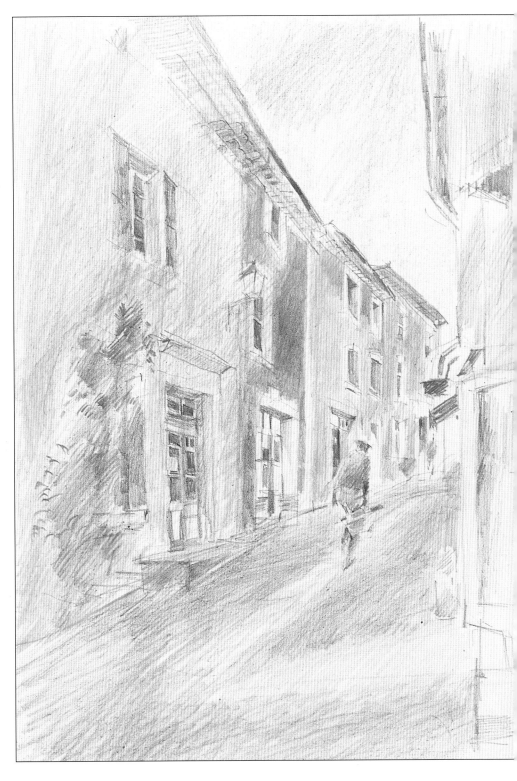

Piece of Hot-pressed watercolour paper	Purple; Olive green; Vandyke brown; Medium black; Crimson; Canary yellow
14 coloured pencils: Indian red; Light blue; Cobalt blue; Rose pink; Apricot; Carmine; Venetian red; Brown ochre;	Putty rubber (for erasing mistakes) Craft knife (for sharpening pencils)

FIRST STEPS

1 ▶ Sketch the scene

Use an Indian red coloured pencil to sketch the houses, checking the angles of the roofs, doors and windows with your pencil. You might find it helpful to mark in the eye-level line – this runs horizontally across the end of the road. For a little human interest, add a figure halfway along the street.

2 ▼ Fill in the sky
Define the nearest doorway and develop the three rows of tiles on the eaves. Using a light blue pencil, shade in the sky. As you move forwards in the picture plane, change to a cobalt blue pencil and make the sky darker – this gradation of dark to light helps to give a sense of recession. Shade the figure with the light blue pencil.

COLOURING THE WALLS

Various coloured pencils are used to capture the beautiful, warm, peachy shades of the house walls. Some are blended by working one layer over another, while others are used on their own.

3 ▶ Use warm shades for the walls
Shade rose pink over the walls of the two furthest houses, working over the nearer of the two with an apricot pencil to make a pale peachy colour. On the next house, shade the wall with a carmine pencil, then return to apricot for the first house in the street.

4 ◀ Add overall shadow
Continuing with the apricot pencil, shade the narrow strip of house wall showing on the right. Tone down the carmine house wall with Venetian red and brown ochre. With a purple pencil, use loose, lively strokes to add shadow overall (see Expert Advice opposite), to fill in some of the windows and to suggest the distant figure. Mark in the creeper with an olive green pencil, making textural dots and dashes.

5 ▶ Deepen tones
Use cobalt blue to add dark tone to the figure to help build its form. Work the same blue over the purple shadow on the road. Colour the ramp outside the shop on the left with brown ochre. With Vandyke brown, shade some of the window recesses and the gutter along the roof edge.

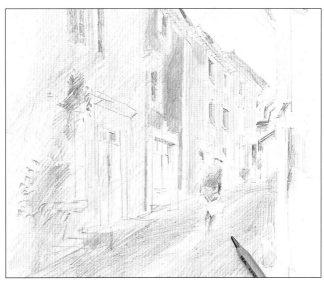

6 ▲ Develop the whole picture Draw the awnings on the right with cobalt blue and medium black. Fill in the shutters of the first house with Indian red, then define the window panes in Vandyke brown, leaving the frames as negative shapes. Use these brown shades for other window details, too. With medium black, emphasise the gutter and right-hand roof. Add olive green to the right-hand door, then warm up the road with Indian red.

7 ▲ Put in door and window details With Indian red, draw the wooden frame on the nearest door. Block in the glass panes with medium black. Darken the panes in the window above in the same way.

EXPERT ADVICE
Showing shadow

It's important to establish that the left side of the street is in shadow. To do this, lightly work purple over the road and the left-hand houses. This cools down the warm ochres and pinks of the walls without completely hiding the colours. It also unifies the picture and makes the house on the right – which is in sunlight – look brighter.

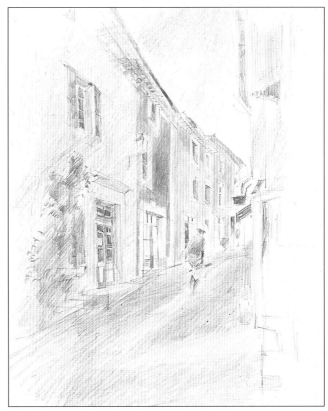

8 ▲ Add more details Blend crimson pencil over the walls of the carmine and pink houses. Develop the door of the carmine house with Indian red, then, with the medium black pencil, define the far window panes, the mouldings over the near door and the wall lamp. Add detail to the figure with Indian red, medium black and canary yellow. Lightly shade the right-hand wall with medium black.

The atmospheric scene is now almost complete. Warm colours dominate the picture, even though much of the streeet is in shadow. Just add a few more details to the houses and the figure to sharpen up the drawing.

9 ▼ **Work on the windows** Work more peach pencil over the near wall. Using medium black, darken the window recesses and shade in the glass panes in the second door along, leaving some white showing for reflections.

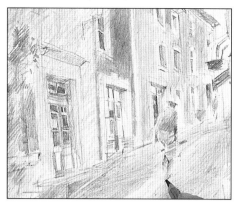

10 ▲ **Complete the figure** Using medium black, extend the roof gutter. Then emphasise the division between the third and fourth houses with Indian red. Finish the figure, using Venetian red on the hands and face and medium black on the feet.

THE FINISHED PICTURE

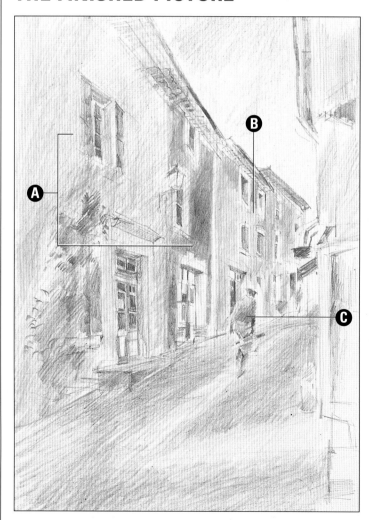

A Warm colours
The typical ochres, peaches and pinks of southern French village houses were rendered with warm shades of coloured pencil.

B Receding view
The architectural features of the further houses were deliberately left sketchier, so as to enhance the impression of the street receding into the distance.

C Human interest
A figure carrying French bread was put into the scene to give a sense of scale, enliven the empty stretch of road and add a little local character.

Using a bamboo pen

Cut your own bamboo pen and make a lively ink drawing. The spontaneous marks capture the rustic feel of fresh vegetables in a trug.

In spite of the extensive array of art equipment available these days, some of the liveliest pictures are those drawn with the simplest tools. This still life of vegetables was drawn in pen and ink, using both a bamboo pen that you can make for yourself (see overleaf for instructions) and an ordinary dip pen.

Fluid lines

With a bamboo pen, you can create wonderfully fluid and expressive lines. The nib has a softer feel than a metal nib and moves smoothly over the paper. You can make both heavy and fine lines, depending on the pressure you use. If a few blots and irregular marks appear here and there, these simply add to the excitement of the drawing. After using the pen for a while, you can resharpen the nib with a craft knife to keep it firm.

For a spontaneous effect in your drawing, try working in ink right away, without an initial pencil sketch. Alternatively, you can plot the outlines in pencil first, then work over the top in pen.

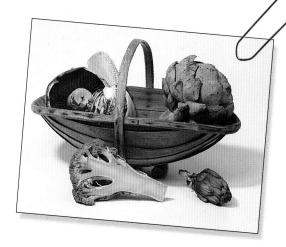

▼ To convey the variety of wonderful textures in this still life, the artist used both a metal-nibbed pen as well as a bamboo one.

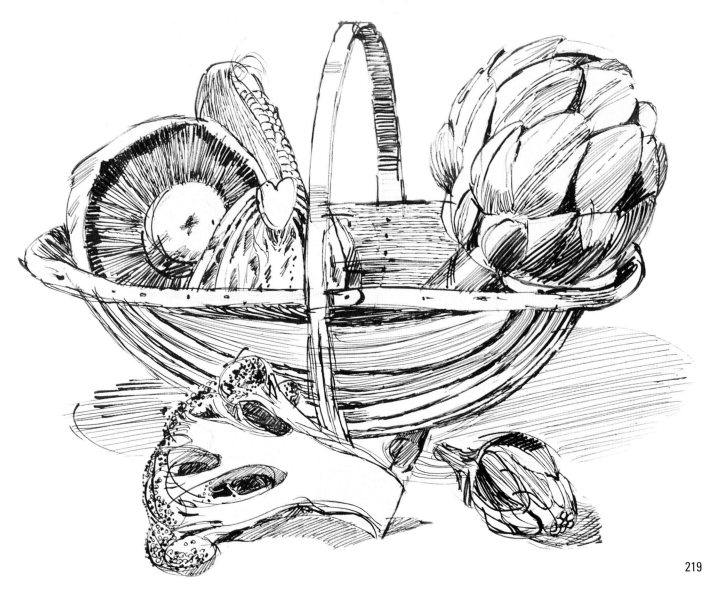

CUT A BAMBOO PEN

Making your own bamboo pen is simple, inexpensive and fun. All you need is a length of bamboo, readily available from garden centres, and a few basic tools. For safety when using a craft knife, make sure you direct the blade away from your body.

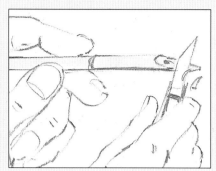

1 ▲ Shape a nib Cut a 20cm (8in) length of bamboo with a junior hacksaw. Trim one end at a 45° angle. With a craft knife, flatten the angle of the tip and carve away the sides until the nib is the thickness and width you want.

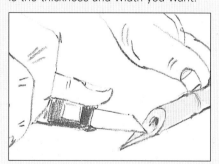

2 ▲ Cut a slit Rest the nib on a cutting board and, using the craft knife, cut a slit along the centre. The ink is held in this slit and will be slowly released as you draw with the pen.

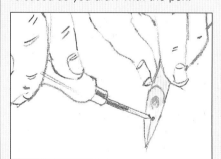

3 ▲ Make a reservoir Using a bradawl, bore a small hole at the base of the slit. This creates a reservoir so that the pen can hold a little more ink. To make the pen more versatile, cut a second nib of a different width at the other end of the bamboo.

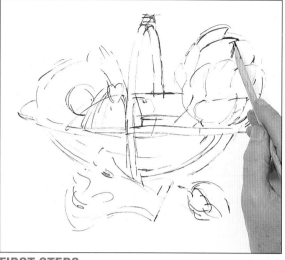

FIRST STEPS

1 ▲ Make an ink sketch Dip a bamboo pen into black Indian ink and draw the outline of the trug and the vegetables. Don't worry if you make errors – you can rectify these by painting them out with bleedproof white gouache (see Trouble Shooter on page 222).

2 ▶ Put in the cast shadows Develop the shape of the broccoli by drawing its florets in more detail, then begin putting in the gills of the mushroom. Look at the shapes of the shadows cast on to the white surface and hatch these in lightly with fine lines.

3 ◀ Change to a metal nib With the bamboo pen, draw the cast shadow of the trug on the left with a few lines. Now change to a dip pen with a fine metal nib and draw more mushroom gills, making the lines slightly irregular for a natural look. Use cross-hatching to darken the shadow at the top of the mushroom.

MAKING MARKS IN PEN AND INK

The type of mark you make in pen and ink depends on the nib you are using and how much pressure you apply to it as you move it over the paper. Some metal nibs are more flexible than others and give a greater range of strokes. Bamboo pens give characterful, slightly irregular marks.

▲ **These bold, decisive lines and dark hatching were made with the tip of a bamboo pen.**

▲ **A fine metal nib was used to create delicate lines, dotted textures and light hatching.**

CONTINUE WITH THE DETAILS

Carry on working with the dip pen with the fine metal nib to develop fine detail on the vegetables. Darker outlines and tones can be filled in later with the bamboo pen.

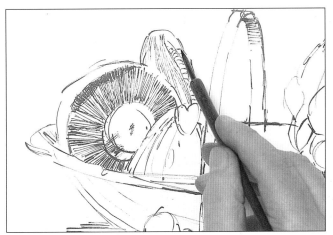

4 ▲ **Put in the corn kernels** Hatch tone under the trug handle. Complete the mushroom gills and make the shadow at the top even darker with closely worked lines. Draw the papery texture of the corn-on-the-cob leaves with loose hatched lines and the neat rows of kernels with small semicircular lines.

5 ▲ **Show more textures** Begin work on the red cabbage in the trug, alternating the straight spines of the leaves with the crinkly texture in between. Turning to the artichoke, show the fibrous texture of the leaves with thin ink lines. Make the lines irregular so that the effect is not too rigid, using the same technique as for the mushroom. Render some dark tone to show the shadows between the leaves.

6 ◄ **Develop the drawing overall** Continue working texture into the artichoke leaves, then move to the small artichoke in front of the trug and roughly hatch in texture on this too. Use hatched lines to indicate shadows on the top rim of the mushroom. Then strengthen the outline of the broccoli florets. Make long, irregular horizontal strokes to show the wooden texture inside the trug.

7 ▼ **Work on the trug** Darken the shaded area under the front rim of the trug. Using loose, sweeping lines, shade the front of the trug – these lines also help to build up the trug's curved form. Complete the shadow cast by the trug with a series of bold, well-spaced straight lines.

8 ▶ **Add texture to the broccoli**
Create texture on the broccoli head with tiny circles, blotting some of them with your finger to achieve a variety of tones. Shade the hollows between the stalks, using close marks for the dark tone and lighter hatching for the mid tone.

9 ▼ **Return to the bamboo pen** Using the thicker nib of the bamboo pen, mark a dark outline around the mushroom gills. With the same pen, put in some darker lines and dotted texture on the red cabbage.

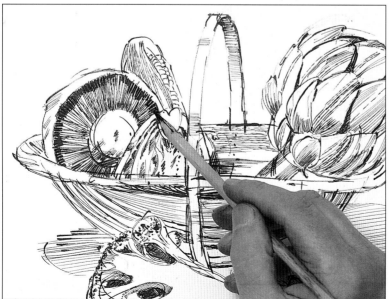

TROUBLE SHOOTER

CORRECTING MISTAKES

The joy of working with pen and ink is the spontaneity of the technique. Occasionally, however, you might misjudge a proportion or overdo a flourish. Small errors are simple to rectify by painting over them with opaque, bleedproof white gouache. Alternatively, on hard, smooth papers, you can first scrape away most of the ink marks with the blade of a craft knife without damaging the paper surface.

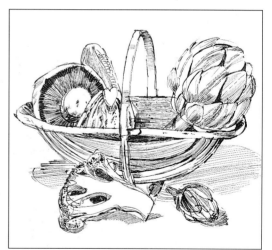

10 ▲ **Improve the textures** Change back to the metal nib to complete the lines inside the trug. Then return to the bamboo pen to darken the tone on the small artichoke and cross-hatch its shadow. Suggest the texture of its leaf tips with small circles. Clean up any errors with bleedproof white gouache and a No.4 round brush (see Trouble Shooter above).

If you want to work on the drawing a little more, you could heighten the tonal contrast by darkening the shadow areas. Extra details will sharpen up the picture.

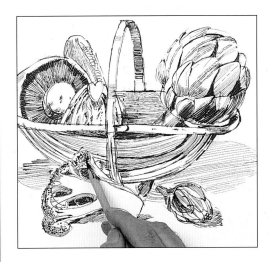

11 ◄ **Increase the contrast**
Use the bamboo pen to hatch more horizontal lines along the trug handle. Render darker tone on the side of the large artichoke. Darken the hollows in the broccoli and dot more texture on to the florets.

12 ▲ **Put in the final details** With the metal nib, add detail to the mushroom stalk. Draw fine fibres and more corn kernels on the cob. Use the bamboo pen to mark nails on the rim of the trug and dark lines between the segments of the trug's base.

THE FINISHED PICTURE

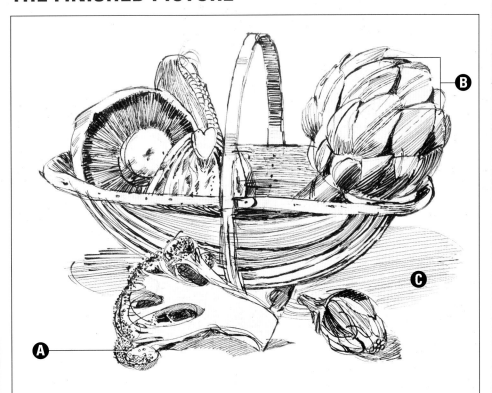

A Textural effects
The texture of the broccoli florets was created by working tiny circles and dots close together. Both bamboo and metal nibs were used for a range of effects.

B Contrasting line widths
The fine lines on the artichoke leaves were made with a metal nib, while the thicker marks were made with the broader nib of a bamboo pen.

C Tonal shadows
The cast shadows are varied in tone – mid tones were rendered with well-spaced hatching lines, while a dark effect was created by much closer hatching.

Self portrait

If you can't find a willing model to sit for you, the obvious answer is to draw a portrait of someone who is always available – yourself.

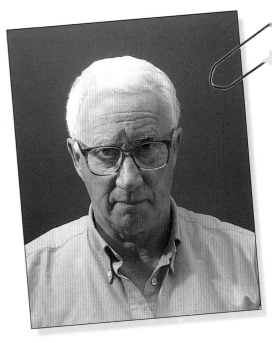

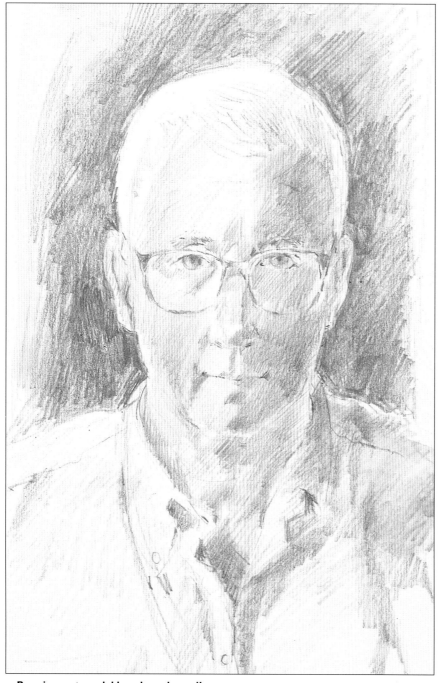

▲ By using water-soluble coloured pencils, the artist was able to combine lively shading with soft washes of colour.

If you are new to portrait drawing, you might feel uncomfortable about asking someone to sit for you until you have had more practice. Instead, an excellent way to find out more about the human face in your own time is by studying your reflection in a mirror and drawing from this.

For a full-face portrait, set up a mirror in front of you, about 30cm (12in) beyond your drawing board, so that you can see your head and shoulders comfortably and clearly. Alternatively, to view yourself from different angles, place two mirrors so that one reflects the image from the other.

It is natural to frown slightly as you look hard at your features and concentrate on capturing them on paper. Try to avoid doing this by consciously adopting a relaxed expression.

Light and colour

For this self portrait of the artist, the lighting was set up on the left, illuminating this side of the head and throwing the right side into shadow. This helped to emphasise the three-dimensional form of the features, as well as giving an interesting contrast of tones.

The lively colour on the face was achieved by gradually building up the flesh tones with layers of coloured pencil. Warm brown and rose pink are useful shades for flesh tones. They can be blended with a little water where required.

FIRST STEPS

1 ▼ Sketch the head Use a warm brown water-soluble coloured pencil to sketch the head and shoulders. Measuring the proportions with the pencil, mark guidelines to position the eyes, nose tip and mouth (see right). Sketch the features and indicate the main shadows.

2 ▼ Strengthen the shadow Still using the warm brown pencil, shade the upper lip. Darken the shading on the right side of the face, taking it down to the shirt.

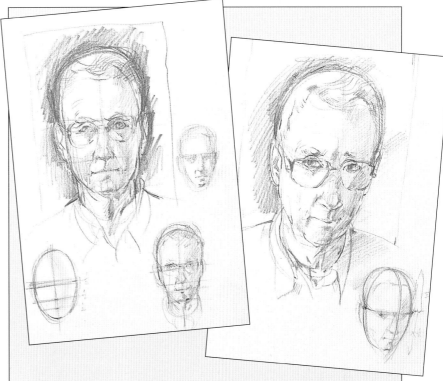

STRAIGHT ON OR AT A SLIGHT ANGLE?

A front view of your face (left) is easier to observe in a mirror and your features are positioned symmetrically. Notice how the eyes come about halfway down the head. The tip of the nose is about halfway between the eyes and chin, and the mouth halfway between the tip of the nose and the chin.

You can also try drawing yourself with your head slightly turned (right). This may be more pleasing in terms of composition, but is a more awkward position to achieve with a single mirror. You need to sit at an angle to the mirror or to turn your head frequently. The same guidelines for positioning the features apply, although the lines need to be curved to follow the form of the head.

BRING IN MORE COLOURS

Now that the structure of the face and the main tonal areas are mapped out, introduce more colours to build up a realistic flesh shade and define the features. Some of the colours can be blended into a wash with water.

3 ▶ Introduce a warm pink Extend the warm brown shading to the left side of the neck and very lightly shade the left side of the face, including the glass of the spectacles' lens. Then change to a rose pink pencil to warm up the flesh colour on the face and neck.

4 ▼ Define the eyes Darken the shadow above the nose, under the chin and on the right of the face with the warm brown pencil. Define the spectacles, shading lightly over the right lens. Develop the eyes, colouring the irises with a light blue pencil, then use the same colour to shade loosely over the shirt and add cool shadow to the white hair.

5 ▼ Shade a dark background Using a dark grey pencil, work lively shading across the background. Minor adjustments to the head outline can be made at this stage. The dark colour throws the head into relief and forms a strong contrast to the artist's white hair. Hatch a few textural lines over the right side of the hair.

6 ▲ Brush on some water Emphasise the pupils with the dark grey pencil, then change to a cobalt blue pencil to liven up the colour of the shirt. Now dip a No.1 brush into water and wash over the background to soften the dark grey pencil lines. Clean the brush, then use it to blend the two shades of blue in the shirt.

7 ▲ Warm the tone Using an Indian red pencil, warm up the tone on the right of the face. A little tone at the corners of the mouth lifts it into a smile. Shade lightly across the face with warm brown and rose pink, leaving highlights of white paper. Redefine the features with the warm brown pencil.

The lively rendering of the artist's face is now complete. There is always room to add a few more details to the features, but don't overwork them and risk losing the spontaneity of the drawing.

8 ▶ Shade a darker background With the dark grey pencil, deepen the tone around the head, fading the colour out towards the edges. Add texture to the eyebrows with a few jotted marks in warm brown and dark grey. Extend the shirt with light blue hatching.

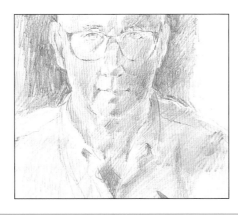

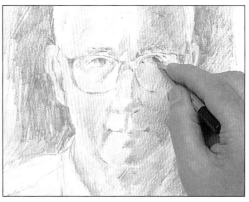

9 ▲ Add final definition Use light blue again to add depth to the irises. With Indian red, put in the final definition on the eyes, including the inner corner of the eye on the right. Darken the pupils with dark grey.

THE FINISHED PICTURE

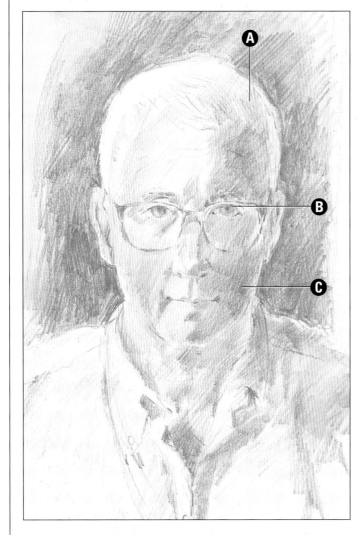

A Hair texture
Just a few loose lines in light blue and dark grey were drawn on the shaded side of the white hair to suggest its texture.

B Sensitive detail
The facial features, especially the eyes, were sensitively drawn with a sharp coloured pencil. They show the artist's character without becoming too dominant.

C Blended flesh tones
Layers of brown and a warm pink were worked lightly over one another, visually blending to give a warm and lively flesh colour to the face.

Composing carpentry tools

With their interesting shapes and worn appearance, these old woodworking tools make an ideal still life.

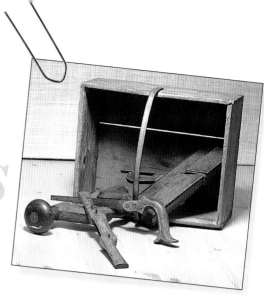

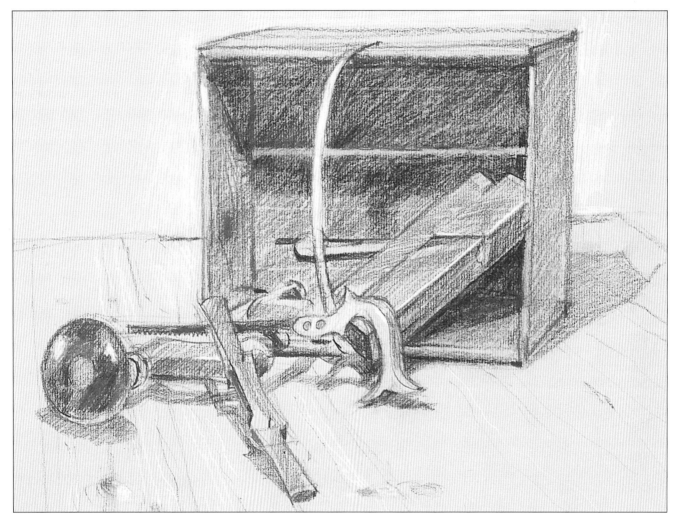

S oft, chalky Conté pencil and textured Ingres paper are a good combination of materials to bring out the character of these fascinating old woodworking tools (from left to right, a brace and bit, a spokeshave, a pad saw and a moulding plane). The wooden table and the light-coloured hessian form a suitable natural background to the still life.

Conté pencils in browns, black and white were used to build up the picture

and beige Ingres paper harmonises well with these colours. Unlike untoned paper, a tinted paper allows you to use a white Conté pencil to create crisp, eye-catching highlights.

Conté effects

You can achieve different effects with Conté, depending on how you handle the pencil. The rich, dark shadow inside the box was built up with layers of colour

▲ **Conté pencils in a range of shades are ideal for the natural colours of wood.**

shaded with the side of the pencil, for example, while the grain on the table was finely drawn with the tip. Dense tone, on the knob of the brace and bit, was rendered by putting increased pressure on the pencil; paler areas, such as the spokeshave to the right of it, were created with light, loose shading.

Piece of beige Ingres paper	Putty rubber (for erasing mistakes)
5 Conté pencils: Sepia; Burnt umber; Black; Sanguine; White	Craft knife and glass-paper (for sharpening pencils)
2B charcoal pencil	Spray fixative

FIRST STEPS

1 ▶ Make an initial sketch Draw the box using a sepia Conté pencil. Sketch the tools – the brace and bit protruding from the left of the box with the spokeshave and pad saw resting on it, and the plane on the right. Indicate the cast shadow to the right of the box and rough in the table top.

2 ▼ Start on the shadow areas Changing to a 2B charcoal pencil, strengthen the outlines of the box and tools where they lie next to dark-toned areas. Then, with a burnt umber Conté pencil, begin to fill in the mid-toned shadow inside the box. Notice how the shadow cast by the plane forms a dark triangle at bottom right.

3 ▲ Extend the shadows Still using the burnt umber pencil, work on the saw handle, describing its curved fish-tail shape. Firm up the outline of the box and continue shading its interior, pressing harder with the pencil where you want the tone to be darker.

BUILDING UP DARK TONE

The shadow inside the box is darkest towards the top. Rather than rendering this tone as a solid mass of black, build it up gradually with layers of burnt umber and black for a richer look.

4 ▶ Bring in deep tones With the burnt umber pencil, complete the mid-toned shading inside the box, then work over this with heavier shading to create the darkest area at the top. Deepen this tone still further with the charcoal pencil, strengthening the top and right edges of the box with dark charcoal lines.

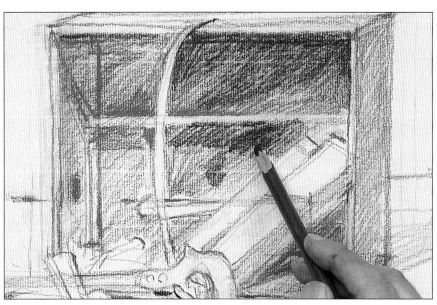

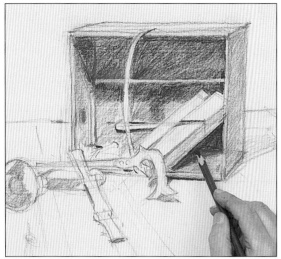

5 ◄ **Complete the dark tones** Continuing with the charcoal pencil, even up the deep shadow at the top of the box and in the right-hand corner. Work carefully around the plane, so that it retains its shape. Darken the edge of the plane's handle and blade detail.

EXPERT ADVICE
Achieving a sharp edge

If you are shading freehand along a straight edge, such as the gap in the base of the tool box, it can be difficult to achieve a clean, neat finish. You can avoid a ragged effect by shading over the edge of a piece of scrap paper. When you remove the paper, a perfect straight edge is revealed.

6 ► **Put detail on the tools** Change to a sharp black Conté pencil for the more detailed work. Shade the saw blade and define its handle. Refine the shapes of the other tools with the black pencil in a similar way.

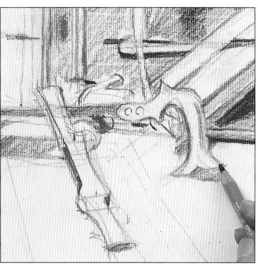

7 ▼ **Introduce warm colour** Carefully draw the saw teeth. Build up the form of the brace and bit with tonal shading, letting the beige paper stand for highlights. Draw the tools' shadows on the table. Bring in some warm colour by working sanguine Conté over the plane and spokeshave.

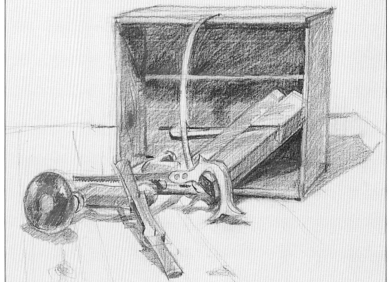

8 ▲ **Add final details** With the black Conté pencil, complete the shadows of the tools on the table and shade the bottom edge of the plane. Add variation to the deep shadow inside the box with a further layer of burnt umber shading. With a dash of sanguine, warm up the knob on the brace and bit, then use this colour to suggest a few knots of wood in the table top.

To add more contrast to the drawing, use a white Conté pencil to emphasise the brightest highlights on the box and tools.

9 ▶ Improve the highlights
Emphasise the lightest tones in the drawing with touches of white Conté pencil, adding highlights to the box handle, the saw handle, the brace and bit, the lower edge of the plane and the top edge of the box.

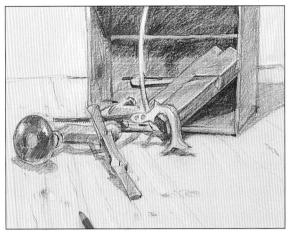

10 ▲ Work on the table texture Loosely mark grain lines on the table top with white, sepia and sanguine Conté, then add more knots in sanguine. Suggest the light-coloured hessian background with a little white Conté around the box.

THE FINISHED PICTURE

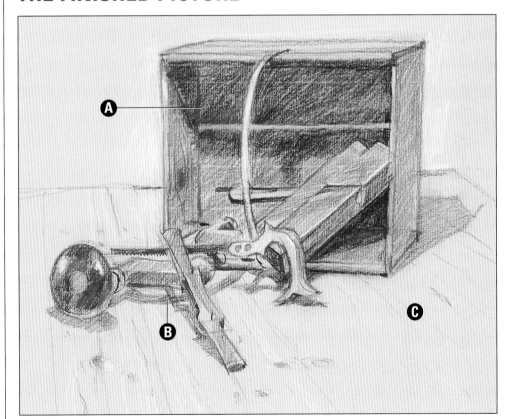

A Layers of shading
The rich, deep brown shadow inside the box was built up with layers of burnt umber and black to give a subtle, variegated finish.

B Shadow shapes
The cast shadows are not nearly as deep as those in the box – so they have been rendered with rather loose strokes.

C Wood grain
Just a suggestion of the wood grain on the table top is enough to convey its texture, and helps lead the eye towards the still life.

Portrait of a girl

Using black and grey drawing sticks – together with the traditional colours of sepia and sanguine – helps give this portrait a timeless charm.

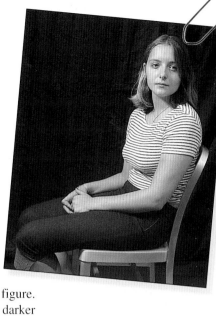

Sanguine, sepia, black, grey and white – these traditional colours and shades have been favoured through the centuries by artists such as Leonardo da Vinci (1452-1519) and Peter Paul Rubens (1577-1640) for drawings and preparatory cartoons for paintings. They have been used to good effect in this portrait of a girl, although a more modern note has been introduced with a little blue pastel on the model's jeans.

The initial drawing and the darkest tones were rendered with the black drawing stick, and a grey drawing stick provided a strong tone for the background. A warm, flesh colour was introduced with sanguine, while sepia and white created contrasting lights and darks in the model's hair.

White was also used for the striped T-shirt, which plays an important part in helping to define the contours of the figure. The grey Ingres paper stands for the darker stripes on the T-shirt, and is a useful, mid-toned support that suits the neutral and earth shades.

◀ By omitting the model's lower legs, the artist creates a compact composition with a strong diagonal running from bottom left to top right.

YOU WILL NEED

Piece of grey Ingres paper

2 artist's drawing sticks: Black; Grey

2B charcoal pencil

3 Conté pencils: White; Sanguine; Sepia

2 soft pastels: Prussian blue; Pale flesh

Putty rubber (for erasing mistakes)

Craft knife (for sharpening pencils)

FIRST STEPS

1 ▼ **Make a sketch** Using a black drawing stick, sketch the head at the top right of the paper, putting in guidelines to help position the facial features. Mark the central axis of the body, then draw the torso and legs. With the side of the stick, lightly shade the background.

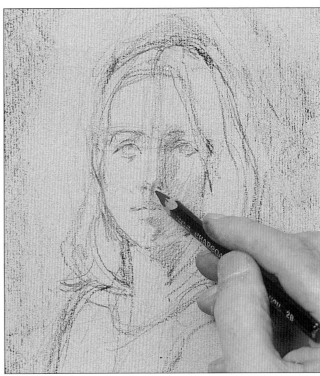

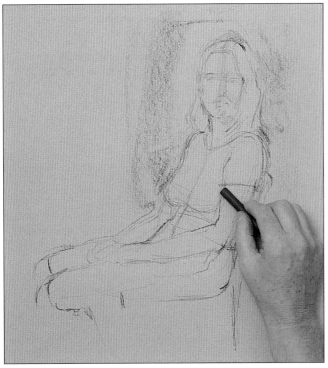

2 ▲ **Draw the features** Change to a sharp 2B charcoal pencil and put in the shaded area on the right of the face down to the neck, leaving the prominent cheekbone and the forehead unshaded. Now bring out some of the detail in the eyes and nose. Lightly shade the shape of the mouth, defining the line where the lips meet.

INTRODUCE WARM COLOUR

At this stage, you can start to warm up the flesh colour by using a sanguine Conté pencil on the face and arms. The addition of further neutral colours helps to extend the range of tones in the portrait.

3 ▶ **Add sanguine Conté** Dot in highlights on the eyes with a white Conté pencil and darken the pupils with the charcoal pencil. Then, with a sanguine Conté pencil, add colour to the brow, cheeks, lips and just below the nose. Work some sanguine over the shaded parts of the arms and hands.

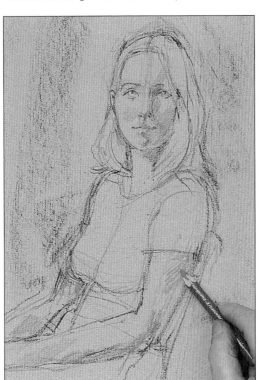

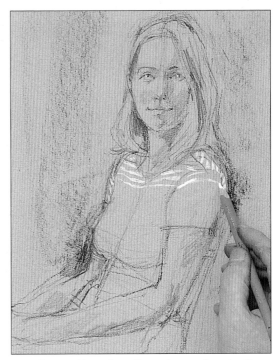

4 ▲ **Draw white stripes** Extend sanguine shading down the neck. Change to a sepia Conté pencil to render the dark tones in the hair. With the white Conté pencil, begin drawing stripes on the T-shirt. Notice how they curve on the sleeve, indicating the shape of the shoulder underneath.

5 ▶ **Continue the stripes** Work stripes across the rest of the upper body, using them to define the shape of the breasts, stomach and back. Take up the sepia pencil and add more shading to the hair, so that it frames the face on the right. Using the white Conté pencil, brighten the hair with a few highlights and lighten the chair with a pale outline.

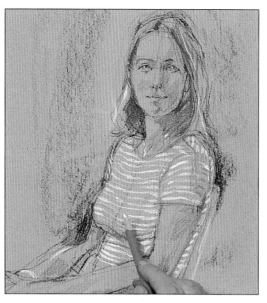

EXPERT ADVICE
Creating a smile

Facial expressions can be changed with tiny adjustments to the drawn features. Whether your model is smiling or not, you can create a subtle closed-mouth smile by adding little upturned marks at each corner of the mouth. This is preferable to an open-mouthed smile with teeth showing, which can easily look like a grimace.

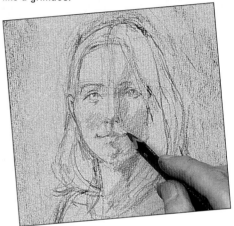

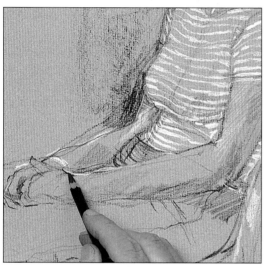

6 ◀ **Work on the hands** Continuing with the white Conté pencil, render light tone on the upper arms and outline the forearms down to the hands. Changing to the charcoal pencil, add definition to the hands and shade the top part of the jeans.

7 ▶ **Introduce grey shading** Put in white highlights on the brow, the tip of the nose, the cheek-bones, above the mouth and on the hands. Now use a grey drawing stick on its side to extend the dark background. Shade the jeans in grey, too, working the creases with darker lines made by pressing harder on the pastel tip.

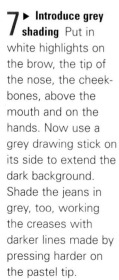

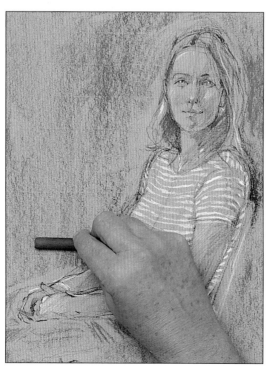

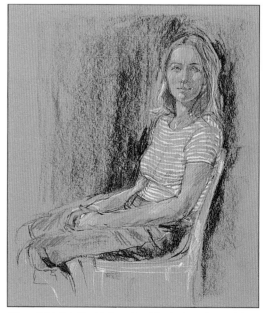

8 ▲ **Add details** Using the black drawing stick, darken the shading around the body. Rub on some dark tone on the shaded part of the jeans, indicating the seamline. With the white pencil, add a few streaks to the hair and build up the shape of the chair. Warm up the face with more sanguine Conté, brightening it with additional highlights in white.

Although the portrait owes its character to the use of neutral and earthy colours, it is fun to inject a splash of colour by using a blue soft pastel on the jeans and in the eyes.

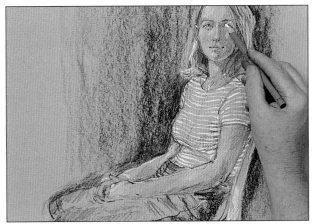

9 ▲ **Strengthen darks and lights** With the charcoal pencil, deepen the shadow on the underside of the hair and strengthen the background tone above the legs. With the white Conté pencil, draw highlights on the eyelids, under the eyes, on the left of the chin and on the ear.

10 ▼ **Put in a splash of colour** Sharpen the facial features with the charcoal pencil. Then, with a Prussian blue soft pastel, rub some colour over the jeans, darkening the deepest shadows with a little black Conté blended over the top. Touch in a little blue on the irises. Finally, add a few warm highlights on the hair with a pale flesh soft pastel (see Finished Picture below).

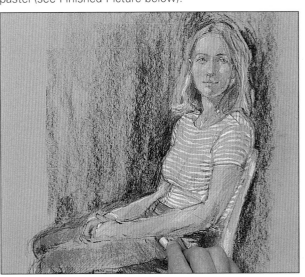

THE FINISHED PICTURE

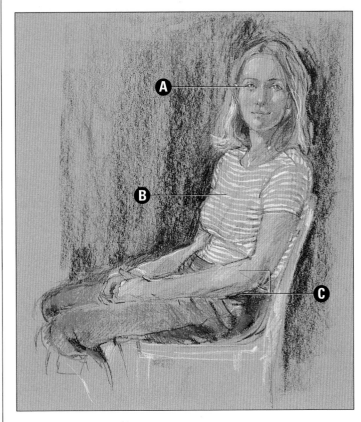

A In the eyes
The artist draws the viewer's attention to the eyes by sharply defining the lids, eyeballs and pupils. He also adds highlights on the tops of the lids and tiny catchlights in the eyes themselves.

B Revealing form
The stripes on the T-shirt are helpful to the artist as they follow the form of the figure underneath.

C Flesh tones
To describe the flesh tones, sanguine is used for the shadow areas while the paper is left untouched on the lit areas. The white Conté is used only for the palest highlights.

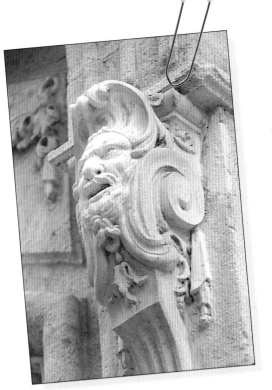

Decorative details

Use pencil and watercolour wash to depict the intricate details and warm tones of a classical head carved in honey-coloured stone.

Old buildings often have a wealth of decorative features that can provide inspiration for artists. Stone carvings, such as this classical head from Aix-en-Provence in France, are interesting to draw because they have well-defined contours and are often highly embellished with garlands, curlicues and drapes. Figurative carvings of this kind also offer a softer contrast to the hard geometric lines of the building itself.

Choosing a subject

When you visit old buildings, look out for floral carvings, gargoyles, religious statues and mythological figures placed above doorways and windows or on columns. If they are positioned too far up on the building to draw easily, try taking a photo with your camera, set at maximum zoom.

Observe carvings from different angles – a head is likely to look more interesting viewed from the side or at a three-quarter angle rather than straight on. Ideally, the light should be bright enough to cast strong shadows that will bring out the three-dimensional nature of the subject. By half-closing your eyes, you can identify the areas of light and dark tones more readily.

▶ **The strong lines of this carved stone head are rendered with a vigorous pencil drawing enhanced with tonal washes.**

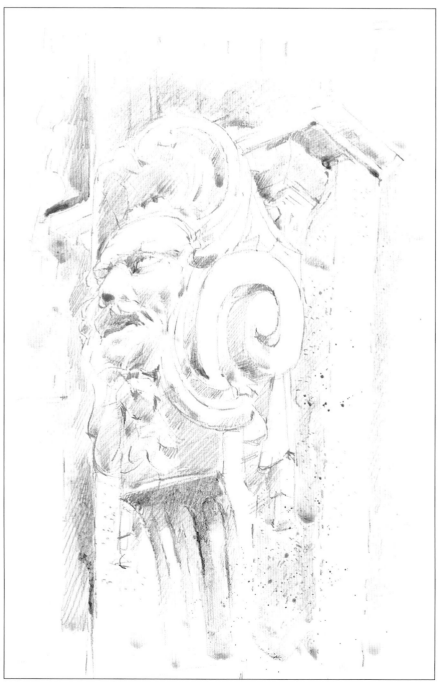

FIRST STEP

1 ▶ Make a pencil sketch Using a 4B pencil, first establish the straight edges of the column above the carved head. Then roughly sketch the head with its beard and highly stylised hair. Mark in the facial features. Draw the large curlicue to the right of the face before continuing with the straight lines of the column to the side of and below the head.

YOU WILL NEED

Piece of Hot-pressed watercolour paper

Graphite pencils: 4B and 6B

Putty rubber (to erase mistakes)

Craft knife (to sharpen pencils)

3 watercolours: Raw sienna; Cobalt blue; Sepia

Brushes: No.1 squirrel; No.4 soft round

Mixing palette or dish

Granulation medium

BUILDING UP FORM

For the next few steps, start to build up a tonal picture. This will throw the stonework into relief and bring out the complexities of the carving. Add more definition to the carved features with a well-sharpened pencil.

2 ▼ Strengthen the drawing Strengthen and sharpen your initial lines, checking the angles of the column as you go and making sure all parts of the structure line up correctly. Change to a 6B pencil to begin rendering shadow on the face, curlicue and column.

3 ▶ Work on the shading Develop the shadows on the head, working on the mouth, nose tip and hollows of the hair and beard. Darken the column to the left of the hair. On the lower part of the column, draw fluted carving, then hatch across this area.

4 ▲ Define the column Complete the shading on the hair, then draw a few small curls just above the forehead. Returning to the column, begin defining its facets with hatching, pressing harder with the pencil to show the deepest shadows in the corners.

5 ◄ Model the face Define the eye and nose, and add very dark tone inside the mouth. Show the planes of the cheek with blocks of shading, and darken the tone on the beard. Hatch around the lower edge of the curlicue, putting the darkest tone into the spiral where it narrows. Then shade loosely across the top of the column.

6 ▼ Add definition overall Define the face further with line work and shading, particularly on the eyes and moustache. Draw the draped detail just below the curlicue. Working carefully around the face, shade down the left-hand side of the column. Bring out the fluted pattern on the lower column by hatching around the grooves, leaving them as paler shapes.

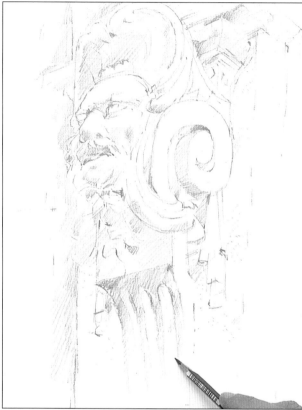

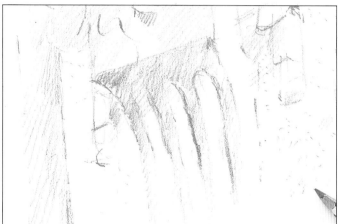

7 ▲ Create texture One of the characteristics of the old stone column is its pitted, weathered surface. Show this textured effect with scattered dots and flecks made with the pencil. Extend the right-hand edge of the column with dashed lines and a little hatched shading.

 **EXPERT ADVICE
A grainy look**

You can give normally smooth watercolour an interesting grainy texture by diluting it with a clear liquid known as granulation medium. This mix dries on the paper to create a mottled or speckled effect – perfect for representing the texture of the masonry in this project.

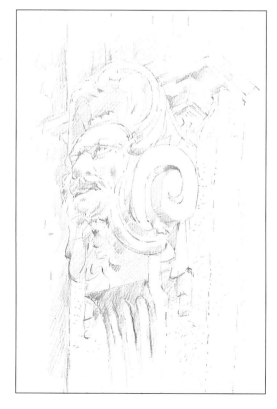

8 ◄ Complete the column The stone column is allowed to fade out gradually at the edges to avoid giving a hard outline to the composition. Lightly draw the ribs of the column above the head and roughly outline some carved detail at top left.

By adding washes of watercolour mixed with granulation medium, you can enhance the drawing with a grainy, stone-like surface.

9 ▶ **Add textured colour** Mix raw sienna watercolour with a little cobalt blue and some granulation medium. Using a No.1 squirrel brush, paint over the column and curlicue. Brush more colour on the hair and beard of the carved head.

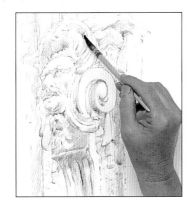

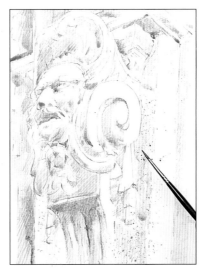

10 ◀ **Deepen tones** Add sepia to the mix and paint the wall on the right. Mix in more cobalt blue for the darker areas. Adding more raw sienna, paint the column top and touch in shadows on the face. Vary the texture by spattering with a No.4 round brush.

THE FINISHED PICTURE

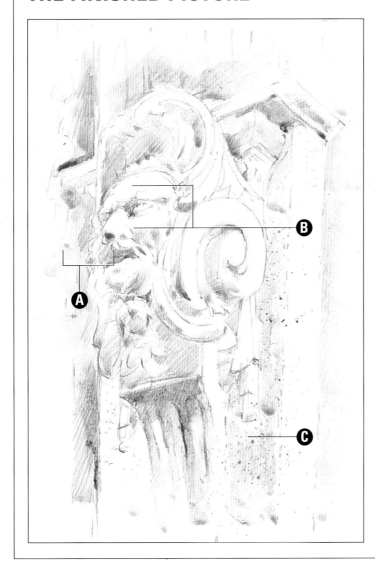

A Warm washes
The watercolour washes not only warm up the picture with their golden hues but also reinforce the mid and dark tones on the carving.

B Pale tones
The pale tones were created by letting the paper show through. In contrast to the washes, these areas really seem to leap forward.

C Weathered wall
Various techniques were combined to create the rough texture of the wall: pencil mark-making, use of the granulation medium and spattering paint.

A game of chess

The rules of perspective are the same whether you are looking at a landscape or an object immediately in front of you, as this chessboard illustrates.

In a landscape or street scene, the effect of perspective on roads, telegraph poles and buildings is easy to see – parallel lines in the scene appear to converge as they go off into the distance. This impression of convergence is still true of parallel lines on a smaller, more immediate scale and is illustrated perfectly by looking at a chessboard set squarely in front of you. Here, too, the lines seem to converge towards the back of the board.

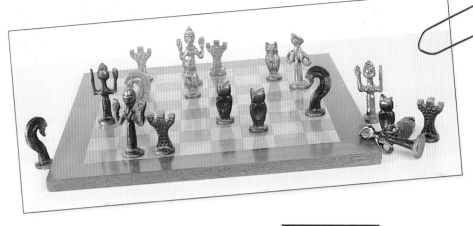

Shorter and narrower

To show this effect in a drawing, you need to extend the sides of the chessboard and the lines of squares parallel to them to an imaginary point on your eye level – this will give an accurate rendition of what you actually see.

Another visual effect that takes place is foreshortening. The lines of squares that run across the board gradually become compressed as they recede into the distance, so the squares nearer look wider than those farther away. To achieve a strong impression of foreshortening, set the chessboard quite high – at about mid chest level.

This pen-and-wash drawing is

worked on hot-pressed watercolour paper, which has a smooth surface ideal for pen work and watercolour washes. Plot out your initial perspective drawing of the chessboard with a soft pencil, as you might have to erase some of the lines when you check angles.

If you are worried about getting the lines straight in the early stages, use a ruler. Once you start working in ink, though, keep your line work freehand.

▼ **Fine pen work captures the details of chess pieces, while the tones are rendered in watercolour washes.**

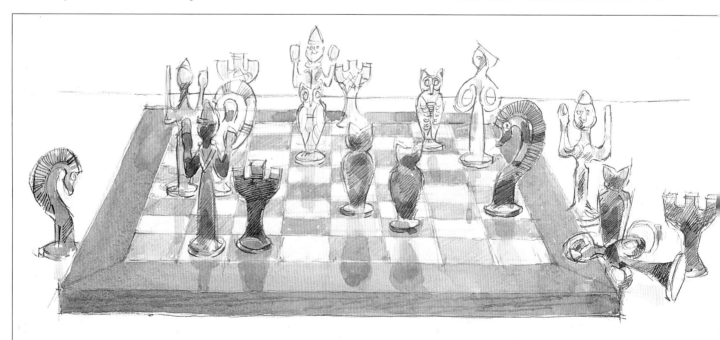

FIRST STEPS

1 ▼ **Make a perspective drawing** Using a 3B pencil, draw the front of the chessboard near the bottom of the paper. Now draw the sides of the board, checking the angles with two pencils held out at arm's length, or by using croppers with swivelling arms. Extend these lines to the vanishing point on your eye-level line. You can then mark off the squares at regular intervals across the front of the board, extending these lines to the vanishing point too. Next, mark the horizontal bands of squares, judging the spacing by eye or using the method shown in the box on the right. Start to sketch the chess pieces.

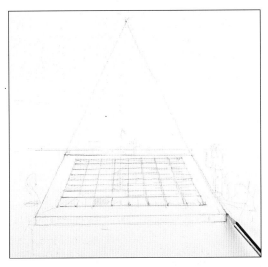

2 ▼ **Shade in the squares** Still working in pencil, shade in the dark squares to check that you have put in the correct number and that the board looks accurate overall. Make any necessary adjustments. Work up the chess pieces to the left and right of the board.

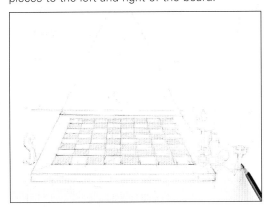

3 ▶ **Outline the chess pieces** Draw the outlines of the chess pieces on the farthest squares, checking how high they stand – you can use the back of the table as a guide. Gradually moving towards the front of the board and working over the marked squares, outline the remaining chess pieces.

A SERIES OF SQUARES IN PERSPECTIVE

Here is a simple and accurate way of drawing a series of same-sized squares or rectangles in perspective. This technique will help you not only with a chessboard, but also with such features as a railway line with sleepers at regular intervals, or a path with paving slabs of equal size.

1 Draw the first square (or rectangle) ABCD by eye. Check that the angles of AC and BD are the same, using a protractor if necessary. Then extend lines CA and DB to meet at a vanishing point (VP) on the horizon.

2 Mark diagonals AC and BD across the square. Through the intersection of these two lines, draw a vertical line FE and extend it to the vanishing point.

3 Now draw a line from C through E, extending it to the right at H. Draw a line from H to G, parallel to AB. You now have a new square (GHAB), which is a repeat of ABCD in perspective. To create another square, repeat this step in GHAB.

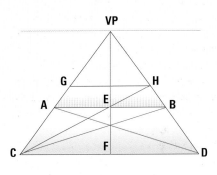

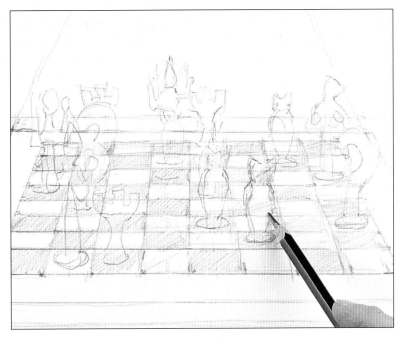

4 ▶ Rub out the squares

Using a putty rubber, erase the lines of the chessboard squares that fall behind the chess pieces. The shapes of the pieces will now begin to stand out from the background.

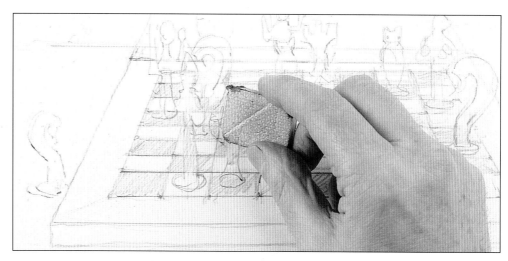

DEVELOP THE DRAWING IN PEN

Now that the chessboard is accurately sketched, you can begin to give definition to the drawing by changing from pencil to a sepia pen. Depth and tone will be developed with washes of watercolour.

5 ▶ Start the pen work

Using a sepia waterproof fibre-tip pen, strengthen the outlines of the chess pieces on the right of the board. Work with expressive lines rather than just going over the previous pencil marks. Put in details of the facial features.

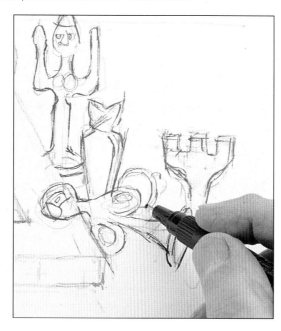

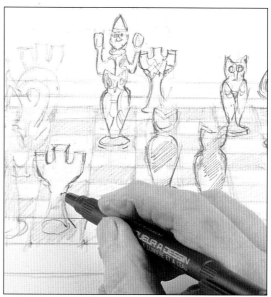

6 ▲ Add tonal shading

Continue working up the chess pieces on the board, adding features such as the hats on the figures of the bishop and king, the wings on the owl-shaped pawns and the crest on the bird-like knight. Using fine hatched lines, put in some tonal shading on the pieces.

7 ◀ Outline the board

Working across to the chess pieces on the left, complete the hatched shading and details – the forms of the figures now begin to emerge. With long strokes of the pen, work over the pencil outlines of the chessboard and table.

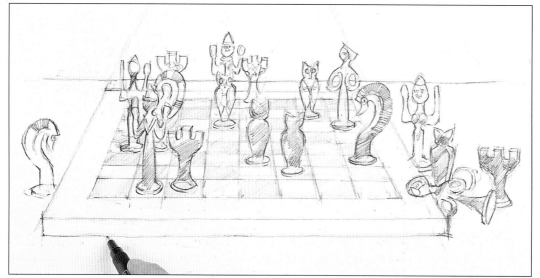

8 ▸ Begin using watercolour

Using a No.4 round brush, mix a medium wash of burnt umber watercolour and paint the dark squares on the chessboard. This immediately gives the board a sense of solidity and throws the chess pieces into relief.

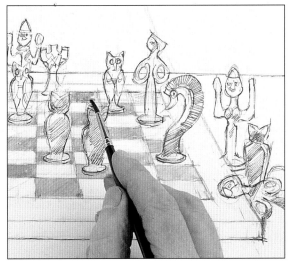

A FEW STEPS FURTHER

By adding even darker washes of the burnt umber watercolour, you can model the chess pieces more effectively. If you want to work a few extra details on the figures, allow the watercolour to dry, then draw on top of it with the waterproof pen.

9 ▸ Put in pale tones

Mix a very pale wash of burnt umber and paint the light squares on the board. Suggest the cast shadows of the pieces on the shiny surface, using the medium wash on the pale squares and a deeper wash on the dark squares. Change to a No.1 squirrel brush and work the medium wash around the edge of the board.

10 ▾ Work darker tones

Mix a strong wash of burnt umber. Using the No.4 brush, build up the form of the black chess pieces with the strong and medium mixes. Put a little pale colour on the gold pieces to model their form too. Returning to the squirrel brush, paint the strong wash of burnt umber around the border of the chessboard.

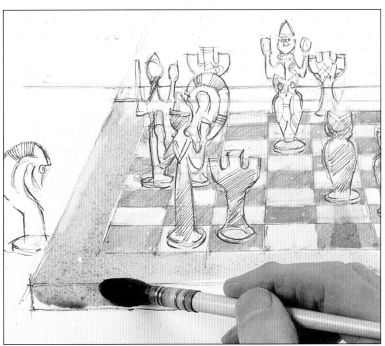

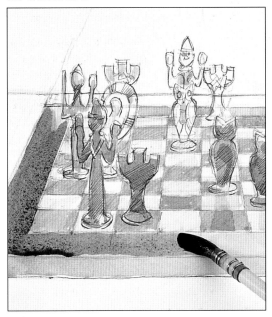

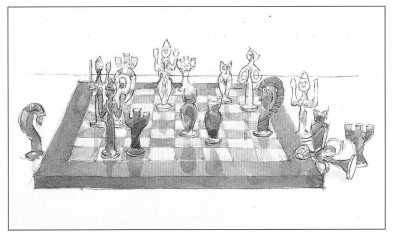

11 ▴ Add more reflections

The deepest tone is on the front edge of the board. Make a stronger mix of burnt umber for this and paint it on. Look for more of the chess pieces' cast shadows on the surface of the board and add these in varying tones – the reflections help to anchor the pieces to the board and create a feeling of depth.

12 ▶ Define the chess pieces Use the No.4 brush to describe a wood grain texture on the edge of the board. Then develop the forms of the gold chess pieces with a pale wash of burnt umber and the black chess pieces with a very strong mix of burnt umber.

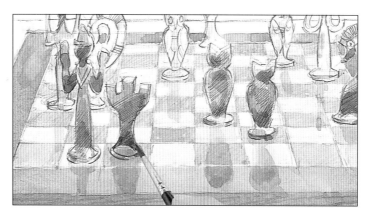

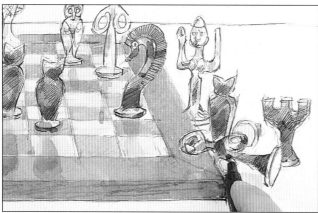

13 ◀ Return to the pen Once the watercolour has dried, you can put in some final detailed touches with the pen. For example, add more hatched shading to the chess pieces on the right.

THE FINISHED PICTURE

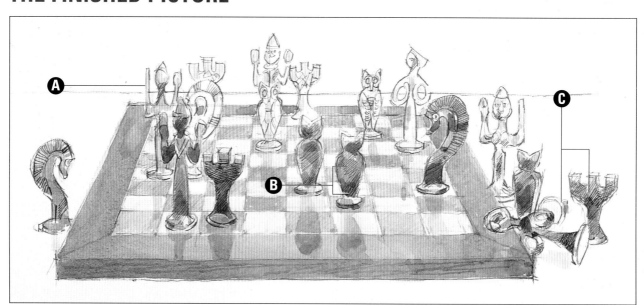

A Sharp details
By using waterproof ink, the artist ensured that the drawn lines remained clear and sharp, even after the watercolour washes were applied over them.

B Shades of umber
Washes of varying strengths were mixed to provide a range of lights and darks. These varied tones were used to build up the form of the chess pieces.

C Captured pieces
The randomly arranged pieces next to the board add a little life to the image. They allow the board to be placed to the left of the picture, creating a pleasing, off-centre composition.

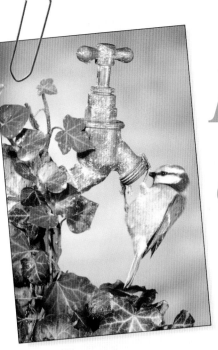

Bird study in coloured pencils

Bring an acrobatic blue tit to life with the help of canary yellow and kingfisher blue pencils.

When you are drawing a small garden bird, such as this blue tit, you'll need a delicate touch to convey the soft texture of the feathers on its body. To emphasise the distinctive lines of its markings and the clarity of its colouring, on the other hand, it is better to use firmer, more precise marks. Coloured pencils are an ideal medium for this project. The leads can be used on their sides for subtle shading and sharpened to fine points for detailed work.

Painting with pencils

This picture is a shaded drawing rather than a line drawing. The artist built up colours layer upon layer so that they mixed optically to produce new, richly glowing hues. The texture of the Not watercolour paper gives an attractive, grainy appearance to the image and allows specks of the white surface to show through. For deeper colours, such as those on the bird's dark head stripe, you will have to dig in hard with your coloured pencils to cover all the white.

Composition

When composing the picture, feel free to rearrange any distracting elements. Here, the ivy leaf near the bird's tail was left out so that it didn't spoil the clean lines. The leaves and background were faded out around the edges of the composition to create a pleasing oval shape.

▶ **This blue tit has a three-dimensional quality, achieved by building up its form and feathery texture over many stages.**

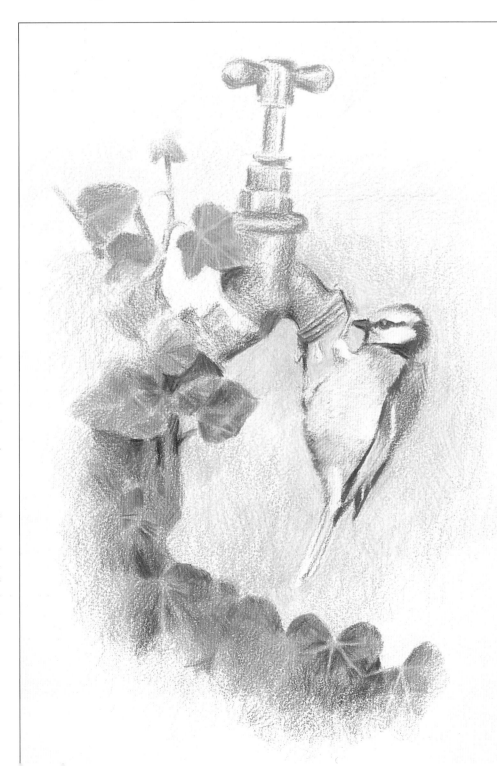

FIRST STEPS

1 ▼ Map out the picture Using the kingfisher blue pencil, outline the bird and tap. Draw some of the ivy leaves on the left to show the outer edge of the drawing. Using the side of the lead, suggest tone by shading the dark areas on the leaves, tap and bird. Define the bird's beak and head stripe with heavier pressure on the tip.

2 ▲ Add more leaves Continuing with firm strokes, darken the blue shading on the bird's head and wing. Draw a few more ivy leaves on the left and bottom of the composition and shade them lightly. Look for the shadows on the leaves and begin to differentiate the dark tones from the light ones by working across some of the leaves more energetically.

3 ▼ Show the leaf veins Extend the ivy leaves towards the right, underneath the bird. Describe the veins on the largest leaves by shading carefully around them, leaving the white paper showing through to form negative shapes.

DEVELOPING THE PICTURE

From step 4 onwards, many more colours are introduced into the picture. In some places, several colours are layered over one another to create a range of vibrant shades.

4 ◄ Blend blue and yellow Change to a canary yellow pencil and work over the blue leaves, including the white veins – the blue and yellow blend visually to give a range of greens. Shade yellow over the bird's breast. Then continue right across the background, working with the side of the lead and changing direction now and again to create an even finish. Fade out the colour towards the edges of the picture to avoid a hard edge.

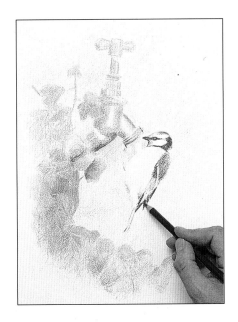

5 ◄ **Work up detail** Work a grass green pencil over the background, then use the same colour to brighten the leaves. Changing to brown ochre, describe the structure of the tap, including its facets and screw thread. Leave white paper to stand for highlights. Use the brown ochre on the tree stump and to draw some ivy stems. With a sharp Prussian blue pencil, define the beak, head markings and wing tips on the bird, pressing hard to make a rich colour. Darken the shadow under the tap with a black pencil.

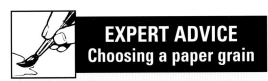

EXPERT ADVICE
Choosing a paper grain

The degree of texture in a drawing depends largely on the grain of the paper. On smooth paper (left), the pigment covers most of the surface. On medium paper (centre) – such as the Not watercolour paper used by the artist in this project – the pigment doesn't fill the grain as much. On rough paper (right), lots of white paper shows through, producing a pronounced texture.

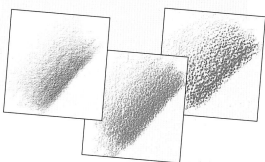

6 ► **Develop the bird** Returning to the Prussian blue, draw the legs and claws, and jot in some feathery marks on the chest. Sharpen the black pencil and define the eye, beak, head markings and wing tips – the dark colour enhances the brightness of the white areas. Continue with the black, feathering in short strokes on the underbody. Work a little brown ochre over the body.

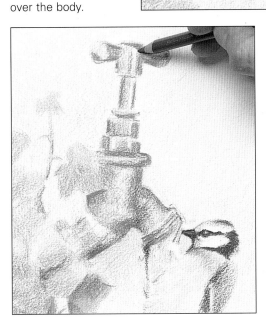

7 ◄ **Add definition to the tap** Work a little more brown ochre on to the bird's chest and strengthen the yellow feathers with deep cadmium. With a mid brown pencil, build up the shadows on the tap to refine its form. Emphasise the darkest shadows with a deep grey pencil.

8 ▲ **Create a rich colour blend** Now blend several colours – deep grey, viridian, leaf green, Prussian blue – to produce deep, rich colours on the tree stump and leaves. Work around the veins, leaving them as light green. With deep grey, define the bird's top leg and add more feathering to the body. Brighten the bird with cerulean blue and intensify the background around it with grass green.

As the focal point of the composition, the blue tit can be worked up further by strengthening its colour and adding details to its plumage. The ivy leaves, too, will look deeper and richer with more blended pigment.

9 ▶ Model the bird Strengthen the background around the bird with leaf green. Darken the underbody and tail with deep grey. Use white to pick out pale feathers. Deepen the bird's chest with Naples yellow and its back with kingfisher blue. Draw a strong line of Prussian blue along the wing, then feather in strokes on the body with black.

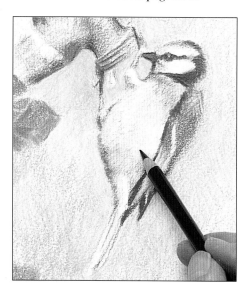

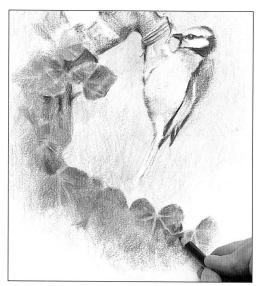

10 ▲ Darken the leaves Build up the depth of colour in the leaf·shadows by blending black, leaf green and Prussian blue, pressing hard to fill the grain of the paper. Finally, work the leaf green over the veins.

THE FINISHED PICTURE

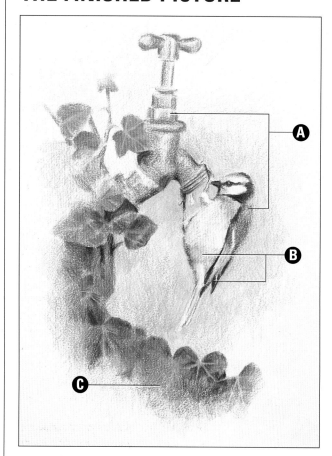

A Hard lines
The sharp lines and straight facets of the tap differentiate the hard metal surface from the soft feathers of the bird.

B Bird's plumage
The fine details of the bird's markings were worked with well-sharpened coloured pencils, using both firm lines and feathery strokes.

C Blended colours
A wonderful depth of colour was developed by working a range of shades one over the other, so that each hue glows through the subsequent layers.

Tonal drawing

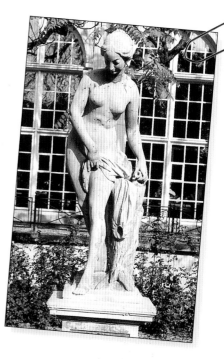

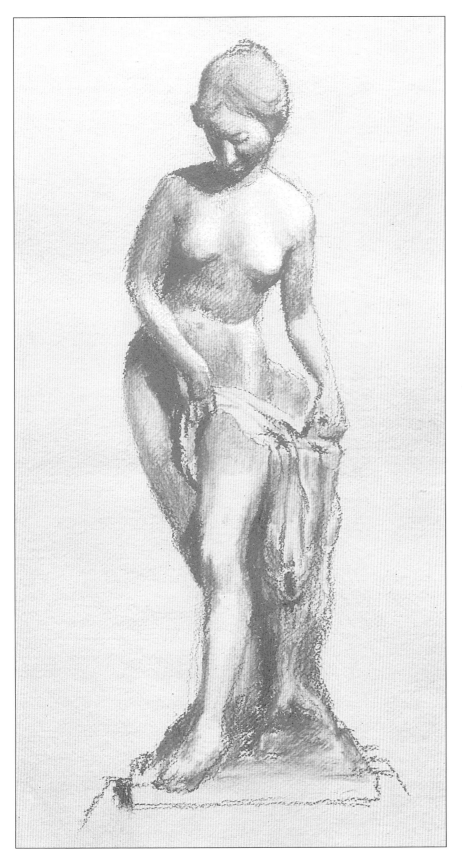

Draw in the style of the Old Masters, using a sanguine hard pastel to portray the fluid grace of this stone carving.

I f you do not have a life model to pose for you, drawing a classical statue is a good substitute. The one used as the inspiration for this project leans gracefully towards a tree stump and has a garment draped across her leg, offering a variety of textures. The sunlight falling on the statue creates deep shadows that contrast with the light stone.

Building up tones

The subject is built up as a tonal drawing with minimal line work. Form the figure by using the hard pastel to create dark and medium tones and leave the grey paper to stand for the light tones.

Hard pastels are square-shaped. You can use them on their sides to lay down broad areas of flat colour, breaking them into shorter lengths if necessary. The pastels can also be sharpened to a fine point for more detailed work.

◀ **A classical statue is an ideal subject for practising careful observation of tone when drawing a figure.**

1 ▼ Establish the figure Using a sanguine hard pastel, lightly draw the outline of the figure. Set up the tonal pattern from the outset by working the main areas of shadow.

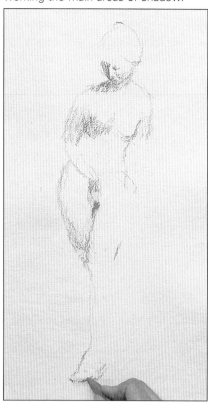

2 ▼ Distinguish dark and mid tones Darken the shadows on the face, shoulder and under the breasts by pressing harder with the pastel. Add dark tone where the right arm casts a shadow across the hip. Now create a mid tone on the torso by shading less heavily.

DEVELOPING THE PICTURE

Use a torchon to smooth and blend the pigment – this tool will give you more flexibility in creating a range of tones. With the pointed tip, you can work into even quite detailed areas.

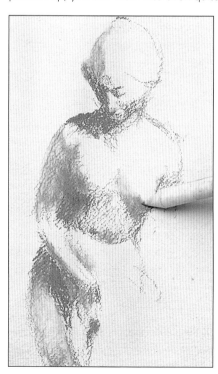

3 ◄ Smooth out the pigment Rub the tip of a torchon over the heavily applied pigment on the thigh and under the breasts. Then, using the colour you have picked up on the torchon, work a light tone over the lower thigh, the breasts and the hair. Work over the right arm with the torchon and define each side of the forearm with picked-up colour.

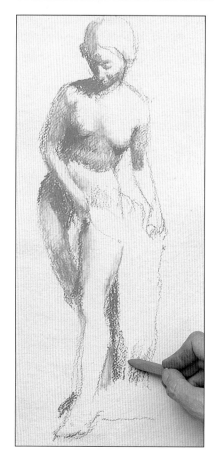

4 ◄ Add more line drawing Work into the face with the torchon, then rub it over the torso up to the shadow between the breasts. Changing back to the sanguine hard pastel, define the hairline and draw the statue's left arm and leg. Outline the draped fabric and the tree stump. Now add more tonal shading – a mid tone on the left upper arm and a dark tone for the shadow between the leg and tree stump.

5 ▶ Develop the legs Darken the tone around the fabric in the statue's hand. Build up a deep tone for the shadow cast by the statue's left knee. With the torchon, smooth over the dark shading on the right thigh and transfer some of this pigment to create a mid tone on the left knee and foot.

EXPERT ADVICE
Making a sharp tip

The square ends of hard pastels are not suitable for drawing small details. However, you can easily sharpen a stick to a very fine point. First carve away some of the pigment with a craft knife to round off the end. Then insert the stick into a pencil sharpener with a large hole and sharpen it in the usual way.

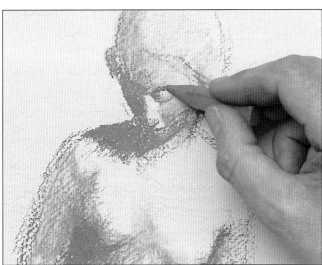

6 ◀ Draw facial details Rub the torchon over the hair and face to show the mid tones here, but leave the nose pale. Sharpen the sanguine hard pastel (see Expert Advice above) and define the eyebrow, lip and nostril.

7 ▶ Extend the tonal shading Develop the shadows on the left arm and smooth them with the torchon. Continuing with the torchon, extend the mid-toned shading over the stomach and left hip. Develop the tree stump with the hard pastel and torchon.

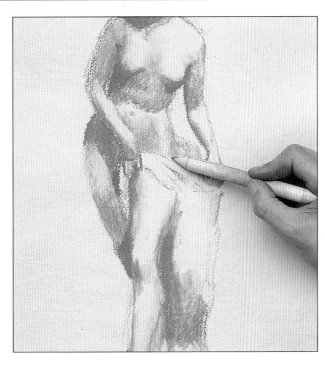

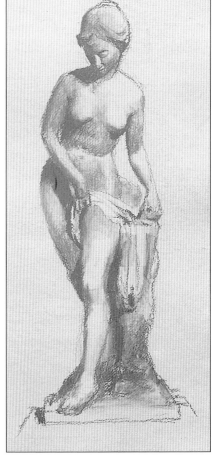

8 ▲ Complete the shading Redefine the hair by drawing a few strands. Darken the deepest shadows on and around the legs. Put a mid tone on the left thigh with the torchon. Define the toes with pastel. Then draw fabric folds and the top of the plinth. Shade the fabric, plinth and stump and work over them afterwards with the torchon.

A FEW STEPS FURTHER

Although the statue is now tonally correct, you might like to extend the tonal range by using a white hard pastel. This creates a tone lighter than the grey of the paper.

9 ▶ Add texture
Sharpen the sanguine hard pastel and add more folds to the fabric, rubbing in some mid tone with the torchon. Draw grain lines on the tree stump. To create highlights here, you can remove pigment with a putty rubber.

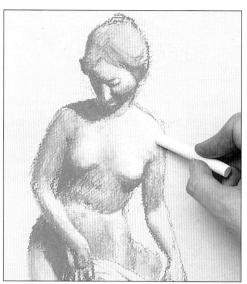

10 ▲ Create the lightest tone
Use a white hard pastel to highlight areas of the statue. Shade it over the shoulder, breasts, arm and hip. Add a little white to the facial features and the temple.

THE FINISHED PICTURE

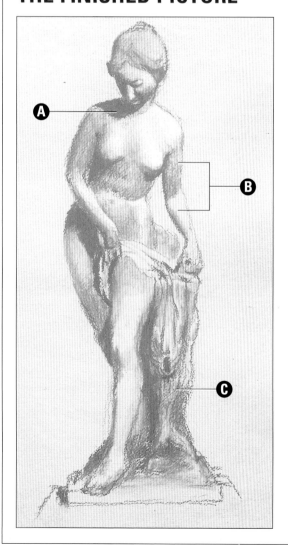

A Heavy pressure
The darkest tones in the drawing were created by pressing down on the hard pastel, so that the pigment completely filled the grain of the paper.

B Soft contours
The rounded forms of the limbs were built up by clever use of tonal shading, the paler areas appearing to come forwards while the darker areas recede.

C Textural contrast
As a contrast to the smooth surface of the body, the tree stump was drawn with plenty of texture to give a rough, gnarled appearance.

Experimental still life

This still life of fruit and vegetables gives you the chance to be inventive and make use of a range of different materials, tools and techniques.

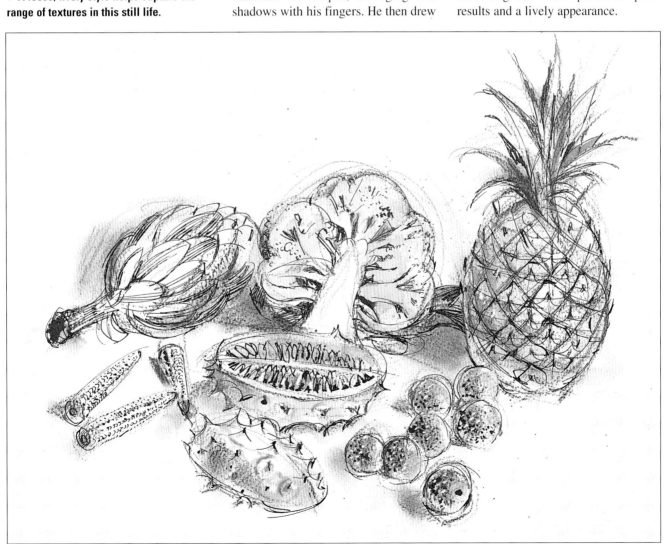

The liveliest drawings often result from using a combination of media and techniques in a free, experimental way. This group of fruit and vegetables makes an ideal subject for an expressive drawing. The basic shapes are not complex, but there is a good variety of textures to play around with. The pineapple and the bright yellow kiwano fruit have exciting spiky

▼ **A loose, lively style helps capture the range of textures in this still life.**

skins, the artichoke is smooth but fibrous and the lychees have a rough, pitted surface.

Unexpected results

The fruit and vegetables were spread well apart, allowing the artist to consider each item individually and to work out an imaginative way to portray it. He started with a bold drawing in sanguine Conté pencil to establish the shapes, smudging soft shadows with his fingers. He then drew

the main features with a dip pen and ink before experimenting with techniques such as wax resist, spattering and scratching off. These produced quick results and a lively appearance.

FIRST STEPS

1 ▶ Draw the basic shapes Use a sanguine Conté pencil to draw the shapes of the fruit and vegetables as ovals and circles. Begin to show their individual textures. A pattern of crossing diagonals and curves suggests the skin of the pineapple; light shading on the rough paper imitates the lychee skin.

2 ▼ Put in some shadows Work on the yellow kiwano fruit, drawing spikes on the skin and seeds inside. Show the hollows in the cauliflower and develop the pineapple skin and leaves. Now put in some of the shadows. Rubbing with your finger, smudge the shaded side of the pineapple.

USING OTHER MEDIA

Once the basic composition of the still life is established, introduce pen-and-ink work and a few experimental techniques. Each fruit and vegetable has a characteristic surface and it's fun to discover effective ways of describing these.

3 ▶ Change to a dip pen Lightly shade the Conté pencil over the pale side of the lychees, then fix the pigment with spray fixative and leave to dry. Change to a fine dip pen and Indian ink and work over the pineapple, redefining the skin segments and the leaves.

4 ◀ Develop the pen-and-ink work Continue working on the pineapple, emphasising its spiky texture. Similarly, work over the spiky skin of the kiwano and draw its seeds. Outline the cauliflower florets and dot in their texture, then draw over the artichoke leaves and define the fibrous stalk. Dot texture on to the lychees and baby corn cobs (see Expert Advice opposite).

254

EXPERT ADVICE
Dab and blot

Using a fine dip pen for line and textural work will produce sharply defined marks. You can soften and broaden them by smudging with your finger. Try this, for instance, on the textured dots of the lychees and the seeds in the kiwano.

5 ▲ **Try using wax resist** Take a white candle and rub it at random over the cauliflower florets to act as a resist. Water down a little Indian ink and paint it over the wax with a Chinese brush, blotting off any areas that look too dark with kitchen paper. The wax repels the ink, leaving the waxed areas light and giving a good imitation of the cauliflower's texture.

6 ▶ **Paint with a rigger** Use the wax resist technique on the seed area of the kiwano, then paint some of the dilute ink over the lychees. Now rub pigment from the sanguine Conté pencil on to some scrap paper and wet it with clean water, using a No.4 rigger brush. Brush the resulting colour on to the kiwano skin to show the orange linear pattern.

7 ▼ **Spatter on texture** Spattering is a quick way of adding texture. Make a darker mix of Indian ink and water and pick some up on a No.5 soft round brush. Hold the brush over the lychees horizontally and tap the handle with your finger so that the ink spatters droplets on and around the fruit.

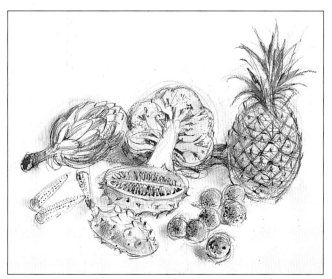

8 ▲ **Work with brush and pen** Using the No.5 brush and the paler ink wash, paint shadows on the pineapple. Change back to pen and ink to draw fibres on the artichoke leaves, then dot more texture on the cauliflower and baby corns.

Take a look at your work and see if you can improve the textures with any other techniques or marks. To lighten areas, you can scratch off pigment with a sharp blade.

9 ▶ Scratch off colour With the tip of a craft knife blade, scratch away some of the colour from the lychees, creating spots of white. Do the same on the kiwano seeds.

10 ▲ Add the final touches Use the sanguine Conté pencil to extend some of the cast shadows and smudge them with your finger. Emphasise the ridged texture on the baby corn cobs with tiny curved lines.

THE FINISHED PICTURE

A Strong contrast
One of the main features of the picture is the contrast between the two drawing mediums – the soft sanguine Conté pencil and the crisp black pen and ink.

B Wax resist
The wax resist technique creates a random effect of mottled white and grey areas, giving a good impression of the texture of the cauliflower florets.

C Convincing surface
Conté pencil rubbed over rough paper, spattered and dotted ink, scratched-off colour – all these effects contributed to the tactile appearance of the lychees.